Prison Picasso

The Millionaire Prisoner's Way to Sell Arts and Crafts

by

Josh Kruger
The Best-Selling Author of Pen Pal Success and Cellpreneur

Freebird Publishers
Box 541, North Dighton, MA 02764
Info@FreebirdPublishers.com
www.FreebirdPublishers.com

Publisher & Distributor: Freebird Publishers
Box 541 North Dighton, MA 02764
Web: FreebirdPublishers.com
E-Mail: diane@freebirdpublishers.com
Corrlinks: diane@freebirdpublishers.com
Toll-Free: 888-712-1987
Phone/Text: 774-406-8682
Send Letters to the Editor to the above address

All Freebird Publishers titles, imprints, and distributed lines are available at special quantity discounts for bulk purchases for sales promotions, premiums, fundraising educational or institutional use.

ISBN: 978-1-952159-33-6

Printed in the United States of America

PRAISE FOR THE MILLIONAIRE PRISONER BOOKS

"The Millionaire Prisoner is a terrific guidebook for prisoners who desire to make something more of their life, even while in custody."
- Christopher Zoukis, author of *College for Convicts; Federal Prison Handbook;* founder of prisonlawblog.com and prisoneducation.com

"The Millionaire Prisoner is one of the best books a prisoner can read. From A – Z, this book is the ultimate blueprint for how to hustle and win legally, from your prison cell, turn your negative into a positive, and get REAL money. If you read and implement the information in this book, you are guaranteed prosperity. It's a must-have in every prisoner's collection."
- Mike Enemigo, author, CEO of The Cell Block, and self-made Millionaire Prisoner

"I love your book … My mom paid $20 for it. It's worth it."
- Johnathan R., Texas Prisoner

"The Millionaire Prisoner is a must-read for all prison entrepreneurs. The information/perspective it gives is unique and motivating."
- King Guru, co-author of *How to Write Urban Books for Money and Fame, Prisoner Edition*

"It is like a breath of fresh air to be working on a manuscript that is so positive and helpful to people who need that kind of support. You will most surely be an inspiration to many who read your books. Your words have helped me also as I type."
- Jane Eichwald, *Ambler Document Processing*

"The Millionaire Prisoner is a mandatory must-have book for any prisoner that is tired of just going through the motions in prison. The Millionaire Prisoner honestly changed my way of thinking. If you're tired of asking your family and friends for money and want to make your own, get this book and learn how to become a Millionaire Prisoner."
- Joshua "Butterbean," Snyder, Illinois Prisoner

"[Y]our book is like the gospel to all prisoners and go-getters. I ordered your book The Millionaire Prisoner and I love it because it's full of wisdom, can put money in my pocket, and gives us lessons based on morals, integrity, and principles that will set the stage for success with no limits!"
- Jewell Saunders, Missouri Prisoner

"Two thumbs up for this book. One would have to be a complete fool not to take advantage of the program that is shared in The Millionaire Prisoner."
- Jeremey Winsor, Illinois Prisoner

"I am so grateful that I had the opportunity to read The Millionaire Prisoner…it was the sole inspiration when I first started this mail-order company. Your wisdom and example have helped me grow into my potential. I would not be where I am today without the knowledge you shared in your teachings."
- Steven Ortiz Soto, *Ortiz Publishing Group*

"Thank you for writing The Millionaire Prisoner. For me, this book will be one book that I will never throw away."
- Donnell Harrison, New York Prisoner

"You have meticulously put together a book that can give hope and inspiration to anyone who is even slightly interested in improving his condition. This book is jam-packed with any and every tactic necessary to build a wholesome and productive life!"
- Isaac "Sabur" Cook, Texas prisoner

On *Celebrity Female Star Power*

"Josh Kruger has done it again. Other companies may offer lists but nothing like the thousands of addresses in this book. This book is worth hundreds of dollars! The price alone makes this book a steal. If you like celebs as I do, then this book is a MUST have for you too."
- A. Meyer, Illinois Prisoner

On *Pen Pal Success: The Ultimate Guide to Getting and Keeping Pen Pals.*

"In a nutshell, armed with the knowledge of my results thus far: Would I buy Pen Pal Success again? For sure. Was it worth the money? Absolutely. Did I benefit from it? Without a doubt. Thanks to your publication I have met some great people from around the world. And my life is enriched because of it."
- Russel H., Federal Prisoner

"I'm pleased to say that your system does work, one gal has fallen madly in love with me."
- John H., Akron, Ohio
- *"Read Pen Pal Success. It can show you how."*
- Krista Smith, author of *Pen Pals: A Personal Guide for Prisoners*

"You're a genius. I just came off a visit with my girl. Your book works! Thanks, bro."
- C.B., Illinois Prisoner

DEDICATION

To my beautiful mother, Cheryl Lynn: Thank you for giving me the gift of life and supporting me all of these years. And thanks for putting me in those art classes when I was a kid. Your life has been a masterpiece in that you stood by three challenging kids through rough times and still kept giving back to those who were less fortunate. You are a work of art that is priceless.

To my "gorgeous nightmare," Skylar: You will always have a place in my heart. Thank you for getting me back on track. If you were a painting, it would be a dark and twisted masterpiece in which people would easily get lost. To hell and back. Etf ♥ LOD!

TABLE OF CONTENTS

WARNING-DISCLAIMER

This manual/directory is designed to provide helpful and informative material on buying, trading, selling, and investing in arts and crafts while behind bars. It contains the opinion and ideas of its author, not necessarily those of the publisher. It is sold with the understanding that the author and publisher are not engaged in rendering professional services in this manual. If the reader requires personal assistance or advice, a competent professional should be consulted.

It is not the purpose of this manual/directory to reprint every tip, tactic, and/or strategy that is available to a prisoner for making money off arts and crafts, but instead to complement, amplify, and supplement other books. You're urged to read all the available information and material, including the books listed throughout this manual/directory. Learn as much as you can, then develop your strategies and implement your plan. This manual/directory is designed to provide accurate and authoritative information regarding arts and crafts. While every effort has been made to ensure factual accuracy, no warranties concerning such arts are made.

Making money off arts and crafts is not some pie-in-the-sky get-rich-quick scheme. Anyone who wishes to achieve prosperity by selling arts and crafts must decide to invest a lot of time and effort into it. The advice and strategies contained in this manual/directory are to educate and entertain. While it was the author's quest to make this manual as complete, up-to-date, and error-free as possible. However, there will be errors, both typographical and in content. Because of this, it should be used as a guide, and not the be-all, end-all on making money off arts and crafts by prisoners.

The fact that a website, business, organization, and/or association is listed or referenced in this manual/directory as a citation and/or a potential source of further information does not mean the author or publisher endorses the website, business, organization, and/or association, or what those entities may offer. It should also be noted that the websites listed, and other entities referenced herein, may have, by the time you're reading this changed, disappeared, closed, and/or dissolved.

Some terms mentioned in this book are known to be or are suspected of being trademarks of different entities. The use of a term in this book should not be regarded as affecting the validity of any trademark or service mark.

This manual/directory should not substitute for competent advice from an art broker/dealer specializing in selling arts and crafts. You should never automatically go against the advice of your broker/dealer because of something you've read in this manual/directory. Reading this manual/directory doesn't create an author-publisher relationship or contract between you and the author, the publisher. And even though the author has sold art before, and may in the future, he's not your broker/dealer. Reading this manual/directory doesn't create an art brokerage/dealership between you and the author or publisher.

Anyone who takes offense that the author uses "he" instead of the politically correct "he or she or him or her" throughout the book, the author and publisher apologize ahead of time. They have done this because prison is still a male-dominated world, although women prisoners are the fastest-growing segment in the prison-industrial complex of America. The author has tried to use "you" and "they" as much as he could, but in some places, he couldn't. If you're transgender or a female prisoner, he's speaking to you also. Don't let the fact that the author may have used a male

pronoun cause you to get dismayed. You can experience success just as much, if not more than male prisoners can.

This manual/directory is not intended to teach you how to draw, paint, sketch, sculpt, build, do crafts, or any other technique, or practice in the art and crafts world. There are already enough books on the market for such. The author and publisher specifically disclaim any views about the type, technique, or quality of your art or crafts.

The author and publisher specifically disclaim any responsibility for any liability, loss, or risk, personal or otherwise, which is incurred consequently, directly, or indirectly, of the use and application of any of the contents of this manual/directory.

INTRODUCTION

*"Adapt what is useful, reject what is useless,
and add what is specifically your own."*
– Bruce Lee

In prison, anyone can be anything they want. Most of us prisoners have built-in bullshit detectors that we've honed over our lifetime. I've spent over 27 years of my life incarcerated, and I've heard all kinds of games that prisoners run. One of the biggest areas of prison life where you can't fake stuff is the size of your bank account. If you got money, you could live like a king inside prison. If you got money, you go to the commissary regularly, have magazine subscriptions, and order anything your prison allows. Of course, money isn't everything. But it certainly helps your incarceration go smoother. Because of this, I've made it my mission to find prisoners who are making money legally while inside. Then I try to use what they're doing in my own life so I can make my prison stay better, easier, and smoother. Sometimes it works for me, sometimes it doesn't. Writing books works for me. I started writing books because I saw other prisoners doing it and making money. This will be my sixth book in seven years. In research for my *Millionaire Prisoner* books, I found many prisoners who were making things happen. Some of you may know some of these prisoners from my articles in *Inmate Shopper,* or my books, *The Millionaire Prisoner, Cellpreneur, and Pen Pal Success?* They can help you just as they've helped me. I tell my story in all my books which I'll now share briefly for those of you who haven't read it or heard it before.

"An expert is a person who has made all the mistakes that can be made in a very narrow field."
– Niels Bohr

WHO AM I AND MY ROLE IN YOUR LIFE?

I'm a 42-year-old author serving a life sentence for a felony murder conviction. I started doing time when I was 14. On this bid, I have been down since 1999. I used to be in a gang in a small town in central Illinois. I sold drugs and did armed robberies. I was dumb as hell. I had every opportunity to go down a different path. I had a job offer to work at UPS. I was enrolled in community college for Computer-Aided Drafting (CAD-CAM). I also had a good-paying job at a major distribution center in the Midwest. But I couldn't stay the course and the streets kept calling me. So, I wound up in prison. While inside, I graduated from Crown Financial Ministries and experienced numerous successes, and my share of failures also. You'll read about some of them in this book. *Prison Picasso* is just another step in a series of steps that lead to my ultimate goal of helping as many of my fellow prisoners as I can achieve their success.

For the past 15 years, I have become obsessed with finding strategies that prisoners could use to better their lives. At first, I did this so that I could find the keys to building a better life for myself. But I quickly realized that by helping my fellow prisoners out of their ruts, I could benefit all mankind, and help myself at the same time. As Dr. Mike Murdock says, "your mess becomes your message." Becoming an author has helped me in all areas of my life. The thing I love most is when I get letters from other prisoners thanking me for writing the books that I have. That's worth more to me than all the royalty checks I have ever received. Yet still, I've always known that there were people (including prisoners) who were making a whole lot more money than me. A lot of them were using arts and crafts to do that.

WHY PRISON PICASSO AND NOT ANOTHER BOOK?

My last book project, *Celebrity Female Star Power,* started as a few paragraphs in my first book, *The Millionaire Prisoner* (now published by Mike Enemigo at The Cell Block). I wrote about how Texas death row prisoner James Allridge used his artwork to win the support of Hollywood stars like Elizabeth Taylor, Robert Redford, and Susan Sarandon. (More about Mr. Allridge later in this book.) After that, I kept coming across other prisoners who had contacted celebrities from their prison cells. Then I was moved into a cell with a prisoner named Ju-Boy. He loved celebrity birthdays and collected them by stalking celebrity gossip shows, magazines, and newspapers. I saw magazines like *US Weekly, OK, and Star, which* were more popular with the prisoners around me than *Prison Legal News.* So, I did a celebrity address book. If you're into female celebrities, then you'll want to grab a copy of *Celebrity Female Star Power* today! (See the ad at the back of this book.)

Just like *Celebrity Female Star Power,* this book started as part of *The Millionaire Prisoner.* In the "Ways and Means" chapter of *The Millionaire Prisoner,* I discuss using arts and crafts, as a way, to become a *Millionaire Prisoner.* Then I kept seeing all these prisoners doing great arts and crafts inside, only to sell them for items from the commissary. Believe me, I love having a full property box with snacks that I can eat any time I want. What prisoner wouldn't? Except now, I think bigger than a full commissary list. I think in terms of millionaires, not prisoners. That was my idea for this book: Why can't I teach my fellow prisoners how to become self-made *Prison Picassos* in their own right? So, I did the research, and you have the results in your hands right now. That's what this book is about. Teaching you the strategies that can help you achieve all your dreams in the art world. My *Millionaire Prisoner's* mission statement has always been to deliver quality information to your cell that you can use right away to make things happen. No fluff, no filler, just game laced by a Cellpreneur who is living out what I preach and teach.

WHY PRISON PICASSO AFTER PABLO PICASSO AND NOT ANOTHER ARTIST?

First, because his name is easily recognized after all these years, I humbly admit that it's a marketing ploy, and *"Prison Picasso"* sounds better than the other choices I had available. Second, and this is most important, is because he's the ultimate artist success story. When he died in 1973, his estate was estimated to be worth $750 million. He was also prolific. He produced over 13,000 paintings and about 300 sculptures. He had charisma and was a seducer. He produced so much and was everywhere that his art became familiar. One of his paintings sold for over $100 million. Picasso achieved face and name recognition. I hope you can do that also. We can learn a lot from Picasso. He left a simple blueprint for you to follow to achieve success in the world, no matter what your chosen vocation is:

- Be productive in your work!
- Get exposure for your work!
- Connect with people everywhere!

I will show you how to do that in this book. Because if you can do these three things, you can become successful. Picasso is the archetype you should strive for.

"We artists are indestructible; even in a prison, or in a concentration camp, I would be almighty in my world of art, even if I had to paint my pictures with my wet tongue on the dusty floor of my cell."
– Pablo Picasso

Picasso is not the only expert I've drawn from or found in my research. Writing a book is a collaborative effort, even if I do sit alone in my cell while I'm writing.

About the Experts

Here are some of the people that I've learned from in my research for this book. I also humbly admit that I heavily quote from them in this book, and I've stolen all their great ideas.

Kim Solga

Kim operates KidsArt, an online-art education, and e-commerce website. She has her artwork on Solga.com, and her own Etsy shop, Blue Otter Art. She has a blog, MyEtsyBlog.com, which is dedicated to helping beginners set up and promote an Etsy shop. She is the author of the fantastic book, *The Everything Guide to Selling Art & Crafts Online,* and operates the blogging community sellingartsandcraftsonline.com.

Cory Huff

Cory is the author of the great book, *How to Sell Your Art Online: Live A Successful Creative Life on Your Terms.* He's the founder of TheAbundantArtist.com and blogs regularly about leaving "the starving artist" mentality behind at theabundantartist.com/blog.

Brainard Carey

Brainard is the author of two books, *Making It in the Art World* and *New Markets for Artists.* He's an artist, professional coach, and frequent lecturer on career development. His conceptual art projects are created under the name of PRAXIS in collaboration with his wife, Delia Corey. They have been exhibited at the Whitney Museum of American Art, MOMA, and other venues around the world. He operates the website: yourartmentor.com.

Daniel Grant

Daniel is a contributing editor of *American Artist* magazine. He is the author of numerous books, including *The Business of Being an Artist*; *The Fine Artist's Career Guide,* second edition; and *Selling Art Without Galleries.* His articles and essays have appeared in such publications as *ARTnews, Art in America, The New York Times,* and *The Washington Post,* among others.

Jackie Battenfield

Jackie is an artist and author. Her work is represented in galleries throughout the United States and over a thousand collections worldwide. She teaches professional practices at Columbia University and for the Creative Capital Foundation. Her book is *The Artist's Guide: How to Make a Living Doing What You Love.* You can find out more on the book's companion website, artistcareerguide.com.

Kari Chapin

Kari is the author of *Grow Your Handmade Business* and *The Handmade Marketplace.* Combining her background in marketing and publicity with an avid enthusiasm for crafts and social networking, she offers personal coaching and creative business e-courses at karichapin.com. You can follow her on pinterest.com/KariChapin.

Tad Crawford

Tad is a lawyer and publisher of Allworth Press in New York City. He is the author or co-author of many books on business and the creative professions. He was the recipient of the Graphic Artists Guild's first Walter Hortens Memorial Award for service to artists. He has also been a grant

recipient from the National Endowment for the Arts for his writing on behalf of artists. You can learn more about his books by calling 1-800-491-2808 or visiting allworth.com.

"Creativity is knowing how to hide your sources."
– Albert Einstein

A WORD ABOUT PRISON PICASSO

This book is not an instructional how-to manual showing you how to do artwork or make craft items. There are plenty of those books on the market already. Nor is this book the first one to deal with prison art. In *Cellblock Visions: Prison Art in America,* Phyllis Kornfield deals with the process of artmaking in prisons, not the political aspects of prison reform. In *Marking Time: Art in the Age of Mass Incarceration,* Nicole Fleetwood deals with the politics of artmaking in prisons, and in her words: "art as politics in an era of massive human caging and other forms of carceral power." I leave those areas to them. In *Prison Picasso,* I deal with how a prisoner can sell arts and crafts to better their financial life. I leave the scholarly works to the scholars in universities across America. I do encourage you to get, read, and study both *Cellblock Visions* and *Marking Time.* Both are great books and will open your eyes to a lot of stuff about art in prison. Just because I'm not a scholar doesn't mean we cannot learn from them.

"One of the reasons why it is crucial to attend to the art practices of the imprisonment is because the carceral state not only removes people from their homes and neighborhoods; it also shapes how prisons and people confined to them are viewed in public life."
– Nicole Fleetwood

HOW TO GET YOUR MONEY'S WORTH FROM THIS BOOK

Read it, peruse it, study it. Prop it up so you can see the cover and title staring at you daily. Keep coming back to it for advice and inspiration. No company, artist, or resource has paid me to list them in this book. I included the people and places I found in research that I felt could help you become a *Prison Picasso.* You may know about other companies, people, or resources not listed in this book. Use them. Test them out. This book is not the final say of arts and crafts books. It should be enough to get you started on your journey though.

Lastly, there have been some companies in the past who have preyed on prisoners by charging them fees ($ money upfront) to display or submit their work. You should never have to pay money to get your work reviewed or accepted for publication/showing/exhibiting. It's not standard business practice in the art world. There are a few tiny exceptions. Some contests have an entry fee. And some art and craft shows' have a booth rental fee or application fee? Other than that, beware of people or companies that ask for upfront fees to display or accept your work.

Those of you who know my work understand that it's my mission to bring to your cell quality how-to information that you can use in your life right now. But the only way this knowledge can become wisdom is if you implement it into your life. To help you do this, I came up with a simple formula for reading and studying how-to information that can help you master it. (I had the help of the late, great motivational speaker and author Zig Ziglar, in coming up with this formula. For more on this,

read "The Art of Reading Non-Fiction" in my book, *The Millionaire Prisoner.)* Here's how you can read this book to get the most from it:

1. Read through this book quickly to get the gist of the message, underlining, or highlighting the things that really "grab" you. Only stop to look up words you don't know or write them down to look up later. This first reading allows you to become familiar with the book.

2. As you read this book the second time, keep a notebook of ideas generated by the book that you can personally use. The objective is not to see how quickly you can get through the book, but what you can get out of the book.

3. In your third reading, invest time and patience in gleaning additional ideas you may be missing in your second reading. Carefully examine each chapter. Go over what you have highlighted or underlined. Put anything you missed in your notebook.

4. The fourth reading will enable the book to become an integral part of you, enhancing your effectiveness. After this reading, you can place the book in your collection, and it will be a treasure trove, reading and willing to supply you with any knowledge you may need.

5. Find other prisoners who have read this book, or share it with them, and then discuss it together to see what you got out of it. You may gain additional insights from their ideas and thoughts that you didn't see on your own.

A WORD ABOUT THE ART/CRAFT MARKET ADDRESSES

This book is divided into many different niche market sections. From contexts to art fairs, to poster and print-sellers. I compiled these listings from numerous sources, including but not limited to, magazine articles, books, and online sources. At the time I'm writing this the COVID-19 pandemic is raging all around us. Some of these companies may never reopen after this crisis. Always try to have someone check their website for their current status. Or e-mail them to find out. If you send them a SASE and get a "return-to-sender" finger on your envelope, please let me know. That way I can update the listing in future editions of this book or take them out completely.

The other reason I've included the listings that I did was to inspire you. To spark your imagination, and to get you to think outside your cellblock. The *Millionaire Prisoner* mindset thinks beyond commissary items. Once you see how much some of these companies are selling artwork for, you'll have a new outlook. And you should come up with a bunch of new ideas. One idea could pay for the cost of this book.

"The world of reality has its bounds; the world of imagination is boundless."
– Rousseau

Also, be patient when contacting companies or people about your work. Some of these people get large quantities of submissions every day. They may not have gotten around to reviewing your work yet. Lastly, there have been some companies in the past who have preyed on prisoners by charging them fees ($ money upfront) to display or submit their work. You should never have to pay money to get your work reviewed or accepted for publication/showing/exhibiting. It's not standard business practice in the art world. There are a few tiny exceptions. Some contests have an entry fee. And some art and craft shows' have a booth rental fee or application fee. Other than that, beware of people or companies that ask for upfront fees to display or accept your work.

A FEW FINAL WORDS

I invite you to stay in touch with me. The tips, tactics, and strategies that I advocate using in this book will need to be updated as better processes become available. I intend to learn those new processes and use them…and share them with you. If you find some successful systems that a prisoner can use, or if you experience success using this book, write me and let me know about it. There's a questionnaire in the back of this book that I hope you'll fill out and return to me. I just might put you in the next edition of this book or other *Millionaire Prisoner* products. Also, so that I can congratulate you. Not just for what you achieved, but for making the world a better place by beginning to break the cycle of prison. Let's get to it. You can start your *Prison Picasso* journey by turning to the next page.

"I am always doing that which I cannot do, so that I may learn how to do it." –
Pablo Picasso

"Let's skip all the stress and drama this year and just plan a staycation."

"The principle of true art is not to portray, but to evoke."
– Jerzy Kosinski

CHAPTER 1

A PRISONER'S JOURNEY WITH ART

*"The quality of a painter depends on the amount of the
past he carries with him."*
– Pablo Picasso

You are already a professional artist. Yes, you are. Have you ever sold handmade greeting cards to your fellow prisoners in exchange for commissary? That makes you a professional. You are making money off your art. You're doing arts and crafts so you can eat. So, you don't starve. Another prisoner may do craft items. I know one who makes bracelets and rings out of yarn or string braided up. He dyes them different colors and can put names or letters in them. He sells them for $3 to $5, depending on how many characters you want on your bracelet. I have bought a few of them for mom for Mother's Day, and one for my wife. She wore her pink bracelet as a hair tie to keep her dreadlocks out of her face when she played football. What's the difference between him selling bracelets to us prisoners and the artist who sells her bracelets on Etsy.com? Nothing – except whom they sell to, how, and where they sell their art. Prison Picasso is geared to helping you take your art outside of prison and into the free world. That way you can build your career and get a better return on your investment of time.

MILLIONAIRE PRISONER'S ART STORY

I know all about your struggle. I've been there. I am an artist. When I was a kid, I used to sit in my room listening to music and drawing. This was the middle of the 1980s, and my mom's boyfriend at the time, Ralph, had a huge collection of comic books. I remember him having Conan, Red Sonja, and other comics. He also had an extensive record collection, and I loved the Iron Maiden covers. I would pick a comic or album cover and take it to my room and draw it. Not trace it. But set it up on my drafting table and draw it. Then I'd run downstairs and show my mom and Ralph. They saw that I had a little talent, so my mom enrolled me in an art class at the local community college. That was fun and I learned a lot.

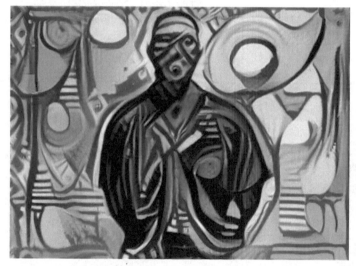

My first experience with an art contest was when I was in the 4th grade at East Park elementary school in Danville, Illinois. East Park used to be a junior high school for 6th, 7th, and 8th graders. Then the Danville school district decided to close all the little neighborhood schools and turn East Park into one big elementary school for kindergarten to 5th grade. The principal announced that they would have an art contest to determine the new image of the mascot "Eddie East Park." The kids would vote, and the winner would get a prize and be announced in front of the whole school during an assembly. I went home and got to work. At the time I didn't know any better, so I took different parts of different characters and made my character. I made my Eddie East Park, so he was holding a basketball with some high-top sneakers. I spent all night on it.

The way the contest was set up is that you had to win your class contest first, then the class winners would be voted on by the whole school. The main competition in my class was a Latino kid named Ezekiel. He was a better artist than I was, but he was too shy. I was not shy, and I had all the girls in my class on my side because I always flirted with them. I won the class for Mrs. Smoots' 4th-grade room. After that, everywhere I went, kids were telling me they liked my Eddie East Park the best. I felt like I was going to win. Sure enough, when the votes were tallied, I had won. That next week, I would be called up in front of the whole school and given my prize money. Eddie East

Park would be my drawing immortalized forever, and I was going to spend my money on my secret crush, Annette Hernandez. Or so I thought.

About three days later the principal, Mr. Denman, called me and Mrs. Snoots out of class. He had my original drawing in one hand and another photo in the other. He told me that even though I had won the contest they couldn't use my drawing because the face of my Eddie East Park looked like the face of the character in that other photo. A "concerned parent" had shown it to him. Snitch! They were going to award the prize to the second-place kid. I told him I could fix it. I would change the face. But he said it was too late. So, during the assembly the following week, I watched in horror as Eddie East Park became a box with arms. I screwed that one up. I'm sorry to all the future kids of East Park who had to witness their mascot be a box with arms. I watched as Mr. Denman handed the other kid the winner's check and I wanted to cry. I looked over and saw that Annette Hernandez was looking at me with her big brown eyes all sad. It was then that I knew I had blown more than just the art contest. That was my first experience with copyright law, and I vowed it would be my last. After that, I started getting into trouble at school. I was diagnosed with ADD and impulse control. I tried to tell the school's psychologist that it's all because every day I come to school I see a box with arms named Eddie East Park greeting me. He wasn't going for that. I hated how school was. Why did I have to wait till the rest of the class got done? Boring. I barely made it out of elementary school and didn't do art that much.

> *"All the problems of the human race stem from man's inability*
> *to sit quietly by himself in a room."*
> *– Blaine Pascal*

A few years later, I ended up in the Illinois Youth Center at St. Charles. It's a prison for juvenile delinquents. IYC- St. Charles is most famous for the place where the movie "Bad Boys" with Sean Penn was filmed at. When I arrived at St. Charles, I was 15 and if I didn't straighten up my act, I would be there until I was 21. I ended up doing two years there. Before I left, I got my first experience with art therapy. In the summer of 1994, we had a psychologist who brought in two college students from one of the area's schools. They were going to school to be art therapists and were going to intern at St. Charles. I happened to get assigned to one of the art therapy classes. The intern who worked with us was a beautiful, tall brunette with a soft spot for yours truly. When we had art therapy, I'd slip her my little love letters. She couldn't write me back, but she would pull me out of school and take me on "therapy walks" around the pond inside the fences of St. Charles. Hey, she was helping me with my issues, and we were working on the "art" of love. I'll leave it at that because anymore, and this will have to go in one of King Guru's Pretty Girls Love Bad Boys books. (Maybe if I would have read his books way back at East Park, I could have got Annette Hernandez?) Then my art therapist intern left to go back to school, and I hated art again.

During one of the art therapy classes, I met another kid who was a graffiti artist. We called them "taggers" because that's what they did. They "tagged" their names all over the place. He was from Chicago, and he had all these photos of places that he tagged. Some he had to climb up the side of a train trestle to tag underneath it. Or climb up onto a billboard. He was not only risking injury but also getting arrested. He was my first introduction to an artist showing off their work with photographs.

I was paroled out of IYC-St. Charles in 1995. I had gotten my G.E.D. while inside so I immediately enrolled in Danville Area Community College (or DACC) for their Computer Aided Drafting Program. I planned to get my Associate Degree in Applied Sciences for CAD-CAM and then go to the University of Illinois in Champaign to become an architect. I have always loved to build stuff. I could sit there for hours by myself and build model cars and airplanes. I liked the idea of using my art to build and I knew architects made a lot of money. And some, like Frank Lloyd Wright, were

very famous. That was my plan to get my family out of the hood. That plan didn't last long. The streets called me. So, I took my Pell grant check and went back to the block. A few months later, I was in the Vermilion County jail for armed robbery.

At that time, you could only spend $25 a week on commissary in our county jail. The food they served us was horrible. So, I wanted a way to add to my commissary stash. My friend Casper was an albino dope-fiend who had been to adult prison and used artwork to hustle. He and another older convict taught me how to do art on envelopes. I would buy a box of plain, blank white envelopes at the Commissary and draw cartoon characters and other pieces on them. Then I would sell them to my fellow prisoners for "ghetto burgers." A ghetto burger was a jumbo Oatmeal Pie opened and placed with a Nutty Bar inside of it and made into a sandwich. A ghetto burger was worth 60¢ in the commissary and it would fill you up at night when your stomach was in your back. I set up a system where I'd work during the shift change lockdown from 2:30 pm to 4 pm every day. I could knock out 2 or 3 envelopes each day. I would plan ahead, and do Mother's Day, Happy Birthday, Thank You, Thanksgiving, and Christmas-themed envelopes. My Mother's Day and Christmas envelopes always sold out. I made a nice income in food, and I never went hungry. Once I got shipped off to real prison, I stopped doing artwork. I was too busy gangbanging and playing poker.

Some years later, after being sentenced to life in prison, I picked up art again while at Stateville Correctional Center in Juliet, Illinois. I used to watch all the painting shows on PBS because we didn't have cable TV at Stateville back then. I liked Bob Ross. So, I went to the commissary and bought a bunch of paints and brushes and canvases. Then I started painting. I wasn't trying to make money off them. I was just passing time and having fun. I did a few landscapes and sent them home. I ended up going to segregation for a shank and when I got my property back all my painting supplies were missing. Then I got transferred to another prison that didn't sell all the art stuff as Stateville did. So, I started writing books to pass time constructively.

Over the years, I have met a lot of prisoners who were way better artists than me? At Pontiac Correctional Center in Illinois, the LTS staff holds a weekly art class in the gym. Some guys just go to it to socialize. But a lot of guys go to it to learn how to do their artwork better. It was during one of my trips to the art class at Pontiac that I got the idea for this book. I kept asking myself why do most prisoners only sell their art for commissary? Why couldn't they sell their arts and crafts for real money like people in the free world? I knew they could, but I kept hearing a quote in my head, "they would do better if they knew better." This book will help you do better because after you're finished reading it, you'll know better.

"Every child is an artist. The problem is how to remain an artist once we grow up."
– Pablo Picasso

POLITICAL 'TOON By Arkee

"The artist needs a roof, a crust of bread, and his easel, and all the rest God gives him in abundance. He must live to paint and not paint to live."
– Albert Ryder

POLITICAL 'TOON By Arkee

"As an artist, you are a creator, an inventor, and an innovator. You have that in common with some of the greatest business minds in the world today."
– Brainard Carey

"No great artist ever sees things as they are. If he did, he would cease to be an artist." Unknown

"An artist never really finishes his work; he merely abandons it."

Paul Valéry

CHAPTER 2

PRISON PICASSO MONEY MATH

" When bankers get together for dinner, they discuss Art. When artists get together for dinner, they discuss money."
– Oscar Wilde

THE BIGGEST ART MYTH

Ever heard the term "starving artist"? If you haven't, you can understand it. A lot of you do arts and crafts in prison so you can eat. Or get soap and toothpaste. Some of you are doing better than others. Okay, a few of you do arts and crafts because you love to do it and it helps pass the time? You would do it for free so any income you get is a bonus. This might not be a book for you? This book is for those artists (and crafters) in prison who are tired of getting scraps for their work. *Prison Picasso* is for the prisoner who wants to go from selling a painting for $40 to selling it for $400, then $4,000…and maybe $40,000? It's possible.

And it can be probable if you're willing to put it into the work. The first step is to get rid of the "starving artist" mindset of settling for commissary items. Instead, you will, and can, replace that mentality with the *Millionaire Prison Picasso* mindset. That is one with no limits. Your art (or craft) does not understand or respect prison walls and boundaries. So, you should not respect any limiting money walls and boundaries about your art. The internet has leveled the playing field. You can reach collectors on the other side of the world. And you can do it all from your prison cell if you want to? You can start small and build your way up. This book will help you do it.

"The goal here is to build a life that makes creating your best work not only possible but inevitable. And so, we must exchange this idea of a starving artist with a new term: Thriving Artist. If you don't want your best work to die with you, you must train yourself to think and live differently than the ways we've been told artists behave. Don't starve for your art. Help it thrive."
– Jeff Goins, Real Artists Don't Starve

No more excuses. No more fear. Believe in yourself. Believe in your dreams. Anything is possible. This is the first step to becoming a *Prison Picasso:* believing that you can. I believe that you can. The rest of this book will show you "how" you can, and "where" you can. Be inspired because your life is about to change for the better.

"It is not fate that bars your path. It is not a lack of money or opportunity. It is yourself – your attitude towards life. Change it – and you change all."
– Robert Collier

MILLIONAIRE PRISONER MONEY MATH

To make money, you need to go where the money is. And since I'm saying that a *Prison Picasso* can become a millionaire, I must show you the math behind it all. Simply put, to gross a million dollars you must sell:

- 1 million greeting cards at $1 each
- 500,000 greeting cards at $2 each
- 200,000 greeting cards at $5 each
- 100,000 greeting cards at $10 each
- 50,000 portraits at $20 each
- 20,000 portraits at $50 each
- 10,000 paintings at $100 each
- 2,000 paintings at $500 each
- 1,000 paintings at $1,000 each
- 500 paintings at $2,000 each

- 200 paintings at $5,000 each
- 100 paintings at $10,000 each
- 50 paintings at $20,000 each
- 10 paintings at $100,000 each
- 1 painting at $1 million!

No matter what type of product your art or craft is, the math will be the same. As you look at the numbers above, you can see that low prices won't make you a millionaire. Trust me, I know. I write and sell information products. I wish I would've started selling $1,000 paintings instead of $20 books. Small numbers don't make millionaires.

> *"You have to sell a lot of books to make what you can from the sale of just one painting."*
> *– Jeremy Tessmer, The Gallery*

… or one sculpture, or whatever your art is. Start thinking outside the cell; start thinking like a *Prison Picasso*. Try to think about how you're going to get those higher prices for your artwork. The number one key is who you're selling your artwork to. If you're selling to collectors at auctions, you'll command higher prices than visitors in the prison visiting room. If you're selling on eBay, you'll command higher prices than Slim three cells down. also, as you sell more, have an exhibition, or win some contests, you can raise your prices. Think big, win big.

SELLING ARTS AND CRAFTS TO THE AFFLUENT

It's simple. You can sell your arts and crafts to the prisoners around you who can only afford to pay peanuts. Or you can market your work to people who have the money to pay you its actual worth. It's up to you. There's a whole world of people who collect prisoner arts and crafts. There's an even bigger world of people who collect arts and crafts no matter who made them. Do you know why most prisoners who do artwork only sell to their fellow prisoners? Because it's easy. But just because something is easy doesn't make it smart. you spend the same amount of time on a painting or sculpture regardless of who you eventually market it to. Doesn't it make better sense to get the most money for your time? I think so. I hope you do too. You didn't work for $5.00 a day in the free world so why would you do that now?

RESOURCE BOX

To help you understand the value behind marketing to affluent art collectors, I suggest you read the following books:

- *No B.S. Marketing to The Affluent* by Dan S. Kennedy
- *Marketing to the Affluent* by Dr. Thomas Stanley
- *The Art of Selling to the Affluent* by Matt Oechsli
- *Let Them Eat Cake* by Pamela Daziger
- *The $12 Million Stuffed Shark* by Don Thompson

All of these books can be found online. Contact Freebird Publishers about ordering them if you don't have someone to help you.

Most of you will not read those books, so let me give you some numbers to help you understand the money spent on art.

- Japanese conceptual artist On Kawara's painting *Nov. 8, 1989,* sold for £310,000 in February 2006

- Mark Rothko's painting *White Center* sold for $72.8 million in May 2007

- Jean-Michel Basquiat's picture *Unititled* sold for $14.6 million in May 2007

- Andy Warhol's silkscreen *Green Car Crash (Burning Car 1)* sold for $71.7 million in May 2007

- John Currin's *Fisherman* sold to S.I. Newhouse for $1.4 million

- A 1918 Modigliani portrait, *Le Fils du Concierge,* sold for $31 million in 2006

- An early 1900s Cezanne watercolor, *Nature Morteau Melon Vert* sold for $25.6 million in May 2007

- Yves Klein's *IKB 234* painting sold for $1.8 million in June 2006

- Pablo Picasso's *Garcon á la Pipe* sold for $104 million in 2004

- Pablo Picasso's *Dora Maar au Chat* sold for $95.2 million in 2006

- Vincent van Gogh's *Portrait of Dr. Gachet* sold for $90 million in August 1997

- Constantin Brancusi's sculpture, *Bird in Space,* sold for $27.5 million in 2005

- David Smith's sculpture *Cubi XXVIII* sold for $23.8 million in 2005

- Jackson Pollock's painting *NO.5, 1958* sold for $140 million in 2006

- Chris Ofili's *Afrodizia* sold for $1 million in 2005

- Clement Clarke Moore's handwritten Christmas poem, "A Visit from St. Nicholas" sold for $255,000 in 1994

- Peter Doig's *White Canoe* sold for $11.4 million in 2007

- Francis Bacon's *Study from Innocent X* sold for $52.7 million in May 2007

- Jeff Koons's sculpture *Ushering in Banality* sold for $4 million in November 2006

Most of the above pieces were sold at auctions or in private dealers to rich art collectors. but that shouldn't deter you. Even new and emerging artists command higher prices than anything you can get at your prison.

- Hunter college student Ashley Hope sold a painting for $6,000 in December 2005

- Columbia University student Natalie Frank sold a painting for $16,000 in December 2005

- Yale student Logan Grider's *My New Home* sold for $5,000 in December 2005

Can you find another prisoner to give you that for a painting? I think not. In *The $12 Million Stuffed Shark,* Don Thompson says that for a mainstream art gallery, an oil painting on canvas by an artist with no gallery history would go for $5,400 - $10,800. In "Dreaming of a Gallery," I list the full contact information of some mainstream galleries. And some non-mainstream ones also. What all of this shows you is that you need to raise your prices for your art/crafts as soon as you move them outside the prison setting!

JAY-Z PAID $4.5 MILLION FOR A PAINTING!

As I was reading *Kite (#5)* magazine, I saw that they broke down Jay-Z's billion-dollar net worth. That caught my eye because I love reading *Forbes* and other magazines that break down the net worth of billionaires. According to *Kite,* Jay-Z owns $70 million worth of art, and in 2013 he paid $4.5 million for Basquiat's "Mecca" painting. He also has a song on his *Magna Carta…Holy Grail* album called "Picasso Baby" in which he raps the opening bars: "I just want a Picasso / in my case, no, my castle." I love the fact that *Kite* did that. I just wish they would have broken it down even more. Like, who is Basquiat? And why is Jay-Z buying art?

Jean-Michal Basquiat was born in 1960 in Brooklyn. He was a high-school dropout with no formal art training who moved to L.A. in the early 1980s. Besides his art, he also dated singer Madonna before she became famous. Basquiat died in 1988 at the young age of 28. The key reason Jay-Z is buying art is that it's a collectible asset that grows in value. He understands that assets are what make you wealthy, not spending money on things that decrease in value. Most of the prisoners around me only want to get OTS ("off the shit") and read *ATMs* or *Buttman's.* They should listen to Jay-Z in *Tom Ford:* "I don't pop Molly / I rock Tom Ford." And they should pay attention to its investment moves. We all need models. If you want to get wealthy, you can't go wrong with Jay-Z as a mentor to look up to. Let me give you some more examples to get you in the *Prison Picasso* mindset.

"When you pay high for the priceless, you acquire it cheaply."
– Joseph Henry Duveen

BE INSPIRED BY BIG MONEY ACT MOVES

Reading ArtNews.com can help you appreciate the value of art and show you all the big money being paid for the artwork. Andy Warhol's *Triple Elvis 1963* sold for $81.9 million. His *Four Marlons* sold for $69.6 million at the same Christie's Auction in November 2014. An untitled 1970 painting by Cy Twombly sold for $69 million also. Brett Gorvy, who is Christie's international head of Post-war and Contemporary Art said that there were 500 bidders from 43 different countries. Like I said before, art is big business!

Can you do these numbers in your prison cell selling to your fellow prisoners? I think not. but you can certainly do better than $3 to $5 for a greeting card. One of my former cellmates was making $500 a month from his art. he did portraits and tattoos. Portraits in ink were $25 a face, or $40 for two faces on one page. Tattoos were $50 to $200 depending on the work done. And he taught himself how to draw while in segregation! What can you accomplish if you put your mind to it?

"Money doesn't make you different. It makes your circumstances different."
– Malcolm Forbes

On the next page is an advertisement from the July/August 2020 issue of *Architectural Digest*. I have included it here to illustrate two points I hope you will learn. First, there is big money in art. Look at the prices on these paintings being sold by Questroyal Fine Art, LLC. the highest is $95,000. The lowest is $40,000. Growing up, the house I lived in didn't even cost $40,000 to own outright. Just like their ad says, even in times of crisis, "the intrinsic value of paintings has not changed." Some of you may think that your life is in crisis right now. Here's living proof that art could be your way out.

The other point that I want you to see is based on "right angle marketing." Why would a gallery advertise in a magazine like *Architectural Digest*? Can you see the right angle there? A lot of people who read it are looking for house and building design tips. Especially interior design tips.

And wealthier individuals read and subscribe to *Architectural Digest.* You can find it in some upscale doctor's offices as well. Wealthier people buy more art because they understand it's an asset if chosen right. Remember Jay-Z and his $70 million art collection? Now you can begin to think in terms of right-angle marketing when it comes to your arts and crafts. Think outside the cell!

> *"Being an artist is a chosen profession, not a vow of poverty."*
> – Jackie Battenfield

> *"Works of art, which represent the highest level of spiritual production, will find favor in the eyes of the bourgeois only if they are presented as being liable to directly generate material wealth."*
> – Karl Marx

This is the first step to becoming a *Prison Picasso*: believing that you can make big money for your art. Don't settle for the typical prison scraps. Go after real money. Even Pablo Picasso followed this same strategy. After he got out of art school, he moved to Paris so his art could be seen more, and he would have more opportunities. He met writer Gertrude Stein in 1905 and painted her. She was an art collector and helped his career along. Picasso also gave his work to collectors because he knew that would make his art more valuable. How are you doing the same? I'll show you how you can in this book.

STATEVILLE SPEAKS

VOICES FROM THE INSIDE • SUMMER-FALL 2020

FROM THE BACK PAGE TO THE FRONT PAGE

Stateville Speaks cartoonist Arkee Chaney was serving life without parole. Then he was released in June. This is his story.

By Arkee Chaney

I was born in Shelby, Mississippi on January 10, 1944. When I was very young, my family moved to Memphis, Tennessee. My father was a preacher, but he was just like the Temptations song, "Father was a Rolling Stone." Pop had a whole bunch of females. So, my mother left him. He stayed in Tennessee and the rest of us moved to Chicago. We lived with my auntie for a while before moving to the Altgeld Gardens projects on the north side of Chicago.

I started drawing when I was seven by tracing pictures. After a while, I didn't need to trace anymore. I could just draw anything I wanted. Art class was the only thing I liked about school. I would draw turkeys, pumpkins, and other stuff on the blackboard in the hallway at school.

My father's name was Mabel. I was his first son, so he named me Mabel. I didn't like going to school because of that. My mother would walk me into school, sit me down at my desk and tell the teacher to keep an eye on me. Other kids at school would make fun of my name and say "Mabel, Mabel, set the table, don't forget the red-hot peas" – and the fight was on! Or, I would just leave during recess and never come back.

The first time I stole something, I was eight years old. I saw an older dude I knew put an apple in his pocket at a store. He called me over and handed me an apple. I stuck it under my shirt, and we walked out. And when I ate that apple, it was the sweetest apple I had ever tasted because I took a chance on doing something.

I stayed out of school because everyone called me "Mabel" and in recess we would fight. So, I got with some other dudes – some young crooks – and we started hanging out, going downtown, sneaking into movies, doing anything we could think of doing. I used to get into all kinds of trouble. If it was trouble, I was in it because everyone in my posse was a crook. So, I was a crook too. And we'd get busted sometimes.

I spent time in juvenile detention centers. I remember when I first got to Parental Juvenile Home, I cried myself to sleep under the covers. I didn't want anyone to see I was crying because they'd consider me weak. Then, I got used to being there. Before that, I was at Audy Home, then Parental, then St. Charles Juvenile Home, then house arrest then county jail.

One time, a dude kept calling me "Arkee." I asked him why he called me that, and he told me that Arkee means "my brother" in Arabic. So, when I was 18 I changed my name to Arkee. The government doesn't want to acknowledge that as my name because I wasn't born with it, but I felt like I was in control of myself when I named myself Arkee. That's who I am. That's been my name since I was 18.

A few years later, I enlisted in the Army and served for about eight months before I ended up in

See ARKEE, page 4

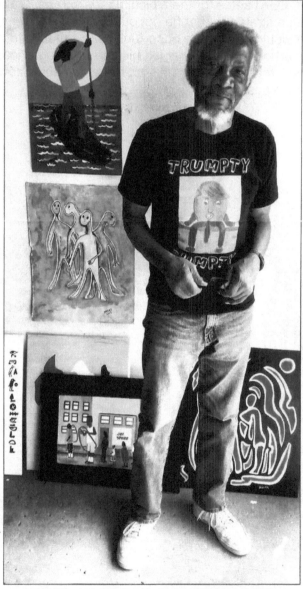

Arkee Chaney in his art studio, August 2020. Photo by Sal Barry

Hope...Redemption...Change

ARKEE, from page 1

the Georgia State Penitentiary. I just stayed in trouble. I was on leave, spending time in Augusta, Georgia. I bought a radio from a dude, but the radio was stolen, so I was arrested for buying stolen goods. The lawyer I was given, Joseph B. Dewitt – I'll never forget his name – told me I should plead guilty to buying the stolen radio. I told him that I didn't know it was stolen. I actually knew it was stolen, but I wasn't going to tell him that. But he insisted, so I pleaded guilty. The judge turned his chair around, looked at the wall behind him, then spun back around and said "I don't see how you got into the Army anyway. Ten years ought to straighten you out." And he gave me 10 years prison for buying a stolen radio worth $20.

Back then, prisons in Georgia were segregated. Whites were on one side of the prison and blacks were on the other. Guards would shake down the black prisoners routinely, but not the white prisoners. I was on the boxing team in prison, and we didn't mess with each other, but prisoners who were not on the team would come at me with a knife. I got stabbed three times. I thought they were going to kill me in prison because I was raising so much hell. I was really angry when I was locked up. I'd get into arguments with the warden and cuss him out.

About four or five years into my sentence, some young lawyers out of law school took my case and got my sentence commuted. It was about one in the morning when I was released from prison. I was loaded in a vehicle, took into a field with no houses or nothing; just a light shinning down from a single pole. Out in the middle of nowhere, in the middle of the night, in the segregated South, I thought I was going to be lynched. About a half an hour later, a Greyhound bus came, and I went to Atlanta. I was still really angry when I got out. I'd walk down the streets in Atlanta, and people would see me and cross to the other side. I was messed up in the head. I ended up back in Chicago and hooked up with a dame named Sandra. We lived together for about a year. I still had a lot of craziness in me. I just got into any kind of trouble that would come up.

I took up a trade as a welder and got a job making "burglar bars" to go over windows. I told my boss I had been in the penitentiary. He was cheating me and his other employees, so I quit.
I ended up in prison in Illinois three times. The first two times were for stealing $35 and $80. Illinois had a "three strikes" law, and my third strike was in 1987 for a robbery. I was staying with my sister who had mental problems. She had a boyfriend named Billy. My sister was going to get evicted because she could not pay rent. She had two kids and we did not want her to get kicked out. So, we stuck up a cab driver and stole his money. Later that day, my sister confronted Billy because the

money we gave her had blood on it. He told her what happened, and she reported us. The day the police arrested me was the same day my sister got evicted. I probably would have stuck up someone else, even if my sister wasn't getting kicked out. That's the type of mentality I had at the time. I acknowledge that because I know it ain't gonna happen no more. I'm through with it.

I was given a life sentence without the possibility parole in 1987. Prisoners who are incarcerated before 1978 are eligible for parole. Even though my "first strike" was before 1978, I was not eligible for parole because my "third strike" was in 1987.

While in prison, I focused on my art. I started doing cartoons when I was in the Georgia State Penitentiary. I would do them for a newspaper for free. When I was in Stateville, a paper in Chicago was buying my cartoons for a while. Most of my ideas came from looking at the news. Some of my cartoons came from when someone would say something, and it made sense. If it was something I could use, I'd use it.

When I first got to Stateville, I thought I was in there for life. But after a while, I knew I would one day get out. Dudes used to see my work and tell me "Hey, Arkee, you keep doing that art, you're going to get out of the joint."

I'd spend my days in the art room making art. Three o'clock rolls around and I'd go back to my cell and continue doing artwork. They'd call chow, I'd go eat, come back and still paint. I'd work sundown to sunup. If I had a cellmate, he would just put his head under the covers at night. I used to have to force myself to lay down and go to sleep. If I started something, I wanted to finish it. I could make seven or eight paintings in a good week.

The best way to get at me and make me angry was to mess with my art. The guards would often take my brushes, my paints and my paintings. One time, I called Bill Ryan about it, and the prison returned my paintings to Bill. Another time, a guard took one of my paintings and gave it to a female guard, who hung it in her office. I asked her for it back, but she wouldn't give it to me. I told her I would go on a hunger

strike, but she was serious about not giving back my painting, so I didn't. But any time they want to take something, they take it. The ones you really had to worry about was Orange Crush. They once took about 30 of my paintings. Godinez, who was the director at the time, walked by my cell and asked if I was still doing artwork. I told him about my paintings that were taken by Orange Crush. About 15 minutes later, I had my paintings back. Godinez used to give us credit when we did something good, and he was a pretty good dude anyway.

I met Dr. Margaret Burroughs[1] when I was in Stateville. She created the DuSable Museum and the South Side Community Arts Center in Chicago, a place for African American artists to showcase their work. She was educated at the Art Institute of Chicago and was known for her time spent teaching in prison. One day, she came into the art room and offered me a spot in her weekly art class, which I accepted. I'm glad she did because she used to bring me paint galore!

Dr. Burroughs taught me how to teach by encouraging people. Nobody taught me, so I didn't know how to teach right away. I'd teach others art but look at their work and say, "Man, you can't even draw a straight line! What's wrong with you?" I was putting dudes down instead of lifting them up. I was being hard on others because I didn't know how to teach. And then I saw how Dr. Burroughs would teach. I'd try to get

my students to think about what they were doing, and they would do some good work.

About a year ago, attorneys Jenny Sobel[2] (former Assistant Federal Defender) and Wendy L. Bloom (from law firm Kirkland & Ellis LLP), went to bat for me and got me out of prison. They filed a clemency petition. On June 23, the guard came to my cell and said, "Pack your stuff, Chaney – you're getting out of here." I was released from prison after serving 33 years of a life sentence.

I didn't know a lot of stuff when I got out. I was taken to a hotel. An elevator took me up to the floor my room was on. The next day, I couldn't get the elevator to work. I pushed the button, but the elevator didn't come, so I took the stairs. I didn't know that you had to swipe a card to get the elevator to work.

And those smart phones. You can put music on phones now! I don't mess with that. There are cars that talk to you (GPS) and people charging you an arm and a leg for anything. I went to a store and bought some potato chips, corn chips and candy and they wanted $20.50! It costs $4 to buy a mocha coffee.

I am presently living with Bill Ryan. For my first 60 days out of prison I had to wear an electronic monitor on my ankle. I had to be inside from 7 pm to 7 am. They actually called Bill's house to check up on me once at 4:30 am. Now, I am making art full-time in Bill's garage, which I converted to my art studio. My goal is to get a bigger art studio, and anyone getting out of the joint can have a job helping me out. That's what I want to do.

My advice to those that are in prison is don't give up. If you give up, then you ain't got no hope. It's like a dude in a race who says he can't win; he can't win because he said he can't. Keep hope alive. That's what I've been saying all of this time: keep hope alive.

To purchase artwork by Arkee Chaney, visit www.arkeestudios.com

1 – See Stateville Speaks May 2011 issue for an article about Dr. Burroughs

2 – Jenny Sobel is now the Executive Director of the Illinois Prison Project, who is working for clemency for two groups of prisoners: former military veterans, and prisoners who are serving life under the "three strikes" law. See Stateville Speaks Fall/Winter 2019 issue for more about the Project. ■

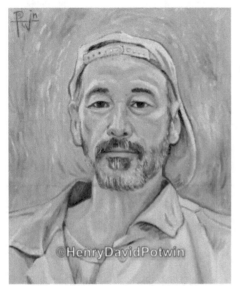

Henry David Potwin

Potwin was sentenced to Federal prison in 1994 which he describes as the most cathartic event in his life. "*This black sense of loss became the lens that focused my innate creative drive to crystalline clarity. During that period of my life, I seized the opportunity to light a spark in the minds of a considerable number of disenfranchised individuals as an art teacher. I gave them encouragement and the opportunity to discover their latent talents. Their pride of accomplishment was my reward as well.*"

Potwin's artwork can be seen and purchased on henrydavidpotwin.com

I'm quite content to be a painter of pictures. For me, painting is a synthesis that considers the myriad aspects of human awareness expressed in visual form. It melds together philosophy, physics, sociology, emotion, mysticism, and eroticism with craftsmanship. I like to tweak the colors to tease the eye with a sense of light and expressed energy. I consider my work 'conceptual realism'."

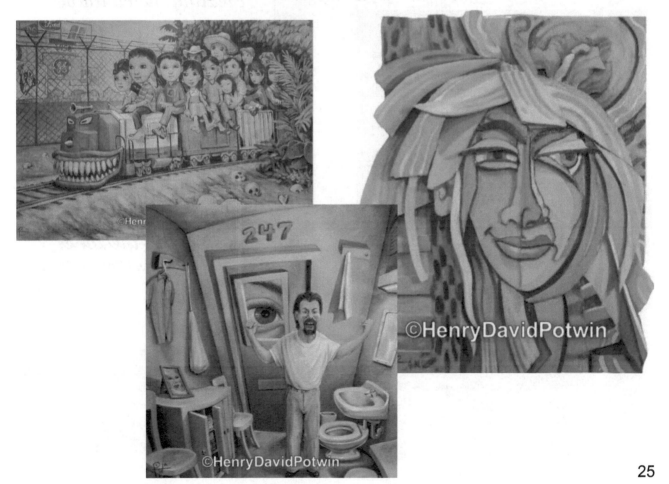

Potwin also published a coloring book from his artwork which is available for purchase through Freebird Publishers.

Prisonyland is not your ordinary adult coloring book! Potwin's artwork depicts the prison's reality of harshness in his inventive style by telling a story through each piece of art.

Venture through the pages of Prisonyland with Henry David Potwin's unique one-of-a-kind art.

All his art titles and many more of his collections are available to view and purchase at henrydavidpotwin.com.

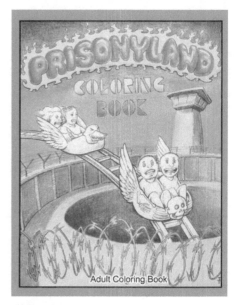

Adult Coloring Book

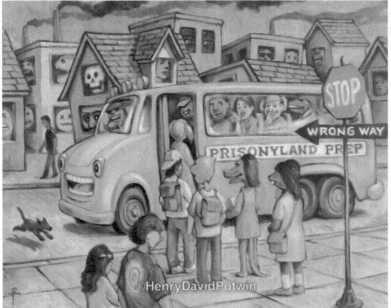

*"When a person is involved in the act of creating, he could be anywhere, and the experience is the same. When you are **in the zone** you are no longer in prison but escaped into the act of creation. I spent as much time as possible **in the zone.**"*
— *Henry David Potwin, Artist*

26

CHAPTER 3

BE INSPIRED AND GET CREATIVE

"To be successful, you must be willing to do the things others won't do to have the things tomorrow others won't have."
– Les Brown

In all my books, I like to share examples of successful prisoners. I do this not to glorify their pasts, but to show you that others have done it. To inspire you, here are some real-life *Prison Picassos.*

While inside Sing Sing Correctional Facility, formerly Ossining Correctional Facility, is a maximum-security prison operated by the New York State Department of Corrections and Community Supervision in the village of Ossining, New York is where Anthony "Tony" Papa learned to paint. Eventually, Whitney Museum gave him an exhibition of his paintings. He also wrote a book based on his life experiences called, *15 to Life.* And then Governor Pataki granted him executive clemency. Now there's a movie being made about his life. How's that for making money off your art or craft?

Or how about former Texas death row prisoner James Vernon Allridge III? He's now deceased after he was executed in 2004. But before they killed him, he turned his art into a profitable enterprise. He would sell a box of greeting cards for $10, or a large print for $465 over the internet. His artwork depicted monarch butterflies, anemones, Koala bears, and tiger lilies. Allridge's artwork made him famous as he had Hollywood celebrities like Elizabeth Taylor and Robert Redford supporting him through letters. Susan Sarandon even visited him on death row after buying artwork from him! He said, "my art allows me to give back something purposeful, productive, constructive, and meaningful." And it allowed him to make money! Can't beat that. You could do the same! (For more about Allridge, see the July 2005 *Prison Legal News).*

Vladimir Bukovsky was a political prisoner and was housed in some of the worst prison conditions ever. I read about him in the June 2015 edition of *The Sun* magazine. While he was in the hole, or "the box" as he called it, he would smuggle a piece of pencil lead in his mouth so he could draw. he would draw elaborately detailed castles on scraps of newspaper or the floors and walls. Bukovsky said, "it saved me from apathy, from indifference to living. It saved my life." Maybe art will save your life also? If you want to know more about Vladimir Bukovsky's journey, you can read his book, *To Build a Castle: My Life as a Dissenter.*

What do these examples mean for you? They show you can do it also. In this book, I'll give you some strategies and tactics that others have used to succeed in the art world. I'll show you some that I use. But all of these tactics and knowledge will mean nothing if you don't believe that anything is possible, and that prison doesn't stop shit. I'll say that again: PRISON DOES NOT STOP SHIT!

"When you get your attitude right, you can handle anything the world throws at you. Even life in prison."
– Bill Dallas

PRISON PICASSOS PRODUCE ART AND CRAFTS

No matter how inspired you are after reading about those prisoners or the millions paid out in the last chapter, you still must produce. Nothing moves until you move. Ideas are no good unless you put them to work. You have to produce products that you can sell. Or you find another prisoner who can produce them, and you sell them and split the profits. The key is to get creative. Ask yourself the following questions:

- Why do you want to sell arts and crafts?
- What are your financial goals?
- How much money do you need each year?
- Do you have the know-how to get it done?
- Do you have the materials, supplies, and tools that you need to create your arts and crafts?

- Does your cellmate know what you're about to start? Will he/she be supportive or be a problem?

- Have you discussed your new venture/ideas with your family and friends?

- Are there any classes that you need to take or sign up for?

A few years ago, I read about a prisoner who intentionally got sent to seg over and over so that he could be left alone to write his poetry. I'm not suggesting you intentionally go to seg, but I certainly understand why he does that. Your cellies and bunkmates might not understand your dream? If it's going to be a problem, request to be moved. If you live in a dorm-style cell housing, I feel for you. Try to find a space/time where you can be left alone. Then make that the time you work every day, so it becomes a habit and other people get used to it.

HOW TO GET UNSTUCK OUT OF ANY RUT

There will be times when you're not inspired, can't come up with any ideas, or don't feel like working. So, don't. Go for a walk around the yard by yourself. Look at the clouds. What do you see? Sketch it. Play a sport you like. Associate with friends whose company you love. Sometimes when I get stuck in my writing I stop and play solitaire on my tablet. After a few games, I'll be ready to get back to it. Just getting away from your work can recharge your batteries.

Frank Lucas, of *American Gangster* fame, would lock himself in a room and block everything out. He called it "backtracking." That's how he came up with the idea to smuggle heroin directly from Southeast Asia in coffins during the Vietnam conflict. It made him rich.

Bestselling author Ryan Holiday (*Trust Me, I'm Lying*) said that for one of his books, he set a start date of January 1st. Then in the November before it, he entered his "drawdown period." He quit reading and just spent time resting and thinking. He'd take long walks and spend time contemplating the upcoming project. A few days before his start date, he had a dream that told him what he needed to do. So, he did it. Great things come from the subconscious.

"Winners have the ability to step back from the canvas of their lives like an artist gaining perspective. They make their lives a work of art - an individual masterpiece."
– Denis Waitley, Ph.D.

HOW TO COME UP WITH CREATIVE IDEAS

Keep inspiration ideas in folders and notebooks. Write stuff down. Sketch it out. Tear photos out of magazines. Then periodically go through your folders or notebooks. Put them into new orders and arrangements. Kari Chapin has a "Wall of Wonder" where she puts images and ideas. You might not be able to do that at your prison? That's okay. Just use some kind of system where you do it.

Organize your property box and/or storage bins. Reuse old containers creatively. Always carry a notebook and pen with you. Jot down ideas as they come to you. The prison hospital can be a place where you get stuck in for hours at a time. While there, plan a project on paper. At my prison, they stopped us from taking books to the hospital. So, I started buying the little address books they sell on commissary. I take that and a little 3-inch flexible ink pen. They fit right in my shirt pocket, and I sit there jotting down ideas, thoughts, or sketches. I even do this when I'm jogging around the track in the yard.

Coming up with new ways of using old images can be your ticket to fame and fortune? Daniel "Dapper Dan" Day was a gambler who started making clothes by changing up clothing trademarks for famous rappers like LL Cool J, Eric B and Rakim, and even U.S. Supreme Court Justice Sonia

Sotomayor, who was then a lawyer. Andy Warhol constantly knocked off other artists and even his logo is copied from the Campbell's soup logo. Some of his most famous paintings are a set of soup cans with the labels torn. He did a set of 32 hand-painted soup cans for $2,000 in 1962. In 1995, gallery director Irving Blum sold that set to the Museum of Modern Art for $14.5 million. What ideas can you come up with from looking at old images?

"A man should learn to detect and watch that gleam of light which flashes across his mind from within, more than the luster of the firmament of bards and sages."
– Ralph Waldo Emerson

8 WAYS A PRISON PICASSO COULD GET MONEY

In *The Ultimate Side Hustle Book,* Elana Varon lists 450 moneymaking ideas. There were 8 of them that I believe a prisoner could do with arts and crafts. Here they are:

- Calligrapher
- Caricature Artist
- Cartoonist
- Fiber Artist
- Fine Artist
- Illustrator
- Portrait Artist
- Tattoo Artist

She said that "hobbyist calligraphers" charge an average of $150 to design a menu for a wedding. Custom documents may sell for as little as $15 for a quote on a poster to more than $1,000 for artwork. I'll talk about some of the other ones in this book as well. Just know that there are different types of artists and crafters. The more specialized you can become, the better quality of work you will produce. And the better-quality piece you put out the more you can charge for it. That's the goal of *Prison Picasso:* to aid you in becoming the best you can be so that you can become a *Millionaire Prisoner* off your artwork or craft. As a further example, let me talk about a popular way that artists make money while in prison.

BIG MONEY WITH PORTRAITS

Remember how I mentioned that one of my prisons had an "Art Class?" Guys would go to the class and show each other how to perfect their pieces. A lot of these guys were great artists and crafters. But most of them didn't have the right mindset. They would spend all day making cards only to sell each card for $5. Or a wonderful painting for $40. Small numbers don't make Millionaire Prisoners. Remember the "Money Math" section from the previous chapter? They would have to sell 200,000 cards at $5 each to gross a million. At $40 they would have to sell 25,000 paintings to gross a million. That's not probable in prison. Even if you're not an artist, you could buy theirs for pennies on the dollar and sell them for hundreds, if not thousands, by using the strategies in this book. You must think bigger than the box you find yourself in.

I know one prisoner who did large portraits of Obama when he was in the White House. He sold them online for $400 each. What celebrity portraits could you do? At the beginning of 2020, if you could have painted stuff to honor former NBA star Kobe Bryant and his daughter Gigi, you could

have made a lot of money. People still might buy them. They still buy paintings and drawings of other stars like Elvis Presley, Marilyn Monroe, Michael Jackson, and other dead celebrities. The key would be to think about what the public wants. Or just follow the current fad or latest craze. This book is a good place to start.

Andy Warhol started doing portraits for $25,000 each. By the 1980s he was charging $40,000 for a portrait he'd do in a day! Remember my old celly that made $500 a month with portraits and tattoos? He did his portraits in ink so he could charge more. And he taught himself. The only thing he needed was a good photo of the person's face, some white paper, and some ink pens. Imagine if he would have done portraits of famous people?

RESOURCE BOX

If portraits are a niche you want to try out, then I encourage you to study some of the below books:

- *You Can Draw in 30 Days* by Mark Kistler
- *Colored Pencil Painting Portraits* by Alyona Nickelsen
- *Draw Real People!* by Lee Hammond
- *Portrait Revolution* by Julia L. Kay
- *Portraits With Character* by Giovanni Civardi
- *You Will be Able to Draw Faces by the End of This Book* by Jake Spicer
- *The Fundamentals of drawing Portraits* by Barrington Barber
- *I'd Love to Draw* by Andrew Loomis

Contact Freebird Publishers about ordering if you don't have anyone to help you.

In *Making Time: Art in The Age of Mass Incarceration,* Rutgers University professor Nicole R. Fleetwood tells the story of federal prisoner George Anthony Morton. He spent 9 years inside and became a master portrait artist. Once he got out, he was accepted into the Florence Academy of Art – United States. Then he became the first American-born student to be accepted into the Florence, Italy campus. All of that happened because of the portrait skills he honed while inside a prison.

Maybe portraits can be your ticket to the big money? Or just drawing in general? Painting is not the only way to command high prices. Sometimes you can do it differently. One artist who does it differently is Owen Garrett. He's a pencil artist who sells his work to corporate clients in a series instead of one piece of art to a single customer. So instead of making hundreds of dollars for each sale, he makes tens of thousands of dollars. Sometimes he even makes upwards of a hundred thousand dollars per sale. You can see his work at pencilneck.com.

Pay attention to all the examples given in this book. These people are real-life masters. By their example, you can find the keys to a better life. They can show you how to turn your life around. Speaking of that.

"An artist must first find his or her artistic voice and then locate his or her market. Both surely exist."
– Daniel Grant

HOW TO TURN YOUR CELL INTO AN ART STUDIO OR CRAFT SHOP

Prison is not an ideal place to do arts and crafts. The typical prison cell is the size of a small bathroom. Most times it must be shared by two prisoners. To become a Prison Picasso, you must commit yourself to daily work. Here are some tips that will aid you in creating the most productive studio out of your cell.

1. *Light.* Prison can be a dreary place, but the best light to work by is daylight. So, place your desk or chair by the window if you can. If that's not possible, the light should come over the shoulder opposite of your drawing or painting hand. As most prisoner artists already know, this takes away the shadow. Do not beam your desk lamp directly onto your easel. That creates a contrast in the cell and can be distracting. You want the light to seem as natural as possible.

2. *Preparation.* Make sure that you have all your work materials and tools within reach before you start. You don't want to interrupt yourself by having to get up to search for something after you've already started.

3. *Posture.* Don't get *too* comfortable. If you're using a desk or table, it should be set up so that your thighs are parallel with the floor. Keep your feet flat on the floor, back upright. A lot of prisoners find it more comfortable to stand up when painting.

4. *Space.* Keep your material spread out so that you have room to work. I turn the bottom bunk in my cell into a desk. Some experts say the material you're working on should be kept approximately 20 inches away from your eyes. A lot of prisoners get strained eyes or headaches after drawing or painting for long periods. Keeping your material at this distance should help with that problem.

5. *Time.* Try to pick a time when you will not be interrupted by outside influences. In prison, this sometimes means staying up at night when the prison is quiet or skipping the yard so you can work alone. I have ADD and I've found that working with headphones on helps me. The music tunes out all the jailhouse jibber-jabber. Keep out all distractions.

HOW TO READ MAGAZINES AND
NEWSPAPERS FASTER AND BETTER

Like most of the prisoners, I spoke to, I only learn a few things from each magazine issue. Over the years, I've seen many different theories and tactics about how to conquer a newspaper or magazine to get the most out of it in the least amount of time. Here's one of them that I've found to be most profitable and productive.

1. Go through the whole newspaper or magazine quickly. Just scan the headlines. As you do this, make a note next to the articles you want to read. Pay attention to where the articles are contained if more than one page.

2. Have a goal about what you're trying to get out of the material. Stick to that goal. Don't just read to read.

3. Read the articles you noticed or marked when you did your previous scanning.

4. Cut out any articles, photographs, and/or comics that may be of use to you later. Save those items. (If you share your magazines and newspapers with other prisoners then you will have to wait to perform this step until they're done with them.)

5. Throw out the rest of the newspaper or magazine as soon as possible. Extract the gold from the mine but get rid of the waste.

If you follow the above steps, you will conquer more mags and newspapers in a shorter period. You also won't be filling your mind or cell with useless junk. One prisoner that I taught this trick to went so far as to make Saturday his "magazine day." Throughout the week, he just scanned every magazine or newspaper he got using the above steps. Except he didn't read the articles, he put them in a folder. On Saturday, he reads all the magazine articles while watching college football. The rest of the week he's free to work on more important tasks.

TOP 15 ARTIST MAGAZINES

You need a continuing voice of sound advice, ideas, inspiration, and tips. Since you can't get on the web to research, one of the best ways to stay up to date is to read magazines. Any artist who could subscribe to the below magazines would have an excellent source of ideas and tips. Here they are:

1. *Art Business News*
2. *The Artist's Magazine*
3. *Sunshine Artist*
4. *Art News*
5. *Artforum*
6. *American Artist*
7. *Art in America*
8. *Professional Artist*
9. *Southwest Art*
10. *Modern Painters*
11. *Juxtapoz Art and Culture*
12. *Tattoo*
13. *Pastel Journal*
14. *Watercolor*
15. *Watercolor Artist*

60+ CRAFT MAGAZINES TO PERUSE!

American Craft (americancraftmag.org)

American Patchwork & Quilting (allpeoplequilt.com/magazines)

Artists' Café Magazine (americanquilter.com)

Art Jewelry Magazine (artjewelrymagazines.com)

Art Quilting Studio (stampington.com/art-quilting-studio)

Bead & Button (bnb.jewelrymakingmagazines.com)

Bead (beadmagazine.co.uk)

Beads and Beyond (beadsandbeyondmagazine.com)

Bead Style (bds.jewelrymakingmagazines.com)

Beadwork (beadingdaily.com)

Cardwork (cardmakermagazine.com)

Cardmaking & Papercraft (cardmakingandpapercraft.com)

Complete Cardmaking (papercraftmagazines.com)

Crafts (craftsmagazine.org.uk)

Craftseller (craft-seller.com)

Create With me (stampington.com/create-with-me)

Creative Cardmaking (creativemagazines.com)

Creative Knitting (creativeknittingmagazine.com)

Crochet! (crochetmagazine.com)

Crochet Today! (crochettoday.com)

Cross-Stitch & Needlework (ww.c-sn.com)

Cross Stitch Card Shop (cross-stitching.com/magazines)

Designer Knitting (thegmcgroup.com)

Felt Magazine (artwearpublications.com/au)

Generation Q Magazine (generationqmagazine.com)

Good Old Days (goodolddaysmagazine.com)

Handwoven (weavingtoday.com)

Just CrossStitch (just-crosstitch.com)

Knit Now Magazine (knitnowmag.co.uk)

Knitscene (knitscene.com)

Knit Simple (thegmcgroup.com)

The Knitter (theknitter.co.uk)

Love of Quilting (fonsandporter.com)

Make (makemagazine.com)

Martha Stewart Living (marthastewart.com)

McCall's Quilting (mccallsquilting.com)

Modern Quilts Unlimited (modernquilts.mgumag.com)

Papercrafter Magazine (papercraftermagzine.co.uk)

Piecework Magazine (interweave.com)

Quick & Easy Crochet (quickandeasycrochetmagazine.com)

Quick Cards Made Easy (cardmakingandpapercraft.com)

Quilt (quiltmag.com)

Quilter's Newsletter Magazine (quiltersnewsletter.com)

Quilter's World (quiltersworld.com)

Quilting Arts Magazine (quiltingdaily.com)

Quiltmaker (quiltmaker.com)

Sew Beautiful (sewbeautifulmag.com)

Sew It All (sewitallmag.com)

SewNews (sewnews.com)

Simple Quilts & Sewing (quiltmag.com)

Simply Homemade (simplyhomemademag.com)

Simply Knitting (simplyknitting.co.uk)

The Stampers' Sampler (stampington.com/the-stampers-sampler)

Step By Step Wire Jewelry (jewelrymakingdaily.com)

Stitch (sewdaily.com)

Take Ten (stapington.com/take-ten)

Threads (threadsmagazine.com)

Yarn Magazine (artwearpublications.com.au)

You can find more arts/craft magazines in *Bacon's Media Directory* or *Samir Husni's Guide to New Magazines* (mrmagazine.com). *Folio* magazine also provides information about new magazines, whether launches or redesigns.

You can also get some of these magazines from discount magazine providers. Here are the main ones that work with prisoners. Send them a SASE and a letter to get their price lists.

Alice S. Grant Publications, Inc.
P.O. Box 28812
Greenfield, WI 53228
(*The Millionaire Prisoner's* favorite magazine provider)

Tightwad Magazines
P.O. Box 1941
Buford, GA 30515

The Magazine Wizard
P.O. Box 1846
Bloomington, IN 4740

Sample Request Letter

To: Alice S. Grant Publications, Inc.
P.O. Box 28812
Greenfield, WI 53228

Dear Alice S. Grant,

I have enclosed a SASE for more information about your discount magazine subscription services, please.

Thank you in advance for your cooperation in this matter. I look forward to hearing from you soon.

Respectfully Requested,

[Your Name Here]
[Your Address Here]
[Your City, State, Zip Code Here]

Encl: SASE

CHAPTER 4

ART EDUCATION

"One could get a first-class education from a shelf of books five feet long."
– Charles Eliot, former president of Harvard

What exactly is education? The dictionary defines it as: "the action or process of educating or of being educated." To break it down even further, you must determine what "Educate" means. Educate has several meanings, but two are perfect for a *Prison Picasso:* "To learn by formal instruction and supervised practice, especially in a skill, trade, or profession," and "to learn developmentally, morally, or aesthetically, especially by instruction."

"Education is the most powerful weapon which you can use to change the world."
– Nelson Mandela

For a Millionaire Prisoner who is becoming a *Prison Picasso,* there are two kinds of education. One is formal. You can get a formal education by going to school, college, university, and/or career school. This is what most people think of when they come across the word "education." But the second form of education is informal schooling. You don't have to be in college to get a powerful education or to learn. In this chapter, I will briefly deal with both forms of learning and then you can decide your needs. The one thing that I can say about learning, whether through formal classroom studies or by way of informal instruction, is that it has the power to free you from enslavement. You'll be surprised at how many doors will be opened to you once you begin educating yourself. This chapter can help you on the journey.

"Only the educated are free."
– Epictetus

YOUR PERSONAL STYLE OF LEARNING

There are four main ways of learning. They are as follows:

1. By reading (books, magazines, newspapers, reports, etc.)
2. By hearing (listening to others, audiobooks, TV, and radio)
3. By watching (television, internet, video, demonstrations, etc.)
4. By doing it through experience

You must find your optimum learning mode. I can learn through all four modes, but my best is by reading. One of the strengths of having ADD is that I over-concentrate on something for a long period of time at the exclusion of everything else. This allows me to read nonstop on a subject I'm interested in and learn in a way that is easiest for me. You need to find your optimal mode of learning so that you can begin reaching your potential.

One word about the last mode of learning above – *doing it* or *by experience.* This option is great if you have a mentor helping you. (A mentor can do it by television, like Bob Ross, or other art shows on PBS!). But it's not good if you're trying things on your own without doing any research to see what's the right way first. Just remember that you need to put yourself in situations where you can learn the fastest, gain the most knowledge, and comprehend what you learn so that you can use it in your life.

THE MOST BASIC WAY TO GET AN EDUCATION

In prison, the easiest way to get educated is by reading. A lot of prisoners read. The most popular reading material is urban novels, and hip hop or pornographic magazines. But those are not the most profitable periodicals to read if you're trying to become a *Prison Picasso.* Don't get me wrong, I like to look at sexy, naked women just like every other prisoner does. Except, I like royalty checks from book writing more. So, I read and study books that will help me do that – get royalty checks. What are you reading? Will it help you make money from arts and crafts?

Nelson Mandela became a voracious reader while in prison. He read everything he could get his hands on. He didn't have a television in his cell to pacify him. Mandela also completed his bachelor's degree through a correspondence course. Once he was released from prison, he became president of South Africa. It was by reading in his cell that he educated himself in preparation for his future.

It was in a dark, solitary cell, using the light coming under the cell door to read by, that Malcolm Little recreated himself and went from "Detroit Red" – the pimp, to Malcolm X – the revolutionary.

These two examples, Mandela and Malcolm, are arguably two of the most famous, and greatest ex-cons that we can learn from. If they spent time in their cell reading books, why aren't you?

"People don't realize how a man's whole life can be changed by one book."
– Malcolm X

Instead of the urban novel, read art books. Read craft magazines. Read business books and magazines. Learn from others by reading about how they did it. You should read about the art business if you want to start your own. Read about how to deal with people because you've only been dealing with thugs, criminals, and convicts. Dealing with people will be one of your greatest obstacles upon your release. Any books that will help you will be profitable.

"No matter how busy you may think you are, you must find time for reading,
or surrender yourself to self-chosen ignorance."
– Confucius

Reading and practicing your art or craft should occupy your time more than watching television. TV is mostly negative. It's what the old heads call the pacifier or the stupid box. I'm not saying you have to quit watching all tv. But unless you're watching an art/craft show on tv then you don't have to watch daytime tv. Instead, read an arts and crafts magazine. Watch an art show like Bob Ross to learn a new technique or tip. Spend your time practicing your art and putting out quality pieces. Do the opposite of what most of the other prisoners do around you.

AN INVESTMENT THAT PAYS THE BEST INTEREST

Some of you may think that you don't have the money to buy arts and craft books or magazines. That's only an excuse, and excuses are the bricks that make the house a failure. There are numerous books on prisoner projects in the United States. They offer free books to prisoners upon request. Write them and request books on arts and crafts.

Some of you may have heard the saying "sacrifices have got to be made." When it comes to money, your education will only be expensive until you consider the cost of ignorance. My ignorance got me life in prison. The cost was unmeasurable. My whole financial future changed when I answered a small, classified ad that said *How to Get Rich in Mail Order.* In response to my inquiry, I was given the opportunity to purchase a book for $26 that would tell me how to make money. I decided to sacrifice a little commissary that month and order the book. It was the best decision I ever made. That one book has taught me how to make thousands of dollars. What sacrifices are you willing to make to get what you want?

"If a man empties his purse into his head, no man can take it away from him. An investment in
knowledge always pays the best interest."
– Benjamin Franklin

HOW TO GET THE LOWEST PRICE FOR ANY BOOK

You'll need to enlist someone from your network, but you can find used books online at amazon.com and half.com. My favorite website is BookFinder4U.com. Book Finder allows you to search over 100 bookstores and 60,000 individual booksellers in a single search. They also have over 90 million, used and out-of-print, books in their database. All you need to do is have them type the book and author name into Book Finder, then click on "Compare Prices." They will give the best price online.

Also, have them check out AbeBooks.com. Abe Books has over 100 million books being sold by over 13,000 booksellers around the world. You can use it to find rare books.

Some people tout Amazon as the best bookseller in the world. But always have your assistant check elsewhere. Sometimes the biggest isn't always the best when it comes to price. I found books for $1 plus shipping, and even a penny plus shipping. Utilize the web to get the lowest price available. If you don't have anything in your network to assist you, then utilize an inmate internet service provider. But make sure you do the math; it still could be cheaper to order the book(s) from Edward R. Hamilton or another discount mail-order bookseller?

HOW TO BECOME AN EXPERT IN ARTS AND CRAFTS

You don't have to ever do anything to become a so-called "expert." An expert is just someone who knows more than you about a topic. Think about all the talking heads on TV who are recognized experts on a topic, yet they've never got any results in that field. You can do it with this system. It works, as I've used it over the years to learn. As you'll see, each step can easily be accomplished by a prisoner.

1. Pick a specific topic in the arts/crafts field. Then read over anything you have available about this topic. Utilize the steps in this book to get the most out of what you read.

2. Read more texts and magazines on the subject. The prison library may have some materials available. Or request them from the Book to Prisoner projects. You could also start with *The Complete Idiot's Guide to* and *For Dummies* series of books which are great to start with. Don't let the names fool you. Those books are packed with the information you need. As you read those books, write down any books or magazines mentioned in the text. Pay attention to other sources listed. Also, write down the names of the experts who keep being quoted in the books you read.

3. Go back over your original books, records, and notes. Your examination should now be heightened because of your other reading.

4. Consult your mentor or write the experts that you wrote down with any questions that you have. Ask them what other materials you can study. to get the best response, try to ask questions that the expert can answer off the top of their head. No matter what your topic is, there's an expert on it. Here's a way to find experts on your topic:

 * Have someone you know do a search on your topic at findarticles.com. They can enter your search term and select "free articles only," and they would get all the available free articles on your topic.

 * Get them to print out the articles on your topic and send them to you.

 * Read the articles to get the names of experts and authors of the articles. They should list their website and/or book at the end of the article. Write that down.

- Do an online search to get the expert's contact information. You can also search for experts on guru.com and elance.com.

5. Follow through on anything your mentor or expert suggests. Do not neglect this step.

6. Study any opposing views or texts. Sometimes authors list ways to contact them. Do so. Never assume, always ask questions.

7. Incorporate what you learn into your life by acting on it, trying it out, and testing it. Get some results and experience.

8. Keep consulting your mentors and experts. Keep studying your materials until you've mastered the subject or topic. Always keep up to date with new technologies and ideas that pertain to your type of art or craft.

"If you're an expert in something, you will never go hungry."
– Paul Sarnoff

BON-A-FIDE PRISON EXPERT

Most of us prisoners have heard of Robert "the Birdman of Alcatraz" Stroud. He became interested in birds while incarcerated at Leavenworth prison in Kansas. Stroud became an expert on canaries and authored several books and magazine articles about them. He was able to do this from segregation and extreme isolation. The Birdman is just another example of a prisoner finding his niche and becoming successful. You can do it in the art world as well.

"I believe the true road to pre-eminent success in any line is to make yourself a master in that line."
– Andrew Carnegie

HOW TO ENROLL IN COLLEGE

Up to this point, I've mostly dealt with getting an informal art education through non-fiction books and magazines. But some of you may want a formal degree for your art profession. What should you do? Start by taking any classes that your prison has to offer. If you don't have your GED or high school diploma, get it. If you have your GED, then enroll in college classes. Some prisons still offer them. Others have special college programs that you can enroll in. If your prison doesn't offer college courses, then you'll have to do it by mail.

It is at this time that I have to recommend the book, *Prison Education Guide* by Christopher Zoukis. Chris was a prisoner in the federal system and got his degree while inside. He even edited the *Education Behind Bars* Newsletter. Have someone check out his websites for you: prisoneducation.com and ChrisZoukis.com. In his book, *Prison Education Guide,* he shows how and where you can get an education by mail while in prison. You can order it from *Prison Legal News* for $49.95 at:

Prison Legal News
P.O. Box 1151
Lake Worth, FL 33460
(561) 360-2523

While you're at it, have them check out the free online directory that lists all the art schools across the world: artschools.com. They also offer tips on financial aid as well.

Some of you may be able to obtain these resources and should start right away. Here are the steps you could take:

1. Get your GED or high school diploma. If you already have it, you'll need copies of your transcripts to show the school you plan on enrolling in.

2. Define what type of art degree or certificate you want to get? This should be based on what interests you. Some schools offer specialized classes like "art history" or others. So, pick something you're interested in.

3. The U.S. Department of Education provides a helpful 60-page booklet *Take Charge of Your Future: Get the Education and Training You Need.* Write them and request a copy of it:

 The Education Publication Center
 P.O. Box 22207
 Alexandria, VA 22304
 Publication ID# ED00534P

4. Write the schools and contacts in the *Prison Education Guide* or the few at the end of this chapter. Request their brochures, course catalogs, and enrollment guidelines.

5. Read all the relevant information that you get from the schools and educational offices.

6. Pick a school and curriculum that fits the objective of your life. Don't go to school just to go to school. Have a plan and a purpose!

7. Set up a program with your prison's education department for approval if need be. If your prison doesn't offer college courses, your biggest hurdle will be the end-of-course proctored exams that most correspondence courses require. See if the GED teacher or chaplain at your prison will allow you to take the tests in front of them.

8. Get funding and enroll (more about funding in a minute).

9. Complete all your course work on time and always be respectful to your teachers. Remember, they are there to help you.

10. Keep repeating the steps above until you have the degree or certificate you want.

Once you complete, you're your first few courses you can begin to develop your system of study. Be sure to save all your correspondence with your school, teacher, and examiner. Save all transcripts and diplomas/certificates that you obtain. You may want to transfer your credits, show a foundation of your schoolwork, or need it for a future employer?

Since a legitimate degree by mail will cost you thousands of dollars, funding your education may be the hardest part of obtaining a formal education while in prison. It's not impossible to get, and as proof, allow me to share with you the story of Troy Evans.

HOW TO GET FREE MONEY FOR COLLEGE

Troy Evans spent seven years locked up in a federal gulag. He wanted to get a college education so that his time behind bars wouldn't be wasted. Unfortunately for him, around that time, Congress cut Federal Pell grants for prisoners. Did Troy let that stop him? No, he set out to obtain scholarships, grants, and foundation assistance. It took him six months of filling out applications, writing essays, begging, pleading, and selling before he landed a scholarship for one class. That was his start, and he walked out of prison with not one, but two college degrees, a 4.0 GPA, and a designation on both the Dean's and President's lists. Troy is now a professional speaker and author and took the time to share some ways to obtain free money for school with me. I've incorporated his thoughts into mine and present them to you now.

- Your first attempts should be through the school or university you have chosen to attend via correspondence. Most schools offer some type of scholarship program and/or package through an alumni association, a foundation, or a scholarship group.

- Next, apply for federal and state aid. As I was putting the final touches on this chapter, I read that Congress recently enacted Pell Grants for prisoners enrolled in a "correctional education program." What that truly means, remains to be seen. But it should allow you to get money for college. No more excuses.

- Get a list from your state's Department of Commerce of all the civic and service clubs in the area. For example, Kiwanis, Rotary Club, Lions, Elks, etc. Also, try and get one from the state your school is located in. Contact each group individually. Sometimes, they offer money for "hard luck" cases such as prisoners.

- Write any nonprofit, social work, and association involved with helping others in your area. Contact churches and religious organizations within your area. Ask them to help you in your quest for an education.

- Look into private scholarships. Troy says these will be your bread and butter in the future. There are scholarships based on every criterion you can think of, and there are several great books on scholarships out there. Three are Peterson's *Scholarships, Grants, and Prizes;* Daniel Jo Cassidy's *Scholarships, Grants, and Loans;* and *The Ultimate Scholarship Book* by Gene and Kelly Tanabe.

- Lastly, you'll need to research public and private foundations, and trusts. These places must give away money for all kinds of things to keep their tax-exempt status. For more information on these resources, see *Foundation Grants to Individuals,* published by the Foundation Center. It will give you the complete contact information, and the criteria for applying for a foundation grant. (Because I was curious, I reviewed the book to see how many foundations and trusts I could have if I wanted to go to school? I found over 50 of them!)

You must learn how to write essays correctly. Most scholarships are going to require that you write them showing why you deserve the scholarship. Also, in any classes that you're able to get into, do your best. You must be able to show people that their money is going to be a worthy investment.

That's the basic outline that was gleaned from Troy. For more information about Troy and his life, have someone check out his website: TroyEvans.com, or read his book, *From Desperation to Dedication: An Ex-Con's Lessons on Turning Failure into Success.*

> *"There is absolutely no reason why you cannot secure funding for your education while incarcerated. It is only a matter of beating the bushes. The money is there, but the effort must be there to make it happen. If you're serious about obtaining an education via correspondence while incarcerated, I'm living proof it can happen; you only need to want it bad enough."*
> *– Troy Evans*

Do you want it bad enough? You should because it's one of the keys to a better life.

ART AS REHABILITATION

In the September 2020 issue of *Prison Legal News,* Kevin Bliss detailed his "Prison Art is Rehabilitation." London-based prison art initiative Fine Cell Work does work with United Kingdom prisoners to use these skills for therapy and rehabilitative potential. According to Bliss, Fine Cell Work has worked with around 7,000 prisoners and ex-prisoners worldwide. Some of the pieces

these convicts have created now hang in Kensington Palace. In March 2020, auction house Sotheby's featured eight pieces from Fine Cell Work. All of this just proves that becoming a *Prison Picasso* can be therapy and financially beneficial at the same time.

In a review of the book, *Marking Time: Art in the Age of Mass Incarceration* by Nicole R. Fleetwood, in *Prison Legal News* (January 2021), Ed Lyon wrote about *ArtNews's* review of Professor Fleetwood's book. In that review were profiles of artists who used arts and crafts while in prison to better themselves. You can do the same. It all starts with your art education.

"Everyone holds his fortune in his own hands, like a sculptor the raw material he will fashion into a figure. But it's the same with that type of artistic activity as with all others: We are merely born with the capability to do it. The skill to mold the material into what we want must be learned and attentively cultivated. – Johann Wolfgang von Goethe

Here are some correspondence schools that offer art courses:

RESOURCE BOX

For more information you may want to check out the following resources:

- *What They Didn't Teach You in Art School* by Rosalind Davis and Annabel Tilley
- *What They Didn't Teach You in Design School* by Phil Cleaver
- Artist Career Training, artistcareertraining.com. (Has a monthly newsletter and weekly tips)

Contact Freebird Publishers about ordering if you don't have anyone to help you.

Adams State University
Office of Extended Studies
208 Edgemont Blvd, Ste. 3000
Alamosa, CO 81102
(800) 548-6679
exstudies.adams.edu
exstudies@adams.edu

California Miramar University
9750 Maramar Rd, Ste. 180
San Diego, CA 92126
(858) 653-3000
calmu.edu

Colorado State
University at Pueblo
Distance of Continuing Education
2200 Bonforte Blvd. Pueblo, CO 81001
(800) 388-6154
coned.colstate-pueblo.edu

University of North Carolina
The Friday Center
Center for Continuing Education
Campus Box 1020
Chapel Hill, NC 27599-1020
(800) 862-5669

Stratford Career Institute
1 Champlain Commons, Unit 3
P.O. Box 1560
Saint Albans, VT 05478-5560
scitraining.com
admissions@scitraining.com

Check out other art schools to see if they're legit. Contact:

National Association of Schools of Art and Design (NASAD)
Commission on Accreditation
11250 Roger Bacon Dr., Ste. 21
Reston, VA 20190-5248
(703) 437-0700
info@arts-accredit.org
ARTS-ACCREDIT.org

Sample Letter Requesting Education Resources

Adams State College
Office of Extended Studies, Box CC
208 Edgemont Blvd.
Alamosa, CO 81102

Date: (Month-Day-Year)

Dear Adams State:

I saw your address in *The Millionaire Prisoner* and I'm interested in taking a college course by mail. Would you please send me your course catalog, tuition applications, and enrollment guidelines?

Thank you for your cooperation in this matter. I look forward to hearing from you soon.

Respectfully requested,

Any Prisoner
Any Prison
P.O. Box
City & State, USA 99999

Sample Letter Requesting Educational Booklet

The Education Publication Center
P.O. Box 22207
Alexandria, VA 22304

Re: Publication: ED00534P Date: _____

Dear Education Publication Center:

I saw your address and information in *The Millionaire Prisoner* and would like a copy of your guide: Take *Charge of Your Future: Get the Education and Training You Need*, Publication ID: ED00534P

Thank you for your cooperation in this matter. I look forward to hearing from you soon.

Respectfully requested,

Any Prisoner
Any Prison
P.O. Box
City & State, USA 99999

CHAPTER 5

HOW TO CREATE GOOD LUCK IN YOUR LIFE

"Luck is the residue of design"
– Wayne Allyn Root

Maybe it's the Irish side of my bloodline? Or the fact that I've always been good at betting on sports. People (especially my fellow prisoners) always tell me I'm lucky. The reason it looks like luck is because they don't see the hours of study and practice, I put in every week. Is it lucky to put in five or six hours every day to write this book? No, instead it's hard work. That's how I get lucky. Here's how a *Prison Picasso* can prepare so that they get a lucky break also:

- Write out your goals and your plan to become a *Prison Picasso.* Not only your overall goals, but your weekly, and monthly ones as well. Go over them every week to check your progress.

- Do something. Lots of it. Practice your craft. Be prolific and produce. Learn from your mistakes. Babe Ruth had more strikeouts than home runs. Michael Jordan missed thousands of shots in his career. Both are Hall of Famers and remembered for their successes.

- Relax and don't take things too seriously. Life is a game. Have fun and embrace that reality.

- Read different magazines, books, and newspapers than what you're used to. Talk to different people. Watch different documentaries and TV shows. Get outside of your comfort zone and look for opportunities.

- Put yourself in the right places to be seen and to meet the right people. That means writing letters, getting online, and networking with other artists, collectors, gallerists, and successful people in the art world.

- Keep going in the face of adversity. Persevere. Even if no one has answered your first 5 letters, write 5 more. Even if no one has bought your first 10 paintings, paint 10 more. Failure is only failure if you give up. Your success is just around the corner. Or on the other side of the hill. You'll never get there if you quit.

- Pay attention to your intuition and gut feelings. How many times have you met someone and had a bad feeling? Then later you realized that they were a liar, con artist, or thief? That was your instinct telling you to leave. Learn to heed and listen to your hunches. Most of the time it's your subconscious telling you something important.

- Help others without expecting anything in return. Share. Teach one to reach one. Give back. Karma is real. So, pay it forward. That way the Universe will give you more.

RESOURCE BOX

For more about getting luck on your side, here are some books you may want to get and study:

- *The Luck Factor* by Dr. Richard Wiseman

- *How to Attract Good Luck* by A. H. Z. Carr

Contact Freebird Publishers about ordering if you don't have anyone to help you.

Let me show you how a *Prison Picasso* can use their tablet to attract good luck.

HOW TO USE YOUR TABLET FOR SUCCE$$

At the end of the movie *Inside Man* (starring Clive Owen and Denzel Washington), Owen's character has locked himself in a makeshift cell for a week behind a fake wall in the bank's storage room. He says, "there's a vast difference between being stuck in a tiny cell and being imprisoned."

How true. (By the way, it's a great movie and if you haven't seen it, you should watch it.) Becoming a *Prison Picasso* starts with the right mindset. You get it by realizing that even though you're in prison, your mind is free. Or it can be and should be! In this section, I'll show you how to use an MP3 player or tablet to help free your mind and get the right attitude.

A lot of prisons and jails allow us to purchase tablets. Some prison systems even give them out free. The version that I have, and use, is a GTL Inspire tablet. Yours may be different, but the strategy will be the same. You can do two things with your tablet. The first, and what most prisoners do, is listen to music and play games all day. That's fine if you're already a *Prison Picasso.* Are you? If not, then you need a different strategy. Your life won't change until you do something different in your life! A prison is a negative place. The whole mentality is one of lack. Of pain. Of past mistakes. You must guard your mind against this negativity. Some of you will have to reprogram your mind. I had to. You can start this process by changing your state. This is how *Prison Picassos* get a free mind.

The easiest way to change your state is to get up and move. When you wake in the morning, don't lay around in bed. Get up and do something. Make your bed. Put on your shoes. Exercise. Draw something. Paint. Do anything, except lay in bed. Here's what I do. I get up, make my bed, wash up, and brush my teeth. These three things tell my body that I'm up for the day. Then I turn on my tablet and listen to it while I exercise. It wasn't always like this. When I first got my tablet, I just listened to all the songs I had never heard from my favorite artists. Then my wife told me I needed to get back on the grind. And fellow Cellpreneur, Mike Enemigo, told me I had to catch my second wind and start writing again. So, I came up with a different strategy. One day I was playing around on my tablet and ran searches for my mentors. Then I ran searches for Anthony Robbins, Chris Widener, Jim Rohn, Earl Nightingale, and Napoleon Hill. They all came up. There are other classic talks and books on the tablet as well. I like to listen to them when I exercise or watch basketball and football. You can do the same.

Some speeches that I like to listen to are those from Motiversity. My favorites are by Walter Bond. He's a former NBA player and the speech I like best is *Shark Mindset 2.* I have a shark tattooed on my arm and I identify with the shark as my spirit animal. Ever since I read Harvey Mackay's fantastic book, *Swim with the Sharks Without Being Eaten Alive,* I have tried to keep moving like a shark. Sometimes I falter and need a push forward or a pick me up. Listening to these speeches help me change my state and get ready to tackle the day. Are you getting up each day just to survive prison? Or are you getting up to thrive? Or to seize the day? A shark is constantly on the hunt. Are you? I know it sounds like some hocus pocus stuff but listening to these talks can aid you on your journey.

When I write articles and my books, I like to listen to music. I have attention deficit disorder and music helps me tune out the daily prison noise and focus on my writing. Some of my favorite songs are "Lose Yourself" by Eminem, "Hall of Fame" by The Script, and "I Just Want to be Successful" by Drake. Stephen King listens to hard rock while writing his horror novels. My cellmate Buzz listened to music when he did all his tattoo work. So did Conman when he did his artwork. Here's something I learned from millionaire author and investor, Tim Ferriss (*The 4Hour Workweek, the 4Hour body,* and *Tools for Titans*): Listen to the same playlist repeatedly. One, it allows you to just work and not worry about messing around with the tablet. Two, it does something to your mind and allows you to get into a zone. Ferriss explains the science of it better than I do. I just know it works. If you use your tablet in this way, then you want to listen to motivational music. Or music that moves your spirit. If I'm writing my wife, then I listen to love songs. If I'm writing an article about getting money, I'll listen to songs that talk about hustling or getting money. What songs get you inspired to do your

arts and crafts? Those are the ones you should listen to. It may take you a few hours to put together these playlists, but it will pay off. This strategy can help you to become a *Prison Picasso*.

For more information on how music can help you, be sure to check out the book, *Your Playlist Can Change Your Life* by Galina Mindlin, Don Durousseau, and Joseph Cardillo.

Another strategy that can give you an edge is self-help hypnosis. You can use your tablet to do this. Pick a time when you won't be bothered by staff or other prisoners. Then tune into a program or talk that is dealing with the problem you want to work on or the area where you want an edge in. Some of the better programs are the hypnotic talks on your tablet. I listen to some of them before I go to sleep. Search for Brainwave Mind Voyages, Binaural Beat Brainwave, Hypnotic, and Subliminal Systems. There are hundreds of hypnotic talks that you can listen to. Maybe they can be the secret weapon that helps you get past your sticking points.

> *"Self-talk is reinforcing, and people stay stuck in whatever self-talk they've been embracing. Telling yourself your own sad story may be comforting, but it keeps you in prison."*
> *– Perry Marshall*

Here are some of my favorite people to listen to on my tablet that you may want to check out.

Walter Bond	J. Earl Shoaff
Charles F. Haanel	Billionaire P. A.
Marko Halilovic	Ernest Holmes
Dr. Joseph Murphy	Marcus Taylor
William Hollis	Og Mandino
Pete Cohen	William H. Danforth
Chris Traina	Daron K. Roberts
Matt Wilson	Napoleon Hill
Eddie Truck Gordon	Brian Bullock
Logan Taylor	Roger Hamilton
Trent Shelton	Joe De Sena
Bobby Maximus	Earl Nightingale
Jeremy Lopez	Coach Pain
Freddy Fri	Anthony Robbins
Abdel Russell	Elliott Hulse
Billy Alsbrooks	Robert Greene
P. T. Barnum	Ronald A. Burgess, Jr.
Adam Phillips	Sun-Tzu

These are just a few to get you started. In the future, we hope to get some *Millionaire Prisoner* talks on the tablet. For now, do the opposite of what every other prisoner is doing and use the tablet to help motivate you. Become better, become more.

> *"Only dead fish swim with the stream."*
> *– Dan S. Kennedy*

CHAPTER 6

F.O.C.U.S.: TIME REVOLUTION FOR PRISON PICASSOS

"Concentrate all your thoughts upon the work at hand. The sun's rays do not burn until brought to a focus."
– Alexander Graham Bell

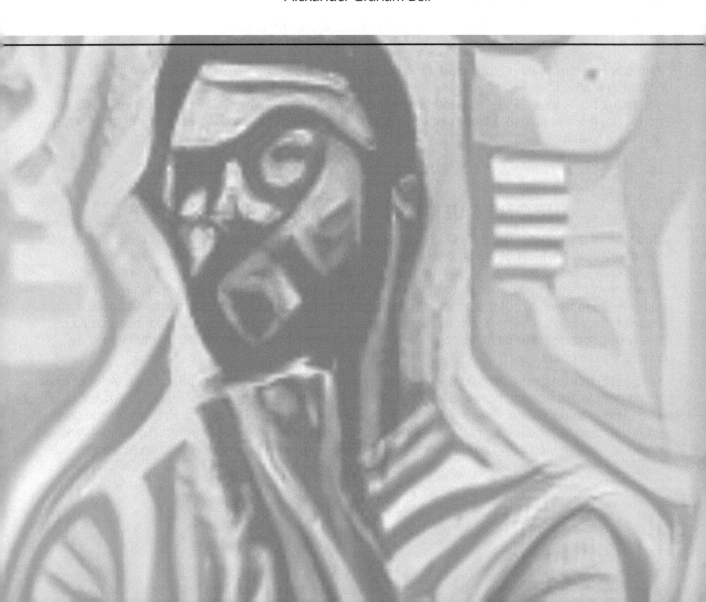

Why discuss a time revolution and not time management? Because when you're in prison your time is already managed for you! You're told when to go to the chow hall to eat. You're told when to go to the yard or gym. You're told when to go to the chapel. You're told when to go to school or work. You're told when to lock up. Even if you're in a minimum-security prison, you're still under someone else's time management system. What you need is a time revolution so you can make time serve you instead of you serving time. In this chapter, I'll show you how.

"The first step towards success is taken when you refuse to be a captive of the environment you first find yourself in."
– Mark Caine

As much as you may dislike President Trump's political views, he has come up with some good business ideas. In one of his books, he has a chapter on "F.O.C.U.S." which stands for: *F*ollow *O*ne *C*ourse *U*ntil *S*uccessful. When I first read that I thought it sounded cool. But I didn't implement it into my life. I still tried to multitask and get everything done all at once, which meant that I didn't really h important done.

Then I read a book called *The One Thing* by Gary Keller, with Jay Papasan. In the book, he also quotes the F.O.C.U.S. principle. That's when it all clicked for me. It all comes back to F.O.C.U.S. if you want to achieve great things.

"The secret of getting ahead is getting started."
– Mark Twain

Anthony Robbins teaches the same thing in his *Time of Your Life* seminar. He calls it the "Rapid Planning Method," or RPM for short. The principle behind it is to ask yourself three questions so you focus on "Results, Purpose, and Massive Action," because what you focus on is what you will go to. So, the first step to a time revolution is to find out specifically where you want to go or what you want to achieve.

"If you chase two rabbits you will not catch either one."
– Russian Proverb

THE ONE QUESTION YOU MUST ASK YOURSELF

Because of my books, I get a lot of prisoners coming up to me and telling me their ideas. They want to get my opinion. Most of the time I ask them to stop and answer one question, "What do you specifically want to achieve?" They normally look at me dumbfounded and say, "I want money." That answer is not good enough for me, so I ask them again, "What do you specifically want to achieve?" I'm trying to get them to clarify their goal or objective. Until they know that specific answer, they can't possibly know the correct road to take. Their idea may be good, but it could be the wrong road for their ultimate objective. You won't know how to use your time until you know where you're going.

My goal in this chapter is to get you to transform your life by how you treat prison time. A lot of free-world people will ask you how you spent your time in prison. Your answer should be, "I'm not spending or serving time. I'm investing my time, so it serves me." The goal is to learn how to use your free time to produce something valuable that brings in a measurable return. To do that, you're going to have to stop doing some things you're doing right now. Let me give you an example.

HOW I WROTE A BOOK IN THIRTY DAYS

From 2002-to 2008 all I did was spend my in-cell time writing pen pals. The reward I sought was weekly visits, phone calls, and occasional money orders that they could/would send. Yes, I achieved what I wanted, as you know if you've read my book *Pen Pal Success*.

As I look back on those years, I think about how stupid I was. I wasted six years writing every day. In contrast, fast forward to 2014 when I'm in segregation and spend thirty days working on Pen Pal Success. That thirty days of work produced far more results financially, more than anything else in those six years. Don't get me wrong, those pen pal years were fun, and that experience led me to write Pen Pal Success. I just wasn't happy. I wasn't fulfilled. That came after I started writing my books. How did I write a book in thirty days? Focus! I got up every morning and went to work. I was in segregation, so I had no distractions. I ate, slept, and wrote, a simple strategy for success.

"Happiness is not pleasure. Happiness is victory."
– Anthony Robbins

Because I wasn't accomplishing my objectives in the time frame that I wanted, I realized I had to change it up. So, what did I do? I went on a search to find prisoners who were achieving huge things behind bars. I wanted to read their books to see what they were doing to get their results. I knew it had to be different than what I was doing. I thought that if I stole their daily habits, I could start getting the same kind of results they were getting.

MILLIONAIRE PRISONER SUCCESS STRATEGY

My journey led me to study Eddie Bunker and how he wrote his books while in Folsom Prison (as well as other California prisons). I studied Danny Trejo, Billy Wayne Sinclair, Paul Wright, Jerry "the Jew" Rosenberg, Malcolm X, and Nelson Mandela. One prisoner that I learned a lot from is Michael Santos. He's free now and a millionaire. I read all of his books. One of his books shows you a typical day inside prison for him. It's called *Prison! My 8,344th Day*, and it's a great expose on how he used his days to invest in his future. Here's what he wrote:

"My objective is to succeed upon release. I don't care about a prison reputation and I'm indifferent to staff perceptions. The pursuit of success upon release drives me every decision, and that has been the case since the beginning of my term."

Notice what he said. His "objective" drove "every decision." That was his one thing, his focus. He got it. This is the first step to a time revolution. Finding out what your one thing is. You must ask yourself some questions to clarify your objective. This strategy is to find what is the key to deciding the tactics to use to get there. Remember this formula:

Strategy = the what + tactics = the how to

Strategy is the overall goal and tactics are how you achieve that goal. I'll give you some tactics throughout this book. First, we must find out what your main objective is.

"When you walk with purpose, you collide with destiny."
– Bertice Berry

Josh Kruger

THE QUALITY OF YOUR LIFE IS DECIDED BY YOUR QUESTIONS

There are two steps to finding out your main objective. Both require you to ask yourself some questions. What do you want? What specifically do you want? For me, I wanted $6,000 a year or $500 a month. How did I come up with that number? I added up everything I would need to live well in prison (commissary, GTL music subscriptions, magazines and newspapers, e-mail, and phone) and then I divided the cost per month to get my amount. I'm doing life in prison so that's all I needed to live rich here. Once I came up with that number, my next question became, "What's the one thing I can do to earn $6,000 a year ($500 a month) that by doing it everything else will be easier or unnecessary?" (Thank you, Gary Keller, for teaching that question in *The ONE Thing*.) The answer for me was to create and sell how-to information products.

Can you specifically tell me what you want? Here's an exercise to help you figure it out. Picture your perfect life. What vision comes to mind? What kind of car are you driving? What kind of house do you live in? What kind of food are you eating? Do you have any kids, a wife, or a husband? What museum is your art in? What collector has your arts and crafts in their collection? Write your answers down and be specific. One of my neighbors told me he wanted a Lamborghini. "Okay," I said, "I'll give a 1985 Lamborghini Countach." But he didn't want that. He wants a blue Lambo, a new one. So, I told him to write it down, "I'm driving a blue 2025 Lamborghini Gallardo." That's specific. Imagine this perfect life. Then write it down in the present tense like it's happening: "I'm living in a _____ in the city of _____"; "I'm driving a 20__ _____"; "I own a ___ and I bring in $____ a year"; "I have a _____ and we have _____ kids."

These are just some fill-in-the-blank examples. Yours could be different. The key is to find out the answers so you can specifically find out what you need to do to create this perfect dream life? Write it all down now.

> *"If you can't explain it to a six-year-old, you don't understand it yourself."*
> *– Albert Einstein*

Did you write down all the stuff you want? If not, go back and do it. If you, did it, I want you to look at your list and see how many require money to get them? House, car, business, and toys are all money goals. So, you can add them all up together and that's your money goal.

Now look at your list and decide which one is the most important to you? Think about the "why" behind it. What emotion does it bring forth? Mine was based on fear. I feared living the rest of my life in prison and not having what I needed. My family wouldn't be around forever. A lot of my life friends were older and didn't have anybody in the free world to help them out. I hated that feeling because it scared me. I decided to never be in that position. Emotion is a powerful incentive. So put the feeling – the why – behind what you want. Once you have it all written down then find the ONE item on the list that if you accomplished it would make all the others easier or unnecessary. Think about this. Because whatever you select will be your FOCUS. Now that you know what your goal is – where you want to be – you need a map to get there. The first step to creating your map is to use the 80/20 rule.

THE 80/20 RULE FOR PRISON PICASSOS

The 80/20 Principle is a book by Richard Koch based on the Pareto Principle. What it demonstrates is that 80% of the results you achieve come from 20% of the actions you take. Richard Koch grew $4 million in 1990 into $230 million in 2014 using the 80/20 principle to invest in companies Wouldn't you like to get those same types of results in your own life? I would. We can start by using the 80/20 principle to evaluate our time. If 20% of the actions you take produce 80% of the results you get, that means 80% of the actions you take produce 20% of the results you get. Put another

way. If you wrote 10 letters this week, two of them would get you what you wanted and the other eight might do diddly-squat. The key is to find out that 20% works and do more of that, and to stop doing the 80% that doesn't work.

"If you pay attention to the wrong thing, you could waste your entire life polishing turds."
– Perry Marshall

Based on this 80/20 principle, I'm going to give you some guidelines to use to come up with the tactics you'll use daily that will help you achieve whatever you want. These are based on my personal experiences and the studies I did of other successful prisoners.

"Focus is a matter of deciding what things you're not going to do."
– John Carmack

12 STEPS TO ACCOMPLISHING MORE

Remember these tactics as you go about your day and start getting things done.

1. Before you read anything ask yourself, "will I need this information for something immediate and important? If not, don't read it.

2. Don't mistake busyness for business. Cleaning your cell and doing laundry will not help you achieve your goals. Michael Santos paid another prisoner to do it for him so he could use his time for more important things.

3. It's not the quantity of your work that matters, but the quality. No multitasking. Focus, and work on one task until it's done.

4. No news radio or talk radio while you're working on your ONE thing. Music? Yes, if there's no talk in between songs. No television, except a maximum of two hours a night. Or one ball game or one movie only!

"Poor people have big TVs. Rich people have big libraries."
– Jim Rohn

5. Be prepared for delays or lockdowns on movement. Do something productive while you wait. Read. Write. Sketch. Paint. Sculpt.

6. Choose your allies carefully. Because you're a sum of the 5 people who you spend the most time with. You also need people who respect you enough to leave you alone while you work.

"Surround yourself only with people who are going to lift you higher."
– Oprah Winfrey

7. Find unconventional ways to invest your time. It may require you to do the opposite of your prison peers. For me, it meant skipping yard to work on a book chapter.

8. Don't let people steal your time away with dumb questions or idle chatter. I put headphones on and ignore everybody when I'm writing.

9. Don't try to cram everything into one hour. Take breaks. Studies show that short (1/2 hour) bursts of work with breaks after them produce higher quality.

10. Bundle tasks together. Clean your cell/wash clothes. Answer mail/e-mail. Read magazines/newspapers.

11. Exercise. Even if it's just a brisk walk for 15 minutes in the morning. It's good for your body and energy levels.

12. Eat healthily. Your body is a temple. Treat it as such. Feed it as such.

"People do not decide their futures, they decide their habits and their habits decide their futures."
– E. M. Alexander

CARVE OUT A BLOCK OF TIME

Here's the most important tactic in this chapter. Find a time block of at least four hours a day where you can work on your ONE thing. You want this to be a high-energy time for you. And you need it to be the time where you will have no distractions. Michael Santos got up early in the morning so he would have the study room all to himself. Eddie Bunker stayed up late into the night when his prison was quiet. I do the same thing. When can you find this time to work on your arts and crafts? Find it, then schedule it daily.

"One hour per day of study will put you at the top of your field within three years. Within five years you'll be a national authority. In seven years, you can be one of the best people in the world at what you do."
– Earl Nightingale

After you have found the time block that will allow you to work uninterrupted you need to list what you will do during that time. The key is to do a daily "To-Do List" the night before. What is your ONE thing? Painting? Drawing? Tattooing? Sculpting? Whatever it is, you schedule that first thing every day. Each art piece or craft item will have steps you need to take to complete it. So, write out those steps and do them. The key is to schedule this *To-Do List* the night before and then make sure to review it once you get up in the morning.

"When you create a list of everything you have to do the next day, your subconscious mind will then work on that list all night long while you sleep. Often you will wake up in the morning with ideas and insights on how to do the job better and in less time."
– Brian Tracy

Use your time block as "creative time." Use the rest of the day to do the trivial and mundane. Invest those four hours to become the best at your craft that you can be. Think leverage. Ask yourself, "Is what I'm doing to get my art done anywhere close to the highest and best approach out there?" If not, stop doing it and go do the best thing!

"Anything that isn't relevant, that you're not competent in, or that you're not completely passionate about should be delegated to somebody else."
– Jay Abraham

THE PRISON PICASSO FORMULA

Becoming a Prison Picasso is partly doing the arts and crafts and part selling it. You may not enjoy one of them? But you must do both if you want to grow from making commissary items to collecting thousands of dollars off your work. As you start your new career you need to be more focused on

your arts and crafts. So, use your four hours in the morning for that. Then find an hour later in the day where you focus on the business side of it. Write a letter. Send an e-mail. Research markets and ideas. Eventually, you'll need to get it to where you go 50% on creating your art/crafts, and 50% on selling them. Just remember that you must produce art/crafts to have something to sell.

Here's the formula for success. Work six days a week. Do your work at the same time every day so it becomes a habit. Take at least one day off where you don't do anything. No art/crafts. No business. Just play. Watch TV or go outside and play sports. Take a break. You do this so that you don't get burned out. At first, you will not be good at this time revolution stuff. It goes against what most prisoners do. But I guarantee you that when you start getting royalty checks off your art/crafts you'll love it. If you can find your craft and focus on it daily with a purpose behind it, you can get all that your heart desires. Write out your map and your daily To-Do List and then become the most productive prisoner at your prison. That's how you'll become a Prison Picasso.

> *"Our goals can only be reached through a vehicle of a plan, in which we must fervently believe, and upon which we must vigorously act. There is no other route to success."*
> *– Pablo Picasso*

RESOURCE BOX

If you have a tablet and want some more time revolution information and productivity secrets, you may want to search for these:

- *How to Get More Done*
- *Time Management Tips*
- *Time Management Institute*
- *Productivity Secrets*

If you want to read some of the books that I used to become a Millionaire Prisoner in investing my time, then I highly recommend the four books below:

- *No B. S. Time Management for Entrepreneurs, 2nd Edition* by Dan S. Kennedy
- *Master Your Time, Master Your Life* by Brian Tracy
- *The ONE Thing* by Gary Keller
- *The 80/20 Principle* by Richard Koch

All these books can be found online. Contact Freebird Publishers about ordering them if you don't have someone to help you.

> *"There is no 'how.' Just do it."*
> *– Bruce Lee*

21 THINGS TO REMEMBER EACH DAY AS YOU START YOUR DAY

1. No one can ruin your day without your permission.
2. Most people will be about as happy as they decide to be.
3. Others can stop you temporarily, but only you can do it permanently.
4. Whatever you are willing to put up with is exactly what you will have.
5. Success stops when you do.
6. When your ship comes in, make sure you are willing to unload it.
7. You will never "have it all together."
8. Life is a journey…not a destination. Enjoy the trip!
9. The biggest lie on the planet: "When I get what I want, I'll be happy."
10. The best way to escape your challenge is to overcome it.
11. I've learned that, ultimately, "takers" lose and "givers" win.
12. Life's precious moments don't have value unless they are shared.
13. If you don't start, it's certain you won't arrive.
14. We often fear the thing we want the most.
15. He or she who laughs…lasts.
16. Yesterday was the deadline for all complaints.
17. Look for opportunities…not guarantees.
18. Life is what's coming…not what was.
19. Success is getting up one more time.
20. Now is the most interesting time of all.
21. When things go wrong, don't go with them.

CHAPTER 7

YOUR ARTWORK IS YOUR NETWORK

"The more friends the better, especially friends who are interested in art, because your work can reach the world through them."
– Brainard Carey

Multi-millionaire real estate investor and bestselling author, Robert Allen, says that "your income is the average income of your ten best friends." Business consultant and multi-millionaire author, Brian Tracy, says that "the people you choose to work with or for, to socialize with, or marry, to invest through or go into business with, will determine about 85 percent of your success and happiness in your personal life." He offers a simple equation: QR X QR = PS. What it means is that the quantity of your relationship, times the quality of those relationships equals your success. How true.

My own experiences in life bear this out. When I was selling drugs and robbing people, most of my friends had been to prison or jail. I ended up in jail also for 3 years. I met more convicts. After I got out, I continued to hang around my old friends. Now I'm doing life in prison. My life started to change once I reached out to millionaire authors and entrepreneurs. In this chapter, I'll show you some networking secrets you can use to become a *Prison Picasso.*

In his fantastic book, *The Sticking Point Solution,* marketing consultant Jay Abraham, says that we need to create a worldwide personal network of quality business players. He wrote that you need three types of people in your network:

1. People who either have the *answers* you need or can connect you to the ones who do.

2. People who have the *resources* you need.

3. People who can perform *specialized* tasks far better than you – or anyone on your staff.

Trying to make real money off your art from a prison cell will take time. It will be easier if you can find the above type of people. you can do it by using technology and a simple letter writing system. Let me explain.

THE WORLD IS FLAT

Technology has leveled the playing field. We no longer play on a little scale. If we want to, we can play in a global art arena by using e-mail and the internet. A great book to read about this is *The World is Flat* by Thomas Friedman. Another resource that coincides with this is *Abundance: The Future is Better Than You Think* by Peter Diamandis and Steven Kotler. For those of you who don't have access to the internet, you can get over this hurdle by using outside help.

A lot of companies sell services to prisoners offering mail, Facebook, Instagram, and Twitter profiles, and internet research. If you don't have someone in your existing network to help you with this, you'll have to use one of those companies. My favorite, and the only prisoner assistant company that I endorse, is Help From Outside (HFO). I knew the owner, and I used to have an account with HFO. If you're serious about success from prison and don't want to depend on family or friends for help, I highly would recommend HFO. Unfortunately, they have closed permanently.

YOUR OUTSIDE CONNECTION – E-MAIL

Some of you now have access to e-mail at your prison through JPay, GTL, or Corrlinks. If you do, utilize it when building your network. But don't be fooled, these prison-based e-mail providers are severely limited. I use connectnetwork.com via my GTL Inspire Tablet. Yet, I still can't e-mail anybody I want through GTL. They must log on and sign up to send/receive e-mails from me. Of course, every e-mail we send is monitored by the prison. The emerging *Prison Picasso* needs a regular e-mail account. I use Google's Gmail system. But you can use other ones like Yahoo or Hotmail. Here are some tips to remember when setting up your e-mail account:

1. Have a great e-mail address. Most people use their name or something catchy that is significant to them. Don't use goofy e-mail addresses like thugpassion@gmail.com or golddigger@hotmail.com. Put up a professional front.

2. Set up an e-mail auto-response that says: "Sorry, but I'm away from the computer at this time and will get back to you as soon as possible."

3. Be cautious of what you write in your subject lines. this line is what people see first and it helps them decide whether to open your e-mail or not. Most e-mail service providers use 25-character subject lines. So, create catchy, short, subject lines that make someone want to open your e-mail.

4. If you're using e-mail to market your products, then here are some tips that I learned from marketing expert Marcia Yudkin (yudkin.com):

 a. Highlight why your e-mail is important

 b. Don't repeat who you are in the subject box because the "from" box already says that

 c. Use the word *FREE* if you're offering something valuable

 d. Try to create temptation in your 25 characters

Having an e-mail account can open doors for you. It can increase the amount of mail you get and allow you to contact mentors, businesses, and other people who toss out mail from prisoners, but always check their e-mail boxes.

DO YOU HAVE AN E-MAIL SIGNATURE?

If you have your own free-world e-mail account, then you need an e-mail signature (.sig). An e-mail signature is the line of type at the end of your e-mail message. Because you will be trying to sell your art, you need a sig. People must know who you are, what you do, what you have to offer, and how to contact or find you. think of your sig as an online business card. Here are a few reasons why you should have a signature:

- It's free to set up.

- Every time you send an e-mail, it will be attached to it.

- You don't have to retype it over and over.

- It's another easy way to market your product or services.

Here's something I learned from my mentor, Peter Bowerman. A lot of people just list who they are and their accomplishments. Better for you would be to make your sig a call to action. Here's how it could look:

<table>
<tr>
<td>Your photo here</td>
<td>Do you know anyone interested in prison art?
Send them to _____, to learn more about how they can help turn prison into a steppingstone for success.

[Your name]
[Your Prison #]
[Your address]
Facebook.com/prisonpicasso</td>
</tr>
</table>

For a complete look at how to use e-mail to achieve success in this world, I highly recommend freelance copywriter Robert W. Bly's masterpiece, *The New E-mail Revolution.*

Stephanie Halligan started a blog called *Empowered Dollar* on a challenge from a friend. She sent the 3 cartoons she had drawn to her e-mail list and asked if anyone wanted to buy them? They were $45 each. Within a day, she had sold one. So, she started another blog where she put up a daily cartoon for two years straight. They started selling. Now she does illustrations for universities, nonprofits, and major banks. Her art is "motivational cartoons" and is published on her blog, arttoself.com. It all started with one sale to her e-mail list. Do you have an e-mail list?

HOW TO BUILD YOUR NETWORK

Start at your prison. Has anyone else got this book? Share your ideas, thoughts, and notes. Form a *Prison Picasso* mastermind group. Many successful creative artists have used mastermind groups for great success. C. S. Lewis, J. R. R. Tolkien, and their friends met together for 19 years. They called their group "The Inklings." Their group helped produce *The Lord of the Rings* and *The Hobbit.* For more on "The Inklings" read *Bandersnatch* by Diana Glyer. Think that a mastermind group is only for writers and not artists?

The Florida Highwaymen were 27 African American landscape painters who had no formal art training. But each brought something unique to the group. They would paint all night and then go out and sell those paintings the next day. This was in the early 1960s in the Deep South. And over a few decades, they sold over 200,000 paintings. Those paintings are now worth thousands of dollars. For more, read *The Highwaymen* by Gary Monroe.

There are also niche networking groups for arts/crafts. For instance, if you do portraits there are:

American Society of Portrait Artists
2781 Zelda Road
Montgomery, AL 36106
(800) 62-ASOPA
asopa.com

Portrait Society of America
P.O. Box 112.72.
Tallahassee, FL 32302
(877) 772-4321
portraitsociety.org

Or say you paint with watercolors, there is:

American Watercolor Society
47 Fifth Avenue
New York, NY 10003
(212) 206-8986
americanwatercolorsociety.org

National Watercolor Society
915 South Pacific Avenue
San Pedro, CA 90731
(310) 831-1099
nws-online.org

How about the artwork that features animals?

American Academy of Equine Art
c/o Kentucky Horse Park
4089 Iron Works Parkway
Lexington, KY 40511
(859) 281-6031
AAEA.net

American Society of Marine Artists
P.O. Box 369
Ambler, PA 19002
(215) 283-0888
marineartists.org

Society of Animal Artists
47 Fifth Avenue
New York, NY 10003
(212) 741-2880
societyofanimalartists.com

Here are some other national artist networks:

Audubon Artists
47 Fifth Avenue
New York, NY 10003
audubonartists.org

Cowboy Artists of America
P.O. Box 396
Blue Springs, MO 64013
(816) 224-2244
caamuseum.com

Guild of Natural Scientific Illustrators
P.O. Box 652
Ben Franklin Station
Washington, D.C. 20044
(301) 309-1514
gnsi.org

Miniature Artists of America
1595 North Peaceful Lane
Clearwater, FL 33676
(727) 584-3883
miniatureartistsamerica.org

National Sculptors Guild
2683 North Taft Avenue
Loveland, CO 80538
(907)667-2015
nationalsculptorsguild.org

National Sculpture Society
1177 Avenue of the Americas
New York, NY 10036
(212) 764 5645
sculptors.org/nss/

National Society of Painters in Casein and Acrylic
969 Catasauqua Road
Whitehall, PA 18052
(610) 264-7472

Organization of Independent artists
19 Hudson Street
New York, NY 10013
(212) 219-9213
oia.org

Pastel Society of America
15 Gramercy Park South
New York, NY 10003
(212) 533-6931
pastelsocietyofamerica.org

Wildlife Artist Association
5042 Casitas Pass Road
Ventura, CA 93001
(978) 768-7218
wildlifeartistassoc.com

Christians in the Visual Arts
255 Grapevine Road
Wenham, MA 01984-1813
(978) 867-4124
civa.org

Some businesses sell lists of people in the art world who you could send your marketing materials:

World Wide Resources (ar.com)
Caroll Michels Artist Help Network (artistshelpnetwork.com)
Art Network (artmarketing.com)

For $40 to $140 they'll give you a list of contacts. Buyer beware. They don't tell you all you need to know. You won't know if they will buy from a prisoner or not. Sure, you could just buy the list and send your stuff in the hopes of making a connection or some sales. But hope is not a reliable strategy. I've been hoping for 20 years that Illinois will bring back the parole system for lifers like me. Hasn't happened yet. I don't like using hope in my business dealings either. Neither should you. The better way to build your list of contacts is to find them yourself. Use your Facebook friends. Do web searches. Read other artists' blogs and articles. Pay attention to some of the resources in this book. Order and study some of the arts and crafts magazines. Write down all the names and e-mail addresses that you see.

Here are some prison art projects. If it's in your state, join it.

Prison Creative Arts Project (PCAP)
PCAP at the University of Michigan
1801 East Quad
701 East University
Ann Arbor, MI 48109-1245
(734) 647-6771
pcapinfo@umich.edu

Youth Arts: Unlocked
c/o Shelley Spivack
8048 Miller Rd., Ste. D
Swartz Creek, MI 48473

Denver University Prison Arts Initiative
c/o Ashley Hamilton, PhD
2135 East Wesley Avenue, Office 304
Denver, CO 80210
(303) 871-5241
prisonarts@du.edu

Justice Arts Coalition
c/o Wendy Jason
P.O. Box 8261
Silver Spring, MO 20907
info@thejusticeartscoalition.org

Prison Neighborhood & Arts Project
c/o School of Restorative Arts
North Park University
800 W. Buena Ave.
Chicago, IL 60613
contactpnap@gmail.com

POWER OF CHURCHES

For those of you who've read my book *Pen Pal Success,* you know that one of my strategies for getting pen pals was to write churches. One time I wrote a church in St. Louis and the next week I got 23 letters and cards in the mail. Imagine what would have happened if I would have some art to post on the church bulletin board? On the next page is a letter you could use to write churches. It would be best if the art you send has a spiritual theme to fit that church.

DEATH ROW PRISONER'S ART SETS HIM FREE

Ndume Olatushani was on Tennessee's death row for a murder he didn't do. His artwork was shown outside the prison. Because of that, he met the woman who became his wife. She eventually got a law degree to help him out. Then she got a large New York law firm to take his case. He was released in 2012 after 27 years inside. Olatushani said it best: "Art literally freed me." Maybe it can help free you also? You'll never know unless you start building your network.

Letter Requesting Support from Churches

Central Christian Church
P.O. Box _____
Anywhere, USA 00000

Date: _____

Dear Central Christian:

I wonder if you could help me out of a little difficulty.

I'm in search of a Christian who could correspond with me and help me out with my artwork/crafts. (See attachments.) Ever mindful of the scripture: "to have no fellowship with the works of darkness," my quest is imperative because all those around me want to lie, cheat, gossip, and practice many other forms of evil in this den of iniquity. My incarceration causes me a sever limitation in access to those I can have inspirational, uplifting conversations with. So, my search is in essence, for someone who will accept me as their brother and friend.

I would love to share my talent with others. I have tried numerous websites for prisoners to obtain pen-pals, but I have been discouraged because the replies I have received have not been from the type of people I was looking for. Nor did they want to help me sell my artwork.

If your church as a bulletin or prayer request board, would you please post my letter, photo, and artwork on it? Anyone wishing to contact me may do so by writing to me at the below address.

Thank you for taking the time to consider this letter of request. May God bless you and peace be unto you.

Respectfully Requested,

S/_____
_____# _____
_____ Correctional Center
P.O. Box _____
_____, _____ 00000
E-mail: _____

"All my great opportunities have come from friends. You only need one or two good friends, because it's really about having someone who's going to advocate for you. That's the formula for success."
– Hank Willis Thomas

YOUR PRISON PICASSO DREAM CONTACT LIST

Anytime you see a name of someone you'd like to network with, write it down. You do this so you don't forget it. Also, so you can see how many people there are waiting on you to contact them.

This is the format I use:

Name	Business	Expertise
Piper Kerman	author	"Orange Is the New Black"
Richard Stratton	author/director	expert witness for lawsuits
John Legend	singer	Unlocked Futures

Every time I see someone that is doing anything that helps prisoners or even comes close to the prison system, I write their name down like those above. The list gets longer and longer every week. I will eventually contact everyone on that list.

I learned this strategy from former prisoner Michael Santos. He was a prisoner who got 45 years in the federal system under the draconian cocaine kingpin laws of the 1980s. He wrote several books while inside, including *Earning Freedom: Prison! My 8,344th Day;* and *About Prison.* His book *Success After Prison: How I Built Assets Worth $1,000,000 Within Two Years of Release* is highly recommended for any prisoner that's about to go home. When he was inside, he used to send out to people he didn't know in the hopes of building his network. Here's what he said about those letters:

> "Over the years I've sent thousands of these kinds of unsolicited letters out. As a prisoner, my life is akin to being adrift at sea. To free me, I cast a line. The more lines I cast, the more chances I have of finding food to sustain me. The letters I write to people I don't know maybe discarded by the recipients, but I never stop trying. The success I've had over the years convinces me that the effort and stamp are worth the investment. Every year I've increased the depth and breadth of my support network by sending out such letters."

Through his practice, he became friends with university professors, journalists, lawyers, and even law enforcement officers in the Justice Department. They all supported his bid to earn an early release. After he got out, he became an adjunct professor and taught a class on prisons and parole at a University in California. That's how he became known as "the Prison Professor." You can check out his work at MichaelSantos.com.

I know for a fact that his strategy works because I have used it on my own. I was mentored by the late, great Zig Ziglar through letters all because I wrote him a letter thanking him for writing one of his books. Two of my longest-running pen pals have come from me sending out these unsolicited letters. One is my writing mentor. The other is now my surrogate mom. This is why you write these names down. So, you can contact them. And learn from them.

"Make your friends your teachers and mingle the pleasures of conversation with the advantages of instruction."
– Baltasar Gracian

As you read arts and craft magazines write names down. If they list their e-mail or social media handle write that down also. Most of the people who you want to contact will list their addresses on their website somewhere. Especially if they run a business or sell products of some kind. Even if

they don't, you can find their e-mail address. If you need someone to find the address, you could use a service that finds people. Barkan Research does that for $17.95 per person, per search. You need to know their first and last names, their last known address (at least the city and state), their date of birth (or approximate age), and any additional facts, like phone numbers or relatives' names. They typically do this type of search to find witnesses in court cases and defendants to serve lawsuits on. But you could use it for business purposes. Here is the address:

Barkan Research
P.O. Box 352
Rapid River, MI 49878

After you find their address, you can write them a letter or e-mail. It doesn't have to be an elaborate letter. On the next page is one of the letters I use. Adapt it for your situation. The key to this strategy is to ask them a question that can't be answered by reading their book, or their website. If in response to your question they give you another book title to read, get it and read it. Thank them for it. Build good karma. Successful people value their time. So, if they are taking the time to share with you it means a lot. Show them that you value their time and advice by following their instructions. Having a mentor will save you time and money. They should show you the errors in your ways and help you excel. One day you'll be able to show them how much their help aided you on your journey. That will be the ultimate compliment.

"Successful people rely heavily on their mentor. Ordinary people don't."
– Robert G. Allen

NETWORKING WITH CELEBRITIES

You constantly see it play out on TV. A big-name celebrity likes a cause, and it takes off. The founders become famous. Or a celebrity helps a prisoner. Like Kim, Kardashian-West did for Alice Johnson. Now every prisoner is writing Kim trying to get out of prison early. Is that a good idea? Some prisoners say we have nothing to lose. I agree. It's worth a shot. But what about networking with Kim K on social media? Here is what Fubu Founde and *Shark Tank* star Daymond John said about it in a March/April 2020 Inc. article:

> "Twenty-five percent of the people who follow her love her, 25 percent hate her, and the other 50 percent are men who just think she's beautiful. So, you just went down to 25 percent of the 100 percent you're paying for."

His advice is not to go out and pay for a big-name celebrity when you can network with smaller ones much more easily. He also shared his rule of three. Add three times the value you extract before you ask for anything in return. He shares three of his friend's tweets before he asks them to do the same. All of this is great advice that should be followed. Check out more in Daymond John's book, *Powershift.*

"Favor must become your seed before it can become your harvest."
– Dr. Mike Murdock

Just because you're in prison doesn't stop you from reaching out to influential people. James Allridge III had Hollywood celebrities like Susan Sarandon visiting him and buying his artwork when he was on death row. Even if you don't need them right now, you may in the future? So, dig your well before you're thirsty. Here's how.

Get out your "dream contact list." Pick someone. Do they have a website? A newsletter? A blog? Or a book? Sign up for their newsletter. Order their book and then post a review or testimonial on Amazon.com. If they blog, comment on their posts. Use their #hashtag. Follow them on their social

media pages. If they are involved in any associations or organizations, then join them also. One of the best things I did when I first started my own book publishing company was to join the Independent Book Publishers Association (IBPA). When I contacted other successful authors who were IBPA members I said, "I saw your article in *The Independent...*" and they knew I was a member of the IBPA like them. (*The Independent* is the IBPA's newsletter.) Remember Daymond John's rule of three also.

> *"Friendship is born at that moment when one person says to another: What! You too? I thought I was the only one."*
> – C.S. Lewis

Sample Letter Requesting a Mentorship

Dear [insert expert's name],

I hope this letter finds you safe from COVID and in the best of spirits. I just finished reading your [book, blog, post, article], and I can honestly say that it has truly opened my eyes. I'm trying to learn more about becoming a success in [insert whatever the subject is] and would like for you to mentor me.

In making this request, I want you to know that I don't want to be a parasite, but a protégé. I do understand that you time is valuable, so what I propose is sending you a letter here and there with a question that I may have? Then you can answer it if you get some free time. If it's more convenient you can respond by e-mailing me at [put your e-mail address here].

Once again, thank you for writing [insert title of work here]. I really like the part about [insert something you like about their book]. It was a great read. you can quote me on that in any promotions that you do. Thank you for taking the time to consider my letter and request. I look forward to hearing from you soon. May you and your work be blessed in all that you do.

Respectfully Requested,

[Your Name Here]
[Your Number]
[Your Address Here]

Naturally, it would be better for you to join the associations and organizations that you're interested in. That way you can be genuine. Most successful people have built-in lie detectors and can spot phony and fake people. Do not try to run the game. Build real friendships and you'll have a network for life.

PRISON PEN PAL WEBSITES

Most prisoners who I talk to say that they use these websites to try and build outside contacts. I have used them for years and in my book *Pen Pal Success,* I go in-depth on my experiences. I'm semi-retired now from the prison pen pal game, but I still use them occasionally. Let me show you how.

In 2019 I was writing full-time and not looking for any new pen pals. One of my friends who had read *Pen Pal Success* suggested that I go back online. That seed of an idea festered in my mind and I eventually went back to WriteAPrisoner.com. I only did it because my friend said she would write my profile and even write the pen pals for me. Here's the ad she wrote for me:

"Hi! My name is Josh. My friends describe me as smart, initiative-taking, loyal, a good friend, comical at times, polite, generous, kind-hearted, and humble.

"I enjoy the arts. I person an artist who loves to create with words, or you can simply say I'm an accomplished author and poet. I enjoy other types of art as well, especially music. My taste in music is very diverse and eclectic. I enjoy eating, not so much cooking. Although I can make the best peanut butter and jelly. Lol.

"While here I plan on getting my education finished. I also plan on continuing to find ways to build a better society with my cellpreneurial skillset. Also, I'm focused on getting back into court to overturn my case or to get an early release date.

"I look forward to meeting people from all walks of life. I believe diversity is the color that paints the canvas of one bright, beautiful world. I'm willing to correspond for however short or however long if we both have a positive impact on each other because I know the power of a smile or a simple hello.

"Well, I look forward to hearing from you if you made it this far! Here's to a future filled with a lot of laughs and long, beautiful days and star-filled nights. I hope to see a letter that your hand has graced soon. Until then, may you be blessed! Respect."

Of course, I know you want to know about my results? I got numerous hits. Some I do not write anymore. Some I do. Most of the people who responded to this ad were either artists or had an interest in art. My best pen pal off this ad is from Chicago and he does arts and crafts. For my birthday, he sent me two books that helped me complete this book. You'll see some photos of his craft items later in this book. Another response I got was from Rebecca. She is a beautiful, 19-year-old, college student, who is majoring in art therapy. So, the ad worked. I got the responses I should have. But there were some problems also.

First, one girl just wanted to get married so we could go on *Love After Lockup.* And she already had a husband that she was separated from! She lived at home with her mom and didn't have a job. We were not a good fit. Another hit I got was from an accountant in a law firm in New York. I thought he might be someone I could network with. But he only wanted to write e-mails about his foot fetish. For real, I can't make this stuff up. His fantasy was for him to lay on the ground and for me to walk all over him with my size 13, bare feet. He said he wanted me to go so far as to put my feet over his mouth and nose to suffocate him! I'm straight, that's not my cup of tea. He did say he had other prisoners he e-mailed. Hey, whatever floats your boat. All of us have certain preferences. And I'm not passing judgment on y'all. He just wasn't what I was looking for.

The second problem was that after almost 6 months, my profile had only been viewed, 1,304 times. That equals out to about 217 views a month. The cost of my ad was $40, and I paid $10 to add another photo. So, for $50 I got 1,304 page views, or about 4¢ a view. To look at it right, do the math this way. Seven responses on a $50 profile equals $7 a hit. To be fair to those numbers, we must look at the statistics and demographics behind the pen pal game. I'm a lifer, and it says so on my profile page. That brings my response rate down. If I had an outdate that was only a few years away, I would get more hits. The other problem is that we don't know the truth about those 1,304 profile views. Are they 1,304 different people? Or is it one girl (or guy) who looked at my profile then clicked off it, only to click back onto it again? Does that count as two views or one view? I don't

know. What I do know is that if you can circumvent this search process and clone your perfect pen pal your success will increase.

On the next few pages is Pen A Con's information. They have stepped their game up and I like their "Artist Tab" for any *Prison Picasso* trying to get pen pals. Let me know if you have any success with them so I can put you in future books. But first, you must know who your perfect pen pal is?

YOUR PEN PAL AVATAR

Do you know who your perfect pen pal is? What magazines do they read? What TV shows do they watch? What philosophies do they have? What beliefs do they have? What fetishes do they have? What hobbies do they have? What websites do they visit? You ask these questions so you can target your perfect pen pals online. You'll get more quality hits for your money this way.

For instance, here's my perfect pen pal avatar:

> "My best pen pal is a single, lonely woman, 30+, who reads *Inc., Entrepreneur,* and *Prison Legal News* (or believes in prisoner rights). She watches *Love After Lockup, Shark Tank, The Profit,* ABC's *For Life,* and likes sports (either playing or watching)."

If I wanted to do one for college students, it would be like this:

> "My best young pen pal is a college student who is majoring in criminal justice, reads *Prison Legal News,* watches *Love After Lockup,* ABC's *For Life,* and prison documentaries."

For the emerging *Prison Picasso,* your perfect pen pal avatar could be:

> "My best pen pal is a college student who is majoring in Art, and believes in criminal justice reform, reads *Sunshine Artist, ArtNews,* and *Prison Legal News.* She watches *Love After Lockup,* ABC's *For Life,* and prison documentaries."

So how could you find these people? By using Facebook and other social media sites. You could start with the following searches:

- "People who like *Prison Legal News.*"
- "People who like ABC's *For Life.*"
- "People who like *Love After Lockup.*"
- "People who like prison pen pals."
- "People who believe in prisoner rights."
- "People who believe in criminal justice reform."
- "People who like prison art and crafts."

Then go to Google and YouTube to search for "prison pen pal forums" and "prisoner rights forums." When you do searches like this, you'll find some websites and network opportunities. Some that you've never heard of. These will be opportunities for you to connect with people who are empathetic to the prisoner's journey. Don't believe me? Let me show you. For research on this topic, I ran a search for "prison arts and crafts" on Facebook, and here are some of the hits I got:

- Prison Arts Project (William James Association) – Page – 1.1k likes
- Prison and Neighborhood Arts Project – Page – 1.3k likes
- Prison Art and Hobby Craft – Group – 131k members
- Crossroads Prison Art Project – Video – 2.9k likes
- Prison Fellowship's Create – Video – 191k likes for their page
- Colossal Arts & Humanities website – Page – 931k likes

- Pivot Arts – video – 1.4k likes
- UC Davis Art Studio Program – Page 74 likes
- Jack Shainman Gallery – Page – 10k likes
- Exodus Place – Page – 1.8k likes

Add up all the likes above and you have over a million. Just the "Prison Art and Hobby Craft" Facebook Group has 47,000 members! Join that group ASAP and start networking. All you have to do is start posting in these types of groups. Then ask people a simple thought-provoking question. After they answer you ask them the follow-up question: "How did you come to that conclusion?" I had a cellmate who used to do this on phone calls to the party line. After getting the girls on the line involved in a discussion, he would send them to his pen pal page. He came up numerous times like that. This was years before Facebook, Twitter, Instagram, and LinkedIn came out. That same strategy would work on these networks.

> *"Friends are like the warm blue sea; they splash laughter into your eyes."*
> *– Karen Reynolds*

MILLIONAIRE PRISONER FACEBOOK STORY

After my twin brother got out of the fed joint, he helped me build a Facebook page. I've been locked up since 1999 so I had never used Facebook as it did not exist back then. But 17 years later, it was on and popping. He built me a simple page and I would make posts every week. I was able to reconnect with friends that I went to school with and hadn't seen in years. Some of them didn't even know I was doing life in prison! One of them thought I was living in California. Lol.

One day I was in the yard and saw an all-white cat sitting on a boulder sunning himself. At my prison, the yard is in the back o our prison and is carved out of a hill and a rock wall. This type of earth is common to our area of the world – the Shawnee National Forest and Mississippi River area of Illinois. This formation and the way our prison is carved out of the hillside next to the Mississippi River has earned it the nickname, "The Pit." In between the yard fence and the rock wall are all these boulders that have fallen onto the ground. So, there was this cute, white cat chilling like he didn't have a care in the world. I happen to love cats. I had an all-black cat named "Cosmic Creepers" (or "CC" for short) when I was a kid. I got him as a kitten and named him after the witches' cat in the Disney movie "Bedknobs and Broomsticks." I had CC for years until he got into a fight with a raccoon and the coon tore half of CC's face off. He looked like "Two-Face" from Batman, and I wanted to keep him, but my mom and the vet made me put him to sleep. Like I said over again, I love cats. So, I wrote a Facebook post about a-white cat sunning himself next to our yard.

Immediately, the women who were friends on my page all liked it. Then Nikki contacted me. She was a girl who lived in my neighborhood. Her dad and my mom were good friends. She liked my cat story and we started talking. She started coming to see me every week, putting money on my books and accepting all my calls. Then I started talking to another girl who was friends with my sister growing up. We talked on the phone every day and had weekly video visits. I was doing so good that some of the prison guards who worked the visiting room asked me what my secret was? I was on top of the world, and it was all because of Facebook.

Eventually, my brother and I fell out over some business disagreements, and I shut my Facebook page down. OK, that's a lie. He told me since he built it for me, he was shutting it down and I would have to start over. He ended up going to prison for a string of bank robberies. Even though we weren't talking I still didn't want him to go back to prison. I'm sure you're wondering about Nikki and the other girl. Both ended up finding free-world guys and we don't talk anymore. No love lost. I understand it all. I can only imagine what kind of burden it is to be in a relationship with a life-term prisoner like me. I learned a lot. The main thing was that Facebook could deliver better results than any prisoner pen pal website ever could.

SOCIAL MEDIA PEN PAL NETWORKS

A lot of the prison pen pal companies now understand that by using their social media pages they can get better results for us prisoners. And better results (or more hits) equal more word-of-mouth marketing for their business. That means more money for them. It's good for everyone involved if they do it right!

Caged Kingdom is a business that charges $14 for a yearlong pen pal profile on their website, cagedkingdom.net. They also charge $7 for a Facebook promotion. They guarantee your promotion will reach 200 people. These will be people targeted based on the information you provided in your profile application. You may be thinking that 200 people is not much? But remember by WriteAPrisoner.com story? I paid $50 for 1,300 profile views. That same $50 could get me 1,400 targeted views with The Caged Kingdom. And those people should be more responsive than someone just scanning profiles online. When I saw that, I decided to try their services out. Here's what happened.

Caged Kingdom did a Facebook Insights promotion for my profile. It was seen by 213 people, shared by 3 people, and engaged by 13 people. I ended up getting a great pen pal off this promotion. Another girl signed up to e-mail me about their promotion. So, it worked. I'll have more to say about Facebook in a later chapter. The Caged Kingdom also helps prisoners sell their artwork.

For more about the prison pen pal game, you should get a copy of my book, *Pen Pal Success.* I've just updated it with all new content and profiles. It has a special LGBTQ+ pen pal chapter written by transgender princess Skylar Doll also. Order your copy today from Freebird Publishers.

FACEBOOK TARGETING

Because of my success on Facebook, I wanted to offer my readers the opportunity to get the same results. As I write this it costs $20 to target 1,000 people in a Facebook Ad. I asked my virtual assistant if we could offer this same service? She said, "Sure if I get paid to do it." I worked it out with her for her to get her usual $30 per hour. For 40 percent, she'll run a Facebook Ad off my "Millionaire Prisoner" business page to 1,000 people you target. That is $20 for Facebook fees plus $30 for her time and expertise. You will get the results printed off and mailed to you by snail mail. For best results, you should have a page or website you want us to send them to. So, if you got a WriteAPrisoner page you would want us to put at the end of your ad something like this: To learn more visit my page WriteAPrisoner.com/joshuakruger." The same for PenACon or your Facebook page. Or even your prison e-mail provider? It would work best if it was to an online website that prints off your responses, i.e., "hits" and sends them to you. Like PenACon or WriteAPrisoner. If you want to do this to get pen pals or market your arts/crafts, send $50 to:

Amy Bryant
620 Sager St.
Danville, IL. 61832

Fill out the questionnaire on the next page, write it on paper, do NOT remove the book's page, and send it with $50 to the above address.

Facebook Targeting Questionnaire

1. Who would you like to target? Men Women ALL

2. What country? U.S. UK World Other_____

3. What age range? 18+ 21+ 30+ ALL

4. What likes would you want them to have?

5. What is your reason for targeting? Pen Pals? Business?

6. Where do you want to send them? E-mail? Website?

7. Do you have a Facebook Page?

8. Do you have a Pen Pal Page?

NETWORK GROWTH SECRETS

The goal is to build long-term friendships and relationships that are mutually beneficial to both of you. To do that, you need to constantly evaluate these friendships. When you meet someone new, ask yourself the following questions once a week:

- What could I be doing to make both of us happier?

- What could I do less of to make both of us happier?

- What could I start doing to make both of us happier?

- What could I stop doing to make both of us happier?

Go over them with your friends and loved ones. Listen to their answers carefully. When you're with someone, be with them. On the phone? No distractions. When face-to-face, use eye contact. Touch them. Don't interrupt them. Listen to them. Pause before replying. Ask for clarification. Then paraphrase it back to them. Finally, my number one rule is to get rid of negative people in your life.

"A network is not made by just connecting with the right people, but by connecting those people to each other. It's not just who you know – it's who you help."
– Jeff Goins

ADDITIONAL RESOURCES

I could write a whole book about how to network from a prison cell. But I'm limited to only a chapter, so I want to give you some additional resources. If you have a GTL tablet, you can listen to the following for more tips on becoming a better networker:

- *I Hate Networking!* by Will Kintish

- *Successful Business Networking Tips* by Kennedy Imuere

- *Networking* by Jon Robert Quinn

Then, every once in a while, search "networking" on your tablet to see what comes up.

RESOURCE BOX

Some books that you may want to read are:

- *Your Network is Your Net Worth* by Porter Gale

- *Dig Your Well Before You're Thirsty* by Harvey Mackay

- *How to Win Friends and Influence People* by Dale Carnegie

- *Networking Smart* by Wayne E. Baker

- *Connected* by Nicholas A. Christakis

- *Click: The Magic of Instant Connections* by Ori and Rom Brafman

Contact Freebird Publishers about ordering if you don't have anyone to help you.

Always remember that it only takes one yes to change your life. But you'll never get that one "yes" unless you try. So, get out of your comfort zone. Write those letters Send the e-mails. Build your social media networks. Do whatever it takes. You can start by joining the "Prison Art and Hobby Craft" Facebook group. I want to leave you with the following thought from *Real Artists Don't Starve* by Jeff Goins:

"A network is your insurance against anonymity. The greater access you have to influential people in your field, the further your work will spread. Of course, you have to be good, but being good is not enough. Skill gets you in front of the right people, but a network magnifies your reach. Creative success, then, is contingent on your ability to connect well with those who can vouch for your work. It doesn't take a lot of people – just a few friends, you don't need an army, but you do need a network."

CHAPTER 8

ARTISTS & THE LAW

"Learn the rules like a pro, so you can break them like an artist."
– Pablo Picasso

A lot of prisons have rules allowing convicts to make and sell arts and crafts. Some have actual art classes or programs. When I was in juvenile prison in the early 1990's we had an art therapy class. Most of us loved it because one of the therapists was a sexy college girl. But it was cool to use art as a way to escape our incarceration. When I first showed up in the adult prison system in Illinois at the end of the 90s my family came to visit me every week. During one of those trips to the visiting room, I saw paintings and drawings other convicts had done that were being sold. Visitors could buy them if they wanted to. Maybe they have a program like this at your prison? If so, take advantage of it. If not, you may need to check your prison's rules about making and selling artwork. In Illinois, the rule states as follows:

Section 445.40 Arts and Crafts
Committed persons may release to their visitors any art or craftwork that they have produced if approved by the Chief Administrative Officer. *See 20 Ill. Admin Code, Section 445.40*

Most Illinois prisons allow their convicts to produce arts and crafts with materials purchased through the commissary or the Dick Blick company. Check your prison's rules first before you start producing your arts and crafts. I'd hate for you to spend all your work putting together your art portfolio to having given it confiscated by the authorities.

In 1996, the U.S. Court of Appeals ruled that the First Amendment not only protects the right to create art but also the right to sell it. This is consistent with Supreme Court law. See *Joseph Burstyn, Inc. V. Wilson,* 343 U.S. 495, S01-02 (1952) (First Amendment protects forms of creative expression even if they are sold with a profit in mind). Arts and crafts are a form of free speech and freedom of expression. There is a plethora of case law involving the First Amendment and prisoners are guaranteed the right to freedom of expression. See *Jordan V. Pugh,* 504 F.Supp.2d 1109 (D. Colo. 2007). You should go to your prison's law library and research the law in your circuit regarding prisoners' rights. In particular, you want to examine outgoing correspondence rules, business rules for prisoners, and other free speech and freedom of expression cases from prisoners. If you can't physically go to the law library, you can use Westlaw or Lexis-Nexis to research. Some of you have those on your tablets and should use them. The information is out there, you just have to find it and use it.

Most of the cases that I found are about prisoners' writing and publishing, incoming mail and publications, and religious rights. But arts and crafts fall into that same category and under that same First Amendment umbrella. If you have problems with sending your artwork out of prison, be sure to utilize any grievance procedures that your prison system has available. Always try to work it out before going to court. The good thing is that there are people, places, and legal centers that help prisoners and artists. If you must go to court, then make sure you try and contact these organizations first. In *Prison Picasso,* I've included a list of some of these lawyers and centers. But not all prison artwork is protected.

Indiana prisoner Bill McClain, Jr. painted two paintings in 2002-03 that the prison "Recreation Leader" and staff deemed to be a security threat group (i.e., "gang"), or STG materials. The paintings were so-called "white supremacist imager." Once painting depicted Adolph Hitler and three SS officers wearing swastikas. Because of that, prison officials took the painting and wrote a conduct report and revoked 60 days of good time. He was eventually allowed to send the paintings. home. McClain then sued prison officials alleging numerous violations of federal law, including the First amendment. The district court dismissed his claims and he appealed to the Seventh Circuit Appellate Court in Chicago. They ruled against him saying that the prison had a valid reason to curb security threat group material and therefore the confiscation of his painting was justified. See *McClain V. Leisure,* 192 Fed. Appx.544 (7th Cir. 2006). The moral of the story is? Try not to do artwork with any symbols or images that can be depicted as STG or gang paraphernalia.

3 MAIN AREAS OF LAW FOR ARTISTS

When creating your art, it may fall under three areas of law known as "intellectual property" law or "IP" law. These areas are:

- Copyright Law
- Trademark Law
- Visual Artist Rights Act

Let's look at these areas a little more so you can get a better understanding.

COPYRIGHT LAW AS APPLIED TO ARTISTS

Once you create a piece of original art you own the copyright to that piece for your lifetime plus seventy years. That gives you the right to dictate how the artwork is used unless you sell those rights to someone else. In that copyright, you have certain rights that are sometimes called inherent rights. They are:

- You have the right to make copies of the original work.
- You have the right to create other works based on your original work. (These are called "derivative" works.)
- You have the right to sell, rent, or lease copies of your work.
- You have the right to display your work in a public place.

A word of warning: Never sell all these rights all at once! In these rights, you have what is called "divisible copyright." What this means is that you could grant a poster company the right to use your work, but also at the same time, grant another company the right to use it on a greeting card, and another one to use it in a magazine. This is what makes art so valuable. But you must be careful of what you're signing away when you sell artwork usage. In alphabetical order, here are the most popular terms when discussing selling artwork:

- *All Rights*. This means that you will give up your entire copyright to a specific artwork. Never do this unless you feel that you are completely satisfied financially. You could sell "all rights" for a limited period only. If you do that make sure you have a written signed contract for future use, should you have to go to court.
- *Electronic Rights*. This allows a buyer to place your work on electronic media, like a website.
- *Exclusive Rights*. This allows a buyer the right to use your work in a particular market or on a specific product, like a greeting card. This is fine because you could still approach other companies (not a greeting card one though) about other products.
- *First Rights*. This means the buyer gets to be the first person or company to use your artwork. First rights can be for the whole world, or North America, or even just in one state or city. Typically, they are "First North American Rights."
- *One-Time Rights.* Your buyer pays you to use your art once This is what magazines normally pay for. That way you can reuse it again and sell it to someone else after they publish it.

- *Promotional Rights.* This would give a publisher the right to use your artwork in ads or other promotional pieces.

- *Work for hire.* If you sign a contract to do a work-for-hire piece of art, you surrender all rights to it and can never resell that piece ever again. If you agree to a work-for-hire agreement, make sure the money you get is worth your time.

There are a few areas where someone could use your artwork and you do not get paid. For instance, if someone wanted to review your artwork as a critique they could. That's what is called "fair use" under copyright law. But no one can use your artwork to make money off it without your permission.

Normally, when you sell your artwork to a magazine or a book publisher, you are licensing your illustration to them. They are not buying your artwork completely unless they tell you it's for "all rights," or it is a "work-for-hire." This is why you should pay particular attention to any agreements you sign. Licensing, and being able to divide your artwork, is what makes it so valuable. But you must be super careful that you don't sell two companies the same exclusive rights. For instance, I have books published with both The Cell Block and Freebird Publishers. If I signed a contract with Freebird to publish *Pen Pal Success,* I could not then sell rights to The Cell Block. Unless my contract with Freebird was only for a limited time. Then I would be free to approach other publishers once the time limit was over. Therefore, most lawyers will tell you to get all agreements in writing.

WHEN WHERE AND HOW TO USE THE COPYRIGHT © SYMBOL

Here is a proper copyright notice:

<div align="center">
Copyright 2021, Josh Kruger

© 2021, Josh Kruger
</div>

Both are okay. The year should be the year it was first created. You should put your copyright notice where it can be easily seen. Some artists put it in the lower left-hand corner of their work. Others put it on the back of their piece. Either one is fine. If you make reproductions of your artwork, you can also put your copyright notice on the backs of those pieces as well. You do not have to do this in pieces that are sold to magazines. Sometimes you just see the artist's name right by the illustration. The artist still owns the copyright unless they sold all rights. Whenever you sell an illustration to a magazine make sure you get a credit line near it. That way you will build your name and resumé in the art world.

HOW TO REGISTER A COPYRIGHT

You can do it easily online by visiting the United States Copyright Office at copyright.gov. It is cheaper to do it that way. If you can't do it by e-filing, then you must do it by mail. Your first step would be to write them and request the paper forms at:

<div align="center">
Library of Congress, Copyright Office

COPUBS

101 Independence Ave. SE

Washington, DC 20559-6304

Attn: Information Publications, Section LM0455
</div>

You should ask for package 115 and circulars 40 and 40A. If you are registering a cartoon, you should ask for Package 111 and Circular 44. Once you get the forms, you should fill them out and include payment, then send them in. You can register one piece of artwork, or a whole collection. If

you want to do a whole collection you should write "the collected works of (your name) 2020-2021." Mine would look like this:

The Collected Works of Joshua W. Kruger, 2009-2020.

The only problem with this is you must send photocopies of every piece of artwork in that collected work.

WHY REGISTER YOUR COPYRIGHT?

A lot of people don't register their copyrights. You don't have to. But if you don't, and someone starts using your artwork to make money without your permission, you can't take them to court. Well, you could, but it will be a lot harder to get paid, and you wouldn't be entitled to court costs. You should register your original artwork if you think someone might try to steal it in the future. So always use the © symbol on your artwork.

If someone starts using your artwork and you haven't registered it with the copyright office, you can register it then. But you would have to wait till it is registered before you can take legal action against someone by taking them to court. You should first send the person who is using your artwork without your permission a "cease and desist" letter. At the bottom of the letter put "cc: (Your Attorney's Name)". Sometimes that can get you what you want? Keep copies of your letter and any reply you get just in case you must go to court. Hopefully, you never have to.

Intellectual Property (IP) piracy has become a big business online. Especially in other countries. The best way to combat this is to register your work as soon as you can. You get protection in the United States as well as the 20 other countries that have reciprocity agreements with the U.S. If you want to track your images online, you can do reverse image searches. TinEye.com and Google both allow you to do them. What is a reverse image search? It's where you put in your original image, and then they tell you where that image is being used online. Once you find that information it would be up to you to decide what to do about it. Some companies do all of it for you. ImageRights.com is such an all-in-one service. If you plan on being prolific or becoming a really popular artist online, you may want to join such a company. These companies charge monthly or yearly fees so it may not be worth it.

Some artists are now using Creative Commons to limit how their works are used online. On Creative Commons you get to indicate how your work can be used, modified, or shared. If someone doesn't agree to your terms, they can't use your image. If they agree to it, then don't follow your terms, the license is canceled, and they are in violation of your copyright. A lot of reputable people now use Creative Commons, including the Metropolitan Museum of Art. So, you may want to check them out also.

TRADEMARK LAW

A trademark is generally a word, phrase, symbol, design, or a combination thereof, that identifies and distinguishes the source of the goods of one party from those of others. For an artist or crafter, you may need to register your trademark to protect your interests if you're going to sell goods based on your art/crafts. There's a difference between a copyright and a trademark. Copyright

protects an original art piece. A trademark protects brand names and logos used on goods and services. So, if you want to sell a line of t-shirts with your logo design, you should probably register a trademark.

The United States Patent and Trademark Office is an agency of the U.S. Department of Commerce that grants trademarks. They offer free resources on their website (uspto.gov/trademarks). You can also request a copy of their free booklet: *Protecting Your Trademark: Enhancing Your Rights Through Federal Registration* by writing to the commissioner at:

Commissioner for Trademarks
P.O. Box 1451
Alexandria, VA 22313-1451

In January 2017, the USPTO increased fees for all trademark applications and related documents filed on paper. It now costs $600 to file a trademark application through the mail on paper forms. It's a lot cheaper to file electronically over the internet. For more information about that process and the current filing fees you can get help from the Trademark Assistance Center at:

1-800-786-9199
E-mail: TrademarkAssistanceCenter@uspto.gov

If you see the "®" symbol after a service name or logo, that is a legal designation that it's a registered trademark. Unless you have registered your trademark, you can't legally use that ® symbol. You can still use ™ to indicate the symbol is a trademark you have adopted as yours. That gives you "common law" rights-based solely on the use of the mark in commerce. However, owning a federal trademark registration gives you the greatest legal protection and the ability to bring an action in federal court.

One area where artists can benefit from trademarks is merchandising. Or where a company takes your logo or design and puts it on goods and products like clothing, posters, greeting cards, dolls and action figures, toys and games, and other items. Think of companies like *Disney ®*, *Marvel ®*, *Warner Brothers ®*, and the *Precious Moments ®* characters. There's big money in licensing of demarks. If you're considering entering into this type of agreement, I suggest you get (and study) the books listed at the end of this chapter. Never enter any business deal based on oral contracts. Make the other person put it on paper and spell out what and who does what and who gets what! As the famous saying goes, "an oral agreement isn't worth the paper it's written on."

THE VISUAL ARTISTS RIGHTS ACT

The Visual Artists Rights Act of 1990 was an amendment to federal copyright law that provides visual artists the right to claim authorship or attribution of their works. It also allows artists the right to prevent people who own the works from altering or distorting the piece without their consent. If you own the copyright on a painting and someone destroys it, you could sue them for damages. The Copyright Office in Washington, D.C. has created a department under the act for addresses of artists. Some states have their own laws that protect artists. In my state, Illinois has a Consignment of Art Act which partly says, "Any portion of an agreement which waves any provision of this Act is void." It means you can't sign away all your rights to the art you created. New Jersey has something similar, but theirs has a clause that says, "unless the waiver is clear, conspicuous, and in writing." You are encouraged to find out your state's law regarding artists' rights. To be aware is to be alive.

USING OTHER ART TO DO YOUR OWN ARTWORK

A ton of prisoners use pictures out of magazines, other pieces of art, and other images to make their own. You have to be very careful that you do not violate another artist's copyright and wind up in court. Most of the prisoners I see who do greeting cards as a hustle take cartoon images like *Mickey Mouse* ® and put them on a card to send home. That's okay. The problem would come in if they started to reproduce that *Mickey Mouse* ® image onto a lot of cards and sell them in the free world. If they did not get *Disney's* ® permission first, they would be violating that trademark and could be sued. In the "Be Inspired and Get Creative" chapter I talk about Andy Warhol painting Campbell's ® soup cans. He did that in 1962. He just painted a soup can. It would have been different in this day and age if he put that image onto hats and t-shirts and started selling those. If you look at the photos in the "Product Photos and Image Galleries" chapter, you'll see me holding a Hello Kitty ® piece. I'm not selling Hello Kitty paintings to the public so there's nothing wrong with using that photo as a way to prove a point I'm trying to make.

No artist can copyright a style or technique. That's how people learn. In trademark law, there's a term called "trade dress." What that means is that the way a particular artist's work feels by the style, subject matter, color, technique, use of light, and perspective all come together. None of the above in itself is copyrightable but taken together as a whole, they can be. As you get more recognition for your artwork, you may be able to get this type of protection? You would be best to perfect a certain style and subject matter of your own. You want collectors to see your work and know it's yours. There are riches in niches. And if you do that, you will have greater protection under the law in the long run.

THE RIGHT TO PRIVACY

Previously, I mentioned how one prisoner painted portraits of Barack Obama and sold them for $400. And how Andy Warhol made lots of money painting celebrities like Marilyn Monroe and Elvis Presley, among others. There are numerous laws that protect a person's right to privacy. Even your fellow prisoners still have a limited right to privacy. We may not be put on display for entertainment purposes or public viewing. See *Demery V. Arpaio,* 378 F.3d 1020 (9th Cir, 2004). And a prisoner may not be filmed without consenting to the broadcast. See *Huskey V. National Broadcasting Co., Inc.,* 632 F. Supp. 1282 (N.S. Ill. 1986). All of this brings into play the federal Privacy Act, 5 U.S.C. §552, and state privacy laws, respectively. You should check your state's right to privacy laws first before you start doing mass-produced art of real-life subjects, especially celebrities.

The easiest way to protect yourself from being sued is to get written permission from the person before you paint or draw them. Getting them to sign a one-page "Model Release Form" would do the trick. You don't have to do this if you're painting portraits on commission, and you give the only copy to that person. But if you intend to make a duplicate copy and use it to promote your services you should have a written agreement signed stating such.

BETTER TO BE SAFE RATHER THAN SORRY

The easiest way to handle things is to play it safe. This means getting permission ahead of time to use copyrighted or trademarked material. In *Profit from Intellectual Property,* attorneys Ron Idra and James L. Rogers have a great chapter on "Obtaining Permissions." They list three steps you should take:

1. Find out who owns the copyrighted work or trademark.

2. Find out any procedures that the copyright or trademark owner has for obtaining permission; and,

3. Request permission to use the copyrighted work or trademark using a written permission form or agreement.

I used this process to quote several authors in my first book, *The Millionaire Prisoner.* One of them even became my mentor. It's just better to try and get permission first. In this chapter, I'll give you some sample permission letters you can use.

"Be prepared for your art to be bent, folded, spindled, and mutilated, as well as copied, unpaid for, lost, and stolen."
– Jackie Battenfield

CONTRACTS AND AGREEMENTS

So much of your professional life as an artist will depend on agreements between you and someone else. As most of us prisoners already know from experience, people say one thing and do the opposite. Some do it on purpose. Others are just dumb, lazy, and incompetent. Because of this, you must protect your interests. Artist, and author, Jackie Battenfield, has a great "cardinal rule" to follow in *The Artist's Guide: whenever a work of art leaves your hands, it must have a paper trail.* That is to protect your legal rights and interests. You need something in writing. Even if it's just a promissory note saying they'll pay you a certain sum. That would be better than nothing. Preferably, you want definitive signed contracts and agreements. Contract law is governed by the state you live and practice in, or the state where your gallery or dealer/representative lives. You need to learn the rules from your state. Some of the contracts that you should develop are as follows:

- Consignment Agreements
- Art Loan Agreements
- Commission Agreements
- Licensing Agreements
- Work-for-Hire Contracts
- Out-Right Sales Receipts

In *Business and Legal Forms for Fine Artists,* Tad Crawford has sample contacts that you can use to develop your own. Study them and use them. I speak from experience on this next point – make sure you read and understand the fine print and everything you are signing. Ask questions about everything you don't understand. And remember, that you can always negotiate better terms. The better you become, and the more your name is recognized, the more leverage you will have. Just make sure you get it all in writing ahead of time.

A FINAL FEW WORDS ON THE LAW

The law is ever-changing. New cases come out every day. So, you must stay up to date on the latest rulings in the art world if you're going to protect and enforce your rights. I am not a lawyer. I have won several lawsuits in federal court and state small claims court actions as my attorney. How did I learn how to do that? By reading books and practicing.

RESOURCE BOX

If you want to know more about your legal rights as an artist, you are encouraged to read some of the books below:

- *Business and Legal Forms for Fine Artists, Third Edition* by Tad Crawford
- *Legal Guide for the Visual Artist, Fifth Edition* by Tad Crawford
- *Art Law Conversations* by Elizabeth T. Russell
- *Licensing Art & Design* by Caryn R. LeLand
- *Licensing Art 101, 3rd Edition* by Michael Woodward
- *The Business of Being an Artist* by Daniel Grant
- *Art Law in a Nutshell, 4th Edition* by Leonard D. Duboff and Christy King

All of these books can be found online. Contact Freebird Publishers about ordering them if you don't have someone to help you.

Sample Permission Request Letter

[Company Name here] Date: _____
[Company Address here]

Attention: [Artist's Name Here]

Re: Permission Request

Dear _____:

I would like to obtain permission to use the following material: _____ that I
believe is copyright protected by you. I'd like to use it to: _____.
Please grant my request by signing and returning this request. I would greatly appreciate it if
you could return the letter to me no later than _____.

If you do not own the rights for which I see, or if additional copyright permissions are needed,
please indicate who I can contact to obtain these rights.

Sincerely,

[Your Name Here]
[Your Address Here]

I approve this request. S/_____

Sample Permission Form

The Undersigned hereby grant(s) permission to _____ (hereinafter referred to as the "Artist"), located at _____, and to the Artist's successors and assigns, to use the material specified in this Permission Form for the following artwork, book, or other project: _____.

This permission is for the following material:

Nature of material_____

Source: _____

Exact description of material_____

 If published, date of publication_____

 Publisher_____

 Author(s)_____

This material may be used for the artwork, book, or project named above and in any future revisions, derivations, or editions thereof, including nonexclusive world rights in all languages.

It is understood that the grant of this permission shall in no way restrict republication of the material by the Undersigned or others authorized by the Undersigned.

_____ _____
Authorized Signee Date

_____ _____
Authorized Signee Date

VOLUNTARY LAWYERS FOR THE ARTS GROUPS (VLANY.ORG)

If you run into problems and you need the help of an attorney, you should try and contact one of these legal centers in your state. If your state doesn't have a group like this, then you should try one of the pro bono attorneys listed after this section.

CALIFORNIA

calawyersforthearts.org

Beverly Hills Bar association Barristers
Committee for the Arts
300 S. Beverly Drive
Beverly Hills, CA 90212
(310) 553-6644
(310) 344-8720

California Lawyers for the Arts (Oakland)
1212 Broadway, Ste. 834
Oakland, CA 94612
(510) 444-6351
oakla@there.net

California Lawyers for the Arts (Sacramento)
926 J Street
Sacramento, CA 95814
(916) 442-6210
clasacto@aol.com

California Lawyers for the Arts (San Francisco)
Fort Mason Center, Building C
San Francisco, CA 94123
(415) 775-7200

California Lawyers for the Arts (Santa Monica)
1641 18th Street
Santa Monica, CA 90404
(310) 998-5590
usercla@aol.com

San Diego Lawyers for the Arts
Craddock Stropes, Lawyers for the Arts
625 Broadway
San Diego, CA 92101
(619) 454-9696
sandiegoperforms.com/volunteer/lawyer_arts.
html

COLORADO

Colorado Lawyers for the Arts
P.O. Box 48148
Denver, CO 80204

(303) 722-7994
coloradoartslawyers.org

CONNECTICUT

Connecticut volunteer Lawyers for the Arts
Connecticut Commission on the Arts
755 Main St.
Hartford, CT 06103
(860) 256-2800
ctarts.org/vla.htm

DISTRICT OF COLUMBIA

Washington Area Lawyers for the Arts
1300 I Street, N.W.
Washington, DC 20005
(202) 289-4295
thewala.org

FLORIDA

Florida Volunteer Lawyers for the Arts
1350 East Sunrise Boulevard
Ft. Lauderdale, FL 33304
(954) 462-9191 ext. 324
artserve.org

Volunteer Lawyers for the Arts of Pinellas
County
1470 Terminal Blvd., Ste. 229
Clearwater, FL 33762
(727) 453-7860
pinellasarts.org/smart_law.htm

GEORGIA

Southwest Volunteer Lawyers for the Arts
c/o Bureau of Cultural Affairs
675 Ponce de Leon Avenue, N.W.
Atlanta, GA 30308
(404) 873-3911
glarts.org

ILLINOIS

Lawyers for the Creative Arts
213 West Institute Place
Chicago, IL 60610

(312) 649-4111
law-arts.org

KANSAS

Mid-American Arts Resources
P.O. Box 363
Lindsborg, KS 67456
(913) 227-2321
swhitfield@ks.usa.net

LOUISIANA

Louisiana Volunteer Lawyers for the Arts
225 Baronne Street
New Orleans, LA 70112
(504) 523-1465
artscouncilofneworleans.org

MAINE

Maine Volunteer Lawyers for the Arts
477 Congress Street
Portland, ME 04101
(207) 871-7033
tcloutier@lambertcoffin.com

MARYLAND

Maryland Lawyers for the Arts
113 West North Avenue
Baltimore, MD 21201
(410) 752-1633
mdartslaw.org

MASSACHUSETTS

Volunteer Lawyers for the Arts of
Massachusetts, Inc.
249 A Street
Boston, MA 02110
(617) 350-7600
vlama.org

MICHIGAN

Volunteer Lawyers for the Arts & Culture
17515 West Nine Mile Road
Southfield, MI 48075-4426
(248) 557-8288, ext. 14
artservemichigan.org

MINNESOTA

Springboard for the Arts
Resources and Counseling for the Arts
308 Prince St., Ste. 270

St. Paul, MN 55101
(651) 292-4381
springboardforthearts.org

MISSOURI

St. Louis Volunteer Lawyers and Accountants
for the Arts
6128 Delmar
St. Louis, MO 63112
(314) 863-6930
vlaa.org

MONTANA

Montana Volunteer Lawyers for the Arts
P.O. Box 202201
Helena, MT 59620-2201
(406) 444-6430
mac@state.mt.us

NEW HAMPSHIRE

Lawyers for the Arts/New Hampshire
New Hampshire Business Committee for the
Art (NHBCA)
One Granite Place
Concord, NH 03301
(603) 224-8300
nhbca.com/lawyersforarts.php

NEW JERSEY

New Jersey Volunteer Lawyers for the Arts
c/o New Jersey Law Journal
230 Mulberry Street
Newark, NJ 07101
(973) 854-2924
amlaw.com

NEW YORK

Volunteer Lawyers for the Arts
1 East 53rd Street
New York, NY 10022
(212) 319-2787
vlany.com

NORTH CAROLINA

North Carolina Volunteer Lawyers for the Arts
P.O. Box @6513
Raleigh, NC 27611-6513
(919) 699-NCVLA
ncvla.org

OHIO

Volunteer Lawyers and Accountants for the
Arts – Cleveland
113 St. Clair Avenue
Cleveland, OH 44114
(216) 696-3525

Toledo Volunteer Lawyers and Accountants
for the Arts
608 Madison
Toledo, OH 43604
(419) 255 – 3344

OKLAHOMA

Oklahoma Accountants and Lawyers for the
Arts
211 North Robinson
Oklahoma City, OK 73102
(405) 235-5500
eking@gablelaw.com

OREGON

Northwest Lawyers and Artists
Oregon Lawyers for the Arts
621 S. W. Morrison Street
Portland, OR 97205
(503) 295-2787
artcop@aol.com

PENNSYLVANIA

Philadelphia Volunteer Lawyers for the Arts
251 South 18th Street
Philadelphia, PA 19103
(215) 545-3385
pvla.org

ProArts
Pittsburgh Volunteer Lawyers for the Arts
425 Sixth Avenue
Pittsburgh, PA 15219-1835
(412) 391-2060
proarts-pittsburgh.org/vla.htm

RHODE ISLAND

Ocean State Lawyers for the Arts
P.O. Box 19
Saunderstown, RI 02874
(401) 789-5686
artsaw.org

SOUTH DAKOTA

South Dakota Arts Council (SOAC)
800 Governors Drive
Pierre, SD 57501
(605) 773-3131

TEXAS

Texas Accountants & Lawyers for the Arts
1540 Sul Ross
Houston, TX 77006
(713) 526-4876
talarts.org

UTAH

Utah Lawyers for the Arts
P.O. Box 652
Salt Lake City, UT 84110
(801) 533-8383

WASHINGTON

Washington Lawyers for the Arts
819 North 49th
Seattle, WA 98103
(206) 328-7053
wa-artlaw.org

PRO BONO ATTORNEYS

ALASKA

Alaska Disability Law Center
3330 Arctic Blvd., Ste. 103
Anchorage, AK 99501
(907) 565-1002

Alaska Pro Bono Program
P.O. Box 14019
Anchorage, AK 99514-0191

ALABAMA

Alabama State Bar Volunteer Lawyers
Program
415 Dexter Avenue
Montgomery, A 36104
(334) 269-1515

ARKANSAS

Ozark Legal Services Pro Bono Project
4083 N. Shiloh Drive, Ste. 3
Fayetteville, AR 72703
(501) 442-0600

Legal Services of Arkansas
615 West Markham Street, Ste. 200
Little Rock, AR 72201
(501) 376-8015

CALIFORNIA

California Pro Bono Project
480 N. First Street
San Jose, CA 95112
(408) 998-5298

Bay Area Legal Aid
1735 Telegraph Avenue
Oakland, CA 94612
(510) 663-4755

COLORADO

Northwest Colorado Legal Services
P.O. Box 1904
Leadville, CO 80461
(719) 486-3238

Heart of the Rockies Bar Association Pro
Bono Program
1604 H Street
Salida, CO 81201
(719) 539-4251

CONNECTICUT

Connecticut Statewide Legal Services
425 Main Street, Ste .2
Middleton, CT 06457-3371
(800) 453-3320

DELAWARE

Delaware State Bar Association Lawyer
Referral Service
(800) 773-0606

Delaware Legal Aid Society
913 Washington Street
Wilmington, DE 19801
(302) 575-0660

GEORGIA

State Bar of Georgia Pro Bono Project
104 Marietta Street NW, Ste. 100
Atlanta, GA 30303
(404) 527-8700

HAWAII

Volunteer Legal Services Hawai'i
545 Queen Street, Ste. 100
Honolulu, HI 96813
(808) 528-7046

Legal Aid Society of Hawaii
1108 Nuuanu Avenue
Honolulu, HI 96817
(808) 536-4302

IDAHO

Idaho Legal Aid Services
310 North 5th Street
Boise, ID 83701-0913
(208) 336-8980

ILLINOIS

Chicago Volunteer Legal Services
100 N. LaSalle Street, Ste. 900
Chicago, I. 60602
(312) 332-1624

Chicago Legal Clinic
2938 E. 91st Street
Chicago, I 60617
(773) 731-1762

Uptown People's Law Center
4413 North Sheridan
Chicago, IL 60640
(775) 769-1411
uplcchicago.org

INDIANA

Indianapolis Legal Aid Society, Inc.
615 North Alabama Street
Indianapolis, IN 46204
(317) 635-9538

Community Development Law Center
1802 N. Illinois Street
Indianapolis, IN 46204
(317) 921-8806

KANSAS

Kansas Legal Services, Inc.
712 South Kansas Avenue, Ste. 200
Topeka, KS 66603
(913) 223-2068

LOUISIANA

The Pro Bono Project
615
Baronne Street, Ste. 203
New Orleans, LA 70113
(504) 581-4943

MARYLAND

Maryland Volunteer Lawyers Service
1 North Charles Street, Ste. 222
Baltimore, MD 21201
(800) 510-0050

MAINE

Maine Volunteer Lawyers Project
P.O. Box 547
Portland, ME 04112
(800) 442-4293

MICHIGAN

Michigan Legal Services
220 Bagley Avenue, Ste. 900
Detroit, MI 48226
(313) 964-4130

Legal Services of South-Central Michigan
420 N. Fourth Avenue
Ann Arbor, MI 48104
(734) 665-6181

MINNESOTA

Volunteer Attorney Program
314 West Superior Street, Ste. 1000
Duluth, MN 55802
(218) 723-4005

Legal Aid Society of Minneapolis
430 First Avenue North, Ste. 300
Minneapolis, MN 55401-1780
(612) 334-5970

MISSISSIPPI

Mississippi Volunteer Lawyers Project
P.O. Box 2168
Jackson, MS 39225-2168
(800) 682-6423

MISSOURI

Legal Services of Eastern Missouri
4232 Forest Park Avenue
St. Louis, MO 63108
(800) 444-0514

MONTANA

Montana Pro-Bond Project
P.O. Box 3093
Billings, MT 59103
(406) 248-7113

NORTH CAROLINA

Legal Aid of North Carolina
224 South Dawson Street
Raleigh, NC 27601
(866) 219-5262 (toll free)

NORTH DAKOTA

Legal Services of North Dakota
1025 North 3rd Street
Bismarck, ND 58502-1893
(800) 634-5263

NEW HAMPSHIRE

New Hampshire Pro Bono Referral System
112 Pleasant Street
Concord, NH 03301
(800) 639-5290

NEW JERSEY

Legal Services of New Jersey
100 Metroplex Drive
Plainfield Avenue, Ste. 402
Edison, NJ 08818-1357
(908) 572-9100

NEVADA

Volunteer Attorneys for Rural Nevadans
904 N. Nevada Street
Carson City, NV 89703
(866) 448-8276

Legal Aid Center of Southern Nevada
800 S. Eighth Street
Las Vegas, NV 89101
(702) 386-1070

NEW MEXICO

New Mexico Legal Aid
P.O. Box 25486
Albuquerque, NM 87104
(505) 243-1871

UTAH

Legal Aid Society of Utah
450 South State Street
Salt Lake City, UT 84111-3101
(801) 238-7170

VIRGINIA

Virginia Poverty Law Center
201 West Broad Street, Ste. 302
Richmond, VA 23220
(804) 782-9430

Virginia Legal Aid Society, Inc.
513 Church Street
Lynchburg, VA 24504
(866) 534-5243

VERMONT

Vermont Volunteer Lawyer's Project
274 North Winooski Avenue
Burlington, VT 05401
(802) 863-7153

WISCONSIN

Legal Action of Wisconsin
230 West Wells Street, Room 800
Milwaukee, WI 53203
(414) 278-7722

WEST VIRGINIA

West Virginia Legal Service Plan
1003 Quarrier Street, Ste. 700
Charleston, WV 25301
(304) 342-6814

WYOMING

Legal Aid of Wyoming, Inc.
211 West 19th Street, Ste. 300
Cheyenne, WV 82001
(877) 432-9955

You can also find attorneys who specialize in legal rights for artists and crafters on the following websites:

attorneyfind.com
martindale.com
abanet.org

"But on the bright side, we'll
never have to serve jury duty."

"I don't think about art when I'm working. I try to think about life."
– Jean-Michel Basquiat

Jean-Michel Basquiat was an American artist. He became popular as
part of SAMO, an informal graffiti duo who wrote enigmatic epigrams.

CHAPTER 9

YOUR FIRST SALE

"A fair price is the highest one a collector can be induced to pay."
– Robert Hughes

The focus of this chapter is your first sale. In reality, it probably won't be your first sale. You've probably sold some art (or crafts) to your fellow prisoners for commissary? Or even had them send money to your trust fund account? How are you doing with that? Are you achieving your financial goals? Or are you still struggling to make ends meet? While selling your work to other prisoners may bring up the value of your work inside, it doesn't help you become a Prison Picasso. Unless you're in Club Fed and selling your paintings to rich, white-collar criminals for thousands of dollars? If not, then pay attention to this chapter. Maybe you'll be the next artist in prison to go from just surviving to thriving.

The first step you must take is to immediately raise your prices. Yes, I just said that. The whole point of the Prison Picasso system is to get you from selling your art for commissary to making thousands of dollars a year. And hopefully a million dollars in the future? But one of the biggest mistakes I see artists make is to try to be the cheapest on their compound. That strategy weakens the overall market and commits them to poverty. Here's what I mean. A new artist moves into the cell house. He sees other prisoners doing portraits and greeting cards. He asks about the prices and finds out that most of them are doing portraits for $10 a face and cards for $3. So, he puts the word out that he'll do them for $8 a face and buy two cards, get one free. I'm sorry, his time should be worth more than that. What he should do is look to see how he can be better than all the other artists, provide more value, and charge more. As my mentor likes to say: "There's no competition at the top."

The reason why you should charge the most is so you can do less work and get more money for your time. The more money you get, the better supplies you'll get to work with. In return, your work will get better, and you'll be able to charge more. This has worked out for me in book writing. As I got royalty checks, I was able to buy more research books. That helps me put out better content. Of course, I had to take my time and put out quality products first. But once that was done, I continued to invest back into myself and my writing career. You'll be able to do the same with your art/crafts. So, raise your prices!

No matter if you're an artist or a crafter, always price high. It's easier to lower prices as "on-sale" or "special discount." It would be super hard to raise your price on a piece once you've already set it. If your customers can't afford the prices you set, maybe you have the wrong customers? Read *No B.S. Guide to Marketing to the Affluent* by Dan S. Kennedy. Remember death-row prisoner James Allridge? He sold paintings to Hollywood movie stars. Why can't you?

"Money is part of the process of becoming an artist, if for no other reason than it affirms you are a professional, but the decision to be taken seriously is yours alone. You set the tone for how people will treat you, which means you must believe your work is worth charging for."

PRICING FORMULAS

In the book publishing world, we have certain pricing formulas that we use. The art world has them also. The difference between the two is that most books retail for about the same price everywhere depending on size, cover (hardback/softback), and page count. Whereas, in the art world, it's more about who the artist is...I'll show you how to get your name out there in later chapters. For now, I want to give you some pricing formulas you can use to see if you're setting your prices correctly. Remember, these are just guidelines. You can, and should, be doing whatever your market will allow.

One simple way to determine the price for your products is to use a formula that many businesses have used for years. It goes like this:

$$Materials + Labor + Overhead + Profit = Wholesale Price$$
$$Wholesale Price \times 2 = Retail Price$$

To determine "profit" some artists use this formula:

$$Materials + Labor + Overhead \times 2 = Profit$$

Other artists add more to the above formulas. To know the above numbers, you must know how long your materials last? How many greeting cards can you get from a pack of markers, a set of paint, and a stack of card stock? How many paintings can you do from a set of paint and canvas panels? Learn your numbers.

Here are two more price formulas that some artists use:

$$18" + 24" = 42" \times \$50 = \$2,100$$
Or
$$18" \times 24" = 432" \times \$2 = \$864$$

For instance, a painting on an 18" x 24" canvas in the first version would be priced at $2,100. In the second one, the artist uses the linear measurement (18x24=432) and times each linear inch by $2 to get $864. As you can see from above, the higher your prices, the higher your profit. The higher your profit margins, the more/better art/crafts that you can make. You owe it to yourself to get the most you can for your art. Always price high. It's easier to lower prices as "on-sale" or "special discounts" than it is to raise your prices. If your customers can't afford the prices you've set, maybe you have the wrong customers? For more about getting more affluent customers, read *No B.S. Guide to Marketing to the Affluent* by Dan S. Kennedy.

> *"If it is art, it is not for all, and if it is for all, it is not art."*
> *– Joseph Stalin*

Here's something you should remember, especially crafters. "Handmade" means premium and should bring your prices up. Especially if you use unique materials or have a unique style or process. "One-of-a-kind" also should bring your prices up. Look to other crafters to see what they're charging? Most crafters say that your retail price should be twice as much as your wholesale price. Materials matter: a bronze sculpture would command higher prices than a wood one. Keep all of this in mind.

THE POWER OF PREEMINENCE

What is preeminence? It's the ability to surpass all others in a distinguished way. Dan Kennedy and Jay Abraham, both multi-millionaire marketing consultants, teach this. How can you use this strategy in prison? By putting out the best quality of the product you can. That's how you can attract the highest-paying customers. Let me give you an example. I know one prisoner who does elaborate 5x7 and 8x10 greeting cards. Hand-painted ones with made-to-order designs upon request. He commands, and gets, much higher prices than all the other guys at my prison who do cards. Why? Because his cards are of the best quality, and he has the best customer service. I gladly pay his prices for several reasons. First, because every time I order a card, he "wows" me with the result. Second, I'm paying for the reaction I get when I send it home. My people absolutely love the cards he does. That, in itself, is priceless.

So, what does he get in return? He gets a healthy profit margin. He can make fewer cards per week. And he gets a better quality of client because most of us who pay premium pieces for artwork in prison are not complainers. Do you see the lessons to be learned in using preeminence? One of the main ones is that artwork is bought most of the time for how it makes a person feel.

Think about that. Art is just color on paper or some other material (or craft/sculpture). The value comes from what people feel when they look at it. Always remember that.

WHEN TO RAISE PRICES

As you develop your career, you can raise your prices every time you have an exhibition or win an award. In Business of Being an Artist, Daniel Grant tells the story of Colorado Painter Scott Fraser. He says that Fraser's paintings sold at a gallery in the early 1980s for $300. The following year his prices went up to $900. In the 22000s his work was selling for $7,000 to $20,000. Fraser said that each time you break price barriers, you must find a new set of collectors. Makes sense. People who usually pay $300 for paintings probably can't afford to buy $20,000 ones.

Here are some more tips to remember when setting your prices:

- Large paintings command higher prices. Most galleries and collectors have large spaces to fill, so they want big paintings. Try to do the biggest paintings that you can if you're a painter.

- Once you start getting exhibitions and gallery presentations, don't undercut their prices. That's unethical and will get you booted from the gallery. Keep prices consistent.

- Oils and acrylics are worth more than watercolors if done by the same artist. And paintings command higher prices than drawings.

- The more expensive the canvas (paper) your art is on, the more you can charge for it.

- "One-of-a-kind" (OOAK) art or craft items will get more than limited editions. Even the "original" of a limited edition will bring a whole lot more.

- New and engaging artists' works are worth less than established and famous artists.

- If you have celebrity collectors who have bought your artwork, you can get more for your work.

- Galleries in larger cities like New York and Chicago normally get higher prices for their artists' work.

- Prices at auctions normally bring much larger sums because buyers are caught up in a frenzy not to lose to the other bidders.

- You can always barter. Trade art/crafts for other services. Website design. Legal work. Cooking. Other products. They can all be bartered for if you have quality artwork. Just remember to get equal value in return.

- Lastly, remember that you have the final say-so. If you can't sell your art for the price you set, don't settle for lower. Unless you want to and are comfortable doing so.

YOUR FREE-WORLD SALES MACHINE

A few years ago, artist Sandy Tracey was selling small, 5x7 paintings for $30-$50 on her blog, sandytracey.com. Can you sell a 5x7 painting for $30 at your prison? If not, you need to get your work outside of your prison. You can do that by getting your work online. If the free world doesn't see your work, it doesn't exist. Don't believe me? Let me tell you a story that shows you the difference.

I have a friend in my prison who is a writer. He may be a better writer than me? He's certainly more prolific than me. The problem is that he does not send his work out for people to see it. So only he

and I know it exists. I, on the other hand, send my stuff out regularly. That's the difference between being a writer and a published author. You could be the best artist in the whole world, but if no one knows about it, you will not make money. Do you want to sell art for more than those commissary scraps you get at your prison? Then you must send it out to someone so free-world people can start seeing it! I'll have more to say about all of this in future chapters. But for now, just remember that you most likely won't become a *Prison Picasso* by selling to your fellow prisoners. Yes, you could make a nice living, just not a million-dollar fortune. To do that, you need to get your art out into the hands of celebrities and other collectors. You never know who they'll talk to about your art. You never know what can happen from those types of conversations. Get your work out in the free world so it can circulate.

FAME IS IN THE NAME

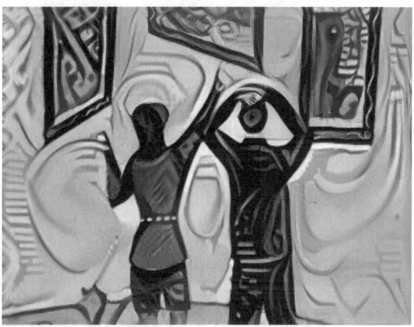

Titling art matters. It never used to. No one can find any record of Leonardo da Vinci calling *Mona Lisa* by *La Gioconda*. Of course, now it has that name. Damien Hirst specifically titles his pieces in ways that will help in marketing. His stuffed shark sculpture that sold for $12 million was titled: *The Physical Impossibility of Death in the Mind of Someone Living*. Some artists use the place where they painted a piece in the title. The more specific the better. Don't say "forest." Title it: *Shawnee National Forest, ND. 1*. See the difference? Be as specific as you can. You're doing this for two reasons. One is to help in marketing. Two, for your recording keeping. You don't want to name different paintings the same thing. Some artists like to use "Untitled." I would only use that once. Think about your art hanging in a gallery. What will the title convey to the viewers who look upon your work? Plot your names carefully and thoughtfully.

THE MOTIVATIONAL SALES RECORD

Keep track of all your sales. Every one of them. Even the smallest ones that you do in your prison. I learned this from authors like Elbert Hubbard and Stephen King. I keep a little notebook of all the money I have made off my writing. It starts with my $50 sale to George Kayer when he ran *Inmate Shopper* for an article. Recently, it listed my royalties from Freebird Publishers and The Cell Block. You use your notebook of sales for motivation and a reminder of where your profit comes from. You can train your mind to start seeing the big million-dollar picture instead of the scraps you make inside your prison.

The second reason you do this is so that you get in the habit of knowing your money math inside out. Once you start making hundreds of thousands of dollars, you'll have to pay taxes. Having all your sales written down will make it easier for your accountant and keep you out of tax court. More about taxes later. For now, start keeping track of all your sales.

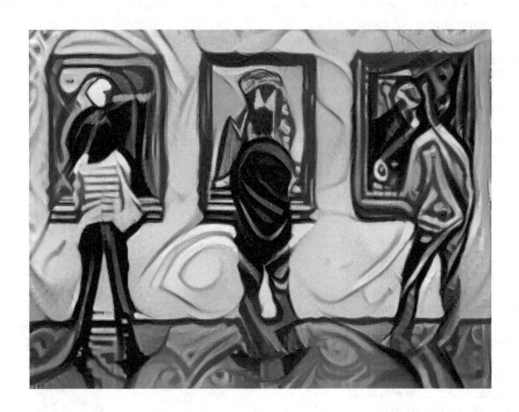

YOUR FIRST SALE

If you are selling art from your cell to a collector by mail, you should use a contract and an invoice. The contract should be sent to them and signed and returned to you before you send the artwork. I have included a simple, sample contract that you can use as a format to do your own at the end of this chapter. Once they send you the correct payment, you should send an invoice detailing the sale with the artwork. Make sure you keep copies of all these documents. I've also included a simple, sample invoice as well. I would personally use these documents even if I was selling my work to other prisoners. I know one guy who sells paintings for $50-$100 to other prisoners. He should be using invoices and contracts. Of course, he looks at his art business as a hobby and not a business. You no longer do that. You're beginning to see what's possible in the art world. Take it seriously and become a professional. That's how you become a *Prison Picasso*.

RESOURCE BOX

If you're still hung upon on raising your prices, I encourage you to read the below book. It will help you get in the right frame of mind even though it's not really for artists or crafters.

No B.S. Price Strategy: The Ultimate, No Holds Barred, Kick Butt, Take No Prisoners, Guide to Profits, Power, and Prosperity by Dan S. Kennedy and Jason Mars

All these books can be found online. Contact Freebird Publishers about ordering them if you don't have someone to help you.

Sample Basic Artwork Sale Contract

AGREEMENT made as of the _____ day of _____, 20 __, between _____ (hereinafter referred to as the "Artist"), located at _____, and _____ (hereinafter referred to as the "Collector"), located at _____, with respect to the sale of an artwork (hereinafter referred to as the "work").

WHEREAS, the Artist has created the Work and has full right, title, and interest therein; and
WHEREAS, the Artist wishes to sell the Work; and
WHEREAS, the Collector has viewed the Work and wishes to purchase it.

NOW, THEREFORE, in consideration of the foregoing premises and the mutual obligations, covenants, and conditions hereinafter set forth, and other valuable considerations, the parties hereto agree as follows:

1. *Description of Work*: The Artist describes the Work as follows:

 Title: _____
 Medium: _____
 Size: _____
 Framing or Mounting: _____
 Year of Creation: _____
 Signed by Artist: Yes No

2. *Sale*: The Artist hereby agrees to sell the Work to the Collector. Title shall pass to the Collector at such time as full payment is received by the Artist pursuant to Paragraph 4.

3. *Price*: The Collector agrees to purchase the Work for the agreed upon price of $_____ and shall also pay any applicable sales or transfer taxes.

4. *Payment*. Payment shall be made in full upon the signing of this Agreement.

5. *Delivery*. The ❑ Artist ❑ Collector shall arrange for delivery to the following location: _____ no later than _____, 20___. The expenses of delivery (including, but not limited to, insurance and transportation) shall be paid by _____.

6. *Risk of Loss and Insurance*: The risk of loss or damage to the Work and the provision of any insurance to cover such loss or damage shall be the responsibility of the Collector.

7. *Copyright and Reproduction*: The Artist reserves all reproduction rights, including the right to claim statutory copyright, in the Work. The Work may not be photographed, sketched printed, or reproduced in any manner whatsoever without the express, written consent of the Artist. All approved reproductions shall bear the following copyright notice: © by (Artist's Name) (Year____).

8. *Miscellany*: This Agreement shall be binding upon the parties hereto, their heirs, successors, assigns, and personal representatives. This Agreement constitutes the entire understanding between the parties. Its terms can be modified only by an instrument in writing signed by both parties. A waiver of any breach of any of the provisions of this Agreement shall not be construed as a continuing waiver of other breaches of the same or other provisions hereof. This Agreement shall be governed by the laws of the State of _____

IN WITNESS WHEREOF, the parties hereto have signed this Agreement as of the date first set above.
Artist _____ Collector_____

Sample Art Sale Invoice

Artist's Name: _____ Date: _____

Artist's Address: _____

Artist's e-mail/telephone: _____

Purchaser's Name: _____

Purchaser's address: _____

Purchaser's e-mail/telephone: _____

This invoice is for the following Artwork created by the Artist and sold to the Purchaser:

Title:

Medium:

Size:

Framing or Mounting:

Year of Creation:

Signed by Artist: ❏ Yes ❏ No

Price $_____

Delivery $_____

Other Charges $_____

Sales or Transfer Tax (if any) $_____

Total: $_____

❏ Please remit the balance due. ❏ Paid in full.

Thank you.

Artist _____

CHAPTER 10

YOUR PORTFOLIO

"The best portfolios have great quality paintings, are painted in series, and are marked with titles, medium, size, framed size, and price."
– Sherry Rhyno, Gallery 31 owner

Before the internet came along, artists would have to visit galleries with their portfolios and show off their work. Because a prisoner can't personally visit a gallery or collector, you must utilize snail mail, e-mail, and other internet strategies to get your portfolio in front of the right people. In this chapter, I'll detail the points behind a successful portfolio. Because it's so important, I have devoted a separate chapter to perfecting an artist's website. Remember this chapter as you read the rest of this book, especially the next chapter: "Your Artist Website."

TIPS FOR A SUCCESSFUL PORTFOLIO

Most prison artists that I talked to want to show off every piece they have produced. But in my research, I have found that less is more. Only your best artwork goes in your portfolio. Why? Because people will judge you based on the worst piece in it. Six to ten images would be best. As you are just starting as an emerging artist, you won't be able to be as selective though. That's okay. Do the best you can with what you got. Here are some more tips to remember when putting together your portfolio.

- Try to find other artists that you admire and see how they do their portfolios. Especially pay attention to any successful prisoner artists who might be your competitors.

- For a printed portfolio, most artists choose a simulated leather one with puncture-proof sides. Common sizes are 11" x 14" or 18" x 24". You can put your loose samples inside of that.

- Always present a neat and organized portfolio. Even when doing a digital portfolio that will be sent via e-mail, pdf, or JPEGs, a neat and organized one is better than some fancy portfolio. (When sending JPEGs via e-mail, they cannot be larger than 600x800 pixels.).

- When doing digital portfolios, have someone look at your portfolio on different devices so they can see if it looks good or not.)

- Try to aim for high-quality images, with no two images of the same subject. The same style, yes, but not the exact subject. The one exception to this rule would be illustrators. Then you need to show a series or progression in your portfolio.

- Have different portfolios set up for different clients. Tailor your portfolio to what they collect.

- When doing the labels in your portfolio, always remember to put name title, medium, size, date, and website URL on them. When doing the "size" of your work, always remember this rule: Height x width x depth, or "HWO", always in that order.

- Never use ink or permanent marker on your photo images as it could wash off or bleed through onto the face of your art photo. If your photos are loose, always label which side is "top" on the label.

- Always put a digital version of your portfolio on your website. And make sure the click-through rate and button are easy to use.

- A printed version should only be used when trying to win serious clients and collectors. Why? Because it's going to cost you more money for postage and putting together a nice, neat, and professional-looking portfolio.

- Do two different portfolios and ask people which one they like best? Use the winner, scrap the loser.

- Update your portfolio every year at a minimum. You can also update it when you archive major successes in your career.

Those are some tips for perfecting a professional-looking portfolio. Because your artist statement and your photos are so important, I will now go more in-depth about both of them.

YOUR ARTIST STATEMENT

Because you're in prison, your work will be viewed without you standing there to explain it. You won't be there to answer people's questions about your process. An artist statement is very important for the Prison Picasso. It has become so important that art schools now teach students how to write them.

Every art book that I read in research for the Prison Picasso system said that most artists don't know how to write a good statement. Gallery owners, museum curators, and art dealers all say that a poorly written artist statement is worse than no statement at all. And that most of the statements they get are useless. Author and artist, Jackie Battenfield, says that when she ran the Rotunda Gallery and got a poorly written statement, she felt sorry for the artist. She also said that a lot of the time she didn't pursue the artist after that. Now that you know how important an artist's statement, we is can look at how to do it right. That way you can stand out above masses of other artists.

"A good artist statement is too important a tool for you to ignore or neglect."
– Jackie Battenfield, author of The Artist's Guide

YOUR FIRST DRAFT

There is no output without input. The first step is to think and let your imagination run wild. Don't worry about grammar or putting together a perfect paragraph at this stage. Just write down whatever comes to mind. Anytime it comes to mind. Keep a pen and some paper next to your bunk or in your pocket. Do that so you can jot down ideas as they come. Don't become discouraged either if it doesn't come naturally. Good writing takes time. I still struggle to get my sentences right. All writers do at times.

To help you brainstorm and come up with your rough first draft, here are some questions to ask yourself. Write down your answers.

- Why do you do artwork? Crafts?

- How did you get started doing it?

- Why do you do it the way you do?

- What does it mean to you?

- How does it make you feel?

- What does your work look like to you?

- What is the vision for your work?

- What artists inspire you?

- Do you work from the main theme? If so, what is it?

- What materials do you use?

- How has your art evolved?

Ask your fellow prisoners about your art. What do they think? Seek out someone who isn't in your circle and get an unbiased point of view. Be open to any questions they may have. Pay attention to the answers you give. You could find a golden nugget inside them.

After you have answered these questions, it's time to write out a rough first draft. Use "I" or "my" or "me." Write in the first person like you were talking to someone at a museum who just asked you about your work. Use the answers to the questions that you wrote down. Just write it all out. Don't worry about the length of the overall piece at this time. When you are done, read it. Read it out loud to yourself. Does anything come to mind? Write it down immediately so you don't forget it. Then give it to a friend that you know who is always reading books and writing. What do they think? Any tips? Do that again with someone else. Add to it if you want. Change it, move stuff around. Play with it. Have fun with it.

Before you go to sleep that night, I want you to read your first draft to yourself. Do this at least 3 times back-to-back-to-back. Then go to sleep. Let your imagination and subconscious mind work on it for you. When you get up, write down anything your mind supplies. If you take naps during the day, do it before you take your power nap. Then write down what's on your mind when you wake up. Sometimes there will be nothing. Other times, you'll have something great. After you have done this a few times, rewrite your artist's statement, incorporating all your new material. Then put it away for a few days, or a week or two. Do your art. Read a book. Listen to music. Do anything but mess with your artist statement.

YOUR SECOND DRAFT

After some time has passed, get out your artist statement. Now is the time to edit your statement. This time you will need to follow some rules to make it the best you can. Get a dictionary and a thesaurus. The overall goal is to come up with two artist statements that you will use. One will be a short, one-sentence statement of no more than 12 words. This is the one that you will use online. Why a maximum of 12 words? Because anything more is too long for a sentence online. If I was coming up with a short sentence for my statement on *Prison Picasso*, it would be: "I paint to escape the oppression of prison." You may use that if you wish. It's not trademarked. If someone were to ask me why I write, I would say, "I write to escape the oppression of prison." Try to come up with a one-sentence statement like this that you can use online.

Your longer statement should be 2 or 3 paragraphs at most. (200-500 words, or one page). One paragraph would be best. Here's what Henri Matisse wrote in the 1908 journal essay, "Notes of a Painter":

> "What I dream of is an art of balance, of purity and serenity, devoid of troubling or depressing subject matter, an art which might be for every mental worker, be he

businessman or writer, as an appeasing influence, like a mental soother, something like a good armchair in which to rest from physical fatigue."

I don't think anyone can argue with that one paragraph. It may take you more than one paragraph. Just remember that you want it to fit on one page of the paper. Sometimes your statement will be placed next to your work at a show. You want it to be a quick revealing read. Sometimes your statement will be read to the jurors at competitions. They should look forward to seeing your work after hearing your statement.

Here are some rules to remember to lighten up your statement and get it right:

- Check punctuation, grammar, and spelling. Use your dictionary.

- Do not use the same words in one sentence. Use your thesaurus to find a better word.

- Do not use big words or flowery language. Simple, plain language is best.

- Do not say, "The purpose of this statement is..." They already know what the purpose is.

- Do not say, "I think" or "In my opinion." Your words are your thoughts and opinions.

- No long sentences! 15 words or less. One and two-syllable words at most. Try not to use three-syllable words.

- Use the same first-person voice throughout. Unless you're quoting someone else talking about your work.

- Write in the active voice, not the passive one. For instance, "I am," instead of "I hope to."

After you have edited your statement, go ahead, and rewrite it. Then read it out loud to yourself. Do you stumble or stutter at certain spots? See why? Maybe you should tweak something there? Give it to somebody to read out loud to you. Can they do it easily? Do they stumble or stutter? Fix it if they do. It doesn't have to be perfect, but it should be good enough. Remember that this is a time for you to stand out from the crowd. Put some time into your artist statement.

"Writing is a Habit, not an Art."
– Ann Handley

One last note. You may be tempted to hide the fact that you're in prison. Don't. People will like the fact that you haven't let prison stop you. And that you are using your time constructively and creatively. Especially if you work under particularly harsh conditions or with unique materials. I am in a maximum-security prison and have been for the last 18 years. I write using 3-inch flexible ink pens. People are amazed that I write books under these conditions. If you have a similar story, put it in your statement. Don't hide it. Don't downplay it. Trust me. You'll get more supporters if they see your struggle.

Your artist statement will evolve over the years as you get more experience and eventually get out of prison. That's fine. Hopefully, you get so recognized that you will no longer need a statement. Until then, spend some time on yours so you can stand out. If you still have trouble getting yours right, then you may want to read *Writing an Artist's Statement* by Ariane Goodwin (artist-statement.com).

SHORT BIO OR RÉSUMÉ

Some people in the art world don't need to see a long artist statement. Instead, they will want to see a curriculum vitae (CV) or résumé. This would detail your professional history, including major exhibitions, shows, and/or sales. It should be short, no more than one to three paragraphs at most.

Of course, it will be shorter when you're first starting. In *The Business of Being an Artist,* Daniel Grant has a brief, but brilliant expose on art artists' resumes. The gist of it is don't pay for frivolous shows and listings just to be able to include them on your résumé. He says that no artist has been rejected by a dealer for having too short a résumé. Let your work samples speak for themselves!

PRODUCT PHOTOS AND IMAGE GALLERIES

Have you ever bought a piece of artwork or craft item from another prisoner without first looking at it? I haven't. I need to see it so I can judge its cost and worth. It's the same for arts and crafts in the free world. Because people online will want to see your work before they buy it, you need to post great photos of your products. Since you're in prison, you'll have someone in the free world take these photos for you. Keep this chapter in mind as you explain to them what you need to be done.

In years past, the first time an art critic, curator, or dealer, saw your work was through a slide that they held up to the light. Those days are over. Technology has evolved and a digital camera is a norm. But just because technology has advanced doesn't mean that the need for great photos of your work is any less diminished. You may produce a masterpiece, but if it's photographed wrong it could be rejected as a shoddy piece. Sometimes your art dealer will take the photos for you. Other than that, unless you got a digital cell phone in your cell, you're going to have to enlist a family member or friend to take the photos for you. What are some of the common mistakes made when photographing arts and crafts? Here are six that are easily preventable:

- The artwork is crooked in the photo

- The colors are off in the photo

- There are background distractions in the photo

- There is a glare from too much light

- Some shadows hide parts of the piece

- There's a lack of focus in the photo

Now that you know the most common mistakes, let's look at how to prevent them.

THE DIGITAL CAMERA

The first step to taking great photos is investing in a quality camera. Have your family member or friend get a digital SLR camera. If you have the money available, you need a point-and-shoot digital camera with a minimum of 7 megapixels, good autofocus, and 4x zoom. If not, then try to get at least a 3-megapixel or a 6-megapixel camera. You want a camera with a flash that can be turned off. The white balance and ISO should be set to automatic. You want your photo images to be 1MB and 3MB in size. As you get more funds, you'll want to invest in a tripod. You want to be professional in what you produce if you want to be taken seriously. Photos of your work area are a great place to start.

"A good product photo is crisp and focused. At a glance, the viewer can see the detail and texture, how well the item is made, and all of its unique handcrafted goodness. A good photo will communicate as much as possible about the real product, everything that an online customer needs to know."
– Kim Solga

So, what are some of the tips you can give to your photographer so that your work is best shown? Here are the most important things to remember:

- Great product photos are done in bright and natural lighting. If taken indoors, you want two photo amps placed at 45-degree angles from the piece and aimed at the center of the work. Some professionals shoot at night or close the curtains to get rid of sunlight.

- The camera lens should be parallel to the product and aimed at the center of the piece. The artwork should fill the whole viewfinder to eliminate extra material like an easel, etc.

- Do not use frames or glass on the art when it's photographed at first. You don't want any hard shadows or hot spot glares.

- You want it so that exact colors show up. Make sure the person taking the photos know how to use the white balance feature on the digital camera. White should be white, not gray. Black should be fully black.

- Use simple, plain backgrounds. A white background is best. You can use plain, white photo paper or black velvet to eliminate distractions and absorb light.

- Artwork is best photographed flat against a wall or lying flat on the floor. This is where a tripod can be helpful, so the camera doesn't move when the photo is taken.

- Do not crop the edges of the artwork. Viewers should see the whole piece.

- If it is a large art piece, a sculpture, or a craft item, then you want to take detailed shots of your product. You want to show details like hand-stitching and quality. Use items like apples or flowers to show size dimensions.

- If your item is usable then have photos taken of your product in use. A video of it in use is even better.

- Have multiple photos taken from different angles and in different settings. Do you want your buyer to imagine how it will look in their home or office?

- If your product is a series or a set, then at least one of your photos should show the entire series or set.

- Think brand for your photos as well. Try to use the same props, colors, backgrounds, and style. Develop your unique style.

Test out different options. You want your products to be photographed in the best possible manner. After the photos are taken, have them saved in .jpg format.

Have them sent to you so that you can review them before they are posted. Check for proper size? Do they show details? Are the colors vibrant? Is the lighting good? Are they level? Have the photos sent to you in every size that they will be seen online. What looks good at a smaller size may not look good in a larger photo and vice versa. Look at the photos in art magazines, catalogs, and books to get ideas about how to photograph your products. Once your photos are posted, they are out there in the world for all to see. So, make sure you are completely satisfied it is the best image possible.

Hopefully, your family member or friend knows how to use Photoshop? There are other free photo editing programs as well:

- Picasa (picasa.google.com) is for Google

- GIMP (gimp.org/downloads) is for MAC computers

- PAINT.net (getpaint.net) is for Windows

But you don't have to download the above services. Google Plus has a free service called Picnik. And iPiccy (ipiccy.com) and PicMonkey (picmonkey.com) are free photo editing services as well.

THE IMPORTANCE OF PHOTO DESCRIPTIONS

After your photos are taken, you're not done. Your next step is to write the descriptions of those photos. You do this for two reasons:

- You'll use them when you send your photos to art critics, curators, and dealers.

- You'll use shortened versions in all your online posts and marketing materials

People who buy arts and crafts like to know how the product or piece was made. Is your process unique? Do you use one-of-a-kind materials? Are you working under extreme conditions at your prison? You can put all of this into the written description of your photos. These descriptions will be different than your overall artist's statement. These descriptions should be for each specific piece or product. The ones you do for your offline written materials can be a little longer than your online descriptions. But they should not be super long. Here's a simple format to follow when coming up with your written photo descriptions:

Image #_____: (Image title), (date)
(paper), (materials), (size)
(short paragraph explaining the piece)
(_____)

Say I painted an art piece of Picasso behind some prison bars in a cell and I wanted to write a written description of the photo I send out? I'd use the above formula to come up with this hypothetical description:

Image #1: *Prison Picasso,* May 2020.
Canvas, acrylic paint, 24" x 24"

Based on one of the cells I used to live in to signify Picasso's quote that no matter where an artist is, he/she can still be a master of their world.

It doesn't have to be long or be fancy or use big words. But most of us know that there's a story behind most art. It's good to let people know that story if you can? When sending multiple photos to possible art/craft middlemen, you will need to include an "Image Description List" with the photos. Here's how it should be done.

- At the top of the page should be your name and full contact information:
 Josh Kruger

 (000) 000-0000
 e-mail:

- The next line should say:
 "Image Description List"

- Then each image should be labeled and numbered to match the order of the photos included. Use the same formula as described above to do your written description lists

That's all there is to it. If you want to, you can have your artist's statement under your name and address to explain who you are and what you're about? That would negate the need to include a separate sheet with your artist's statement.

ONLINE PHOTO IMAGE DESCRIPTIONS

Writing for online media is different than offline. Why? Because people scan when reading online. That's why headlines are so important. In *Everybody Writes,* content marketer And Handley gives the ideal length for online writing for marketers who are trying to optimize their posts:

- Blog Posts should be no more than 1,500 words.

- E-mail Subject Lines should be 50 or fewer characters.

- Website Text Lines should be 12 words at most.

- Paragraphs should be no more than 4 lines.

- YouTube videos should be 3 to 3½ minutes in length.

- Podcast should be no more than 22 minutes long.

- Title Tags should be 55 characters or less.

- Meta Descriptions should be 155 characters or less.

- Facebook Posts no more than 100-140 characters.

- A tweet or Twitter post should be kept at 120-130 characters.

- Domain Names should be 8 characters or less.

These rules are based on studies conducted by online marketers and are designed to get the best response. I'll deal with a lot of these in later chapters, but right now we need to discuss title tags and meta descriptions. (FYI: When I say "characters" that include spaces, periods, etc. Any prisoner who uses a GTL Tablet to send e-mails knows about character limits!)

On your website, your Facebook page, and your blog, you should be building your image galleries. You want these image galleries to be filled with your pieces and/or products. But just posting an image is not enough. You should write specific title tags, or "alt attributes" or "alt tags" for each image. An alt attribute (or alt tag) is a line of text that describes an image. Why is this so important? Because search engines like Google skip over generic alt tags in favor of more specific, keyword-rich, alt tags. Let me use my *Prison Picasso* painting image again for an example. The photo image for *Prison Picasso* would just be a generic listing of characters and/or numbers in the HTML text online. But I could go into the HTML and change it so that it comes up *Prison Picasso* instead of those generic characters. (FYI: HTML stands for Hypertext Markup Language).

When you write these alt tags for your online images try to use specific keywords. No more than one or two though, because search engines will punish those who overload their posts with too many keywords. You can't game the online system anymore so don't try. As mentioned above, you want your alt tags to be short. Copywriter Bob Bly says that alt-tags for images should be less than 125 characters. This is so everything can be seen on a mobile phone screen. Cory Huff of *The Abundant Artist* says that each of your pieces of art should have its page on your site with a description and purchase information, along with social sharing buttons. I agree. Your image galleries should be 500 pixels wide and 72 dpi. And each image should have its own I'll go into more on this when I deal with setting up your website for now, just keep these rules in mind. I know all of this sounds like a bunch of techno-jargon, but it's important. It's very important if you want

your work to stand out above the crowd. The tips in this book will help you go from selling your arts and crafts in the gallery for commissary to selling them for hundreds of dollars, if not thousands. I would not be doing my job as *The Millionaire Prisoner* if I didn't tell you all the tricks of the trade for better online marketing. Take your time and build it right and they will come. Posting great photos is your first step. Back them up with keyword-rich image descriptions and you could be on your way to becoming a *Prison Picasso* yourself.

RESOURCE BOX

If you're still having trouble with your photographs, then you may want to obtain a copy of: *The Quick and Easy Guide to Photographing Your Artwork* by Roger Saddington.

On the next few pages are some photos to give you some ideas. That's me with the "Hello Kitty" artwork. I had my mom blow it up so you can see it better. If you have someone who can help you out with this, you should take advantage of it. The other photos come from my friends. Sidney is

from Chicago and does little figures like the two in these photos. The other photo is from my friend Darrin "Warlock" Shatner. He's a great artist. He also does astrological forecasts and palm readings. Anyone wishing to talk to him about that should contact him on connectnetwork.com or on the PrisonHarmony website he is building with his family. Here's what he said: "Twenty-five years ago while on death row in Illinois, I was guided by my Zodiacal chart telling me that I had artistic talent. So, I started painting for family and friends. Not only has it helped me develop patience, but it has been a profitable venture. I sold one painting for $8,000! Who would have guessed? Seems it was a career move I wasn't aware of. The stars really did guide me in the right direction. Maybe you feel the calling also? Be encouraged because prison doesn't stop shit!"

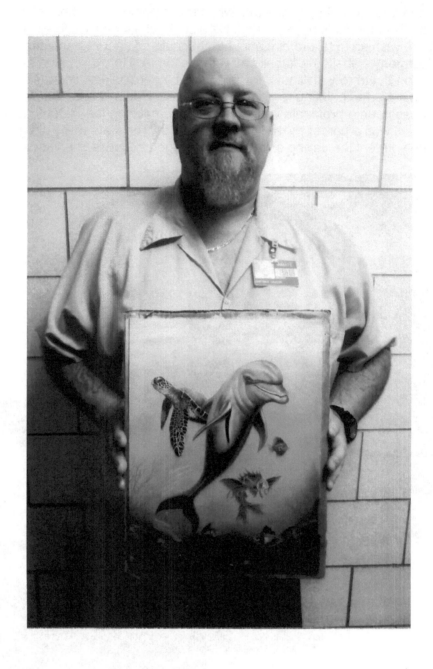

"Painting has been one of the best experiences of my life. I wish I could share it with everyone."
– Darrin "Warlock" Shatner

CHAPTER 11

YOUR ARTIST WEBSITE

"The internet is becoming the town square for the global village of tomorrow."
– Bill Gates

If you want to be taken seriously as an artist, you're going to need your website. It's not enough to have a Facebook page if you're going to take your arts and crafts business to the next level. You don't have to start with this part, but you should get one eventually to tie your brand and platform altogether. Once you set up your own website to go along with your social media profiles, you'll no longer be just a prisoner doing arts and crafts as a hobby. You'll be a professional. You'll start to be taken seriously. In this chapter, I'll give you the keys to setting up a successful website – one that makes you money. Let's get to it.

WEB MALL SITES

Back when the internet first started, a lot of people got rich by opening websites that acted like online malls. Even the arts and crafts world have its own web malls. Some of them are:

ArtQuest.com
ArtCrawl.com
AbsoluteArt.com
ArtFromTheSource.com
A Stroke of Genius (portrait.com)
ArtistsOnline.com
ArtistsRegister.com

There are other websites where you can upload your images and make sales of your art. These websites will just take a commission off each sale. Some of these websites are:

XanaduGaller.com
ModernEden.com
Ugallery.com
SaatchiArt.com
Art-Mine.com

Maybe you'll make sales from these websites, but probably not? Here's what expert Cory Huff (of TheAbundantArtist.com) says about these types of websites:

> "You are an artist, not a commodity. If you are in one of these online art malls, you are one artist among thousands. Browsers will click right by all your stuff because something flashier is right next to you. Even if you get featured as an artist of the day and have a few thousand people look at you, that attention is gone within a couple of hours. Most art collectors are wealthy and educated, so they will expect a sophisticated website if you want to sell your work for thousands of dollars."

In *The Business of Being an Artist (4th Ed.)*, Daniel Grant advises that you should ask the following questions before you go on one of these art mall websites:

- How many people visit the site monthly? Weekly? Daily?
- How are those visitors determined? Are they unique?
- How long on average do browsers stay on the site?
- How much turnover of the artists using the site is there?
- What kind of advertising does the site do? Will continue to do?
- How does the website look? Is it easy to navigate?
- What is the quality of art on the website? Do they regularly update the site, or make changes?

I would suggest you only use those art mall sites if you absolutely must. If you don't have anyone to help you then you're limited in what you can do. The problem with these above art sites is that there are still fees that must be paid, and you'll need someone to upload your images and text. Then fill orders if you get any. If you have someone who can help you with that, then you're better off utilizing Facebook, eBay, and your own website to make sales. We can now look at the real strategies that other artists are using to achieve success with their websites.

3 TYPES OF ARTIST WEBSITES

Yes, there are different types of websites. All are not created equal. For a *Prison Picasso,* there are three types of websites you should consider. They are:

1. A website just for your art/craft items.

2. A website that promotes you as a brand.

3. An industry website for prison art in general.

Depending on who you have in the free world to help you build (and update/maintain) these sites you could do two of them? Or all three? What I suggest you do at first is do just one website. Except you build it so it has many different sections (pages) inside it. This strategy will be the most cost-effective for a prisoner. And it integrates easily with all the other strategies in this book. Especially the one about building your brand based on your art/crafts. After you have a consistent income coming in and the experience behind you, it will be easier to expand into more websites and other avenues.

Setting up a website is even easier now than it's ever been. the cost for such services has lowered dramatically. A lot of prisoners have their own websites. My friend Snow has his own site that he uses to get the word out about his wrongful conviction: freejamiesnow.com. Before he got out, prison education expert Chris Zoukis built prisoneducation.com and prisonlawblog.com. Prisoner Mike Enemigo, CEO of The Cell Block, has built thecellblock.net. And many others are doing the same thing. The first key is coming up with the right domain name.

YOUR DOMAIN NAME – THE URL ADDRESS

This is the first step – purchasing a domain. This will be the Universal Resource Locator (URL) and the name file type to locate your website. The URL for Facebook is Facebook.com. If I was to do one for this book it would be prisonpicasso.com. Here are some other domain names I would consider if I was going to make art my full-time business:

JoshKrugerArt.com
JoshKrugerStudio.com
MillionairePrisonerArt.com
307Shop.com

Notice that all of them have ".com" at the end. You want that because it's the default ending that everyone types of in. Here's a tip to remember when coming up with your domain name: *the shorter the better.* Chicago-based marketing expert Andy Crestodina (OrbitMedia.com) did research into the ideal length for a domain name. The winner? A domain name with 8 characters or less! Think about that. Makes sense because the shorter, the easier it will be to remember and type in. Some artists and experts advise you to just use your name. I like that idea if your name is short. Prisoner and artist, Stephen Lehman, uses his website freeLehman.com, to get the word out about his art and legal issues. If your name is too long or confusing, you'll have to come up with something else. Patrick Schwerdtfeger is an author and speaker. His 113-letter German last name is confusing. So, he registered BookPatrick.com and pointed it to his other site: PatrickSchwerdtfeger.com. You could do the same? No matter what you do, just try to make your domain short, catchy, and easy to type in. Then you can build everything around that property. Here are some other things to remember when buying your domain name.

Purchase the domain name yourself, not in anyone else's name. You want to be in complete control. I had my mom buy a domain name for me when I first started. When I went to try and change it over to my name there was a whole bunch of red tape and hoops that I had to jump through. Lesson learned. Even if you're using a prisoner assistant company for help, make them purchase it in your name! Two of the more popular domain registration services are GoDaddy (godaddy.com) and Register (register.com). Another one is Domains in Seconds (domainsinseconds.com). It should not cost you more than $9 a year to purchase and register your domain. A few more things before you go ahead with your name.

Don't limit yourself with the name you come up with. When I first started, we used O'Barnett Publishing. That title limited us to just publishing. My second company is Carceral Wealth Services (CWS). That is better because "services" can mean anything. And it does not limit me to just books. I'd shorten it even more now to just "Carceral Wealth." Plan out your name carefully. Think about your brand as an artist or crafter.

Lastly, before you register it, check to see if someone is already using the name you have chosen. You don't want to start using "cellpreneur" and then find out I wrote a book with that title and fellow cellpreneur George Kayer already owns that domain. True story. Check on WhoIs.net. Run searches on Google and Yahoo to see if anything comes up? Check with the United States Patent and Trademark Office (USPTO). Check Etsy/eBay, Facebook/Instagram, Twitter/Pinterest, and YouTube/Flickr. Check in the blog directories to make sure no one is using it for a blog name. Once you are sure no one using it or claiming it, then register it everywhere. Sign up everywhere I just mentioned. Especially all the free services and social media networks. That way it will be easier to trademark when you start getting big and more well-known and it will help with search engine optimization (SEO). So that's the strategy: come up with a short, catchy name that you can build your art/craft brand under. The default name is your name if it's shorter and not confusing. Then search to see if someone is already using it. If not, register it everywhere and stake your claim to that intellectual property. Once this is done all you have to do is build your site and get it hosted.

GETTING YOUR WEBSITE BUILT AND HOSTED

Setting up a website is even easier now than it's ever been. There are low-cost do-it-yourself (DIY) services you can use. Even GoDaddy offers website building services. Another one is Weebly.com. One of the easiest platforms to use is WordPress (wordpress.com). This is the favorite platform for a lot of cellpreneurs, including Chris Zoukis. The great thing about using WordPress is that it was built for bloggers, so it easily integrates with a lot of services. Like hosting service Bluehost (bluehost.com), which shouldn't cost you more than $10 a month. If you don't have anyone in your network to do it for you then you'll have to pay a website builder to do it for you. You can find good,

low-cost website builders on guru.com, elance.com, and the *Independent Computer Consultants Association* (icca.org). Timothy Ferriss advocated doing business overseas (where you can find cheaper options) in *The 4-Hour Workweek*. Mike Enemigo says he found his website developer on Fiverr.com. A guy in Pakistan. If you don't trust that, here are some U.S. website designers who are used to dealing with entrepreneurs:

Barbara Zaccone (bza.com)
E-mail: Barbara@bza.com

Jason Petefish (Silver Star Productions)
E-mail: Jason@silverstar-online.com

Bob Horowitz (nohassleweb.com)
E-mail: bob@nohassleweb.com

Terri Karp (webdevelopersstudio.com)
E-mail: terri!@webdevelopersstudio.com

Doug Rohde (rohdemd.com)

One company that I know of has collaborated with prisoners to set up websites: WOW ME WEB DESIGNS. I sent for their info and have included it at the end of this chapter. I do not endorse their company as I have never done business with them. I mainly included their pages so you could see all the options available, and the money/costs involved. Another option is to find a smart college kid who wants to make an extra buck doing your website design. Personally, I'd rather invest some money into getting my website built right the first time. Yet, I do know what it's like when you're first starting out. I started my writing career with $200 and a typewriter so I get it. No matter who you use to get your website designed, here are some more things to remember.

DESIGN YOUR WEBSITE FOR YOUR TARGET AUDIENCE

In *The Artist's Guide,* Jackie Battenfield says you should ask yourself some questions when you start designing your website:

- Where are you trying to go with your website?
- Who do you want to reach with your website?
- What will your target audience need to know?
- What do you want them to remember after they leave?

Use your answers to guide you as you go about designing your website. It's your job to find out the answers to the above questions if you don't know them.

SEVEN PAGES YOUR ARTIST SITE MUST HAVE

Here are the elements and pages that your website should have:

- Homepage
- About the Artist/Crafter
- Media Links
- Contact Info
- Blog
- Photos and Video
- Arts/Craft Products

Let's look at each one of these above more in-depth

HOMEPAGE

This is the first page a visitor will see when clicking on your main URL. As content-marketing extraordinaire Ann Handley says in *Everybody Writes,* "it's a homepage." So, make it like your actual home – a place where visitors feel comfortable and that you're happy to see them. Make sure your homepage is clean and uncluttered. Especially above the fold. Don't complicate things. Your best art piece or craft item should be featured. Then have a "learn more" and a "Buy Now" button that points visitors to your online gallery and your newsletter/blog. That's it. The homepage has one job: to get visitors to come inside and visit your website. Entice them to become involved with you so you can start talking to them as friends and not just as a customer.

ABOUT THE ARTIST/CRAFTER

This is where you can go more in-depth and include your full bio and artist statement. Have a few photos of yourself here also. Especially if you have any professional-quality photos or some of you doing your art/crafts. And as soon as you get them list collectors and customer testimonials.

MEDIA LINKS

This page is where you showcase any media coverage you have received. Also include different length, ready-to-use bios that media people can easily use when writing a story about you. Don't forget photos they can use also. When you first start this page will not have that much on it. Your goal is to fill it up with quality media coverage and plenty of "As Seen In" or "As Seen On" media logos!

CONTACT INFO

This is where you list your full contact information, including e-mail and links to your social media pages. I'd have a tab on every page saying, "Contact Josh Now." When they clicked that tab it would bring them to this page, where they could choose which option they wanted.

YOUR ARTIST/CRAFTER BLOG

A weblog, or "blog" is one way to generate buzz about yourself, your art/crafts, and your industry. In your blog posts, you tell your story. What inspired you to do art/crafts? What obstacles do you have to overcome? Did you overcome it? People are amazed at a prisoner who triumphs over harsh conditions to achieve success. So, share that. Talk about behind-the-scenes news stuff (except to be careful about revealing trade secrets). Here are some more tips to remember when you write your blog posts:

- At first, you should write about what interests you. Don't worry about what others may think. You're an artist so you get free reign to be eccentric! As time goes on you can write more about what your collectors and customers want to hear.
- Don't try to be the voice on everything, instead carve out your niche in the art/craft world.
- Limit your blog to one central idea or theme per blog post. Don't go off on rants and tangents.
- Always give credit to your sources and link to articles where your readers can find more information.
- Have something for people to look forward to. For instance, "Tuesday's Tips" "Wednesday's Wacky News" and "Friday's Forecast."

- Keep your blog posts short. 750 – 1,500 words. Online communication tends to be shorter. If it's important you can go over the 1,500-word limit. Just not every post.
- Ask questions so you encourage your readers to comment on your posts and share them with others. When they comment, make sure you respond!
- Set it up so that your blog posts are automatically fed to your social media pages.
- Update your blog at least one or two times a week, preferably more. The more content you post, the more Google will find you. Stay active or don't even do it.
- Write great blog titles using Keywords. Pique their curiosity. Use numbers. Don't be hyperbolic, grandiose, or misleading in your headlines. Try to keep your headlines to 4 or 5 words, or 50 – 60 characters.
- Understand your audience. Are you a painter? Then who is your collectors? Are you a crafter? Who are your main buyers? Find out, then tailor your content to their needs, challenges, and interests.
- Host giveaways and contests where you give free products out or donate one or two items to charity. Ask your readers and customers to donate also.
- Always try to include photos and images/graphics with all your posts. You can find royalty-free images on sites like ClipArt.com, CreativeCommons.org, DreamsTime.com, FreeImages.com, and PublicDomainPictures.net.
- Cross-reference to old blogs you wrote in the past when you write new ones. This keeps your readers engaged and is good for SEO
- Use bullet points and numbered lists. Like what I'm doing right now in this part.
- Post at the same time when you post. Guy Kawasaki (*The Art of Start)* says the best time to post is between 8 and 10 am on weekdays.
- Experiment with topics and ideas. When you find something that works, work the hell out of it. Look for other things that work, then work the hell out of those also. Be nice, but also be relentless.
- List your blog in the blog directories. Here are a few that I know of:

blogsearchengine.com
blogsearch.google.com
bloggeries.com
blogcatalog.com
mybloglog.com
blogflux.com
technorati.com
blogarama.com
blogexplosion.com
bloghub.com
globeofblogs.com
networkedblogs.com
bloghop.com

If you find out that your collectors and customers don't read blogs, then you may not need to do all of this? I don't blog right now because prisoners can't read blogs. Shortly, I will begin using all of these tips to start blogging for a new target audience: prisoners' families and businesspeople who supply products/services to prisoners. Try it out and

see if you like it, and it brings in new customers and additional income. If not, discontinue it and move on.

"If your customers don't read blogs, then why put yourself through it?"
– Rosalie Gale, unanimouscraft.com

ADDITIONAL RESEARCH

If you have a GTL Tablet you can listen to a 5-part audio series that will give you some more ideas on blogging: *Blogging – How to Make Money with Your Blog*

PHOTOS AND VIDEOS

You must have photos of your art and craft items. people need to see what you're selling. Because this is such an important part of selling your work, I will devote a whole chapter to it next.

ART AND CRAFT PRODUCTS

If you don't have any art or craft items to sell you won't make money. Once you have produced several pieces/products you need to have a specific landing page for each piece. It should have a quality photo(s) or image with a description and alt attribute. It should have all the required purchasing information and a "Buy Now" button. These specific pages should clearly explain three things: what is for sale, how much it is, and how they can get it. In the least number of words. You can have a "Learn More" button where if they clicked on the button, you tell the creation story. Just don't cram everything into one page. Remember that simple and streamlined is always better.

You need all of the above to have a professional-looking and money-making website. Of course, I know a lot of you are not going to be able to get all of this done. So, I want to give you another strategy. Get your domain name and put a one-page website on it that points to your Facebook, Instagram, and Pinterest pages. It would save you a lot of money and be easier to update.

SPECIAL NOTE FOR CRAFTERS

Here's something that I learned from Kari Chapin in *The Handmade Marketplace.* Your online descriptions of your products and craft items should include every detail about what you're selling. Why? Because people have all kinds of allergies. I don't have allergies except for hay fever. So, it never crossed my mind to think if the glue I used to build something may affect my customer's sense of smell? Just keep that thought in mind when writing your product descriptions online. You don't want to get complaints from customers saying you didn't tell them about the wool you used in your knitted sweater and how it broke out their kid. That would be bad for business.

MORE TIPS, TACTICS, AND STRATEGIES FOR WRITING ONLINE

Writing for the internet is different than writing on paper in that it tends to be shorter and more condensed. there's no room to ramble. Your words online should do one thing – make your readers want to get in touch with you or buy your stuff. And you must do it quickly. Here's what expert Kim Solga (SellingArtsandCraftsOnline.com) says about it:

> "Webpages are not like books, magazines, or newspapers. On the Internet, people jump around from place to place, site to site, sometimes barely glancing at a webpage before moving on. You have a few seconds to catch their attention, and the way you put words and sentences onto your webpages plays a huge part in whether viewers will stick around long enough to read your message."

Just like on your blog, you want to write using subheadings, short-one idea paragraphs, bulleted lists, and fewer words. Yes, this does not come naturally to most of us. But you'll get better as you practice. Break long sentences into 2 or 3 short ones. Paragraphs should be 3 or 4 sentences at most. Don't use a lot of exclamation points. Don't use ALL CAPITAL LETTERS as this means shouting online. Use a brief short opening paragraph. Then go into more details in subsequent paragraphs if you're writing something long. Use plain, easy-to-understand words. Don't be a perfectionist though. Get it out and online. You can always come back, edit, and correct it later. Here are some tips for the tech junkies reading this:

- Your main text font size should be between 12 and 16.
- Don't use more than 2 different fonts in your design.
- Avoid light colors or dark backgrounds, keep all body text the same color.
- Make it mobile phone compatible.
- Avoid flash image galleries and landing pages.
- Links should always stand out and be checked to make sure they click through.
- Don't have auto-playing music or mouse effects.
- Don't allow third-party ads on your pages.
- Do not put background images behind your text.
- Keep updating your content every 3 to 6 months.
- Use Google's free keyword tool so you can find what words to use in your online writing. You can sign up at adwords.google.com/o/KeywordTool.
- Make sure your designer properly codes your headlines with tags that search engines recognize.
- Install Google Analytics on your website so you can track how many people come to your site, which page gets the most views, where your visitors come from, and what keywords bring you the most traffic. All of that is for free at analytics.google.com.
- If you want your photo to appear when you comment on something online, set up a free profile at en.gravatar.com.

THE POWER OF LINK BUILDING

In *The Millionaire Prisoner 3,* I have a chapter on using links to bring visitors to your website. As I was researching this book, I read about how an artist in Colorado, Linda Paul, made over $200,000 off her art by cultivating links. Daniel Grant tells her story in *The Business of Being an Artist (4th Edition).* She said she had never spent a cent on search engine optimization. that was back in 2007. Link building can be even more helpful for a cellpreneur, who doesn't have the money to spend on hiring a person to market online for them. Here's how you could do it when writing your online content.

Say you're writing about arts and crafts in Illinois? You should link to other websites that deal with art in Illinois. If you're writing about art/craft programs in Illinois prisons then you should link to the Illinois Department of Corrections site, the Illinois Prison Talk Online page, and any Illinois prison blog site. When Google sees you linking out to other websites – rather than just having links coming INTO your website – that shows in a counter-intuitive way that you are more of a resource, which Google loves. Anytime you write an article, or blog post online, you should link out to at least one other website. Don't try to game the system and write the link many times in a post. That won't work and may get you Google slapped. Just use it once. This is how you can help your website and

posts climb up the search rankings. But how do you climb up the rankings even more? by getting other websites to link back to your website.

BACKLINKS – THE ART OF GETTING VISIBLE

Most of this section was, and is, taught by online business strategist Jason Cimet (GetVisible.com) in his book, *I Need More Clients.* I have reproduced it here with his written permission.

Where do backlinks come from? A backlink simply refers to a link that appears on another website that links to your website. How do you get a backlink? There are many ways to get a backlink. Here are some examples:

1. Someone is asked for free to link to your website.
2. The site owner is paid (whether money or some other exchange of value) to link to your website. This is called a "black hat."
3. You build a different website and link that one to your first website. (This could be considered "grey hat.")
4. You submit a form online that posts the information (including a link to your website) on someone else's website.
5. The site owner discovers your web page and volunteers to link to it. (This is what Google wants to see happen naturally).

There are hundreds of techniques to get quality backlinks. The above examples are just a framework you can reference that describes many different variations of how to acquire backlinks to a website.

Here's the core rule regarding backlinks and rankings. *The more links you get on websites that are contextually relevant to your website AND that are themselves considered to be AUTHORITATIVE (read this to mean powerful) by Google's measurements, the higher your rankings will climb.*

This process of building backlinks is also referred to as OFF-PAGE optimization. Websites that want to increase their organic rankings in a competitive marketplace must grow the backlinks to their sites.

BACKLINKS ARE NOT DEMOCRATIC

It's important to understand that this urgency to grow links is not like a traditional election where you need to accumulate as many votes as you can get by a certain point in time.

First, you must keep acquiring backlinks pretty much forever. Secondly, votes are not treated equally. the value of each vote is NOT the same. A backlink from a legal blog post on CNN or an article by a lawyer on *Huffington Post* is simply far more powerful to a law firm website than a link on a health and wellness site from a guy in his garage who has little traffic or engagement with his content.

SEO companies are constantly on the prowl to find ways to acquire links for their clients that look natural and don't cost too much to acquire. Of course, this idea of costing too much is a relative concept because if you spend $5,000 on efforts to get an article published on a site like CNN with a backlink, it could very well be worth that sum.

You may be wondering how a backlink can have a cost associated with it if Google's guidelines strictly point out that should not pay websites for backlinks.

Let's use a prisoner rights attorney in Illinois to illustrate an answer. Our client has written a blog post on a trend in the prison scene in Illinois where correctional officers are accused of stealing

prisoners' property because they are paid low wages (ok, it's a wacky example but it caught your attention).

We need to reach out to other websites that have content that is relevant to this topic and let these sites know about our client's new article. And our goal is to get these sites to post something about the article and link to the article from their website.

There are two intertwined goals here.

- First, is to get contextually relevant sites to link to the article.
- Second, is to get powerful sites (that may not be very contextually related) to put a backlink on their site to my client's site. This process is called acquiring "link juice."

So where does the idea come from that there is a cost to a backlink? Simply, it's a labor cost to identify and then reach out to these sites. Many companies simply can't afford to execute these types of outreach services. Public relations firms are so expensive because the bulk of their work involves finding and connecting with people that can publish.

THE PURSUIT OF BACKLINKS REFRAMED
AS A VIRTUAL PARTNERSHIP

If you research backlink tactics, you will see that there are all sorts of ways you can get backlinks from other sites. Some kosher, some not so kosher. Some are free and some are not so free.

I want to talk about PARTNERING with other sites not from an actual "reach out and contact them standpoint" but rather from a "mindset" standpoint where the backlinks will flow naturally because of the content, you are guided to create in this partnering mindset process.

If we all agree that rankings (in a competitive environment) are impacted by the quantity and quality of your backlinks (i.e., LINK JUICE), then it also means we can agree that if you give someone a good reason to link to your website it might be easier to get the link. If you start thinking about what you could do as a GOOD PARTNER for these other websites to provide THEM with VALUE, you may start finding them more willing to link to you – thus, an easier pathway to backlinks.

ACQUIRING BACKLINKS STARTS WITH IN-DEPTH RESEARCH

Instead of thinking first about the topic, you want to write about because you see something trending in BuzzFeed, look instead for powerful sites that would be great to get backlinks from and see what kind of content they are publishing and promoting.

As you evaluate the themes within their website content and the audiences they are engaging, consider what type of content you could create for them that would include the Pavlovian response you need – a request by them to link to your site.

If you view yourself as a joint venture partner to other websites, you will likely create keyword-rich content you already need but have it geared for distribution on other sites simply because your content will be more resonant with their needs.

Here's a super-fragilistic type of secret way to find the topics you can write about that will get shared more often.

CONTENT SHOULD STICK OUT AND BE NOTICED

Find an article that has been shared a lot online and that has a lot of views. You want to look for a topic that is relevant to your target audience. Put together your version of that article. I don't mean copy it. I mean to write something on the same topic but with your perspective.

One of the best pieces of content you can write for this purpose is a top 10 list. You don't need to stick to 10. You can use "Seven Ways To…or something like that. Just make a Top something list and that will usually be more popular than a non-list type of content piece. You can also create this same content in the form of a video or image slideshow and then load it up on YouTube or SlideShare.

You can even find someone else's top 10listst and write your own top 15 list incorporating the ideas from the top 10 list. Just give appropriate attributions and put a spin on the top 15 list with your personal flavor.

Before you publish the article or top 10 posting on your site, you need to put the tease in place. You need to reach out to at least 5 or 10 of the websites (and their owners) that shared the original article you found. Connect with them and let them know you are putting out something that might resonate with their readers. This technique is a great – though – labor-intensive way to build your backlink arsenal.

One other type of content you could create is an "infographic" which is a visually better way of writing about statistical data. For more, see *Infographics: The Power of Visual Storytelling* by Jason Lankow, Josh Ritchie, and Ross Crooks. Taking Orders and Getting Paid.

Once you build your site, you're going to have to set up a system to take orders and get paid for your art/crafts. A lot of people just use PayPal (paypal.com). They do everything a merchant account will. Next, you need a shopping cart system. Several shopping cart systems are geared especially for online arts towards craft sellers. They are Big Cartel.com, Silkfair.com, and Shopify.com. A lot of my mentors use Infusionsoft.com. As you grow, you'll need to pick one. When you're selling $10,000 plus in paintings, you'll want a professional shopping cart system.

RESOURCE BOX

For more about the power of backlinks and a way more in-depth look at all things web-based, get a copy of:

Ultimate Guide to Link Building by Eric Ward and Garrett French

There are so many good books on website development that it would take too many pages to list them. So, we'll stick to just artists and crafters. Here's some good ones:

- *How to Sell Your Art Online* by Cory Huff
- *The Handmade Marketplace* by Kari Chapin
- *The Everything Guide to Selling Arts and Crafts Online* by Kim Solga

All these books can be found online. Contact Freebird Publishers about ordering them if you don't have someone to help you.

You can listen to an audio book on the GTL Tablet about link building and online marketing at:

- *Backlinks – Increasing Website Traffic and Page Ranking with Backlinking*
- *Online Marketing Institute*
- *Online Business Institute*

CHAPTER 12

HOW TO WALK ON CLOUDS BY USING VIDEOS

"Video is taking over marketing and the world."
– Robert Bly

There's a lot of talk about using videos to demonstrate online. In *The Copywriter's Handbook, 4th Edition,* Robert Bly writes: "video is taking over marketing and the world. According to a study by Cisco, in 2019 video will have accounted for up to 80 percent of all online traffic. And consumers are 85 percent more likely to buy your product after viewing your video." Because it's so important I'll share with you some secrets that I gleaned from the top video experts. But first, we'll deal with how some prisoners, and former prisoners, are using video to succeed.

PRISON LIFESTYLE VIDEO SUCCE$$

Some prisoners have had their 15 minutes of fame because their videos are going viral. Omar Broadway was incarcerated in New Jersey and got a hold of a contraband video camcorder. he shot some raw prison footage of the control unit he was in and showed all the abuse that prisoners were subjected to. His video footage was smuggled out and picked up by director Douglas Tirola. It was turned into the documentary *An Omar Broadway Film,* put out by 4th Row Films, and shown on HBO. I first read about Omar Broadway in *Prison Legal News.* Then again in Professor Nicole Fleetwood's great book, *Marking Time: Art in the Age of Mass Incarceration.* Sadly, Omar Broadway died in 2016, but his example is living proof of the power of video. His video helped lead to the shutting down of the gang management unit where all the abuse happened. Priceless.

Other prisoners have used crowdfunding campaigns to get money. The best ones are those that have videos. Of course, we can't talk about videos without talking about YouTube.

The publishing gods have a funny way of showing writers things. As I was putting the finishing touches on this chapter, I got the July 2020 *Prison Legal News* in the mail. Anthony Accurso wrote an article titled "The Popularity of YouTube Prison Videos." He detailed how Joe Guerrero has 1.2 million YouTube subscribers to his *After Prison Show.* After 700 videos, which started as grainy amateurish vlogs (video + blog = vlog), he now earns six figures as a social media influencer. His most popular video about how to make a tattoo gun got 2.3 million views. Christina Randall is a former prisoner that has 400,000 subscribers to her YouTube channel and most of them are women. Marcus "Big Herc" Timmons has become a social media star based on his videos and now makes a living speaking. People have always been, and always will be, fascinated by prison life and culture. Think how well MSNBC's *LockUp,* We Channel's *Love After Lockup,* and C&I's *The big House* do.

At the end of King Guru's *Pretty Girls Love Bad Boys,* he says this: "If you can get someone to go on Facebook, Snapchat, Instagram, look us up! Maybe once you see the vlogs and pictures of how we're living inside of these level 4 prisons, then you'll know for yourself that everything that comes from The Cell Block is authentic. Maybe that's what it'll take for some of you to wholeheartedly follow our advice and finally start getting everything life has to offer." The key to what he said is "vlogs." Like other prisoners', you can start with YouTube.

Cory Huff, of *The Abundant Artist* fame, says that you should be the hero of your story: "Putting yourself at the center of the story of your art is a powerful way to communicate the ideas of your art and connect." I agree. The best way to do this would be to tell your story in a short video.

With all of this in mind, how can a *Prison Picasso* use video? Here are some ideas:

- Use video to sell your arts and crafts

- Post a video of yourself on prison pen pal and dating sites to get more hits

- Start a prison vlog to discuss up-to-date topics dealing with prison art, politics, reform, and culture

- Have other people give you testimonials in videos that support your arts and crafts
- Use video as a supplement to an application, artist statement, portfolio, or résumé

These are just some ideas. The sky is the limit. Just because you don't have lots of money doesn't mean you should skip this avenue of success. Not if you want to stand out. Even if you must start by having a family member or friend record your video visit and then post it online? Or having said family member, friend, or client/customer post a video to Facebook as a testimonial about you? Videos can change the game for you.

> *"You'll still be posting photos and writing posts,*
> *but nothing builds trust and value more than video."*
> *– Keith Krance, founder of Dominate Web Media*

That's the evolution that I hope you get after reading this chapter. As I write this, it's the middle of 2020, so think in terms of 2020 technology and beyond. How can you use it to achieve your dreams? Begin to think outside the box you're living in and start using videos to showcase your most important product – you!

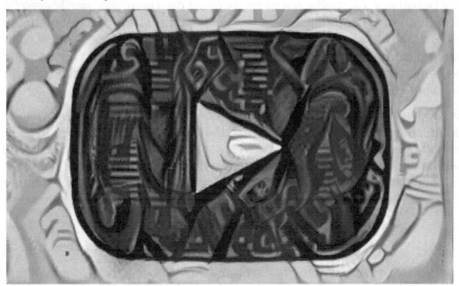

HOW TO MAKE VIDEOS THAT GET VIEWED

Steve Stockman is a writer and director of short films, commercials, music videos, and TV shows. He wrote and directed the award-winning 2007 main feature film *TWO Weeks,* starring Sally Field and Ben Chaplin. His website is stevestockman.com. Here is what he says about video in his great book, *How to Shoot Video That Doesn't Suck:*

> "Great video is a communication tool of unparalleled impact. It can change history, inspire movements, share, and amplify emotions, and build community. The bad video gets turned off. Nobody watches the bad video. Not your employee, even if you tell them to. Not your parents, even if you send them 'the cutest' videos of your kids."

The best videos entertain the audience. They offer intrigue. Leaving the audience seeking more and wanting to know what happens next. So, the first key to video success is to know who your audience is? To make the best video ask yourself the following questions:

- Who is your target audience? Is it a possible pen pal? Is it an art buyer? A gallery? Who is it?

- What is your intention? What do you want the video to accomplish?

- What is your competition doing? Are they using videos? Can you learn from them?

Answer these questions and put yourself in your viewers' place. Try to imagine what they'll feel when they watch your video. Once you know who you're making your video for and what you want to accomplish then it's time to make our video. There will be four types of videos that you primarily use for becoming a *Prison Picasso*. They are promotional videos, how-to videos, interview videos, and video testimonials. Each has its own rules of practice. As Steve Stockman says, "the most memorable home videos and documentaries tell stories. Those stories don't just magically appear in the editing room. You must imagine them before you start shooting." So, what's the story you're trying to tell?

THE VIDEO INTERVIEW

I've put this one first because it's something a prisoner could do. Have your family member or friend record your interview through a video visit. Prepare ahead of time what you want them to ask you and what you'll say. Both of you should be relaxed and go with the flow. If both of you trust each other, then the interview will be better. Do not look at the screen or yourself in the corner of the screen. Look at the camera lens when answering questions. That way you'll be looking directly at the person watching your interview.

If it's the other way around and you're conducting an interview, think about the following things. Think background. Because it matters. For instance, if they are an artist? Have them sit in their studio. Are they an author? Have them sit in a library, or with books behind them. Don't have them sit where people will be walking behind them. They are not a newscaster. Watch good documentaries on TV and see how the backgrounds are carefully chosen to fit the image of the person being interviewed. Remember, it's all about the story you're trying to tell, even in a video interview.

THE PROMOTIONAL VIDEO

What piece of art are you trying to promote? Is it a craft item? Who is it for? Do they already know you? Or is it the first time they are meeting you? Try to think about your target audience (or your customer/client's) needs? Build a relationship with the viewer, not a sale. If you are selling artwork or a craft item, use a video sales letter (VSL). More on those in a minute. If you're promoting something, it's best to have testimonials.

THE VIDEO TESTIMONIAL

I love watching late night/early morning infomercials. Not because I can buy from them. I never have. I watch them learn tricks that I might be able to use in my marketing. Especially now that I've studied video marketing. The best infomercials use testimonials. There is a long-form infomercial on right now where Larry King interviews a "credit secrets" book author. It uses lots of testimonials. We know it works because they keep running it repeatedly. I would love to be able to do that for my books and play them on the institution channels of many prisons across America. If you can use a video testimonial from your customers/clients, you'll sell more arts and crafts.

THE HOW-TO VIDEO

Explain only one thing per video. Think Joe Guerrero's 2.3 million viewed "how to make a prison tattoo gun" video. It's about one topic. Show your audience. Think "show and tell" from grade school. Don't get distracted and off-topic. If it doesn't pertain to the topic of the video, it shouldn't be in the video. When explaining things, try not to use jargon or long convoluted sentences. Do it like you are explaining it and showing it to a kid. People will love to see how you do your art or make your crafts. You don't have to show them all your trade secrets, just a little bit is fine. It did not hurt Bob Ross to show people how to paint like him. He became a multi-millionaire off it. Maybe you're next?

THE VIDEO SALES LETTER (VSL)

Video Sales Letters (VSLs) are used in several different ways. They can be used on the home page of a website to sell what you want visitors to do. These are typically short, 2-3 minutes or less, videos. If it's a video aimed at an art business or gallery on your home page it can be a little longer (4-5 minutes), but not too much longer. VSLs can also be used on second-level pages on your website. These videos are longer, typically 5-7 minutes in length. Lastly, there are long-form VSLs. These run anywhere from 15 to 45 minutes in length. When thinking about the time and length of your videos, use your TV as a gauge of what's proper.

TV commercials are normally 30-second stories. A networking hour is 44 minutes long. That leaves time for the network to put in commercial breaks. A movie trailer is normally 2 ½ minutes long. Infomercials are either 30 minutes or 1 hour long. Here's how you compute those numbers in words when you write your VSL script. Normally, it's 120 words per minute. So, a 30-second commercial will have 60 words max. Of course, there can be more if the speaker talks rapidly. A 10-minute script would have 1,200 words. A 45-minute script would have 7,000 words. Once you write out your script you can use a Voice Overestimate to see how long it will be. Upload your script at:

thevoicerealm.com/count-script.php

9 RULES FOR CREATING AN EFFECTIVE VSL

When creating a VSL you are marketing. Someone must write the script. Here are master copywriter Robert Bly's nine rules for creating an effective VSL. You can find these in his book, *The Copywriter's Handbook, 4th Edition*:

1. Grab the audience's attention.
2. Tell an engaging story.
3. Keep it simple.
4. Use short sentences and short words. No words with more than 9 letters.
5. Use short paragraphs of only 2 or 3 sentences.
6. If you must prove a claim of fact, do it by inserting a chart or graph.
7. Explain the solution within the first minute or two.
8. Don't use more than two numbers in each sentence.
9. Use a positive and enthusiastic voice. But it should also sound authoritative and authentic.

Your opening should be simple. If I was to do a VSL here's what my opening could be:

131

"Hi, I'm Josh Kruger for Carceral Wealth, and today, we'll show you how you can help make your loved one's prison stay easier and better than ever before."

A simple closing to my VSL could be this:

"So, if you want to see what Carceral Wealth can do for you and your loved one, give us a call right away at XXX-XXX-XXXX. We'll give you a free estimate. Want to contact us for more info? Visit millionaireprisoner.com and sign up today. we can't wait to help you make your loved one's prison stay a whole lot better. Call now or send us a message today!"

HOW TO WALK ON CLOUDS BY USING VIDEOS

Richard Clayman is the owner and founder of Cloudwalker Videoworks. He has 25 years of

experience as a Hollywood producer, director, writer, and executive. He also spent a decade teaching at top film schools such as the University of Southern California School of Cinematic Arts. Now he uses all that to write, produce, and direct videos for law firms, finance and insurance companies, non-profits, multi-million-dollar corporations, and municipalities. As a "filmmaker in a sea of videographers," Richard is a seminal voice in the industry. You can learn more at cloudwalkerfilms.com. Here's what he says:

"The most compelling videos have the person looking at the camera and telling us more about who he or she is rather than what he or she does. Ideally, these are 1:00 minute videos for a Home Page, Services Page, and About Us Page. Don't forget – website visitors don't get there by accident. They know what you do. Their unarticulated need is to know who you are, in the context of what you do. The result? Your first meetings will be more like second meetings because the potential client has already decided not on your firm, but you.

"It would be nice to be able to do any of these videos on your own or hire your nephew the film student. This is always a mistake. We all know that everyone has a very deep and personal relationship with TV and film. When something is wrong in writing, performance, makeup, framing, sound, location, music, logo animation – any number of pitfalls – the visitor will know it and immediately ascribe the discomfort in viewing it to your level of professionalism and taste. Not good.

"As in anything else of importance, make sure you hire the best.

"On the other hand, if all of those items are accomplished at a top-level, the visitor will also recognize that, and you will immediately stand above your competition (and most others they encounter on the internet.).

"So, make sure you hire a real professional filmmaker to do your videos and you'll get the best possible result."

Most of us won't be able to hire a professional right away. So, here's some technical stuff you can utilize when making videos. Rick Gee of MarketingProfitStrategiesblog.com says that all you need is a flip-video camera or a Kodak Zi8 pocket camcorder. That Kodak HD camcorder is less than $200 brand new. And if you use YouTube, you can edit your videos for free using YouTube videos that are about 3 minutes long and funny. Great YouTube video experts to study are James Wedmore, Andy Jenkins, and Mike Stewart. Some other video editing software is:

Windows 10 Video Editor Program
Adobe Premiere Pro
Apple Final Cut Pro X
Adobe Premiere Elements (for beginners)

Whoever is shooting the video needs to do the following. Turn off the "zoom" feature. Don't use it. Instead, set the lens all the way wide and move closer to what you're filming. And don't ever use "digital zoom." Matter of fact, turn off all your camera's digital features. Keep the light at your back. Remember to think about your background. Also, use the "rule of thirds" doctrine when shooting a video of someone standing (or sitting) still. This means they should be off to the left or right of the center of the shot. In a third of the screen. *American Greed* on CNBC does this perfectly. Try to use external microphones like booms or clip-on mics. If you or your loved one is going to be a regular vlogger using a webcam, they need a clip-on mic. Those cost less than $25 at stores like Best Buy®. And remember to tell them to look at the camera not the screen!

Edit, edit and edit your videos. Make them short and memorable. So, edit what doesn't work. the mantra is "when in doubt, cut it out." turn off the computer's transition effects before you start editing. When you first start, your videos won't be the best. That's okay. Joe Guerrero's videos started out as homemade, granny mishaps. Now, after 700 videos, he's an expert. Just remember that no video is better than a really bad video. You only get one chance to make a good first impression.

> *"[W]hat you'll find is video ads generate much higher engagement than other forms of ads. You'll get more likes, more shares, and more comments, and those comments will be more positive too, especially if you come across as genuine and friendly. It's easy for people to be negative and critical about someone they haven't seen, who they feel distant from. If they've watched you and listened to you, they'll find it much harder to criticize you."*
> *– Keith Krance, Dominate Web Media*

If you want more help, check out TheVideoMarketingGuru.com. You can also post your videos on Vimeo.com. It's free. you can post your videos across many other platforms through Traffic Geyser (trafficgeyser.com). But you'll have to pay a fee.

If you have a tablet (I have a GTL Inspire™ tablet), see if they have the following on it:

How to Make Money with Online Videos
Optimizing Your Videos for Free Traffic

If you're serious about making videos, then you need to read Steve Stockman's book *How to Shoot Videos That Don't Suck.* A final word from Steve:

> "Art – and video is an art – requires passion. It requires emotion. It requires commitment and a willingness to get up and do what's in your heart, regardless of what others will say. It's hard, and if everyone could do it, there would never be a non-hit song or a non-bestselling book. Studios would never release a bad movie, and every video on YouTube would have the same huge number of hits."

But just because it's hard doesn't mean you can't do it. *Prison Picassos* do what unsuccessful prisoners won't do. To go to the next level and rise above the masses you can use videos. That's how you can walk on clouds from a prison cell. During research for this book, my virtual assistant found a website, prisonart.com.mx. On it was a video that made her "oooh" and "aah" over a handmade purse the Mexican prisoners had made. It was the video that made her purr like a kitten. If they can do it, so can you!

"One should either be a work of art or wear a work of art."
– Eugene V. Debs

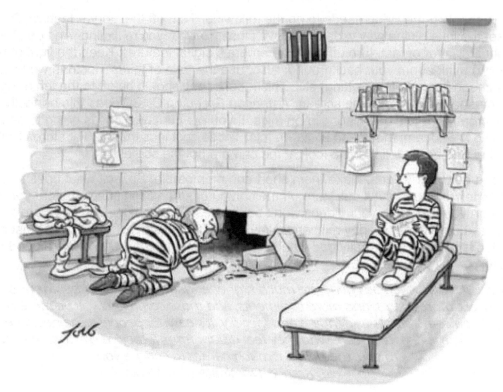

"No, thanks. Reading is my escape."

"Art is anything you can get away with."

– Andy Warhol

Even after his death, Andy Warhol remains one of the most influential figures in contemporary art and culture. He was the most successful and highly paid commercial illustrator in New York.

CHAPTER 13

FREE MONEY FOR ARTISTS

"The lack of money is the root of all evil."
– Mark Twain

The first place to start is with your family and friends. If you've been building your network, you should have some people you can ask? Some of you know that I self-published my first book, *The Millionaire Prisoner*. I used $3,000 from a family member. I asked for a loan, but they said I didn't have to pay it back. I haven't looked back since. Here are a few secrets to remember when requesting money from family and friends:

- Ask them to pay for supplies or books that will help you learn and perfect your craft.

- Have them send the money to the supplier or book company (or Amazon.com) and not to you.

- Don't ask them for money they don't have and force them to say no.

Let's look at these. A lot of people won't give prisoners money because they don't know what it will be used for. But if they can put the order in for you, they may say yes? What I used to do before I got on was fill out the order form and send it to my family or friend so they could write a check and mail it in. Or just order it online for me. It always worked because they'd rather do that than send me money I might blow on candy and cakes from the commissary. Here's what I'd say:

"I'm sending you this order for several reasons. One, it just takes too long for my prison's trust fund office to process orders. By the time they do, my ADD mind will have moved on. Two, and the main reason, is because I'm tired of being dependent on you for money. It's not your fault I'm in here. So, I want to better myself and learn how to make my own money. Plus, this way I won't blow the money on coffee and cakes from the commissary."

Remember to never ask for money they don't have. There's a big difference between money they won't give and money they can't give. A lot of us come from poor families, so we can't ask for $10,000 to start our art gallery. But we may ask for $50 to order books. Know beforehand if they can afford your request.

Also, time your requests. I've been more successful on my birthday, Christmas, and tax check time. the key is to show them their money is being used for the greater good. Don't burn your bridges, build them. After you have asked your family and friends, it's time to branch out. There are other sources of money for artists.

WHERE TO FIND FREE MONEY?

One easy-to-find place is fastweb.com http://www.fastweb.com/. Fastweb is a database of more than 180,000 private sector grants and loans and will let you match yourself to the grants that fit your project for free. Another great source is the Foundation Center (fdncenter.org). After Troy Evans put me up on resources about free money, I had my assistant research The Foundation Center. They have a multitude of resources they publish, including the following directories:

- National Guide to Funding in Arts and Culture

- Grants for Arts, Culture, and Humanities

- Directory of New and Emerging Foundations

- Foundation Grants to Individuals

These directories are expensive. You can access these directories online on the Foundation Center's website for a monthly fee. Check your prison's library first to see if they have any of them? Someone could look at these directories for free in The Foundation Center's offices. They also have 200 plus cooperating libraries where you can look at these directories for free. You can find those addresses at foundationcenter.org.

You can find local foundations within a specific geographical area through the Council of Foundations (cof.org). Or the Regional Association of Grantmakers (rag.org). You may also try The Funding Exchange (fex.org).

Some local arts agencies make small grants. You can find the local arts councils near you through Americans for the Arts (artsusa.org). And each state has an art agency. These agencies provide fellowships. You can find out more by contacting the National Assembly of State Arts Agencies (nasaa-arts.org). The National Endowment for the Arts (arts.gov) also provides grants.

Here's what funding expert Ellen Liberatori says in *Guide to Getting Arts Grants:*

> "Access to public grants has always been very good, in my opinion, and my interaction with government staff has always been very helpful. Nowadays, access couldn't be easier with the Internet, and instead of chasing around for public grant opportunities, you can simply put your name on an e-mail list and the grant notice will come directly to you."

You need to get your e-mail access set up and running so you can make things easier for yourself. Go back and read the "The World Is Flat" section in the "Your Artwork Is Your Network" chapter if you don't remember. But the other reason I put this chapter back here is that to get the funding you'll have to have already taken some of the steps in the chapters before this one. As I show how to get a grant, you'll see what they need to have (like a portfolio) to win the money. Pay attention, as my big homie tells me, "Come correct or don't come at all."

WHAT IS A GRANT?

A grant is funds that are given to you for a cause, project, or an emergency that you don't have to pay back. A grant is not a loan. Who gives out grants? Private foundations, corporations, government agencies, nonprofit organizations, and individual donors. Why do they give out this free money? For a variety of reasons. Foundations must give out a certain amount of money each year to keep their status. Corporations can deduct a percentage of pretax income for charitable causes. Hopefully, all the above donors believe in "paying it forward." It's good money karma. No matter their reasoning, just know the money is out there for you to get.

DIFFERENT TYPES OF ART GRANTS

In *Guide to Getting Arts Grants,* Ellen Liberatori lists eleven types of grants that foundations give. They are:

- Organizational grants for arts programs
- Special projects
- Art career fellowships
- Short-term fellowships
- Travel and study
- Mentoring grants
- Emerging artist grants
- Distinguished artist grants
- Art collaboration grants
- Production grants to finish a work or collection

- Peer learning grants for artists who also work in nonprofits

For the *Prison Picasso,* only three or four of those listed above apply for emerging artists' grants; special projects; and grants to finish a work or collection. The other that may apply is organization grants for arts programs. But only if you're writing a proposal asking for the funds to support your prison art program. Or to start a prison art program. Most of the other types of art grants do not apply because of your physical incarceration. They could apply once you're released from prison. That's beyond the scope of this book. If you're going to be released soon, then by all means take advantage of any opportunity that's available to you. For now, I'll deal with what you can do from your cell. And that's anything you set your mind to!

Have you ever seen the movie *The Shawshank Redemption?* It's based on a Stephen King short story called *Rita Hayworth.* If you've never watched it, you should. There's something that the main character does that I'll share. The prison had closed the prison library because of a lack of funding. So, he started writing a letter every week to the state legislature requesting money to rebuild the library. He eventually got it. Then he started writing two letters a week to get more money.

What can you learn from this? First, you have to shoot your shot. You can't hear a "yes" unless you ask. Second, you can't let a "no" stop you. do you think a prisoner getting money like this is only a fictional account in a Stephen King story? If so, let me remind you about another prisoner who did it in real life. Troy Evans. Remember him? Seven years inside and he walked out with two degrees! Now he's an author and public speaker. How did he do all that? By writing people and asking for grant money, scholarships, and other help. It could be you. But you have to put in the work. You have to write letters. You have to write the e-mails. You have to make the phone calls. Never say no to another person. And always remember that it only takes one yes to change your life.

HOW TO WIN GRANT MONEY

Notice that I said "win" grant money. There will be other people applying for the same grants. So, it's a competition. Whoever stands out the best with the most compelling application will win. But you have something going for you. That special something is the fact that you're a prisoner. Hardly any other prisoners in the gulag will try to win grant money so you will already stand out. And if you put forth a good proposal, you'll stand out. So, with the right mindset and the proper grant application/proposal you can find the money you need to advance your career. Here's what you need to know and what you need to put together.

1. The first thing you must do is research and apply for only the grants you are eligible for. some grants have age restrictions, geographical restrictions, specific types of art restrictions, education restrictions, gender restrictions, and/or all of the above. Do not waste your time applying for grants that you're not eligible for. Use a website like fastweb.com to find these grants.

2. After you have found a grant that you're eligible for, you have to find out what the application process is. Do they have a form online that you are supposed to use? If so, you must use that form and fill it out properly or you will automatically disqualify yourself from the grant process. I provide some sample letters that you can adapt to your circumstances and send to funders to get the ball rolling.

3. If the funder doesn't have a formal application, you need to prepare a proposal package that makes you stand out from the crowd. A typical grant proposal will consist of the following:

 - Cover letter
 - Title Page

- Abstract/Summation

- Introduction

- Statement of Need

- Objections

- Procedures

- Budget

- Future Funding

- Appendix

You should also put any work samples, press clippings, media coverage, and competition awards in your proposal as well.

4. Your proposal should be typewritten or done on a computer. If you have no choice but to do yours in your handwriting, make sure it is done on plain white typing paper and the handwriting is legible. Prepare it like you were doing an appeal brief to the court.

5. Make sure your proposal is submitted in a timely fashion. Most funders have specific deadlines that you must meet. Try to get your proposal in early. It's also good to include a SASE or postcard that the funder can return to you saying they received your proposal. Some funders require that to be included so pay attention.

6. Remember what I said about asking your family and friends for money: don't ask for money they can't give. This applies to foundations, corporations, and other funders. So, ask for moderate amounts from different sources. Do your research and know how much money they have given in the past.

If you don't want to go through the process of trying to win a grant, that's fine. I never have (besides that original $3,000 my family member gave me), and I'm doing fine. The goal is to get you to where you're making thousands of dollars (if not more?) from your arts/crafts, so you don't need a grant.

"Artists who tie their career hopes to grants and awards are likely to meet with repeated frustration. Instead, artists must see themselves as entrepreneurs, learning how to earn rather than simply apply for the money."
– Daniel Grant

FREE MONEY FROM THE GOVERNMENT?

You may have seen the infomercials selling books saying you can get "free money" from the government? In research for this book, I had my assistant go to the federal government's official website (usa.gov) and download what it said about "Government Grants and Loans." Here's what it says:

"The federal government does not offer grants or "free money" to individuals to start a business or cover personal expenses, contrary to what you might see online or in the media. Websites or other publications claiming to offer "free money from the government" are often scams. Report them to the Federal Trade Commission.

"The government does offer federal benefit programs designed to help individuals and families in need become self-sufficient or lower their expenses.

"A grant is one of the ways the government funds ideas and projects to provide public services and stimulate the economy. Grants support critical recovery initiatives, innovative research, and many other programs.

"The federal government awards grants to organizations including:

- State and local government
- Universities
- Research labs
- Law enforcement
- Non-profit organizations
- Businesses

"Most grants intend to fund projects that will benefit specific parts of the population of the community. What you might see about grants online or in the media may not be true. The federal government does not offer grants or "free money" to individuals to start a business or cover personal expenses. For personal financial assistance, the government offers federal benefit programs. These programs help individuals and families become financially self-sufficient or lower their expenses."

To search or apply for federal grants, use the government's free official website, Grants.gov. or FirstGov.gov. The Catalog of Federal Domestic Assistance (cfda.gov). is a database listing information about federal assistance programs? The National Endowment for the Humanities (neh.gov) and Institute of Museum and Library Services (imls.gov) both support arts and humanities. Lastly, the Community of Science Funded Research Database (cos.com) allows you to search grants awarded by five different agencies. Some commercial sites may charge a fee for grant information or application forms. Beware.

The federal government also provides loans. These are different because recipients are required to repay loans, often with interest. The government offers several types of loans, including:

- Student loans
- Housing loans, including disaster and home improvement loans
- Small business loans

You can search for loans on the federal government's free, official website, GovLoans.gov, rather than on commercial sites that may charge a fee for information or application forms.

That's what the federal government says on its website. What does it mean for you? It means unless you are starting an art business, you probably won't use the federal government's money. That's okay. There are plenty of other sources available to get "free" money.

THE POWER OF CROWDFUNDING

You've seen the stories on tv, read about them in magazines, or heard how some people have used crowdfunding websites to raise money. Author Seth Godin raised $287,342 for one of his book projects on Kickstarter. Brainard Carey, and his wife Delia, used Kickstarter to raise $16,000 in 2011 for their non-visible art concept. Painter Gwenn Seemel used it to raise money for her children's series, Crime Against Nature. Singer Amanda Palmer raised $1 million on crowdfunding. Even projects that benefit prisoners have found success. Chef Bruno Abate used IndieGoGo to

raise almost $5,000 to help buy a pizza oven for his "Recipe for Change" program at the Cook County Jail. The Human rights Defense Center (HROC), which publishes Prison Legal News, raised almost $15,000 to help fight toxic prisons. Claudia Whitman used IndieGoGo to raise $2,600 to help with a wrongful conviction investigation into Michigan prisoner Lacino Hamilton's incarceration. In this subsection, we'll look at how a Prison Picasso could use crowdfunding to get the money they need.

WHAT IS CROWDFUNDING?

It's a way to raise money for a specific cause or project by asking a large number of people to donate small amounts in a relatively short period of time. Crowdfunding is done online where it's easy for supporters to share a cause or project with their social networks. Organizations, businesses, and individual artists (yes, prisoners) alike can use crowdfunding for any type of project.

There are two main models of crowdfunding:

1. Donation-based funding, where donors contribute a total amount for a cause or project. Normally in this model, the donors are promised a small gift in return for helping.

2. Investment crowdfunding, where businesses seeking capital sell ownership stakes online in the form of equity or debt. In this model, individuals who fund become owners or stakeholders and have a potential for financial return, unlike in the donation model. This became possible when Title II of the JOBS Act went into effect in 2013. But nonprofits generally cannot utilize equity markets.

Some of the best-known crowdfunding sites are GoFundMe, KiVA, Kickstarter, IndieGoGo, and RocketHub. But there are tons of them. Some estimate there are over a thousand crowdfunding sites? Most of them use the same system:

* Let you set up a page to describe, promote, and post updates about your project, especially with video

* accept online donations

* Are easily and highly shareable on social networks

* Specify the kinds of projects or campaigns that can be on that site (e.g., creative/artistic; entrepreneurial; personal needs; or charitable)

* Charge a percentage of funds raised plus a fee per transaction

Some sites have an "all-or-nothing" policy. What this means is that if you do not reach your monetary goal, you don't get any of the funds raised. So, before you sign up to use a crowdfunding site make sure you read and understand its guidelines, terms, and conditions beforehand.

Also, keep in mind that less than half of all crowdfunding campaigns don't reach their goals. Some experts say it's as low as 15-30% To help you reach your funding goals, I will now share with you how an artist can set up a successful crowdfunding campaign.

THE SUCCESSFUL CROWDFUNDING PLAN

Remember those numerous artists before you have been successful using these sites for projects. Jerry McLaughlin and Rebecca Crowell are artists who came together to use IndieGoGo to do their art books Cold Wax Medium: Techniques, Concepts & Conversations. Other authors have used Pubslush and Unbound. Both are book-only crowdfunding sites. A prisoner I know used Kickstarter

to raise a few hundred dollars so he could buy art supplies off the commissary. So, the first step to a successful campaign is to believe it is possible. Here are the others:

- Pick the right platform: Different crowdfunding sites have slight differences in how they fund, how you can promote, the fees they charge, and what types of projects they accept. For instance, on Kickstarter, you have to wait until your goal is reached to get your money. But Indiegogo allows you to choose to access the funds as they are raised. And some sites charge 3% of funds raised, but Kickstarter and Indiegogo have 5% fees, with additional credit card processing fees. Another issue is whether they will let you use YouTube and other social networks to promote. Some will only let you promote through their crowdfunding site. All these areas should be researched beforehand.

- Build a network ahead of time: It would be much easier to meet your funding goals if you have a built-in network of supporters. That's how singer Amanda Palmer raised $1 million. It's how Jerry McLaughlin and Rebecca Crowell raised $45,000 for their art book project. They used their Facebook community of artists and an e-mail list of over 4,000 people. You should use the tips in the "Your Artwork is Your Network" chapter to build this community.

- Make sure people know what the money is for: This is key. Be specific. For instance, if you need money for art supplies, list them. Don't say, "I need $200 for art supplies." Say, "I need $200 total for the following art supplies." Then describe each specific art supply and price. If it's an art book project, like a comic book or how-to book, list each cost along with the total goal. You must do the research ahead of time and know exactly what you need the money for, so you can tell your network.

- Make perks easy and simple: It's normal practice for donors to get something in return for backing your project, or cause. You want these perks to be simple with different levels. Let's say you were requesting money for art supplies; you could give the following benefits:
 - $10: public thank you on Facebook
 - $25: hand-painted greeting card
 - $50: small painting
 - $100: 18" x 24" watercolor painting

- Post-updates to donors: Let people know and see your progress. For one, it's good karma. Two, you never know where a connection could go. Maybe you'll need more funds down the road? If a donor is happy with how you used the money the first time, they may back other projects in the future.

- Use video: Most successful campaigns use a video to allow possible donors to see who and what they are giving me. Reread the "How to Walk on Clouds" chapter for more about a successful video.

There you have it. Of course, you'll need someone on the outside to help you with this tactic. But don't let someone tell you it's impossible. Prisoners are using crowdfunding sites to get money for their causes and projects. Maybe you can do it also? Do your research first. Then go get the funding to achieve your dreams.

"You are an artist, a visionary, and an educator. You don't need a degree or experience to do this; you just need an idea and the will to see it through to fruition."
– Brainard Carey

SAMPLE LETTERS FOR REQUESTING MONEY

I will now end this chapter with some sample letters and proposals that you can use. Then I will give you some addresses to write to for assistance. Don't copy my letters verbatim, but instead, rewrite them in your own words. That way they fit your ideas and situation. I have a lot of letters from prisoners who have read my first book, *The Millionaire Prisoner*. I love getting them. Except for a lot of you are just copying the letters I include in my books and sending them to me as is. I hoped my readers would adapt the letters to their personalities and circumstances. This will be extremely important for you to do when requesting money. Put your spin on the letters included here. Tell your story. Don't be me, be better than me. Be you – a *Prison Picasso*.

If you write a letter and don't hear anything back in 2 months, write a follow-up letter. If you don't hear anything after that just move on. Some people will not want to work with prisoners. That's just a fact of life. Remember Troy Evans? He's the prisoner I wrote about who got free money to go to school. It took him 6 months of writing letters before he got one grant. Are you willing to write letters with no replies for 6 months? If not, then ignore this chapter? Go to the other ones. for those of you who are willing to do what it takes, here are some sample letters and proposals followed by a ton of addresses of places you can send them to. Good luck.

Sample Inquiry Letter

Date: _____

Dear _____

This letter is submitted by _____ to announce my intention to apply for a _____ grant. I'm an emerging artist and would use a grant of $_____ to purchase art books and supplies. Can you please send me the necessary application forms and requirements?

Thank you in advance for your cooperation in this matter. I have enclosed a SASE for your reply. May you and your foundation be blessed.

Respectfully requested,

[Your Signature]
[Your Address]
[Your E-mail]

Enc.: SASE

Sample Follow Up Letter

Date: _____

Dear _____:

This letter is submitted to follow up to my _____, 20—letter requesting _____. Just in case you did not get around to looking at my proposal, I have enclosed another SASE for your application and requirements please.

Thank you in advance for your cooperation in this matter. I look forward to hearing from you soon.

Respectfully requested,

[Your Signature]
[Your Address]
[Your E-mail]

Enc: SASE

Sample Proposal Letter

Date: _____

Dear _____:

The _____ Correction Center Art Class seeks support of $--- from _____ for a special project entitled "Prison Picasso Arts and Crafts." We believe this project is very much aligned with your goals to protect prisoner rights and teach creative expression through art therapy.

Our class has operated since _____ and has grown every year. Due to DOC budget cuts, we are entirely dependent on charity donations to exist. The requestion $--- will allow us to operate for another – year(s) and help with supplies.

We would like to submit a full proposal with additional information for your further review.

Respectfully requested,

[Your Signature]
[Your Address]
[Your E-mail]

Encl: SASE

Sample Formal Proposal Letter

Mrs. _____

_____Foundation

_____, _____ 00000 Date: _____

Dear Mrs. _____

I am writing to obtain funding for a documentary art project called, simply, *Just Watch What You Say.* This will be a portrait of the First Amendment as it exists for prisoners. The project will be presented both as a gallery exhibition and in book form.

The U.S. Supreme Court has said on numerous occasions that prisoners retain their First Amendment right to free speech and freedom of expression. Yet despite these rulings, prison officials continue to curtail prisoners' rights to free speech and expression. This is a dangerous precedent, especially in these turbulent times. Now more than ever, prisoners should be allowed to tell their stories to help affect change and bring us to a new world where everyone is equal, including prisoners.

Just Watch What You Say is a project intended to give voice to the voiceless. At the same time, it will document the history of First Amendment action and expression by prisoners even as officials try to stop them and punish them for doing so. Focusing on U.S. prisons and jails, the project will combine oral history, artistic impressions of prisoners, and a collection of historical photographs and artwork, borrowed from prisoners, prisoners' family collections, which will be reproduced for a gallery and book presentation. The project will feature a selected number of prison activists and lawyers that can give evidence of the First Amendment as it exists in the carceral world. Though the emphasis will be on the past, the project will lead us through the recent turmoil and protest over excessive force by police.

The project will take one year to complete, including collecting the oral histories, artwork, and photographs, conducting interviews via snail mail and e-mail, and preparing for exhibition.

Upon completion of the project, selected artwork and excerpts from the oral histories will be presented at Rutgers University. (The _____ Arts Council has already expressed interest in supporting this exhibition – see enclosed letter.) We will also prepare an edited text of the oral histories, along with selected artwork and photographs, for publication in book form. Freebird Publishers, which published my previous book, *Prison Picasso,* has expressed strong interest in *Just Watch What You Say* (see enclosed letter).

As author of several successful books for prisoners, and as a life-term prisoner for 21 years (and counting), I feel I have a special understanding of prison culture and prisoners. In fact, the concept for this project arose from many comments that prisoners offered during research for my earlier book.

Since the ____ Foundation has supported projects in the visual arts and prison world in the past, I am pleased to submit this proposal, and to request a contribution of $10,000 toward realization of this project.

I have enclosed a budget, and additional materials about my earlier work, including a resume, along with the letters I wrote about earlier in support of this project. If you have any questions or need additional materials, please do not hesitate to e-mail me at prisonpicasso@gmail.com, or by calling my personal assistant at 217-474-9999.

Respectfully Submitted,

Joshua Kruger

USEFUL ADDRESS FOR THE PRISON ARTIST

Association for Enterprise Opportunity
1601 North Kent Street
Ste. 1101
Arlington, VA 22209
(703) 841-7760
assoceo.org
(locate microlenders who provide loans)

Artists' Fellowship
47 Fifth Avenue
New York, NY 10003
(646 230-9833
artistsfellowship.org
(provides emergency assistance to artists)

Arthouse
Texas Fine Arts Association
700 Congress Avenue
Austin, TX 78701
(512) 453-5312
arthousetexas.org
(Emergency grants for Texas artists)

Marshall and Mary Brondum Special
Assistance Foundation
P.O. Box 3106
Missoula, MT 59806-3106
(provides grants to folk artists)

Change, Inc.
P.O. Box 54
Captiva, FL 33924
(212) 473-3742
(Grants of up to $1,000 for artists in need)

Craft Emergency Relief Fund
P.O. Box 838
Montpelier, VT 05601-0838
(802) 229-2306
craftemergency.org
(Awards to craft artists in need)

Emergency Artist Support League
P.O. Box 7895
Dallas, TX 75209
dallasartsrevue.ocom/EASL.shtml
(Emergency assistance to North Texas artists
in dire temporary distress)

Adolph & Esther Gottlieb Foundation, Inc.
380 W. Broadway
New York, NY 10012
(212) 226-0581
gottliebfoundation.org
(provides up to $10,000 for artists facing
emergencies, such as fire, flood, or medical
care)

Berkshire Taconic Community Foundation
271 Main Street
Great Barrington, MA 01230
(800) 969-2823
berkshiretaconic.org
(financial assistance for New England artists)

Chicago Artist's Coalition
70 East Lake Street
Chicago, IL 60601
(312) 670-2060
caconline.org
(Emergency funds for artists)

J. Happy-Delpech Foundation
Flatiron Arts Building
1935 1/2 West North Avenue
Chicago, IL 60622
(312) 342-1359
(Grants to Midwest artists with AIDS or other
serious illnesses)

Louisiana Division of the Arts
P.O. Box 44247
Baton Rouge, LA 70804-4247
(225) 342-8180
cet.state.la.us/aets
(Grant-in-Aid Program for emergencies)

Max's Kansas City Project
P.O. Box 2067
New York, NY 10013
maxskansascity.org
(Grants to artists)

The Mayer Foundation
20 West 64th Street
New York, NY 10023
fdncenter.org/grantmaker/mayer
(Grants of $2,500 - $5,000)

Aid to Artisans, Inc.
14 Brick Walk Lane
Farmington, CT 06032
(860) 947-3344
aid2artisans.org

Artist Trust
1835 12th Avenue
Seattle, WA 98122-2437
(866) 21TRUST
artisttrust.org

Florida Craftsmen, Inc.
501 Central Avenue
St. Petersburg, FL 33701-3703
(727) 321-7391
floridacraftsment.net

Indian Artist Disaster Relief Fund
C/O Arizona Indian Arts Alliance (AAIA)
P.O. *The Power of Visual Storytelling* by
Jason Lankow. Box 250
Tumacacori, AZ 85640
(520) 398-2226
indianartistsofamerica.com

Joan Mitchell Foundation
P.O. Box 1902
New York, NY 10025
(212) 865-8491

Judith Rothschild Foundation
1110 Park Avenue
New York, NY 10128
(212) 831-4114

George Segal Foundation
136 Davidson's Mill Road
North Brunswick, NJ 08902
(732) 951-0950
segalfoundation.org

REGIONAL ARTS AGENCIES

These agencies provide support and assistance to individual artists and arts organizations:

Arts Midwest
Hennepin Center for the Arts
528 Hennepin Avenue
Ste. 310
Minneapolis, MN 55403
(612) 341-0755
(For ILL, IN, IA, MI, MN, NO, Oh, SD, and WI)

Mid-America Arts Alliance
20 West 9th Street
Ste. 550
Kansas City, MO 64105
(816) 421-1388
(For Ark, Kan, Miss, Neb, OK, and TX)

Mid-Atlantic Arts Foundation
11 East Chase Street
Ste. I-A
Baltimore, MD 21202
(410) 539-6656
(For Dela, D.C., Md, NJ, NY, Penn, VA, and W.V.)

New England Foundation for the Arts
330 Congress Street
Boston, MA 02210-1216
(617) 951-0010
(For Conn, Maine, Mass, NH, RI, and Vermont)

Southern Arts Foundation
1401 Peachtree Street, N.E.
Ste. 122
Atlanta, GA 30309
(404) 874-7244
(For Ala, Fla, Geo, KY, LA, Miss, NC, SC, and TN)

Western States Arts Foundation
207 Shelby Street
Ste. 200
Santa Fe, NM 87501
(505) 988-1166
(For Ala, AZ, Cal, Col, I, Id, Mont, Nev, NM, OR, Utah, Wash, and Wyo.)

FOUNDATIONS AND TRUSTS

The Foundation Center provides invaluable resources online where you can search for foundations that give away money. It's not free though. The Foundation Directory is $19.95 per month. Foundation Grants to Individuals are $9.95 per month. The National Guide to Funding in Arts and Culture is $155. Grants for Arts, Culture, and Humanities are $75. They also have five offices and 200 plus cooperating libraries in all fifty states where you can look through these files. For more, here is their contact information:

The Foundation Center
79 Fifth Avenue
New York, NY 10003-3076
foundationcenter.org

Here are some other foundations that have been known to give money to individuals in the past:

Avery-Fuller Children Center
251 Kearney Street, Ste. 301
San Francisco, CA 94108

The Commonwealth Fund
One East 75th Street
New York, NY 10021-2692

Ametek Foundation
410 Park Avenue
New York, NY 10022

Baker Foundation
P.O. Box 328
Nashua, NH 03301

Biddle Foundation, Inc.
61 Broadway, Room 2912
New York, NY 10006

Blanchard Foundation
C/O Boston Sake
One Boston Place
Boston, MA 02106

Bohen Foundation
1716 Locust Street
Des Moines, IA 50303

Broadcaster's Foundation, Inc.
320 West 57th St.
New York, NY 10019

Cambridge Foundation
99 Bishop Allan Drive
Cambridge, MA 02139

The Clark Foundation
30 Wall Street
New York, NY 10005

Copley Fund
P.O. Box 696
Morrisville, VT 05661

The Cullen Foundation
P.O. Box 1600
Houston, TX 77251

Coulter Foundation
P.O. Box 5247
Denver, CO 80217

Deposit Guaranty Foundation
P.O. Box 1200
Jackson, MS 39201

The Dayton Foundation
1395 Winters Bank Tower
Dayton, OH 45423

Earl B. Gilmore Foundation
160 S. Fairfax Avenue
Los Angeles, CA 90036

Frank R. Seaver Trust
714 W. Olympic Blvd.
Los Angeles, CA 90015

Fairchild Industries
20301 Century Blvd.
Germantown, MD 20874

Charles and Els Bendheim Foundation
One Parker Plaza
Fort Lee, NJ 0702

Ford Motor Company
The American Road
Dearborn, MI 48121

The Hawaii Foundation
111 South King Street
P.O. Box 3170
Honolulu, HI 96802

Haskin Foundation
200 E. Broadway
Louisville, KY 40202

The H&R Block Foundation
4410 Main Street
Kansas City, MO 64111

Horace B. Packer Foundation
61 Main Street
Wellsboro, PA 16901

Inland-Steel-Ryeason foundation
30 West Monroe St.
Chicago, IL 60603

The James Irvine Foundation
One Market Plaza
San Francisco, CA 94105

John B. Lynch Scholarship Fund
P.O. Box 4248
Wilmington, OE 19807

Jane Nugent Cochems Trust
C/O Colorado National Bank of Denver
P.O. Box 5168
Denver, CO 80217

Miles Foundation
P.O. Box 40
Elkhart, IN 46515

Morris Joseloff Foundation, Inc.
125 La Salee Road, W
Hartford, CT 06107

Muskegon County Foundation
Frauenthal Center, Ste. 304
407 W. Western Avenue
Muskegon, MI 49440

New Hampshire Fund
One South Street
P.O. Box 1335
Concord, NH 03302-1335

Northern Indiana Giving Program
5265 Hohman Avenue
Hammond, IN 46320

The Pitton Foundation
511 16th Street, Ste. 700
Denver, CO 80202

Richard & Helen DeVos Foundation
7154 Windy Ill, SE
Grand Rapids, MI 49506

The Shearwater Foundation, Inc.
C/O Alexander Nixon
423 West 43rd St.
New York, NY 10036

Simon & Schwab Foundation
P.O. Box 1014
Columbus, GA 31902

Thatcher Foundation
P.O. Box 7600
Los Angeles, CA 90051

Linocal Foundation
P.O. Box 7600
Los Angeles, CA 90051

Wal-Mart Foundation
702 Southwest 8th Street
Bentonville, AK 72716

Wheless Foundation
P.O. Box 1119
Shreveport, LA 71152

William Penn Foundation
1630 Locus Street
Philadelphia, PA 19103

Xerox Foundation
P.O. Box 1600
Stamford, CT 06904

Yonkers Charitable Trust
701 Walnut Street
Des Moines, IA 50306

For more addresses and resources, you may want to check out the following:

The Council on Foundations
1828 L Street, N.W.
Washington, D.C. 20036
(202) 466-6512
cof.org

The Funding Exchange
666 Broadway
New York, NY 10012
(212) 529-5300
fex.org

Regional Association of Grantmakers
(rag.org)

Americans for the Arts
927 15th Street, N.W.
Washington, D.C. 20005
(202) 371-2830
artsusa.org

National Assembly of States Arts Agencies
1010 Vermont Avenue, N.W.
Washington, D.C. 20005
(202) 347-6352
nasaa-arts.org

National Endowment for the Arts
1100 Pennsylvania Avenue, N.W.
Washington, D.C. 20506
(202) 682-5400
arts.gov

Department of the Interior
Indian Arts and Crafts Board
Main Interior Building
Room 4004
Washington, DC 20240
(202) 208-3773

Department of the Interior
Bureau of Indian Affairs
Office of Trust and Economic Development
1849 C Street, NW
Room 2528
Washington, DC 20240
(202) 219-5274

The Grantsmanship Center
1125 W. Sixth Street (5th Floor)
P.O. Box 17220
Los Angeles, CA 90017
(213) 482-9860

National Charities Information Bureau
19 Union Square West Sixth Floor
New York, NY 10003
(212 929-6300

American Council for the Arts
1 East 53rd Street
New York, NY 10022
(212) 223-2787

Art Information Center
280 Broadway, Ste. 412
New York, NY 10007
(212) 227-0282

Business Committee for the Arts
1775 Broadway, Ste. 510
New York, NY 10019
(212) 664-0600

UNITED STATES ARTS AGENCIES

Look for your state's agency, then send a query letter with a SASE to get their deadlines and guidelines.

Alabama State Council on the Arts
201 Monroe St.
Montgomery, AL 36130-1800
(334) 242-4076
arts.state.al.us
E-mail: staff@arts.alabama.gov

Alaska State Council on the Arts
161 Klevin St., Ste. 102
Anchorage, AK 99508-1506
(907) 269-6610
eed.state.ak.us/aksca
E-mail: aksca.info@alaska.gov

Arizona Commission on the Arts
417 W. Roosevelt St.
Phoenix, AZ 85003-1326
(602) 771-6501
azarts.gov
E-mail: info@azarts.gov

California Arts Council
1300 I St., Ste. 930
Sacramento, CA 95814
(916) 322-6555; (800) 201-6201
cac.ca.gov
E-mail: info@arts.ca.gov

Colorado Creative Industries
1625 Broadway, Ste., 2700
Denver, CO 80202
(303) 892-3840
coloradocreativeindustries.org

Connecticut Commission on Culture &
Tourism
One Constitution Plaza, 2nd Floor
Hartford, CT 06103
(860) 256-2800
cultureandtourism.org

Delaware Division of the Arts
Carvel State Office Bldg., 4th floor
820 N. French St. Wilmington, CE 19801
(302) 577-8278
artsdel.org
E-mail: delarts@state.de.us

D.C. Commission on the Arts and Humanities
200 I St. SE
Washington, DC 20003
(202) 724-5613
dcaets.dc.gov
E-mail: cah@dc.gov

Florida Division of Cultural Affairs
R.A. Gray Bldg., 3rd Floor
500 S. Bronough St.
Tallahassee, FL 32399-0250
(850) 245-6470
dos.myflorida.com/cultural

Georgia Council for the Arts
75 Fifth St. NW, Ste. 1200
Atlanta, GA 30308
(404) 685-2787
gaarts.org

Hawai'i State Foundation on
Culture & the Arts
250 S. Hotel St., 2nd Floor
Honolulu, HI 96813
(808) 586-0300
sfea.hawaii.gov

Idaho Commission on the Arts
P.O. 83720
Boise, ID 83720-0008
(208) 334-2119; (800) 278-3863
arts.idaho.gov

Illinois Arts Council Agency
James R. Thompson Center
100 W. Randolph, Ste. 10500
Chicago, IL 60601-3230
(312) 814-6750; (800) 237-6994
arts.illinois.gov
E-mail: iac.info@illinois.gov

Indiana Arts Commission
100 N. Senate Ave., Room N505
Indianapolis, IN 46204
(317) 232-1268
in.gov/arts
E-mail: IndianArtsCommission@iac.in.gov

Iowa Arts Council
600 E. Locust
Des Moines, IA 50319-0290
(515) 281-5111
iowaculture.gov/aets

Kansas Creative Arts Industries Commission
1000 SW Jackson, Ste. 100
Topeka, KS 66612
(785) 296-3481
kansascommerce.com/caic

Kentucky Arts Council
500 Mero St., Ste. 2100
Frankfort, KY 40601-1987
(502) 564-3757; (888) 833-2787
arts.council.ky.gov

Louisiana Division of the Arts
P.O. Box 44247
Baton Rouge, LA 70804-4247
(225) 342-8180
crt.state.la.us/cultural-development/arts

Maine Arts Commission
193 State St.,
25 State House Station
Augusta, ME 04333-0025
(207) 287-2724
mainearts.maine.gov

Maryland State Arts Council
175 W. Ostend St., Ste. I
Baltimore, MD 21230
(410) 767-6555
msac.org
E-mail: msac@msac.org

Massachusetts Cultural Council
10 St. James Ave., 3rd Floor
Boston, MA 02116-3803
(617) 858-2700
massculturalcouncil.org
E-mail: mcc@art.state.ma.us

Michigan Council for Arts and Cultural Affairs
300 N. Washington Square
Lansing, MI 48913
(517) 241-4011
michiganbusines.org/arts
e-mail: artsinfo@michigan.org

Minnesota State Arts Board
Park Square Court, Ste. 200
400 Sibley St.
St. Paul, MN 55101-1928
(800) 866-2787
arts.state.nm.us
e-mail: msab@arts.state.nm.us

Mississippi Arts Commission
501 N. West St., Ste. 1101A
Woolfolk Bldg.
Jackson, MS 39201
(601) 359-6030
arts.state.ms.us

Missouri Arts Council
815 Olive St., Ste. 16
St. Louis, MD 63101-1503
(866) 407-4752
missouridrtscounsil.org
E-mail: moarts@ded.mo.gov

Montana Arts Council
P.O. Box 20201
Helena, MT 59620-2201
(406) 444-6430
art.mt.gov
E-mail: mac@mt.gov

National Assembly of State Arts Agencies
1200 18th St. NW, Ste. 1100
Washington, DC 20036
(202) 347-6352
nasaa.aets.org
E-mail: nasaa@nasaa-arts.org

Nebraska Arts Council
Burlington Bldg.
1004 Farnam St.
Omaha, NE 68102
(402) 595-2122; (800) 341-4067
artscouncil.nebraska.gov
E-mail: nae.info@nebraska.gov

Nevada Arts Council
716 N. Carson St., Ste. A
Carson City, NV 89701
(775) 687-6680
nac.nevadaculture.org
E-mail: infonvartscouncil@nevadaculture.org

New Hampshire State Council on the Arts
19 Pillsbury St., 1st Floor
Concord, NH 03301
(603) 271-2789
nh.gov/nharts

New Jersey State Council on the Arts
P.O. Box 306
Trenton, NJ 08625-0306
(609) 292-6130
nj.gov/state/njsca
e-mail: feedback@sos.nj.gov

New Mexico Arts
Bataan Memorial Bldg.
407 Galisteo St., Ste. 270
Santa Fe, NM 87501
(800) 879-4278
nmarts.org

New York State Council on the Arts
300 Park Ave. S, 10th Floor
New York, NY 10010
(212) 459-8800
nysca.org

North Carolina Arts Council
MSC 4632, Department of Cultural Resources
109 E. Jones St.
Raleigh, NC 27699-4632
(919) 807-6500
ncarts.org
E-mail: ncarts@ncdcr.gov

North Dakota Council on the Arts
1600 E. Century Ave., Ste. 6
Bismarck, ND 58503-0649
(701) 328-7590
nd.gov/arts
E-mail: comserv@nd.gov

Ohio Arts Council
30 E. Broad St., 33rd Floor
Columbus, OH 43215-3414
(614) 466-2613
oac.ohio.gov

Oklahoma Arts Council
P.O. Box 52001-2001
Oklahoma City, OK 73152-2001
(405) 521-2931
arts.ok.gov
E-mail: okarts.@arts.ok.gov

Oregon Arts Commission
775 Summer St. NE, Ste. 200
Salem, OR 97301-1280
(503) 986-0082
oregonartscommission.org
E-mail: oregon.oartscomm@state.oe.us

Pennsylvania Council on the Arts
216 Finance Bldg.
Harrisburg, PA 17120
(717) 787-6883
arts.pa.gov
E-mail: RA-arts@pa.gov

Rhode Island State Council on the Arts
One Capitol Hill, 3rd Floor
Providence, RI 02908
(401) 222-3880
arts.ri.gov

South Carolina Arts Commission
1026 Sumter St., Ste. 200
Columbia, SC 29201-3746
(803) 734-8696
southcarolinaarts.com
E-mail: info@arts.sc.gov

South Dakota Arts Council
711 E. Wells Ave
Pierre, SC 57501-3369
(605) 773-3301; (800) 952-3615
artscouncil.sd.gov
E-mail: sdac@state.sd.us

Tennessee Arts Commission
401 Charlotte Ave
Nashville, TN 37243
(615) 741-1701; (800) 848-0299
tnartscommission.org

Texas Commission on the Arts
E.O. Thompson Office Bldg. 501
Colorado, Ste. 501
Austin, TX 78711-3406
(512) 463-5535
arts.texas.gov
E-mail: front.deskart.texas.gov

Utah Division of Arts and Museums
617 E. South Temple
Salt Lake City, UT 84102
(801) 236-7555
heritage.utah.gov/Utah-division-of-arts-museums

Vermont Arts Council
136 State St.
Montpelier, VT 05633-6001
(802) 828-3291
vermontartscouncil.org
E-mail: info@vermontartscouncil.org

Virginia Commission for the Arts
1001 E. Broad St., Ste. 330
Richmond, VA 23219
(804) 225-3132
arts.virginia.gov
E-mail: arts@vca.virginia.gov

Washington State Arts Commission
P.O. Box 42675
Olympia, WA 98504-2675
(360) 753-3860
arts.wa.gov

West Virginia Commission on the Arts
The Culture Center, Capitol Complex
1900 Kanawha Blvd. E
Charleston, WV 25305-0300
(304) 558-0240
wvculture.org/arts

Wisconsin Arts Board
P.O. Box 8690
Madison, WI 53708-8690
(608) 266-0190
arts.board.wisconsin.gov
E-mail: artsboard@wisconsin.gov

Wyoming Arts Council
2301 Central Ave.
Barrett Bldg., 2nd Floor
Cheyenne, WY 82002
(307) 777-7742
wyoarts.state.wy.us

PROVINCIAL ARTS AGENCIES

Guam Council on the Arts and Humanities
P.O. Box 2950
Hagatna, GU 96932
(671) 300-1204
guamcaha.org
E-mail: info@caha.guam.gov

Institute of Puerto Rican Culture
P.O. Box 9024184
San Juan, PR 00902-4184
(787) 724-0700
icp.gobierno.pr
E-mail: mgaecia@icp.gobierno.pr

American Samoa Council on Arts, Culture,
and the Humanities
P.O. Box 1540
Fagatogo, Pago Pago AK 96799
(684) 633-5613
americansamoa.gov/arts-council

Virgin Islands Council on the Arts
5070 Norre Gade, Ste. I
St. Tomas, VI 00802-6762
(340) 774-5984
vicouncilonarts.org

Quebec Council for Arts & Literature
79 boul. Revé-Lévesque Est., Ze étage
Québec, Québec G1R 5N5
(418) 643-1707; (800) 608-3350
calq.gour.qc.ca

Saskatchewan Arts Board
1355 Broad St.
Regina, Saskatchewan S4R 7V1
(800) 667-7526
artsboard.sk.ca
E-mail: info@saskartsboard.ca

Yukon Arts Section, Cultural Services Branch
P.O. Box 2703 (L-3)
Whitehorse, Yukon Y1A 2C6
(867) 667-3555; (800) 661-0408
tc.gov.yk.ca/arts.html

MATERIALS FOR THE ARTS PROGRAMS

Remember how in Part 1, I told how Andy in The Shawshank Redemption wrote all those letters so he could get donations for the prison library? Well, if Andy were an artist in prison today, all he would have to do is solicit the organizations that provide materials to artists. This strategy will work best if your prison has an art therapy class and needs additional supplies? You could contact these places and request what you needed. Here they are:

NATIONAL PROGRAMS

Educational Assistance, Ltd.
P.O. Box 3021
Glen Ellyn, Il. 60138
(630) 690-0010
ealworks.org

Gifts-In-Kind
700 North Fairfax Street
Alexandria, VA 22314
(703)836-2121
giftsinkind.org

National Association for the Exchange of
Industrial Resources
P.O. Box 8076
Galesburg, IL 61402
(309) 343-0704
naeir.org

CALIFORNIA

Art From Scrap
Community Environmental Council
302 East Cota Street
Santa Barbara, CA 93101
(805) 884-0459
communityenvironmentalcouncil.org/artfromsc
rap

Creative Reuse/North Bay
P.O. Box 1802
Santa Rosa, CA
(707) 546-3340
creativeuse@earthlink.net

East Bay Depot for Creative Use
6713 San Pablo Avenue
Oakland, CA 94608
(510) 547-6470
eastbaydepot.org

LA Shares
3224 Riverside Drive
Los Angeles, CA 90027
(213) 485-1097
lashares.org

RAFT (Resource Area for Teachers)
1355 Ridder Park Drive
San Jose, CA 95131
(408) 451-1420
raft.net

SCRAP
Scrounger's Center for Reusable Arts Parts
834 Toland Street
San Francisco, CA 94124
(415) 647-1746
scrap-sf.org

SCRAP
Student Creative Recycle Art Program
Riverside County Fairgrounds
46-350 Arabia Street
Indio, CA 92201
(760) 863-7777

COLORADO

Creative Exchange
5273 South Newton Street
Littleton, CO 80123
(303) 347-1193
creativeexchange.org

CONNECTICUT

Connecticut Materials Exchange
62 Cherry Street
Bridgeport, CT 06605
(203) 335-3452

FLORIDA

Resource Depot
3560 Investment Land
Riviera Beach, FL 33404
(561) 882-0090
resourcedepot.net

Reusable Resources Adventure Center
P.O. Bo 360507
Melbourne, FL 32936
(407) 729-0100

GEORGIA

Materials for the Arts
City of Atlanta Bureau of Cultural Affairs
675 Ponce de Leon Avenue
Atlanta, GA 30308
(404) 817-6815
bcaantlanta.com

ILLINOIS

Creative Reuse Warehouse
222 East 135th Place
Chicago, IL 60627
(773) 821-1351
resourcecenterchicago.org

INDIANA

The Reuz Station for Arts and Crafts
The Hammond Environmental Educational
Center
2405 Calumet Avenue
Hammond, IN 46394
(219) 853-2420

KANSAS

The Recycled Materials Center
4601 State Avenue
Kansas City, KS 66102
(913) 287-8888
kidmuzm.org/links/recycle.html

LOUISIANA

Recycle for the Arts
2831 Marais Street
New Orleans, LA 70130
(504) 949-8144
recycleforthearts.org

MAINE

Ruth's Reusable Resources
1 Bessey School
Scarborough, ME 04074
(207) 883-8407
Ruths.org

MARYLAND

The Loading Dock
2523 Gwen's Falls Parkway
Baltimore, MD 21218
(410) 728-3625
loadingdock.org

MASSACHUSETTS

Recycle Shop
Children's Museum of Boston
The Jamaica Way
300 Congress Street
Boston, MA 07130

(617) 426-6500, ext. 416
bostonkids.org

Community Resource/Recycle Center
38 Montvale Avenue
Stoneham, MA 02180
(781) 279-4658

MICHIGAN

Arts & Scraps
17820 East Warren
Detroit, MI 48224
(313) 640-4411
artsandscraps.org

Creation Station
200 Museum Drive
Lansing, MI 48910
(571) 337-8793
recycle@ci.lansing.mi.us

The Scrap Box
581 State Circle
Ann Arbor, MI 48108
(734) 994-0012
scrapbox.org

USPS Project
4800 Collins Road
Lansing, MI 48924-9731
(571) 337-8793

MISSOURI

St. Louis Teachers Recycle Center
3120 St. Louis Avenue
Manchester, MO 63106
(636) 227-7095; (636) 227-7095
sltrc.com

The Surplus Exchange
1107 Hickory
Kansas City, MO 64101
(816) 472-0444
surplusexchange.org

MINNESOTA

Artscraps
1459 St. Clair Avenue
St. Paul, MN 55105
(651) 698-2787
setscrapsorg

MNTap
University of Minnesota Gateway Center
200 Oak Street, S.E.
Minneapolis, MN 55455
(61) 624-1300
mnexchange.org

NEW HAMPSHIRE

Donation Network
18 Franklin Street
Nashua, NH 03064
(603) 645-9622

NEW MEXICO

Wemagination Center
4010 Copper, N.E.
Albuquerque, NM 87106
(505) 268-8580
wedonate@unm.edu

NEW YORK

Hudson Valley Materials Exchange
Building 404
1101 First Street
New Windsor, NY 12553
(845) 567-1445
hvmaterialsexchange.com

INWRAP
29-10 Thompson Avenue
Long Island City, NY 11101
(718) 786-5300

Materials for the Arts
33-00 Northern Boulevard
Long Island City, NY 11101
(718) 729-3001
mfta.org

Materials Resource Center
1521 Lincoln Avenue
Holbrook, NY 11741
(631) 580-7290
materialresourcecenter.org

Materials Reuse Project
274 Oak Street
Buffalo, NY 14203
(716) 845-6500
buffaloalliance.org

Western New York Materials Exchange
3837 West Main Street Road
Batavia, NY 14020-9404
(800) 836-1154
co.genesee.ny.us

NORTH CAROLINA

The Scrap Exchange
Recycling for the Creative Arts
548 Foster Street
Durham, NC 27701
(919) 688-6960
scrapexchange.org

OHIO

Art & More
SWACO
4149 London-Groveport Road
Grove City, OH 43123-9522
(314) 297-8561

Crayons to Computers
1350 Tennessee Avenue
Cincinnati, OH 45229
(513) 482-3290
crayons2computers.org

Rellse Thrift Store
100 N. Columbus Road
Athens, OH 45701
(740) 594-5103
reuseindustries.org

OREGON

SCRAP
School and Community Research Action
Project
390IA N. Williams
Portland, OR 97227
(503) 294-0769
scrapaction.org

MECCA
Materials Exchange Center for Community
Arts
449 Blair Boulevard
Eugene, OR
(541) 302-1810
materials.exchange.org

PENNSYLVANIA

Please Take Materials Project
Creative Artists' Resource Project
2026 East York Street
Philadelphia, PA 19125-1221
(215) 739-2583
pleasetake.org

RHODE ISLAND

Recycling for RI Education
95 Hathaway Center
Providence, RI 02907
(401) 781-1521
rrie.org

TENNESSEE

Materials for the Arts
Community Resource Center
416 Metroplex Drive
Nashville, TN 37243
(615) 781-1086
community-resource-center.com

VERMONT

The ReStore
186 River Street
Montpelier, VT 04602
(802) 229-1930
therestore.org

WASHINGTON

Second Use
7953 Second Avenue South
Seattle, WA 98108
(206) 763-6929
seconduse.com

Just remember. There's money out there. Don't let the fact that you don't have any stop you from going after your dreams. I'm living proof that you can change your life while in prison. It all starts by coming up with ideas and writing letters. Your art is your idea. The question is who knows about it?

RESOURCE BOX

If you want to do some serious study and research on how to get free money for your art class, project/cause, supplies, then I encourage you to have someone order these books from used book sellers online:

- *Guide to Getting Arts Grants* by Ellen Liberatori

- *Free Money for People in the Arts* by Laurie Blum

- *Guide to Corporate Giving in the Arts* edited by Robert A. Porter

- *Guide to Funding for Emerging Artists and Scholars* by Jennifer Sarbacher

- *The National Directory of Grants and Aid to Individuals in the Arts* by Nancy A. Fandel

- *The Complete Guide to Getting a Grant* by Laurie Blum

- *Raise More Money for Your Nonprofit Organization* by Anne L. New

- *Securing Your Organization's Future: A Complete Guide to Fund-Raising Strategies* by Michael Seltzer

- *Guerilla Financing* by Bruce Blechman and Jay Conrad Levinson

All these books can be found online. Contact Freebird Publishers about ordering them if you don't have someone to help you.

"Instead of trying to find the perfect cell mate, try being the perfect cell mate."

"You get whatever accomplishment you are willing to declare."
– Georgia O'Keeffe

Georgia O'Keeffe is one of the most intriguing artists of the 20th century. She is known internationally for her boldly innovative art that captures the emotion and power of objects.

CHAPTER 14

ETSY.COM, EBAY, AND OTHER WEBSITES

"The Internet amplifies the power of weak ties many times over ...
For an artist, weak ties lead to art sales."
– Cory Huff

Growing up my grandparents owned a small antique store called 307 Shop. I loved going there when I was a kid because they had all kinds of cool stuff in "the Shop." We especially loved the Zero candy bars at the front of the store! Another thing I watched my grandfather do, was buy cases of art prints for $1 each. There were mass prints of Dogs Playing Poker, Native Americans, and other famous images. He would then put them into nice picture frames and sell them for a nice profit. The modern-day antique store has evolved, and online websites like Etsy have turned into one big shopping mall filled with all kinds of little art stores, gift and antique shops, and homemade item sellers. If my grandparents were still alive and I was helping them run 307 Shop, I would make sure we had a viable online presence on Etsy.com!

ETSY.COM

Etsy is the largest online seller of arts and crafts. Do you have a presence on Etsy.com? If not, you should. There are no fees to open an Etsy shop and no monthly membership cost. Last time I checked, it cost 20 cents to list each item you're selling, and the listing will stay up for four months.

If you make a sale, then Etsy keeps 3.5% of the sale price. Let's do the math. Say you have an Etsy store with 50 items. You list them at 20¢ each for $10 or 50 X 20¢ = $10.00. You renew them every four months, or three times a year, so your cost is $30 or ($10 X 3 = $30.00). If you make an average of $300 in sales each month, Etsy will take $10.50 or ($300 X 3.5% = $10.50). If that continues every month then you would make $3,474, and Etsy would make $126. Are you making this kind of money now selling your arts and crafts over the gallery at your prison? (FYI: There will be another small fee for credit card purchases/processing.) The whole premise of the TMP philosophy is to think bigger than your current prison cell. If you're currently selling art or crafts out of your cell for commissary items, you're thinking small and limiting your potential. Why not think big? Or as Joseph Robinson advocated so well in his great book by the same name, *Think Outside the Cell*. The internet allows you access to the whole world. And Etsy could be one way you make it big?

You can learn the current procedures, and the correct way, to open an Etsy shop at etsy.com/help/article/246. On the Etsy website, you can have your own personalized shop. You can sell handmade goods, vintage items, and even supplies. You can have your own profile page, and another one to share photos about your business. You can also show five different photos for each product you list. The name of your Etsy store can be up to twenty characters long and it has no spaces in between the letters/characters. It should be original. Nobody can already be using it on Etsy.

Here's a tip to remember about naming your store. Set up a .com in the same name also. Set up Facebook/Twitter/Instagram profiles first. For instance, say I was going to open a "Prison Picasso" Etsy store, I would buy the PrisonPicasso.com domain name and set up all the Prison Picasso social media pages first. Then I would set up my Prison Picasso Etsy.com store. Then I would study the most successful sellers on Etsy to see how I could do it also. You can find out who the most successful sellers on Etsy are by looking at CRAFTCount (craftcount.com). Remember this though – exclude the stores that make lots of sales supplying materials to the artists and crafters on Etsy.

Some of the same rules that apply to your own website also apply to an Etsy store. Have your PayPal account set up so you can use it over your different online platforms. That way you can process orders from credit cards. You need a shop title that is catchy and fits all the SEO rules. Then you can make a shop Banner Image to go with your title. You can find a ton of Etsy banner backgrounds you can use on EtsyBannerGenerator.com. Or you can use shopvaluecalculator.com/free-Etsy-banner-generator written by the staff at Etsy.com. You should have someone send you those articles so you can learn more. You can find them at: etsy.com/blog/en//the-seller-handbook-archive. Etsy also offers apps that assist you. Check them out at: etsy.com/apps. There's also a free weekly newsletter at: etsy.com/e-mails/success. And there are more tips and strategies on the Forums at: etsy.com/forums.

When you list your items on Etsy you are allowed 13 tags. Use them all. But make sure each tag is different. Let's say I was listing a seascape painting I did in watercolor. Here are some tags I might use:

- Josh Kruger artwork
- Millionaire Prisoner watercolor
- Watercolor painting
- Prisoner artwork
- Prisoner watercolor
- Incarcerated painter
- Prisoner painting
- Seascape watercolor
- Seascape painting
- Sunset Seascape
- Prisoner sunset painting
- Lifer seascape
- Sunset painting

You can come up with variations for each product. Some prisoners will want to hide the fact that they are in prison. I wouldn't do that. I learned from Chris Zoukis that it's better to show the world that prison doesn't stop you. That way more people will be willing to help your cause. For you, that means getting the word out about your arts and crafts so you can make money. That's how you become a Prison Picasso!

EBAY

Most of you know what eBay is famous for. It's an auction site where you can get great deals. But you can also sell arts and crafts on eBay as well. Anyone can sell on eBay. There are two ways to sell on eBay. One is eBay Art (ebay.com/sch/Direct-from-the-Artist). You can also sell crafts on

eBay as well. See ebay.com/chp/crafts. You can sell by auction or at fixed prices. There's a small fee to list an item and eBay takes a commission off each sale. Some artists have used eBay to become successful.

In *New Market for Artists*, Brainard Carey tells the story of two artists who used eBay to make a full-time living. Painter Abbey Ryan started with one, small, square canvas a day. Every day she painted the same size painting. Then she would post them on eBay and let people bid on them. The first year she did this her paintings were going for under $100 each. Some didn't even sell. But she still painted every day. After a year, her pieces started going up. Three years after she started, her paintings

were going for $800 - $1,000. She now makes over $200,000 a year just off those small paintings. That's the power of eBay. You can hear Brainard Carey's interview with Abbey Ryan on his website at yourartmentor.com.

The other person who used eBay was graffiti artist TMNK (The Me Nobody Knows). He started out selling his art on the street. Then he started selling on eBay. He posted art pieces on their regularly and sent out e-mails to everyone he knew telling them about what he was doing. Now he gets offers for shows, which he sells out. TMNK went from working as a graphic designer to doing graffiti art to driving luxury cars and living in a half-million-dollar home, with an assistant and his studio. All because of eBay.

What can you learn from these two examples? One is to be consistent. Abbey Ryan painted every day. The other thing you can learn is to brand your art. Ryan painted the same type of art, the same size. TMNK did graffiti art. Lastly, they both promoted each time they put out something new. Ryan sent links to blogs and news outlets and e-mails. TMNK used e-mails also. No matter what website you use it still pays to promote your work.

Tophatter.com is another auction site. Jewelry is the most popular product on Tophatter. So, if you make jewelry you may want to try Tophatter.

RESOURCE BOX

If you have a GTL tablet you can listen to a bunch of audio books about making money on eBay. Check out:

- *How To Make Money on eBay*

ART FIRE

Another site that specializes in selling handmade items is Art Fire (artfire.com). Artfire has no listing fees or sales commissions. You just pay a flat fee. The last time I checked it was $12.95 a month for a ProSeller account. a lot of crafters like ArtFire because it has a built-in feature that allows you to customize your page. Some of them are as follows:

- ArtFire Theme allows you to create your theme.
- ArtFire Blog allows you to post news.
- ArtFire Gallery allows you to post photos.
- ArtFire Merchandise allows you to control how your products are displayed.
- ArtFire Global Product Editor: allows you to modify items.

For more about setting up your profiles send your questions to service@artfire.com. If you choose ArtFire, make sure you use the Kiosk widget for your Facebook pages!

ADDITIONAL WEBSITES TO SELL ON

My advice would be to set up your website, and social media pages, and pick one of the big three (Etsy, eBay, or ArtFire) to sell from. But you may find other sites are better for your type of art or products? Here are some more places you could sell your products on:

Artful Home (artfulome.com)
[Sells handmade items]
artists@artfulhom.com

Artulis (artulis.com)
[For artists and crafters]
help@artulis.com

Bonanza (bonanza.com)
[For arts & crafts, setup is free!]
support@bonanza.com

Coriander (coriander.com)
[Sells handmade items]
support@coriander.com

Craft Is Art (craftisart.com)
[Sells handmade items, set up costs are free. Also has a premium option for $79.99 a year.]

Dawanda (en.dawanda.com)
[Sells handmade items. Setup costs are free on this international site available in 7 different languages.]

GLC Craft Mall (glccraftmall.com)
[Sells handmade items]
info@glcmall.com

Goodsmiths (goodsmiths.com)
[Sells handmade items]

Handmade Artists' Shop (handmadeartists.com)
[Sells handmade items. Costs are subscription-based at $5 a month or $50 a year.]

Handmade Catalog (handmadecatalog.com)
[Sells handmade items. Have a weekly e-newsletter.]

ICRAFT (icraftgifts.com)
[Sells handmade items. Set up costs are $25 plus a monthly fee.]

I MADE IT! MARKETPLACE (imadeitmarket.com)
[Sells handmade items. Has no setup costs.]

MADE IT MYSELF (madeitmyself.com)
[Sells only handmade items. No vintage or mass-produced products. Set up costs include a 3% fee for every item sold.]

MISI (misi.com.uk)
[Sells handmade items. No set up costs but has a 3% fee for each item sold.]

RedBubble (redbubble.com)
[Free marketplace to sell high-quality items on.]

Shop Handmade (shophandmade.com)
[Sells handmade items. Has no setup costs.]
service@shophandmade.com

Storenvy (storenvy.com)
[Sells handmade items. Has no setup costs.]

Supermarket (supermarkethp.com)
[For more information e-mail thisisawesome@supermarkethq.com]

Yessy (yess.com)
[Focuses on fine art.]

Zibbet (zibbet.com)
[Sells handmade goods and fine art. Has a free option.]

ADDITIONAL TIPS FOR SUCCESS

No matter what website you use to start selling your art or craft items, there are little tactics that you can use to get better results. One of those is to always make sure you use "OOAK" if your product is "One of a Kind." Think about that. If your product is an original with no copies, it's more unique and could bring in more money. So always put "OOAK" on your product listings when you can. Here are some more tips:

- If you're doing craft items, try to brand them. You do that by having a consistent design, with the same name across all websites and social media profiles. Try to use professional images on your pages, packaging, and anstationeryry. Remember, a consistent look across everything you put out.

- Differentiate your product line by being unique in logos, colors, themes, and typefaces.

- Pick a name that is easy to remember and easy to pronounce. Write it without spaces to see how it will work as an e-mail address and domain name.

- Think about an avatar image/symbol. Picture the Nike swoosh, Amazon smiley face, and or Twitter's bird. Can you come up with something like that?

- Write great listings and "tags" i.e., the words that people use to search. You add them to your online images. Always test them out, even if you have to ask family or friends for help.

- Make sure you always list size specifications and tell how the product can be used.

- Try to tell a story with your product photos, as well as write out the story behind each product you made.

- Change your listings and all tags up to match the seasons and highlight holidays, i.e., Easter, Mother's Day, Christmas, etc.

- Your online banner is like your store sign. It should have your avatar, slogan, and brand name. But don't overcrowd it, you want a clean, professional look.

Most of you will not be able to go to art fairs or craft shows. So, you must sell online. Start with one site and master that site. As you start selling products, you'll need to keep track of inventory. Here are three programs you could use:

- Craftybase (craftbase.com) is great for crafters.

- Bizelo (eretail.bizelo.com) is designed for online sellers with a focus on Etsy.

- Run Inventory (runinv.com) is simple and free!

I hope by now that you're starting to see the possibilities that exist are unlimited. You don't have to settle for just commissary items for your arts and crafts. You can move on to bigger and better things. There are plenty of websites that can help you do it. Pick one of the ones in this chapter and get to work. You won't be disappointed.

CHAPTER 15

PUBLIC RELATIONS FOR PRISON PICASSOS

*"Painting is not done to decorate apartments. It is an instrument of war
for attack and defense against the enemy."*
– Georges Braque

It's not enough to produce art and crafts. You also must promote your work. I have a friend who does great paintings. The problem is that all his work is sitting at his mother's house. No one knows about it. He'll never become a Prison Picasso that way. Promoting your work to the masses may be the hardest thing for you to do? When I first started writing that's all I wanted to do. But I quickly learned that if I wanted to eat off my writing, I had to get the word out. I had to write letters, place ads, guest write articles, and hype the Millionaire Prisoner brand. That's what you have to do with your arts/crafts. If you want to stay where you're at selling your art for commissary items over the gallery, then skip this chapter. But if you want to go to another level pay attention to the tips in this chapter.

PROMOTIONAL SAMPLES

A lot of artists use promotional samples sent through the mail to new markets and possible collectors. First impressions are worth a thousand words so make sure you put your best foot forward. Make your samples thoughtful and original. You can use postcards, tear sheets, photographs, and e-mail submissions. You should have your website set up with your full portfolio online before you start this process. That way if someone sees something they like they can go check out more of your work. A lot of the listings throughout this book have specifics that you should follow when submitting your work. Do so. Just remember that it's your opportunity to stand out from the crowd. Some prisons sell postcards on the commissary. If so, you should utilize them to get your work done in front of others. If you have someone to help you in the free world here's an idea. Design your postcards and seasonal/holiday greeting cards. Then upload them to the USPS.gov website. There's a special section on the USPS site "Create Greeting Cards & Postcards!" in the Shipping & Mailing section. You can also create cards print-on-demand on Invitation Box (invitationbox.com). Try to think of creative ways to promote your work.

PROMOTIONAL RULE #1

Never send an original piece. Try to send only copies of your work. You will not be present when the reviewer is looking at your work. Art can get lost, stolen, and/or damaged. Only show an original piece if you are there with it. This rule applies to promotional material and not to actual exhibitions or gallery shows of your work. Even then you'll need a contract detailing the insurance and who covers what in case the piece is lost, stolen, and/or damaged.

SOCIAL MEDIA MARKETING

One of the first things a Prison Picasso should do is set up pages on Facebook, Instagram, and Twitter if they haven't already? For one, they are free. Two, these platforms have built-in tools that you can use to promote your craft. There are groups on Facebook already available for the prisoner artist or crafter. Join those groups. Post in those groups. Build your contact and friends list. Remember to follow the tips in the chapter on photos when you post on your social media pages. Because you're a prisoner artist you get to have fun with your posts. You can break some rules. Why? Because as an artist people already expect you to think outside the box. Couple that with the fact that you're in prison and you're a natural rule breaker. Play this up. Don't lie, cheat, or steal. But by all means, don't hide the fact that you're in prison. And don't change your style to suit someone else. Be you. Be original. That's how you will develop a following.

"As an artist, you can do whatever you want. People assume that artists have ideas and motives that they may not understand and give you what has come known as an 'artistic license.'"
– Brainard Carey

How did Lady Gaga become the #1 celebrity in America in 2011? By using social media regularly to attract her fans, called "Little Monsters." How did Barack Obama get more money for his campaign fund that he used to defeat Hillary Clinton and other top democrats? By using social media. Obama used that power to catapult him to the presidency. Why aren't you using social media to get the word out about your arts and crafts?

I could write a whole book about social media marketing. But thankfully I don't have to because there are already some great ones out there that I highly recommend you get and study. They are as follows:

- *Ultimate Guide to Facebook Advertising, 4th Edition* by Perry Marshall, Bob Regnerus, Thomas Meloche, with Mark Ingles
- *Ultimate Guide to Social Media Marketing* by Eric Butow, Mike Allton, Jenn Herman, Stephanie Liu, and Amanda Robinson
- *No B.S. Social Media Marketing* by Dan S. Kennedy & Kim Walsh-Phillips
- *Facebook Marketing: An Hour a Day* by Mari Smith

Start small and implement one thing at a time. If you're working with a family member, friend, or personal assistant, have them do the first assignment first before you give them another task to do. That way they don't get swamped and not do anything at all. Sometimes as prisoners we forget about all of the responsibilities people have in the free world. Be grateful that someone is willing to help you.

PRISON PICASSO SUCCESS STRATEGY

If I was going to start an art career this is what I'd do. I'd set up a simple one-to-three-page website. It would be a clean, neat, organized site. It would have my digital portfolio and my artist statement. Then it would direct the user to my Facebook page. I would do most of my promotions on Facebook. Here's what Brainard Carey says about an artist joining Facebook: "The reason you are getting involved in Facebook at all is the same as the reason for building your website: You want to get your art 'out there,' you want to connect with as many people who are interested in your art as possible, you want more possibilities. In short, you want new things to happen for you and your art."

Because of my previous success utilizing Facebook, I'm partial to the platform. But rightfully so. Facebook already has built-in programs that allow you to target individuals who will be interested in your art (or crafts). For instance, the Facebook Group "Prison Art and Hobby Craft" had over 47,000 members last time I had my assistant check. A friend of mine told me that have more now. Does your prison have 40,000+ people interested in arts and crafts? No, it doesn't. Where else can you find a group that large all in one place? That's the power behind Facebook. But that's only the beginning. Once you notice the common characteristics of your buyers and collectors you can put those stats on Facebook and find other people who meet those same characteristics. No longer do you have to sit around your cell and hope for the best. There's another way to get people to come look at your online pages.

GOOGLE ADWORDS

If you would have Googled "contemporary artist" in 2012, the first ad that came up on the right hand of the screen was for artist Thomas McKnight. Who is Thomas McKnight you may be wondering? He's an artist who has had art commissioned by the White House and has pieces in permanent collections at the Metropolitan Museum of Art and the Smithsonian. How did he get his ad to show up first? By using Google AdWords.

You could do the same. Once you have your website set up and your art is ready to sell you could use AdWords to drive people interested in prison art to your website or Facebook pages. Google AdWords is too much to go into in this book. But I recommend you get a copy of the following book and study it. It may change your life:

- *Ultimate Guide to Google AdWords*, 6th Edition by Perry Marshall, Beyan Todd & Mark Rhodes

"Until every single person on Earth who searches Google finds the things that are looking to buy, there's room for you."
– Perry Marshall

THE BRASS CHECK

If you've never had the opportunity to read Ryan Holiday's books you're missing out. He's a marketing expert and had the opportunity to apprentice with Robert Greene of *48 Laws of Power* fame. I especially love Holiday's books *Trust Me; I'm Lying* and *Perennial Seller*. Here are two ideas I've borrowed from him and altered for us prisoners:

- Newsjack your way into conversations online. What's trending? Write an article or blog post slanted at what all the news media is talking about. But in a way that puts the story back on you. Currently, as I write this, the protests and riots over racial inequality and George Floyd's death at the hands of the police are all over every news outlet. A prisoner could write about the racial inequality problems in prisons as it's a powder keg waiting to explode. For more about how to do this type of marketing, read Newsjacking by David Meerman Scott.

- An artist or crafter, or any prisoner who has something to sell, could do something like this next tactic to get some publicity. Put up a small billboard ad on the main road coming into your hometown. It could say something like this: "Thank you --- County, you sent me away to rot away in prison. Look at me now!" On, if you have your photo and website or Facebook address. On the day it goes up, you have someone take a photo of it and send it to all the local newspapers, radio, and tv stations. With the photo, you say, "I find it outrageous that a convicted murderer (or whatever you are) can put up an outlandish, offensive, billboard in this count." Ryan Holiday says to make it come from "a concerned citizen" and that it made their daughter cry. LBVS. Brilliant. Once the newspaper or tv station runs with it you post that clip or article everywhere. Stunt marketing 101. Just remember that you're not trying to sell products from the billboard, just to get the publicity that you use to get more publicity. To get your name out there. Or back out there. Fame is in the name!

PUBLICITY DO'S AND DON'TS

In his book, *How to Make Millions with Your Ideas: An Entrepreneur's Guide*, marketing master Dan S. Kennedy says these are "The 5 Ps of Publicity":

1. Be Predictive
2. Be Provocative.
3. Be Public (mainstream)
4. Be a Personality.
5. Be Persistent.

Pam Lontos is a publicity expert and author of *Don't Tell Me It's Impossible Until After I've Already Done It*. She's also co-author of *I See Your Name Everywhere*. She says that most people don't know how to get publicity and that there are 15 common mistakes that they make. They are:

1. They think that hundreds of customers will walk through their door from one hit.

2. They are not unique in their approach.

3. They think they can't get into a large publication.

4. They think small publications don't matter.

5. They think their ideas are wonderful.

6. They pitch themselves instead of a story idea.

7. They pitch to the wrong person.

8. They don't find out what reporters, producers, and editors want.

9. They don't answer the reporter's questions. they don't get straight to the point.

10. They don't respect the reporter's time.

11. They don't gear their pitches to a specific publication.

12. They make their pitch an advertisement for their products or services.

13. They do not provide their publicist with material and information promptly.

14. They don't understand the importance of the frequency of publicity.

For a free publicity consultation by e-mail with Pam send her one at Pam@prpr.net. Her free newsletter PR/AR Pulse! is also available on PRPR.net.

Another great site is Paul J. Krupin's directcontactpr.com. He's the author of *Trash-Proof News Releases*, and his website is a huge resource of all things PR-related.

HELP A REPORTER OUT (HARO)

Help A Reporter (helpareporter.com) is a public relations firm that connects media people with sources. When you sign up for it you will get e-mails daily featuring interview requests from reporters, producers, and bloggers. When you see one that fits your expertise in prison, art (or crafts), or something else, you could respond, If the reporter uses you as a source, you will get listed as such: free publicity. Be sure to follow the instructions that the reporter has for responding. Most people can't follow instructions. So, if you can, you will stand out.

Another place to find media presence is on Twitter by using muckrack.com. As you start getting some income from your art/crafts you could sign up for peotnet.com. Unlike HARD, it's not free. But a lot of professionals say it works. Two more that are free are Reporter Connection (reporterconnection.com) and Radio Guestlist (radioguestlist.com). I can't imagine that if Pablo Picasso were alive today, he wouldn't be taking advantage of all the online sources and apps to get publicity. Of course, he would probably have a team of assistants helping to keep his name in front of the press. But just because you only got your mom or your girlfriend to help, you should not stop you from getting your name and work out there.

PRESS RELEASES

You can create a press release linking yourself and your art to timely events in the news. You can send them via e-mail to national media outlets with just the push of a button or click of the computer

mouse. The same press release you send out can be posted on your Facebook page as news. There will be an archive in your newsfeed.

Most guys in prison that I know who artists are don't realize how many times they have available to then contact the media. Off the top of my head, here are 20 reasons why an artist-crafter in prison could send out a press release and post it online on their social media pages:

1. Comment on Prison Industry or Reform moves
2. An award or contest they won
3. Release of a new painting, sculpture, etc.
4. Announce a new exhibition or show
5. Perfection of a crazy, off the wall, and/or controversial artwork or craft item
6. Comment on a relevant news story
7. Donation of artwork to a charity auction
8. Fundraiser they are participating in
9. Free sample giveaways
10. Free video demonstration
11. Anniversary of a special occasion
12. Predictions like a modern-day Nostradamus
13. A joint venture with another company/artist
14. Selling a piece to a celebrity
15. Grant received or one they're giving
16. Any media coverage received
17. Start of a new business or expansion of an existing one
18. Taking a position on a political issue
19. Putting out a book
20. The artist is transferred, released, or sent to segregation for art-related business

Look at the above list and think about how you could tailor them to your circumstances. After you have your website and Facebook pages set up you could start taking advantage of these tips.

Kari Chapin in *The Handmade Marketplace* says that press releases "are really of use only if you need to reach a broad national or international audience and you have no personal connection to the media outlet you are approaching." Brigitte Lyons is a media strategist and does public relations for creative entrepreneurs at bthinkforward.com. She says: "the best way to communicate with the media is to send a short e-mail (no more than three paragraphs), explaining how your product or expertise is a match for their audience."

There are PR people who specialize in getting publicity for artists. The Public Relations Society of America has an online searchable database known as the "Red Book" which is divided by fields of expertise. You can also get information on publicists by phone. Here's their information:

The Public Relations Society of America
33 Irving Place
New York, NY 10003-2376
(212) 995 – 2230
prsa.org

One word of caution: in *Selling Art Without Galleries*, Daniel Grant says that if you do not have a collector base, no sales history, and no gallery presence, then do not hire an art publicist. I agree with him, especially for prisoners. You can have a friend or family member do your press releases and e-mails. You should already be collecting the contact information of possible reliable patrons. Every time you release a new piece or do something noteworthy (get an award, have an exhibition, make a sale, etc.) it should be posted online and sent to your contact list. You don't have to pay a publicist thousands of dollars to get this done.

RESOURCE BOX

For more about getting publicity for your art, you may want to check out the following:

- *Fine Art Publicity Guide, 2nd Edition* by Susan Abbott
- *New Rules for Marketing and P&R* by David Meerman Scott

All these books can be found online. Contact Freebird Publishers about ordering them if you don't have someone to help you.

If you have a GTL tablet, you can listen to the following audio books that could give you some tips about promoting your work:

- *How to Increase Your Ability to Earn Through Self-Promoting*
- *Mega Nasty Sales* by Paul Taylor
- *Mega Nasty Rich* by Paul Taylor

" I havent worried about the price of gas for 18 years. "

"Great things are done by a series of small things brought together."
– Vincent van Gogh

To achieve greatness, one must remember to think positive, filter out the negativity around them, and, no matter what, stay focused on the big picture. Everyone who's ever become someone who has had to train themselves to think this way. It's not something that you're born with; it's something that you consistently choose to work on.

CHAPTER 16

ART FAIRS AND JURIED SHOWS

"Art fairs have surpassed auctions as the premier events for buyers in the market's upper tiers."
– Souren Melikian

When I was a kid, I had a friend named Danny Duckworth. That was my homie. We lived on the same block. He was mixed and lived next door to his white grandparents. His grandfather used to make ceramic craft items and set them up on busy street corners to sell them. He also would set up his mobile store at small festivals. I don't know how well he did, but it must have been good because he did it year after year. In my hometown of Danville, Illinois, they had a few of these little festivals. They had "Arts in the Park" in Lincoln Park. They had the "Little Vermillion Fall Festival" in Ellsworth Park. They had the "May Fest" in Douglas Park. At all these little fairs were booths set up to sell arts and crafts. I'm sure you've seen them yourself when you were in the free world. There are thousands of art fairs, arts and crafts festivals, and juried art competitions each year. You just have to find them. This chapter will help you.

Disclaimer: As I write this, the COVID-19 Pandemic is raging across the world. I do not know how it will affect these fairs and festivals. They could never return, or they could be back to running smoothly once all of this is over with. Always have someone check the website listing for the fair/festival first before writing. If not, it's at your own risk.

Sunshine Artist (sunshineartist.com) lists upcoming shows and competitions each month. You can get it for $25 for 12 months from discount magazine provider Alice S. Grant. *Sunshine Artist* also puts out an *Audit Book,* which lists over 5,000 art shows. Those shows pay to have their information listed in the *Audit Book.* A lot of shows don't do this or can't afford to do that.

artandcraftshows.net lists over 2,000 shows, but there is a fee for accessing that information. artdeadlineslist.com is free but more limited.

The *Art & Craft Show Yellow Pages* cover Connecticut, Delaware, Maryland, Maine, Massachusetts, New Jersey, New York, Pennsylvania, Virginia, and Vermont. It's $37 a year. You can order it from:

<div align="center">

Art & Craft Show Yellow Pages
P.O. Box 13
Red Hook, NJ 12571
(888) 918 – 1313
craftshowyellowpages.com

</div>

The *Midwest/USA Arts & Crafts Events Guide* covers Indiana, Illinois, Kentucky, Michigan, Ohio, Tennessee, Wisconsin, Florida, and Georgia. It costs $30 a year. You can get it from:

<div align="center">

Midwest/USA Arts & Crafts Events Guide
4251 Hamilton Avenue
Cincinnati, OH 45223
(800) 825 – 4332
midwestartscraftsguide.com

</div>

The *Craft & Art Show Calendar* covers the Mid-Atlantic states. It costs $16 per year. You can get it from:

The Craft & Art Show Calendar
P.O. Box 424
Devault, PA 19432
(610) 640 – 2787
hometown.aol.com/rbfinkel/myhomepage/index.html

The *Crafts Fair Guide* is an annotated listing of shows in California. It costs $45 a year. You can get it from:

The Crafts Fair Guide
P.O. Box 688
Corte Madera, CA 94976
(800) 871 – 2341
craftsfairguide.com

The *Art Fair Source Book* has a 2-volume listing of shows nationwide or four regional editions for $97 ($197 for the 2-volume set). You can get it from:

The Art Fair Source Book
2003 N.E. 11th Avenue
Portland, OR 97212-4027
(800) 358 – 2045
artfairsourcebook.com

In his great book, *Selling Art Without Galleries,* Daniel Grant does a good job of asking artists and crafters to consider a lot of questions before entering any art show, competition, or festival. Here are some of those questions:

- Who is responsible for lost, damaged, or stolen art?

- How do they want you to ship your artwork?

- Who pays for shipping and insurance?

- What prizes and categories are offered?

- Will the sponsor take commissions on sales of your art?

- Does everything have to be in a certain price range?

- Does everything have to be up for sale?

- Is the event outdoors? If so, what provisions have been made in the event of rain?

- What type of marketing (to potential visitors and collectors) is planned to ensure strong attendance?

- What type of promotions are planned to ensure that the show gets media coverage?

- If this is the first year of a show, what experience do the sponsors have in staging an art event?

- If there have been prior showings in previous years, whereas the overall attendance and gross sales? And is that information documented?

- Who are the judges or jurors of the competition?

- Do submissions have to be original or can reprints be used?

- If it is both an arts and crafts show, are the crafts one-of-a-kind? Are they production pieces? Are they non-utilitarian? Are they useful? Or are they high-end?

To find out some of the answers to these questions, you should send off a prospectus. You can do it by e-mail if you know the show's sponsor's e-mail address. You should send for this prospectus *before* you send in any artwork or money for entry fees. The prospectus should tell you the following:

- What the show is?

- Where and when it will take place?

- How many artists are to be selected?

- What types of art will be featured?

- The names of jurors selecting the winners.

- How many entries can the artist submit?

As a prisoner, you want to find shows that you can enter by mail. If not by mail, then you'll have to wait till you get out to take advantage of these shows. Unless you got family or friends on the outside who would be willing to go to these shows on your behalf? If you do not have someone like that in your network, and you can't enter by using the mail, then you probably can't take advantage of this avenue?

With the above being said, there are two major art fairs in the United States. They are the Armory Show and the Basel Art Fair. There are smaller ones like Scope and Pool. Sometimes you won't be able to get into these fairs. That doesn't mean anything. Graffiti artist TMNK rented space by the Basel Art Fair in Miami Beach and set up his little art fair. You could do the same thing. Have a family member or friend set up a little art fair of your work on your behalf. To set up an art fair they would need the following:

- Protective wraps or bags to protect your work while customers look through your inventory.

- A canopy or tent to prevent your arts and crafts from the elements.

- Some bins or crates to store your prints in.

- Lastly, you need a display wall where you can show off your best pieces. Typically, these prints are framed so customers can see how your work looks framed.

Another good source to find out about art fairs is *Professional Artist.* (professionalartistmag.com).

There are some unwritten rules (and some written) that deal with what you're supposed to do and what you're not supposed to do at art shows. These mainly pertain to juried art shows, but always keep them in mind:

- If you sell a piece that was entered into the art show, you're not supposed to enter another piece after it.

- The same piece should not be submitted to two different contests or shows at the same time.

- Do not use mediums that aren't part of the show. For instance, if the show is a "watercolor only" one, don't use acrylic on your pieces.

- Don't lie about your credentials. Let your art and crafts speak for themselves.

- Don't undersell your dealers. If they offer discounts make sure they take it out of their commissions, not yours.

- Read the prospectus very carefully, if you don't like the rules or guidelines, don't enter.

"Art is a lie that makes us realize the truth.:
– Pablo Picasso

Because most of us can't traipse down to the local arts and craft show, I've included some of the many shows across the U. S. Find the one closest to your family or friends and have them go check it out or review the guidelines about entering online. Get the prospectus so you can see what is allowed or not, and how much it would be for space at the fair, or to enter the show? Start small and work your way up to bigger shows and fairs. Also, never try to exhibit arts and crafts like yours if you didn't make it. It's ok to do that if you tell people visiting your booth that you didn't paint it. Like a family member putting on a show exhibiting a bunch of different prisoner's work. That would be fine if each prisoner had credit lines on the pieces themselves. Here are some of the major (and minor) art fairs and shows across the U.S.

ART FAIRS AND SHOWS

4 Bridges Arts Festival
30 Frazier Ave., Ste. A
Chattanooga, TN 37405
(423) 265 – 4282, ext. 3
4bridgesartfestival.org

57th Street Art Fair
1507 E. 53rd St., PMB 296
Chicago, IL 60615
(773) 234 – 3247
57thstreetartfair.org

Akron Arts Expo
220 Balch St.
Akron, OH 44302
(330) 375 – 2836
akronartsexpo.org
E-mail: PBumba@akronohio.gov

Allen Park Arts & Crafts Street Fair
City of Allen Park
P.O. Box 70
Allen Park, MI 48101
(734) 258 – 7720
allenparkstreetfair.org

Allentown Art Festival
P.O. Box 1566
Buffalo, NY 14205
(716) 81 – 4269
allentownartfestival.com
Contact: Mary Myszkiewicz
(send SASE for more info)

American Artisan Festival
P.O. Box 41743
Nashville, TN 37204
(615) 429 – 7708
facebook.com/theamericanartisanfestival
E-mail: americanartisanfestival@gmail.com

American Fine Craft Show NYC
P.O. Box 480
Slate Hill, NY 10973
(843) 355 – 2400
americanartmarketing.com
E-mail:
show.director@americanartmarketing.com

American Folk-Art Festival
(707) 246 – 2460
americanfolkartfestival.com
E-mail: gavitee@aol.com

Anacortes Arts Festival
505 O Ave.
Anacortes, WA 98221
(360) 293 – 6211
anacortesartsfestival.com
E-mail: staff@anacortesartsfestival.com

Ann Arbor Summer Art Fair
118 N. Fourth Ave.
Ann Arbor, MI 48104
(734) 662 – 3382
theguild.org
E-mail: info@theguild.org

The Anna Maria Island Arts & Crafts Festival
5312 Holmes Blvd
Holmes Beach, FL 34217
(561) 746 – 6615
artfestival.com
E-mail: info@artfestival.com

Apple Annie Crafts & Arts Show
4905 Rosweld Rd.
Marietta, GA 30062
(770) 552 – 6400, ext. 6110
st-ann.org/womens-guild/apple-annie
E-mail: sagw4905@gmail.com

Arlington Festival of the Arts
270 Central Blvd, Ste. 1078
Jupiter, FL 33458
(561) 746 – 6615
artfestival.com
E-mail: info@artfestival.com

Art & Apples Festival
Paint Creek Center for the Arts
407 Pine St.
Rochester, MI 48307
(248) 651 – 4110
pccart.org

Art-A-Fair
P.O. Box 547
Laguna Beach, CA 92652
(949) 494 – 4514
art-a-fair.com
E-mail: marketing@art-a-fair.com

Art Birmingham
118 N. Fourth Ave.
Ann Arbor, MI 48104
(734) 662 – 3382
theguild.org
E-mail: info@theguild.org

Art Fair at Queeny Park
1668 Rishon Hill Dr.
St. Louis, MD 63146
(636)724 – 5928
artfairatqueenypark.com

Art Fair Jackson Hole
Art Association of Jackson Hole
P.O. Box 1248
Jackson, WY 83001
jhartfair.org
E-mail: artistinfo@jhartfair.org

Art Fair Off the Square
P.O. Box 1791
Madison, WI 53701 – 1791
(262) 537 – 4610
artcraftwis.org/AFOS.html
E-mail: Wiartcraft@gmail.com

Art Fair on the Courthouse Lawn
P.O. Box 795
Rhinelander, WI 54501
(715) 365 – 7464
explorerhinelander.com
E-mail: assistant@rhinelanderchamber.com

Art Fair on the Square
Madison Museum of Contemporary Art
227 State St.
Madison, WI 53703
(608) 257 – 0158, ext. 229
mmoca.org/events

ArtFest By the Sea
270 Central Blvd., Ste. 107B
Jupiter, FL 33458
(561) 746 – 6615
artfestival.com
E-mail: info@artfestival.com

Artfest Fort Myers
1375 Jackson St., Ste. 401
Fort Myers, FL 33901
(239) 768 – 3602
artfestfortmyers.com
E-mail: info@artfestfortmyers.com

Art Festival Beth EL
400 Pasadena Ave. S
St. Petersburg, FL 33707
(727) 347 – 6136
artfestivalbethel.com
E-mail: annsoble@gmail.com

Art Festival of Henderson
P.O. Box 95050
Henderson, NV 89009- 5050
(702) 267 – 2171
E-mail: info@artfestival.com

Artfest Midwest
Stookey Companies
P.O. Box 31083
Des Moines, IA 50310
(515) 278-6200
artfestmidwest.com
E-mail: suestookey@att.net

Artigras Fine Arts Festival
5520 PGA Blvd, Ste. 200
Palm Beach Gardens, FL 33418
(561) 746 – 7111
artigras.org
E-mail: info@artigras.org

Art In Bloom – Cantigny Park
(630) 668 – 5161
Cantigny.org/calendar
E-mail: info@cantigny.org

Art In the Barn – Barrington
Art in the Barn Artist Committee
450 W Highway 22
Barrington, IL 60010
(847) 842 – 4496
artinthebarn-barrington.com

Art in the Park (Arizona)
P.O. Box 748
Sierra Vista, AZ 85636 – 0247
(520) 803 – 0584
artintheparksierravista.com
(Send SASE for more info.)

Art in the Park (Georgia)
P.O. Box 1540
Thomasville, GA 31799
(229) 227 – 7020
downtownthomasville.com
E-mail: karens@thomasville.com

Art in the Park (Virginia)
20 S New St.
Staunton, VA 24401
(540) 885 – 2028
saartcenter.org
E-mail: director@saartcenter.org

Art in the Park – Fine Art Festival
Swartz Creek Kiwanis
5023 Holland Dr.
Swartz Creek, MI 48473
(810) 282 – 7641
swartzcreekkiwanis.org/art

Art in the Park Fall Foliage Festival
Rutland area Art Association
P.O. Box 1447
Rutland, VT 05701
(802) 775 – 0356
chaffeeartcenter.org
E-mail: info@chaffeeartcenter.org

Art in the Park (Holland, Michigan)
Holland Friends of Art
P.O. Box 1052
Holland, MI 49422
hollandfriendsofart.com
E-mail: info@hollandfriendsofart.com

Art in the Park (Kearney)
Kearney Artist Guild
P.O. Box 1368
Kearney, NE 68848 – 1368
(308) 708 – 0510
kearneyartistsguild.com

Art in the Park (Plymouth)
P.O. Box 70240
Plymouth, MI 48170
(734) 454 – 1314
artinthepark.com
E-mail: info@artinthepark.com

Artisphere
101B Augusta St.
Greenville, SC 29601
(864) 412 – 1040
artisphere.org
E-mail: polly@artisphere.org

Art on the Lawn
Village Artisans
100 Corry St.
Yellow Springs, OH 45387
(937) 767 – 1209
villageartisans.blogspot.com
(Send SASE for more info)

Art on the Mall
The University of Toledo
Office of Alumni Relations
2801 W. Bancroft St., Mail Stop 301
Toledo, OH 43606 – 3390
(419) 530 – 2586
toledoalumni.org

Art on the Square
P.O. Box 23561
Belleville, IL 62223
(618) 233 – 6769
artonthesquare.com
clindauer@bellevillechamber.org

Art Rapids!
P.O. Box 301
Elk Rapids, MI 49629
(231) 264 – 6660
artrapids.org
E-mail: art@vullalys128.com

An Arts & Crafts Affair
P.O. Box 655
Antioch, IL 60002
(402) 331 – 2889
hpifestivals.com
E-mail: hpifestivals@cox.net

Arts & Crafts Festival
Simsbury Woman's Club
P.O. Box 903
Simsbury, CT 06070
(860) 658 – 2684
simsburywomansclub.org

Arts, Beats & Eats
301 W. Fourth St., Ste. LL – 150
Royal Oak, MI 48067
(734) 552 – 7535
artsbeatseats.com
E-mail: shannon@artsbeatseats.com

Art's Alive
200 125th St.
Ocean City, MO 21842
(410) 250 – 0125
Contact: Brenda Moore, event coordinator
(Send SASE for more info)

Artsfest
P.O. Box 99
13470 Dowell Rd.
Solomons, MO 20688
(410) 326 – 4640
annmariegarden.org

Arts in the Park
302 Second Ave. E
Kalispell, MT 59901
(406) 755 – 5268
hockadaymuseum.org
E-mail: information@hockadaymuseum.com

Arts on the Green
Arts Association of Oldham County
104 E. Main St.
LaGrange, KY 40031
(502) 222 – 3822
aaooc.org
E-mail: maryklausing@bellsouth.net

Artsplosure – The Raleigh Art Festival
313 W. Blount St., Ste 200B
Raleigh, NC 27601
(919) 832 – 8699
artsplosure.org
E-mail: info@artsplosure.org

Artsquest Fine Arts Festival
Bayou Arts Center
105 Hogtown Bayou Land
Santa Ros Beach, FL 32459
(850) 622 – 5970
artsquestflorida.com

Art Under the Elms
415 Main St.
Lewistown, ID 83501
(208) 792 – 2447
lcsc.edu/ce/aue
E-mail: aue@losc.edu

Artworks of Eau Galle Fine Arts
P.O. Box 361081
Melbourne, FL 32936 – 1081
(321) 242 – 1456
artworksofeaugallie.org
E-mail: artworksfestival@gmail.com

Bartlett Festival of the Arts
118 W Bartlett Ave., Ste. 2
(630) 372 – 4152
artsinbartlett.org
E-mail: art@artsinbartlett.org

Bayou City Art Festival
38 Charles St.
Rochester, NH 03867
(713) 521 – 0133
artcolonyassociation.org
E-mail: info@bayoucityartfestival.com

Beaver Creek Art Festival
270 Central Blvd., Ste. 107B
Jupiter, FL 33458
(561) 746 – 6615
artfestival.com
E-mail: info@artfestival.com

Best of the Northwest
Art & Fine Craft Show
Northwest Art Alliance
7777 62nd Ave. NE, Ste. 103
Seattle, WA 98115
(206) 525 – 5926
nwartalliance.com
E-mail: info@nwartalliance.com

Black Swamp Arts Festival
P.O. Box 532
Bowling Green, OH 43402
(877) 865 – 6082
blackswamparts.org
E-mail: info@blackswamparts.org

Boca Raton Fine Art Show
Hot Works
P.O. Box 1425
Sarasota, FL 34230
(248) 684 – 2613
hotworks.org
E-mail: patty@hotworks.org

Bonita Springs National Art Festival
P.O. Box 367465
Bonita Springs, FL 34136 – 7465
(239) 992 – 1213
artinusa.com/bonita
E-mail: artfest@artinusa.com

Boston Mills Artfest
(330) 467 – 2242
bmbw.com

Bruce Museum Outdoor Arts Festival
1 Museum Drive
Greenwich, CT 06830 – 7157
(203) 869 – 0376, ext. 336
brucemuseum.org

Buffalo River Elk Festival
Jasper, AR 72641
(870) 446 – 2455
theozarkmountains.com

By Hand Fine Art & Craft Fair
1 I-X Center Drive
Cleveland, OH 44135
(216) 265 – 2663
clevelandbyhand.com
E-mail: rattewell@ixcenter.com

Cain Park Arts Festival
City of Cleveland Heights
40 Severance Circle
Cleveland Heights, OH 44118 – 9988
(216) 291 – 3669
cainpark.com
E-mail: jhoffman@clvhts.com

Calabasas Fine Arts Festival
100 Civic Center Way
Calabasas, CA 91302
(818) 224 – 1657
calabasasartscouncil.com
E-mail: artscouncil@cityofcalabasas.com

Carefree Fine Art & Wine Festival
101 Easy St.
Carefree, AZ 85377
(480) 837 – 5637
thunderbirdartists.com
E-mail: info@thunderbirdartists.com

Carousel Fine Craft Show
OCA Renaissance Arts Center & Theatre
1200 E. Center St.
Kingsport, TN 37660
(423) 392 – 8414
engagekingsport.com
E-mail: stephanos@kingsporttn.gov

Cedarhurst Art & Craft Fair
P.O. Box 923
2600 Richview Rd.
Mt. Vernon, IL 62864
(618) 242 – 136, ext. 234
cedarhurst.org
E-mail: linda@cedarhurst.org

Centerfest: The Art Lovers Festival
Durham Arts Council
120 Morris St.
Durham, NC 27701
(919) 560 – 2722
centerfest.durhamarts.org
E-mail: centerfest@durhamarts.org

Centerville Americana Festival
P.O. Box 41794
Centerville, OH 45441 – 0794
(937) 433 – 5898
americanafestival@org
E-mail: americanafestival@sbcglobal.net

Chardon Square Arts Festival
Chardon Square Association
P.O. Box 1063
Chardon, OH 44024
(440) 285 – 4548
chardonsquareassociation.org
E-mail: sgipson@aol.com

Charlevoix Waterfront Art Fair
P.O. Box 57
Charlevoix, MI 49720
(231) 547 – 2675
charlevoixwaterfrontartfair.org
E-mail: cwaf14@gmail.com

Chastain Park Festival
4469 Stella Drive
Atlanta, GA 30327
(404) 873 – 1222
E-mail: info@affps.com

Chatsworth Cranberry Festival
P.O. Box 286
Chatsworth, NJ 08019
(609) 726 – 9237
cranfest.org
E-mail: lgiamalis@aol.com

Chun Capitol Hill People's Fair
1290 Williams St., Ste. 102
Denver, CO 80218
(303) 830 – 1651
peoplesfair.com
E-mail: andreafurness@chundenver.org

Church Street Art & Craft Show
Downtown Waynesville Association
P.O. box 1409
Waynesville, NC 28786
(828) 456 – 3517
downtownwaynesville.com
E-mail: info@downtownwaynesville.com

City of Fairfax Festival
10455 Armstrong St.
Fairfax, VA 22030
(703) 386 – 7800
fairfaxva.gov

City of Fairfax Holiday Craft Show
10455 Armstrong St.
Fairfax, VA 22030
(703) 385 – 1710
fairfaxva.gov

Coconut Grove Arts Festival
3390 Mary ST., Ste. 128
Coconut Grove, FL 33133
(305) 447 – 0401
coconutgrovveartsfest.com
E-mail: katrina@cgaf.com

Colorado Country Christmas Gift Show
Denver Mart
451 E. 58th Ave.
Denver, CO 80216
showcaseevents.org
(Send SASE for info)

Colorscape Chenango Arts Festival
P.O. Box 624
Norwich, NY 13815
(607) 316 – 3212
colorscape.org
E-mail: info@colorscape.org
(Send SASE for more info)

Columbiana Artist Market
104 Mild Red St.
P.O. Box 624
Columbiana, AL 35051
(205) 669 – 0044
shelbycountyartscouncil.com
E-mail: info@shelbycountyartscouncil.com

Conyers Cherry Blossom Festival
1996 Centennial Olympic Pkwy.
Conyers, GA 30013
(770) 860 – 4190
conyerscherryblossomfest.com

Cottonwood Art Festival
2100 E. Campbell Rd., Ste. 100
Richardson, TX 75081
(972) 744 – 4580
cottonwoodartfestival.com
E-mail: serrie.ayers@cor.gov

Craft Fair At The Bay
38 Charles St.
Rochester, NH 03867
(603) 332 – 2616
castleberryfairs.com
E-mail: info@castleberryfairs.com

Crafts At Purchase
P.O. Box 28
Woodstock, NY 12498
(845) 331 – 7900
artrider.com
E-mail: crafts@artrider.com

Craftswestport
P.O. Box 28
Woodstock, NY 12498
(845) 331 – 7900
artrider.com
E-mail: crafts@artrider.com

Custer Fair
Piccolo Theatre, Inc.
P.O. Box 6013
Evanston, IL 60204
(847) 328 – 2204
custerfair.com

A Day In Towne
Boalsburg Village Conservancy
230 W. Main St
Boalsburg, PA 16827
(814) 466 – 7813
boalsburgvillage.com
E-mail: mgjohn@comcast.net

Deerfield Fine Arts Festival
3417 R.F.O.
Long Grove, IL 60047
(847) 726 – 8669
dwevents.com
E-mail: dwevents@comcast.net

Delaware Arts Festival
P.O. Box 589
Delaware, OH 43015
delawareartsfestival.com
E-mail: info@delawareartsfestival.org

Dickens Christmas Show & Festival
2101 N. Oak St.
Myrtle Beach, SC 29577
(843) 448 – 9483
dickenschristmasshow.com
E-mail: dickensshow@sc.rr.com

Dollar Bank Three Rivers Arts Festival
803 Liberty Ave.
Pittsburgh, PA 15222
(412) 471 – 6070
trustarts.org/traf
E-mail: trafmarket@trustarts.org

Alden B. Dow Museum Art Fair
Midland Center for the Arts
1801 W. St. Andrew Rd.
Midland, MI 48640
mcfta.org
E-mail: mills@mcfta.org

El Dorado County Fair
100 Placerville Drive
Placerville, CA 95667
(530) 621 – 5860
elcoradocountyfair.org
E-mail: fair@eldoradocountyfair.org

Elmwood Avenue Festival of the Arts
P.O. Box 786
Buffalo, NY 14213 – 1786
(716) 830 – 2484
elmwooodartfest.org
E-mail: directoreafa@aol.com

Essex Fall Craft Show
Vermont Craft Workers, Inc.
P.O. Box 8139
Essex, VT 05451
(802) 879 – 6837
vtcrafts.com
E-mail: info@vtcrafts.com

Estero Fine Art Show
Hot Works, LLC
Miromar Outlets
10801 Corkscrew Rd.
Estero, FL. 33928
(941) 755 – 3088
hotworks.org

Faire on the Square
117 W. Goodwin St.
Prescott, AZ 86303
(928) 445 – 2000, est. 112
Prescott.org
scott@prescott.org

A Fair in the Park
6300 Fifth Ave.
Pittsburgh, PA 15232
afairinthepark.com
E-mail: fairdirector@craftsmenguild.org

Fall Crafts at Lyndhurst
P.O. Box 28
Woodstock, NY 1248
(845) 331 – 7900
artrider.com
E-mail: crafts@artrider.com

Fall Fest in The Park
117 W. Goodwin St.
Prescott, AZ 86303
(928) 445 – 2000
Prescott.com
E-mail: champer@prescott.org

Fall Festival of Art at Queeny Park
P.O. Box 31265
St. Louis, MO 63131
(314) 889 – 0433
artfairetqueenypark.com
E-mail: info@gslaa.org

Fall Festival on Ponce
Olmstead Park
1451 Ponce de Leon
Atlanta, GA 30307
(404) 873 – 1222
festivalonponce.com
E-mail: lisa@affps.com

Fall Fine Arts & Crafts at Brookdale Park
Rose Squared Productions, Inc.
473 Watchung Ave.
Bloomfield, NJ 07003
(908) 874 – 5247
rosesquared.com
E-mail: info@rosessquared.com

Festival Fete
P.O. Box 2552
Newport, RI 02840
(401) 207 – 9729
festivalfete.wordpress.com
E-mail: pilar@festivalfete.com

Fiesta Arts Fair
Southwest School of Art
300 Augusta St.,
San Antonio, TX 78205
(210) 224 – 1848
swschool.org/fiewstaartsfair.com

Fine Art Fair
Foster Arts Center
203 Harrison St.
Peoria, IL 61602
(309) 637 – 2787
peoriaartguild.org
fineartfair@peopriaartguild.org

Firefly Art Fair
Wauwatosa Historical Society
7406 Hillcrest Drive
Wauwatosa, WI 53213
(414) 774 – 8672
wauwatosahistoricalsociety.org

Fourth Avenue Street Fair
434 E. Ninth St.
Tucson, AZ 85705
(520) 624 – 5004
fourthavenue.org
(Send SASE for info)

Fourth Street Festival for the Arts & Crafts
P.O. Box 1257
Bloomington, IN 47402
(812) 575 – 0484
4thstreet.org
(Send SASE for info)

Frederick Festival of the Arts
11 W. Patrick St., Ste. 201
Frederick, MD 21701
(301) 662 – 4190
frederickartscouncil.org
E-mail: info@frederickartscouncil.org

Friends of the Kenosha Public
Museums Art Fair
5500 First Ave.
Kenosha, WI 53140
(262) 653 – 4140
kenosahpublicmusuem.org

Funky Ferndale Art Show
Integrity Shows
P.O. Box 1070
Ann Arbor, MI 48106
funkyferndaleartfair.com
E-mail: info@integrityshows.com

Garrison Art Center's Fine Crafts Fair
23 Garrison's Landing
P.O. Box 4
Garrison, NY 10524
(845) 424 – 3960
garrisonartcenter.org
E-mail: info@garrisonartcenter.org

Gasparilla Festival of the Arts
P.O. Box 10591
Tampa, FL 33679
(813) 876 – 1747
Gasparilla-arts.com
E-mail: info@gasparillaarts.com

Gathering at the Great Divide
Mountain Art Festivals
P.O. Box 3578
Breckenridge, CO 80424
(970) 547 – 9326
mountainartfestivals.com

Geneva Arts Fair
8 S. Third St.
Geneva, IL 60134
(630) 232 – 6060
genevachamber.com
E-mail: chamberinfo@genevachamber.com

Germantown Festival
P.O. Box 381741
Germantown, TN 38183
(901) 757 – 9212
germantownfest.com
E-mail: gtownfestival.com

Glenview Outdoor Art Fair
Glenview Art League
P.O. Box 463
Glenview, IL 60025 – 0463
(847) 724 – 4007
glenviewartleague.com

Gloucester Waterfront Festival
38 Charles St.
Rochester, NH 03867
(603) 332 – 2616
castleberryfairs.com
E-mail: info@castleberryfairs.com

Golden Fine arts Festival
1010 Washington Ave.
Golden, CO 80401
(303) 279 – 3113
goldenfineartsfestival.org
E-mail: info@goldencochamber.org

Gold Rush Days
Dahlonega Jaycees
P.O. Box 774
Dahlonega, GA 30533
dahlonegajaycees.com
E-mail: info@dahlonegajaycees.com

Good Old Sunshine art Fair
Friends of the Kenosha Art Association
P.O. Box 1753
Kenosha, WI 53141
(262) 654 – 0065
kenoshaartassociation.org
E-mail: info@kenoshaartassociation.org
(Send SASE for info)

Grand Lake Festival of the Arts & Crafts
P.O. Box 429
Grand Lake, CO 80447 – 0429
(970) 927 – 3402
grandlakechamber.com
E-mail: glinfo@grandlakechamber.com

Great Lake Art Fair
46100 Grand River Ave.
Novi, MI 48374
(248) 486 – 3424
greatleakesartfair.com
E-mail: info@gratlakesartfair.com

Great Neck Street Fair
Showtiques Crafts, Inc.
1 Orient Way, Ste. F 127
Rutherford, NJ 07070
(201) 869 – 0406
showtiques.com
E-mail: showtiques@gmail.com

Greenwich Village Art Fair
711 N. Main St.
Rockford, IL 61103
(815) 988 – 1255
rockfordartmuseum.org/gvaf.html
E-mail: nsauer@rockfordartmuseum.org

Halifax Art Festival
P.O. Box 2038
Ormond Beach, FL 32175 – 2038
(386) 304 – 7247
halifaxartfestival.com

Herkimer County Arts & Crafts Fair
100 Reservoir Rd.
Herkimer, NY 13350
(315) 866 – 0300, ext. 8459
Herkimer.edu/ac.
(Send SASE for more info)

Highland Maple Festival
P.O. Box 223
Monterey, VA 24465
(540) 468 – 2550
highlandcounty.org
E-mail: findyourescape@highlandcounty.org

Holiday Fine Arts & Crafts Show
60 Ida Lee Drive
Leesburg, VA 20176
(703) 777 – 1368
idalee.org
E-mail: lfountain@leesburgva.gov

Holly Arts & Crafts Festival
P.O. Box 64
Pinehurst, NC 28370
(910) 295 – 7462
pinehurstbusinessguild.com
E-mail: info@pinehurstbusinessguild.com

Home, Condo, and Outdoor Art & Craft Fair
P.O. Box 486
Ocean City, MD 21843
(410) 213 – 8090
oceanpromotions.info
E-mail: events@oceanpromotions.info

Hot Springs Arts & Crafts Fair
308 Pullman
Hot Springs, AR 71901
(501) 623 – 9592
hotspringsartsandcraftsfair.com
E-mail: sephpipkin@aol.com

Hyde Park Square Art Show
P.O. Box 8402
Cincinnati, OH 45208
hydeparksquare.org
E-mail: hpartshowinfo@aol.com

Stan Hywet Hall & Gardens Ohio Mart
714 N Portage Path
Akron, OH 44303
(330) 315 – 3255
stanhywet.org
E-mail: ohiomart@stanhywet.org

Indiana Art Fair
650 W. Washington St.
Indianapolis, IN 46204
(317) 233 – 9348
indianamuseum.org
E-mail: cmiller@indianamuseum.org

Indian Wells Arts Festival
78 – 200 Miles Ave.
Indian Wells, CA 92210
(760) 346 – 0042
indianawellsartfestival.com
E-mail: info@indianwellsartfestsival.com

International Folk Festival Arts Council
Fayetteville
301 Hay St.
Fayetteville, NC 28301
(910) 323 – 1776
theartscouncil.com
E-mail: bobp@theartscouncil.com

Isle of Eight Flags Shrimp Festival
P.O. Box 17251
Fernandina Beach, FL 32035
(904) 701 – 2786
islandart.org

John Hopkins University Fair
3400 N. Charles St.
Mattin Ste. 210
Baltimore, MD 21218
(410) 516 – 7692
jhuspringfair.com

Jubilee Festival
Eastern Shore Chamber of Commerce
Olde Towne Daphne
P.O. Drawer 310
Daphne, AL 36526
(251) 621 – 8222
eschamber.com

Kalamazoo Institute of Arts

Kalamazoo Institute of Arts Fair
314 S. Park St.
Kalamazoo, MI 49007
(269) 349 – 7775
kiarts.org/artfair
E-mail: joeb@kiarts.org

Kentucky Festival of the Arts
503 Main Ave.
Northport, AL 35476
(205) 758 – 1257
kentuck.org
E-mail: kentuck@kentuck.org

Ketner's Mill County Arts Fair
P.O. Box 322
Lookout Mountain, NT 37350
(423) 267 – 5702
ketnersmill.org
E-mail: contact@ketnersmill.org

Kings Mountain Art Fair
13106 Skyline Blvd.
Woodside, CA 94062
(650) 851 – 2710
kingsmountainfair.org
E-mail: kmafsecty@aol.com

Lake City Arts & Crafts
P.O. Box 1147
Lake City, CO 81235
(817) 343 – 3305
lakecityarts.org
E-mail: info@lakecityarts.org

Lakefront Festival of Art
700 N. Art Museum Drive
Milwaukee, WI 53202
(414) 224 – 3853
mam.org/lfoa
E-mail: lfoa@mam.org

Lake St. Louis Famers & Artists Market
P.O. Box 91
Warrenton, MO 63383 – 0091
(314) 495 – 2531
themeadowsatlsl.com
E-mail: lakestlouisfarmersmarket@gmail.com

Lake Sumter Art & Craft Festival
270 Central Blvd, Ste. 107B
Jupiter, FL 33458
(561) 746 - 6615
artfestival.com
E-mail: info@artfestival.com

LaQuinta Arts Festival
78150 Calle Tampico Ste.215
La Quinta, CA 92253
(760) 564 – 1244
lqaf.com
E-mail: helpline@lqaf.com

Leesburg Fine Art Festival
Paragon Fine Art Festivals
8258 Midnight Pass Rd.
Sarasota, FL 34252
(941) 487 – 8061
paragonartevents.com/lee
E-mail: admin@paragonartfest.com

Les Cheneaux Festival of Arts
P.O. Box 147
Cedarville, MI 49719
(517) 282 – 4950
lescheneaux.net/?annualevents
E-mail: lcifoa@gmail.com

Levi's Commons Fine Art Fair
The Guild of Artists & Artisans
13201 Lewis Commons Blvd.
Perrysburg, OH 43551
(734) 662 – 3382, ext. 101
theguild.org
E-mail: info@theguild.org

Lewiston Art Festival
P.O. Box 1
Lewistown, NY 14092
(716) 754 – 0166
artcouncil.org
E-mail: director@artcouncil.org

Liberty Arts Squared
P.O. Box 302
Liberty, MO 64069
libertyartssquared.org
E-mail: staff@libertyartssquared.org

Lilac Festival Arts & Crafts Shows
26 Goodman St.
Rochester, NY 14607
(585) 244 – 0951
rochesterevents.com
E-mail: lyn@rochesterevents.com

Lions Club Arts & Crafts Festival
Henderson Lions Club
P.O. Box 842
Henderson, KY 42419
lionsartsandcrafts.com
E-mail: lionsartandcrafts@gmail.com

Lompoc Flower Festival
414 W. Ocean Ave.
Lompoc, CA 93436
(805) 735 – 8511
lumpocvalleyartassociation.com
E-mail: lompocvallel@verizon.net

Long's Park Art & Craft Festival
Long's Park Amphitheater Foundation
630 Janet Ave., Ste. A – 111
Lancaster, PA 17601 – 4541
(717) 735 – 8883
longspark.org

Louisville Festival of the Arts
270 Central Blvd., Ste. 107B
Jupiter, FL 33458
(561) 746 – 6615
artfestival.com
E-mail: info@artfestival.com

Madison Chautauqua Festival of Art
601 W. First St.
Madison, IN 47250
(812) 571 – 2752
madisonchautauqua.com
E-mail: info@madisonchautauqua.com

Magnolia Blossom Festival
Magnolia/Columbia Chamber of Commerce
P.O. Box 866
Magnolia, AR 71754
(870) 901 – 2216
blossomfestival.org

Marian Arts Festival
1225 Sixth Ave., Ste. 100
Marion, IA 52302
marionartsfestival.com
E-mail: mafdirector@marioncc.org

Marshfield Art Fair
New Visions Gallery
1000 N. Oak Ave.
Marshfield, WI 54449
(715) 387 – 5562
newvisionsgallery.org

Mason Arts Festival
Mason – Deerfield Arts Alliance
P.O. Box 381
Mason, OH 45040
(513) 309 – 8585
masonarts.org
E-mail: masonarts@gmail.com

McGregor Arts & Crafts Festival
McGregor – Marquette Chamber of
Commerce
P.O. Box 105
McGregor, IA 52157
(800) 896 – 0910
mcgreg-marq.org
E-mail:
mcgregormarquettechamber@gmail.com

Memorial Weekend Arts & Crafts Festival
38 Charles St.
Rochester, NH 03867
(603) 332 – 2616
castleberryfairs.com
E-mail: info@castleberryfairs.com

Mendota Sweet Corn Festival
Mendota Area Chamber of Commerce
P.O. Box 620
Mendota, IL 61342
(815) 539 – 6507
sweetcornfestival.com
E-mail: rfriedlein@mendotachamber.com

Mesa Arts Festival
Mesa Arts Center
1 E. Main St.
Mesa, AZ 85201
(480) 644 – 6627
mesaartscenter.com

MSU Holiday Arts & Crafts Show
49 Abbott Rd., Room 26
MSU Union
East Lansing, MI 48824
(517) 355 – 3354
uabevents.com
E-mail: uab@rhs.msu.edu

Mid-Missouri Artists Christmas Arts & Crafts
Sale
P.O. Box 116
Warrensburg, MO 64093
(660) 441 – 5075
midmissouriartists.webs.com
E-mail: mbush22@yahoo.com

Midsummer Arts Faire
1515 Jersey St.
Quincy, IL 62301
(217) 779 – 2285
artsfaire.org
E-mail: info@artsfaire.org

Mill Valley Fall Arts Festival
P.O. Box 300
Mill Valley, CA 94942
(415) 381 – 8090
mvfaf.org
E-mail: mvfafartists@gmail.com

Milwaukee Domes Art Festival
524 S. Layton Boulevard
Milwaukee, WI 53215
(414) 257 – 5608
milwaukeedomes.org/art-in-the-green

Minnesota Women's Art Festival
2924 4th Ave. S
Minneapolis, MN 55408
womensartfestival.com
E-mail: naomiotre@aol.com

Mission Federal Artwalk
2310 Columbia St.
San Diego, CA 92101
(619) 615 – 1090
artwalksandiego.com
E-mail: info@artwalksandiego.org

Monte Sano Art Festival
706 Randolph Ave
Huntsville, AL 35801
(256) 519 – 2787
montesanoartfestival.com

Mountain State Forest Festival
P.O. Box 388
101 Lough St.
Elkins, WV 28241
(304) 636 – 1824
forestfestival.com
msff@forestfestival.com

Mount Dora Arts Festival
Mount Dora Center for the Arts
138 E. Fifth Ave.
Mount Dora, FL 32757
(352) 383 – 0880
mountdoracenterforthearts.org/arts-festival

Nampa Festival of Arts
131 Constitution Way
Nampa, ID 83686
(208) 468 – 5858
nampaparksandrecreation.org
E-mail: burkeyj@cityofnampa.us

New Mexico Arts and Crafts Fair
2501 San Pedro St. NE, Ste. 110
Albuquerque, NM 87110
(505) 884 – 9043
nmartsandcraftsfair.org
E-mail: info@nmartsandcraftsfair.org

Newton Arts Festival
Piper Promotions
4 Old Green Rd.
Sandy Hook, CT 64821
(203) 512 – 9100
newtonartsfestival.com

New World Festival of the Arts
P.O. Box 2300
Manteo, NC 27954
(252) 473 – 5558
darearts.org
E-mail: dareartsinfo@gmail.com

Niantic Art & Craft Show
P.O. Box 227
Niantic, CT 63571
nianticartsandcraftshow.com
E-mail: artshowwwoody@yahoo.com

North Charleston Arts Festival
P.O. Box 190016
North Charleston, SC 29419 – 9016
(843) 740 – 5854
northcharlestonartsfest.com
E-mail: culturalarts@northcharleston.com

North Congregational Peach & Craft Fair
17 Church St.
New Hartford, CT 06057
(860) 379 – 2466
northchurchucc.com

OC Fair Visual Arts Competition
88 Fair Drive
Costa Mesa, CA 92626
(714) 708 – 1718
ocfair.com/competitions
E-mail: sanderson@ocfair.com

Oconomowoc Festival of the Arts
P.O. Box 651
Oconomowoc, WI 53066
oconomowocarts.org

Ohio Mart
Stan Hywet Hall and Gardens
714 N. Portage Path
Akron, OH 44303
(330) 836 – 5533
stanhywet.org
E-mail: info@stanhywet.org

Ohio Sauerkraut Festival
P.O. Box 281
Waynesville, OH 45068
(513) 897 – 8855, ext. 2
saueerkrautfestival.com
E-mail: barb@waynesvilleohio.com

Oklahoma City Festival of the Arts
Arts Council of Oklahoma City
400 W. California
Oklahoma City, OK 73102
(405) 270 – 4848
artscouncilbkc.com
E-mail: info@artscouncilokc.com

Old Capitol Art Fair
P.O. Box 5701
Springfield, IL 62705
(405) 270 – 4848
socaf.org
E-mail: artsinfo@yahoo.com

Old Fourth Ward Park Arts Festival
592 N. Angier Ave. NE
Atlanta, GA 30308
(404) 873 – 1222
oldfourthwardparkartsfestival.com
E-mail: info@affps.com

Old Town Art Fair
1763 N. North Ave.
Chicago, IL 60614
(312) 337 – 1938
oldtownartfair.com
E-mail: info@oldtowntriangle.com

Old Town Art Festival
Old Town San Diego Chamber of Commerce
P.O. Box 82686
San Diego, CA 92138
(619) 233 – 5008
oldtownartfestival.org
E-mail: otsd@aol.com

Omaha Summer Arts Festival
P.O. Box 31036
Omaha, NE 6813 – 0036
(402) 345 – 5401
summerarts.org
E-mail: ebalazs@vgagroup.com

On The Green Fine Art & Craft Show
P.O. Box 304
Glastonbury, CT 06033
(860) 659 – 1196
glastonburyarts.org
E-mail: info@glastonburyarts.org

Orange Beach Festival of Art
26389 Canal Road
Orange Beach, AL 36561
(251) 981 – 2787
orangebeachartsfestival.com
E-mail: helpdesk@orangebeachartcenter.com

Orchard Lake Fine Art Show
P.O. Box 79
Milford, MI 48381 – 0079
(248) 684 – 2613
hotworks.org
E-mail: info@hotworks.org

Palm Springs Fine Art Fair
HEG – Hamptons Expo Group
223 Hampton Rd.
South Hampton, NY 11968
(631) 283 – 5505
palmspringsfineartfair.com

Panoply Arts Festival
The Arts Council, Inc.
700 Monroe St. SW, Ste. 2
Huntsville, AL 35801
(256) 519 – 2787
artshuntsville.org/panoply-arts-festival

Paradise City Arts Festivals
30 Industrial Drive E
North Hampton, MA 01060
(413) 587 – 0772
paradisecityarts.com
E-mail: artist@paradisecityarts.com

Patterson Apricot Fiesta
P.O. Box 442
Patterson, CA 95363
(209) 842 – 3118
apricotfiesta.com
(Send SASE for more info)

Pend Oreille Arts Council
P.O. Box 1694
Sandpoint, ID 83864
(208) 263 – 6139
artinsandoint.org
E-mail: poactivities@gmail.com

Pennsylvania Guild of Craftsmen Fairs
Center of America Craft
335 N. Queen St.
Lancaster, PA 17603
(717) 431 – 8706
pacrafts.org/fine-craft-fairs
E-mail: handmade@pacrafts.org

Peters Valley Fine Craft Fair
19 Kuhn Rd
Layton, NJ 07851
(973) 948 – 5200
petersvalley.org
E-mail: info@petersvalley.org

Piedmont Park Arts Festival
1701 Piedmont Ave.
Atlanta, GA 30306
(404) 873 – 1222
piedmontparkartfestival.com
E-mail: info@affps.com

Prairie Arts Festival
201 Schaumburg Court
Schaumburg, IL 60193
(847) 923 – 3605
prariecenter.org

Pungo Strawberry Festival
P.O. Box 6158
Virginia Beach, VA 23456
(757) 721 – 6001
pungostrawberryfestival.info

Pyramid Hill Annual Art Fair
1763 Hamilton Cleves Rd
Hamilton, OH 45013
(513) 868 – 8336
pyramidhill.org

Quaker Arts Festival
P.O Box 202
Orchard Park, NY 14127
(716) 667-2787
opjaycees.com
(Send SASE for info)

Rattlesnake and Wildlife Festival
P.O. Box 292
Claxton, GA 30417
(912) 739-3820
evanscountywildlifeclub.com

Rhinebeck Arts Festival
P.O. Box 28
Woodstock, NY 12498
(845) 331 – 7900
artrider.com
E-mail: crafts@artrider.com

Riley Festival
312 E. Main St., Ste. C
Greenfield, IN 46140
(317) 462 – 2141
rileyfestival.com
E-mail: info@rileyfestival.com

Royal Oak Outdoor Art Fair
211 Williams St.
Royal Oak, MI 48068
(248) 246 – 3180
romi.gov
E-mail: artfair@ci.royal-oak.mi.us

SACO Sidewalk Art Festival
P.O. Box 336
12 ½ Pepperell Square, Ste. 2A
Saco, ME 04072
(207) 286 – 3546
sacospirit.com
E-mail: sacospirit@hotmail.com

Salt Fork Arts & Crafts Festival
P.O. Box 250
Cambridge, OH 43725
(740) 439 – 9379
saltforkfestival.org
E-mail: director@saltforkfestival.org

Sandy Springs Artsapalooza
6100 Lake Forest Drive NE
Sandy Springs, GA 30328
(404) 873 – 1222
sandyspringsartsapalooza.com
E-mail: info@affps.com

Santa Cali Gon Days Festival
210 W. Truman Rd.
Independence, MO 64050
(816) 252 – 47455
santacaligon.com
E-mail: lois@ichamber.biz

Santa Fe College Arts Festival
3000 NW 83rd St.
Gainesville, FL 32606
(352) 395 – 5355
sfspringarts.com
E-mail: Kathryn.lehman@sfcollege.edu

Sausalito Art Festival
P.O. Box 10
Sausalito, CA 94966
(415) 332 – 3555
sausalitoartfestival.org
E-mail: info@sausalitoartfetival.org

Sawdust Art Festival
935 Laguna Canyon Rd
Laguna Beach, CA 92651
(949) 494 – 3030
sawdustartfestival.org
E-mail: info@sawdustartfestival.org

Scottsdale Arts Festival
7380 E. Second St.
Scottsdale, AZ 85251
(480) 874 – 4671
scottsdaleartsfestival.org
E-mail: festival@sccarts.org

Scottsdale Celebration of Fine Art Celebration
of Fine art
7900 E. Greenway Rd., Ste. 101
Scottsdale, AZ 85260-1714
(480) 443 – 7695
celebrateart.com
E-mail: info@celebrateart.com

Sell-A-Rama
Tyson Wells Sell-A-Rama
P.O. Box 60
Quartzsite, AZ 85346
(928) 927 – 6364
tysonwells.com
E-mail: tysonwells@tds.net

Shipshewana Quilt Festival
P.O. Box 245
Shipshewana, IN 46565
(260) 768 – 4887
shipshewanaquiltfest.com
E-mail: info@shipshewanaquiltfest.com

Sidewalk art Mart
Mount Helena Music Festival
225 Cruse Ave., Ste. B
Helena, MT 59601
(406) 447 – 1535
downtownhelena.com
E-mail: jmchugh@mt.net

Skokie Art Guild Fine Art Expo
Devonshire Cultural Center
4400 Greenwood St.
Skokie, IL 60077
(847) 677 – 8163
skokieartguild.org
E-mail: info@skokieartguild.org

Solano Avenue Stroll
1563 Solano Ave.Ste.101
Berkeley, CA 94707
(510) 527 – 5358
solanostroll.org
E-mail: info@solanostroll.org
(Send SASE for info)

South County YMCA Gift & Craft Fair
12736 Southfork Rd.
St. Louis, MO 63128
(314) 849 – 9622
gwrymca.org/southcounty
E-mail: teri.varble@gwrymca.org

South Jersey Pumpkin Show
B&K Enterprise
P.O. Box 925
Millville, NJ 83321
(856) 765 – 0118

The Southwest Arts Festival
Indio Chamber of Commerce
82921 Indio Blvd.
Indio, CA 92201
(760) 347 – 0676
southwestartsfest.com
E-mail: swaf@indiochamer.org

Spanker Creek Farm Arts & Crafts Fair
P.O. Box 5644
Bella Vista, AR 72714
(479) 685 – 5655
spankercreekfarmcom
E-mail: info@spankerrcreekfarm.com

Springfest
Southern Pines Business Assoc.
P.O. Box 831
Southern Pines, NC 28388
(910) 315 – 6508
southernpines.biz
E-mail: spbainfo@southerpines.biz
(Send SASE for info)

195

Spring Festival, An Arts & Crafts Affair
P.O. Box 655
Antioch, IL 60002
(402) 331 – 2889
hpifestivals.com
E-mail: hpifestivals@cox.net

Spring Green Arts & Crafts Fair
P.O. Box 96
Spring Green, WI 53588
springgreenartfair.com
E-mail: springgreenartfair@gmail.com

St. Charles Fine Art Show
2 E. Main St.
St. Charles, IL 60174
(630) 443 – 3967
downtownstcharles.org
E-mail: info@downtownstcharles.org

Steppin' Out
Downtown Blacksburg, Inc.
P.O. Box 233
Blacksburg, VA 24063
(540) 951 – 0454
blacksburgsteppinout.com
E-mail: events@downtownblacksburg.com

St. George Art Festival
50 S. Main St.
St. George, UT 84770
(435) 627 – 4500
sgcity.org/artfestival
E-mail: atadmn@sccity.org

St. James Court Art Show
P.O. Box 3804
Louisville, KY 40201
(502) 635 – 1842
stjamescourtartshow.com
E-mail: mesrock@stjamescourtartshow.com

St. Louis Art Fair
225 Meramec Ave., Ste. 105
St. Louis, MO 63105
culturalfestivals.coom
E-mail: info@culturalfestivals.com

Stockley Gardens Fall Arts Festival
801 Boush St., Ste. 302
Norfolk, VA 23510
(757) 625 – 6161
stockleygardens.com
E-mail: aknox@hope-howe.org

Strawberry Festival
downtown Billings Alliance
2815 Second Ave. N
Billings, MT 59101
(406) 294 – 5060
downtownbillings.com
E-mail: inatashap@downtownbillings.com

Summer Art in the Park Festival
16 S. Main St.
Rutland, VT 05701
(802) 775 – 0356
chaffeeartcenter.org
E-mail: info@chaffeartcenter.org

Summerfair
7850 Five Mile Rd.
Cincinnati, OH 45230
(513) 531 – 0050
summerfair.org
E-mail: exhibitors@summerfair.org

Summit Art Festival
13 SE Third St.
Summit, MO 64063
summitartfest.org

Sun Fest, Inc.
P.O. Box 1404
Bartlesville, OK 74005
(918) 331 – 0456
bartlesvillesunfest.org
E-mail: sunfestbville@gmail.com

Sun Valley Center Arts & Crafts Festival
Sun Valley Center for the Arts
P.O. Box 656
Sun Valley, ID 83353
(208) 726 – 9491
sunvalleycenter.org
E-mail: festival@sunvalleycenter.org

Surprise Fine Art & Wine Festival
15940 N. Bullard Ave.
Surprise, AZ 85374
thunderbirdartists.com
E-mail: info@thundrbirdartists.com

Syracuse Arts & Crafts Festival
115 W. Fayette St.
Syracuse, NY 13202
(315) 422 – 8284
syracuseartsandcraftsfestival.com
E-mail: mail@downtownsyracuse.com

Tallman Arts Festival
426 N. Jackson St.
Janesville, WI 53548
(608) 756 – 4509
rchs.us
E-mail: astrobelwise@rchs.us

Taos Fall Arts Festival
P.O. Box 675
Taos, NM 87571
(575) 758 – 4648
taosfallarts.com
E-mail: tfafvolunteer@gmail.com

Wyandote Street Art Fair
2624 Biddle Ave.
Wyandotte, MI 48192
(734) 324 – 4502
wyandottestreetartfair.org
E-mail: hthiede@wyan.org

A lot of these shows are put on by the same company. It would be best for you to contact these businesses to see what upcoming shows are going to be held in your area. Here are some of the companies:

Long's Park Amphitheater Foundation
Melissa Wirls
630 Janet Avenue, Ste. A111
Lancaster, PA 17601
(717) 735 – 8883
longspark.org
E-mail: info@longspark.org

Family Festivals Association, Inc.
David Stoner
P.O. Box 166
Irwin, PA 15642
(724) 863 – 4577
familyfestivals.com
E-mail: info@familyfesttivals.com

CCM Events
Darren Skanson
4214 E. Colfax Ave
Denver, CO 80220
(720) 941 – 6088
coloradoartshows.com
E-mail: info@ccmstudios.com

Splash Festivals, Inc.
Cindy Flynn
17 N. Peachtree St.
Norcross, GA 30071
(678) 427 – 6450
splashfestivals.com
E-mail: splashfestivals@gmail.com

Quail Hollow Events
Ola Rubinstein
P.O. Box 825
Woodstock, NY 12498
(845) 516) 4342
quailhollow.com
ola@quailhollow.com

Hobday's Artwork& Co.
Marilyn Hobday
P.O. Box 275
Landisville, PA 17538-1601
(717) 898 – 6297
heartoflancasterartsandcraftshow.com
mehobday@comcast.net

Amdur Productions
Amy Amdur
P.O. Box 550
Highland Park, IL 60035
(847) 926-4300
amdurpriductions.com
info@amdurproductions.com

Sioux City Art Center
Erin Webber-Dreeszen
225 Nebraska Street
Sioux City, IA 51101
(712) 279 – 6272
siouxcityartcenter.org
ewebber@sioux-city.org

Mountain Art Festivals
Dick Cunningham
P.O. Box 3578
Breckenridge, CO 80424
(970) 406 – 1866
mountainartfestivals.com
mountainartfestivals@gmail.com

TNT Events Inc.
Andy Rudzitis
10975 Dorwood Rd
Burt, MI 48417
(352) 344 – 0657
tnteventsinc.com
tnteventsinc@yahoo.com

Paragon Festivals
Bill Kinney
12326 Thornhill Court
Lakewood Ranch, FL 34202
(941) 847 – 8061
paragonartevents.com
admin@paragonfestivals.com

DePasquale Enterprises, LLC.
Cathy DePasquale
P.O. Box 278
Selden, NY 11784
(631) 846 – 1459
depasmarket.com
cathy@depasmarket.com

Deer Path Art League
Suzanne Wetterline
400 E. Illinois Rd.
Lake Forest, IL 60045
(847) 234 – 3743
deerpathartleague.org
info@deerpathleague.org

Harvest Festival
Jordana Glenn
1145 Second St., Ste. A332
Brentwood, CA 94513
(925) 392 – 7300
harvestfestival.com
info@harvestfestival.com

Country Folk Art Shows, Inc.
Rhonda Blakely
15045 Dixie Hwy
Holly, MI 48442
(248) 634 – 4156
countryfolkart.com
shows@countryfolkart.com

Cultural Festivals
Sarah Umlauf
225 S. Meramec Ave, 105
Clayton, MD 63105
(314) 863 – 0278
saintlouisartfair.com
info@culturalfestivals.com

Rose Squared Productions, Inc.
Howard Rose
12 Galaxy Court
Hillsborough, NJ 08844 – 3836
(908) 874 – 5247
rosesquared.com
howard@rosesquared.com

Beaux-Arts Fund Committee
Vicki Rocker
17622 Hubbard Road
East Moline, IL 61244
(309) 706 – 1434
beauxartsfair.com
BeauxArtsFair@gmail.com

Rees Carillon Society
Connie Haskett
1420 Wood Mill Drive
Springfield, IL 62704

(217) 306 – 1838
carillon-rees.org
connie.haskett@coldwellbanker.com

Wisconsin Valley Art Association
WVAA Staff
P.O. Box 1791
Wausau, WI 54402-1791
wivalleyart.org
wisonsinvalleyart@gmail.com

Almond Tree Events
Jon and Kristi Polzin
1983 Plantation Lane
Kronenwetter, WI 54455
(715) 359 – 5861
almondtreeevents.com
AlmondTreeEvents@charter.net

Buckler Shows
June Font
1697 Doyle Rd
Deltona, FL 32725
(386) 860 – 0092
bucklerrshows.com
Buckershows@yahoo.com

Wild Wind Folk Art & Craft Shows, LLC
Carol Jilk
P.O. Box 986
Stowe, VT 05672
(814) 688 – 1516
wildwindfestival.com
info@wildwindfestival.com

Greater Augusta Arts Council
Pax Bobrow
P.O. Box 1776
Augusta, GA 30903
(706) 826 – 4702
artsintheheart.com
pax@augustaarts.com

Integrity Shows
Mark Loeb
P.O. Box 21667
Detroit, MI 48221
(734) 216 – 3958
integrityshows.com
mark@integrityshows.com

Wisconsin Dells Art Association
Hope Hill

P.O. Box 183
Wisconsin Dells, WI 53965
(608) 981 – 2321
wisdells.com
hopehillhotmail.com

Weehawken Creative Arts
Ashley King
P.O. Box 734
Ridgway, CO 81432
(970) 318 – 0150
weehawkenarts.org
questions@weehawkenarts.org

Festivals of Cedarburg, Inc.
Elizabeth Albers
P.O. Box 406
Cedarburg, WI 53012
(262) 377 – 3891
cedarburgfestival.org
cedarburgfestivals@yahoo.com

Durham Arts Council, Inc.
Susan Tierney
120 Morris Street
Durham, NC 27609
(919) 560 – 2787
centerfest.durhamarts.org
stierney@durhamarts.org

Warrens Cranberry Festival, Inc.
Kim Schroeder
P.O. Box 146
Warrens, WI 54666
(608) 378 – 4200
cranfest.com
crranfest@cranfest.com

Woodwill Corporation
P.O. Box 5186
Hauppauge, NY 11788
(631) 234 – 4183
woodwill.com
jrwoodwill@aol.com

Rio Grande Festivals
Ruth Gorr
1685 W. Uintah St.Ste.102
Colorado Springs, CO 80904
(505) 273 – 7363
riograndefestivals.com
info@riograndefestivals.com

Craftproducers
Charley Dooley
P.O. Box 300
Charlotte, VT 05445
(802) 316 – 5019
craftproducerrs.com
info@craftproducers.com

Huachuca Art Association
Lois Bravo
1835 Paseo San Luis
Sierra Vista, AZ 85635
(520) 803 – 0584
artintheparksierravista.com
Libravo@live.com

American Craft Council
Meanie Little
1224 Marshall Street NE, Ste. 200
Minneapolis, MN 55413
(800) 836 – 3470
craftcountcil.org/shows
shows@craftcouncil.org

Gilmore Shows
Carley Gilmore
13400 Sutton Park Dr., S#1201
Jacksonville, FL 32224
(336) 282 – 5550
gilmoreshows.com
carleygilmore@gilmoreshows.com

Waccamaw Arts & Crafts Guild
JoAnne Utterback
P.O. Box 1595
Myrtle Beach, SC 29578
(843) 446 – 3830
wacg.org/art-in-the-park
jutterback@sc.rr.com

Huffman Productions, Inc
Jennifer Huffman
P.O. Box 655
Antioch, Il 60002
(402) 331 – 2889
hpfestivals.com
hpfest@cox.net

Carolina Shows, Inc.
Russ Hunt
P.O. Box 853
Matthews, NC 28106

(704) 847 – 9480
madeinthesouthshows.com
festivals@madeinthesouthshows.com

Winterwoods, LLC
Pattie Seitz
1017 Saw Mill Way
Landsdale, PA 19446
(215) 264 – 2546
Premier Promotions
Dan Kaczynski
5016 Oleander Drive
Wilmington, NC 28403
(910) 799 – 9424
wnypremierpromotions.com
wnypremier@cc.rr.com

Blue Ribbon Events
Danielle Lynch
4182 Bay Beach Lane #743
Ft. Myers Beach, FL 33931
daniellesblueribbonevents.com
blueribboneventsllc@gmail.com

Thunderbird Artists
Denise Colter
15648 N Eagle Nest Dr.
Fountain Hills, AZ 85268
(480) 837 – 5637
thunderbirdartists.com
info@thundebirdartists.com

Artrider
Laura Kandal
P.O. Box 28
Woodstock, NY 12498
(845) 331 – 7900
artrider.com
crafts@artrider.com

SIK Promotions
Suzanne King
P.O. Box 530234
St. Petersburg, FL 33747
(727) 322 – 5217
sikpromotions.com
suzfest@gmail.com

Events Management Group
Denis Wynn
P.O. Box 109
Virginia Beach, VA 23451
(757) 417 – 7771
emgshows.com
info@emgshows.com

Hot Works, LLC
Patty Narozny
P.O. Box 1425
Sarasota, FL 34230
(941) 755 – 3088
hotworks.org
patty@hotworks.org

M.Y. Promotions, Inc.
Sally Mere
16481
Slater Road
North Fort Myers, FL 33917
(239) 707 – 3467
mypromotions.com
myprmo@mypromotions.com

Artisan Promotions, Inc.
Jackie Ralston
10956 La Salinas Cir
Boca Raton, FL 33428
(561) 465 – 3676
NEChrristmasFestival.com
info@NEChristmasFestival.com

Quality Promotions
Amy Hastings
7597 Northport Drive
Vestal, NY 13850
(607) 759 – 3397
quality-promotions.com
amyehastings@aol.com

Conrad Enterprises
Chris Beaty
940 S. 1st Ave
Canton, IL 61520
(309) 647 – 0400
conradenterprises.com
conradent@sbcglobal.net

Vivid Special Events
Patty Siamson-Healy
1814 5th St. SE
Winter Haven, FL 33880
(407) 346 – 3705
artandcraftfestival.com
patty@artandcraftfestival.com

Raab Enterprises, Inc.
Sharon Raab
7560 Hi-View Dr.
North Royalton, OH 44133
(440) 724 – 4485
raabenterprises.com
raabshows@gmail.com

Craft Productions, Inc.
Karen Yackley
(815) 878 – 2728
craftproductionsinc.com
info@craftproductionsinc.com

American Art
P.O. Box 480
Slate Hill, ID 10973
(845) 355 – 2400
americanartmarketing.com
hellow@americanartmarketing.com

Huff's Promotions
Kelly Locker
P.O. ox 277
Bolivar, OH 44612
(330) 493 – 4130
huffspromo.com
shows@huffspromo.com

Dash Events, LLC
Liz Gore King
1685 W. Uintah St#102
Colorado Springs, CO 80904
(505) 273 – 7363
dashevents.com
liz@dasheventsdenver.com

"I SOUND FUNNY? YEAH, I'M CALLING FROM MY CELL PHONE!"

"Art should be something that liberates your soul."
– Keith Haring

Keith Haring was an American artist whose pop art and graffiti-like work grew out of the New York City street- culture. He took the New York City subway system by storm in the 1980s.

CHAPTER 17

EXHIBITIONS

"Art washes away from the soul the dust of everyday life."
– Pablo Picasso

In *The Business of Being an Artist,* Daniel Grant starts his book out with a chapter about "Exhibiting and Selling Art." That's illustrative of how important exhibitions are to the up-and-coming artist. In this chapter, I will offer you some tips and tactics on how to get your work shown in an exhibition.

During my research for this book, I read about Treacy Ziegler. She's a teaching artist who runs a correspondence art class through *Prisoner Express.* She also has produced *Without the Wall,* an art exhibit of prison art. I also found out that every year for the last eight years, there has been at least one art exhibit of works produced from inside prison. Here they are:

- *Marking Time: Prison Art and Activism* (Rutgers University, 2014)

- *Shared Dining* (Brooklyn Museum of Art, 2015)

- *On the Inside* (Abron's Art Center, NYC 2016)

- *Visions of Confinement* (Hunter East Harlem Gallery, 2016)

- *Carceral States* (Maier Museum of Art – Randolph College, VA – 2017)

- *Walls Turned Sideways: Artists Confront the Justice System* (Contemporary Art Museum, Houston – 2018)

- *Mirro/Echo/Tilt* (New Museum, 2019)

- *Marking Time: Art in the Age of Mass Incarceration* (Museum of Modern Art, Manhattan – 2020)

The last one above I found in the March 2021 *Prison Legal News.* In it, Ed Lyon wrote an article titled: "Prisoner Art on Display in New York City Exhibition." He details how Professor Nichole Fleetwood of Rutgers University was able to curate an art exhibit at the famous Museum of Modern art. Some of you may remember Professor Fleetwood's name from me recommending her wonderful book, *Marking Time: Art in the Age of Mass Incarceration.* That book is one that inspired me to write this one. But I mention all of this as living proof that you can get your art into an exhibit if you want to.

MUSEUM EXHIBITIONS

On the list above, five of those were held at museums. A prisoner could build their name around their work if they were to get a museum to hold an exhibition of their craft. Most prisoners won't even try so you could get a let-up just by reaching out. *The Official Museum Directory* is published by the National Register Publishing Company for over $300 and lists over 11,000 entries. It comes out each year. While that 4300 is likely priced too high for most of you, check to see if you can find it in your library's reference section. Another great book that comes out every year is *Art in America: Annual Guide to Museums, Gallerists, Artists.* It lists thousands of places you could place your art with. Ofif you have someone to help with online research, you could find a local museum with a simple Google

search. Have a family member or friend check out the museum's website for the details about how to submit your exhibition proposal. Then shoot your shot. Remember that it only takes one yes to change your life. It would probably be easier to get your local museum to exhibit your art rather than one across the country.

NON-TRADITIONAL ART SPACES

Museums are not the only place to exhibit your art/crafts. Art can be hung anywhere. Some prisons allow prisoners to exhibit their art in prison visiting rooms. Some artists have been known to loan their pieces to coffee shops, cafes, hair salons, libraries, restaurants, churches, post offices, hotels, banks, car washes, and other businesses. I think a lot of the prison artwork that I've seen over the years would get a lot of attention in a tattoo parlor. Think about that.

Another place that I kept finding in my research was college art galleries. There are thousands of colleges, universities, and local community colleges across the United States. Most of them have art classes and spaces that artists can exhibit in. Does your hometown have a college? Is there a university close by to your prison? Start with those schools. You can find all the information you need by searching the school's website. The way to become a *Prison Picasso* is to think outside the box you find yourself in. The goal of exhibiting your work is to build your contact list and clientele that end up collecting your work. That way you can go from scrounging around for commissary goods to making thousands of dollars off your arts and crafts. Getting other people and places to exhibit your work is one way to do it. This book is filled with other ways as well.

MILLIONAIRE PRISONER CASE STUDY

One of my favorite stories in Professor Fleetwood's book, *Marking Time,* is that of Gil Battle. He did 20 years and got out. Then he took his art skills and used a dentist's drill to etch prison settings onto ostrich-egg shells. Yes, you read that right. He used a dentist drill on ostrich-egg shells. His exhibit, *Hatched in Prison,* was shown at the Rico/marasca Gallery in NYC. For more about his work or the exhibit, check him out at: gilbatle.com/hatched-in-prison.

VIRTUAL ART EXHIBITION

Because of the COVID-19 pandemic, a lot of art exhibitions got canceled. Some moved their shows online. This may be the way that a prisoner could hold exhibitions. Your family member or friend could set them up for you? One of the things that hurts an online exhibition is the interaction with the people viewing your work. So, if I was going to do an online exhibition I would either record myself talking about each piece of art or go on a video visit and have it recorded where I talk about your art. Then that could be played at the click of a button. In the least, you should write out detailed descriptions about each piece of work on exhibit. There's a story behind your work. Let your viewers see and hear it.

If you're considering an online art exhibition you may want to look at Eventeny.com. They host over 900,000 exhibitors and could support hundreds of thousands of online visitors at one time. It's free to start so check them out.

ART EXHIBITION TRICKS OF THE TRADE

Exhibitions of your work can lead to more success and sales. It could lead to more prestige. The bigger the gallery or museum doing the exhibition the better for your career. What would it do for you if your work was shown in a major museum in New York City? I hope you get to find out. But first, you should know some stuff to protect yourself and your art. When you loan your artwork so it can be shown in an exhibit you typically keep all ownership rights. Yet, the saying that an oral agreement isn't worth the paper it's written on is true. Because of, this it's wise to have a written contract detailing all the below-listed points before you loan any of your work to an exhibition:

- List the parties involved, with complete addresses, phone numbers, and e-mails for contact information;

- List the date of the loan and when the work shall be shown and what happens if it wasn't shown;

- State whether the art can be shown with other artist's work or by itself or in a collection;

- State whether there are any restrictions on how the art should be treated;

- State if and when and how you should be paid if the work is sold during the exhibition;

- State who is responsible for getting the work to and from the exhibition;

- State who is responsible for any other expenses to get the work ready for the exhibit;

- Make sure the exhibitor is responsible for any damage, theft, or any other problem that arises once you ship it to the exhibitor and until you get it back.

You should also have a receipt prepared ahead of time that lists all the works that you're sending. then the exhibitor can sign for it and give you a copy back after they get the artwork. The receipt should list the name of the artwork, the medium used to perfect it, the size of the piece, any framing or mounting, insurance value, and the condition in which it was received. You can get a great sample contract and receipt for loaning your artwork to an exhibition in *Business and Legal Forms for Fine Artists,* by lawyer Tad Crawford. Or you can find one online with a service like LegalZoom? No matter if you use one online, or a book, make sure it has language like this in it:

> "No work may be photographed, sketched, painted, or reproduced in any manner whatsoever without the express, written consent of the artist."

You must protect yourself. While it would be great to get a museum to take your work on loan for an exhibition, it wouldn't be that good if someone tried to reproduce your work and make money without your permission.

If you get your work into an exhibition or have a solo exhibition, don't forget to use the marketing tactics you learn in this book to get the word out. Do a press release. Send out e-mail notices. Let everyone know about the exhibition. Once the exhibition has begun, keep track of all those who view your work. Get their feedback. Capture their e-mail addresses if possible. After the exhibition is over you can send them thank you cards and periodic updates about your work. This is just another way to build your artworld contact list. Always be on the lookout for p9laces where you can exhibit your work at.

CHAPTER 18

ARTISTS' REPRESENTATIVES AND CONSULTANTS

"The art trade is the least transparent and least regulated major commercial activity in the world. Anyone can purchase a business license and become a dealer. There is no required background, no test, no certification."
– Don Thompson

After you've built up your portfolio, got a website up and running, and think you're ready to take the next step? Maybe you should check into letting an art representative handle the business side of things so you can focus on the art? The art rep would do the promotional work while you do the creative work. Sound good? What's the catch you might ask? Well, in typical deals with them, an art rep would get 25 – 30% of the profits for representing you. In art licensing, they typically receive 50% of the profits. Make no mistake about it, you can do all the work yourself. Even some art reps advise you to do just that at first so you can learn the business. Realistically, you're not going to be able to get an art rep if you have no portfolio. Why? Because art reps are always looking for the next sure thing. If you have some experience and have put together a nice portfolio, then you may want to contact some of these art reps I have included.

FYI: Art Illustrators' Reps are different than Fine Artists' Reps. They are in different markets. Reps who work with illustrators sell to ad agencies, publishers, and magazines. Fine artist reps sell to galleries, museums, corporate art collectors, interior designers, and art publishers. Know, and understand, which market you belong to. Then approach the right one.

ART CONSULTANTS

Art consultants are people who shop for art to deliver it to collectors. They want to help a collector put together a good collection. They want to help a collector put together a good collection. Most of the time they do not buy directly from artists. Instead, they purchase their art from galleries, auctions, and fairs. But there are a few who will, and do, work with artists directly. These consultants sell art to individual buyers, corporations, hotels, and interior designers. A prisoner could use an art consultant on their side. You can search Google for "art consultants" to find some in your area. Or you can check out Brainard Carey's updated list of art consultants in his newsletter. See it at: yourartmenter.com.

If you do find some you want to contact remember these tips. Get to know the consultant and their preferences. Don't pay upfront fees. No reputable art consultant asks for money to represent you. They get paid out of the sales they make for you. Send them a professional e-mail with a link to where they can view photos of your art. A one-click link, to your art, not the home page of your website! Keep following up with any consultants you have contacted. Ask them if they're looking for any particular type of art? Keep networking!

ILLUSTRATOR'S REPRESENTATIVES

American Artists Rep, Inc.
1 Chatsworth Ave., Ste.518
Larchmont, NY 10538
(212) 682 – 2462
aareps.com
(send a query letter, flyer, or tear sheets)

Artisan Creative, Inc.
(310) 312-2062
artisancreative.com
E-mail: lainfo@artisancreative.com
(first contact, e-mail resumé, must have 2 years' experience and great portfolio)

Artworks Illustration
(212) 239 – 4946
artworksillustation.com
E-mail: artworksillustration@earthlink.net
(first contact, send samples by e-mail)

Carol Bancroft & Friends
P.O. Box 2030
Danbury, CT 06813
(203) 730 – 8270
carolbancroft.com
E-mail: cbfriends@sbcglobal.net
(specializes in children's book publishing)
(Send 6 samples or more with narrative scenes with children or animals interacting)

Berendsen & Associates, Inc.
5 W. Fifth St., Ste. 300
Covington, KY 41011
(513) 861 – 1400
illustratorsrep.com
(Send a query letter, at least 10 samples of style)

Bernstein & Andriulli
58 W. 40th St., 6th Floor
New York, NY 10018
(212) 682 – 1490
ba-reps.com
E-mail: info@ba0reps.com
(Send query e-mail with digital files)
(This firm requires exclusive career representation)

Joanie Bernstein, Art Rep
756 Eighth Ave. S
Naples, FL 34102
(239) 403) 4393
joaniebrep.com
E-mail: joanie@joaniebrep.com
(send samples by e-mail)
(Exclusive representation required)

Blasco Creative Artists (Jean Blasco)
110 S. William St.
Mount Prospect, Il 60056
(847) 637 – 7986
blascocreative.com
E-mail: jean@blascocreative.com
(send samples by e-mail)
(regular mail submissions will not be returned)

Cornell & Company, Illustrations & Design
44 Job Hill Rd.
Trumbull, CT 06611
(203) 454 – 4210
cornellandco.com
(send a query letter, color copies)

CWC International, Inc.
330 Pearl St., Ste. 2B
New York, NY 10038
(646) 486 – 6586
kokoartagency.com
(submission guidelines online)

Linda De Moreta Represents
(510) 769 – 1421
lindareps.com
E-mail: linda@lindareps.com
(send samples by e-mail)

Libby Ford Artist Representative
320 E. 57th St., Ste. 10B
New York, NY 10022
(212) 9355 – 8068
libbyford.com
(submission guidelines online)

Holly Hahn & Co.
1852 W. Greenleaf
Chicago, IL 60626hollyhahn.com
(send flyer/brochure & tear sheets)

Scot Hull Associates
3875 Ferry Rd.
Bellbrook, OH 45305
(937) 433 – 8383
scotthull.com
E-mail: scott@scotthull.com
(send samples by e-mail)

Cliff Kenect-Artist Representative
309 Walnut Rd.
Pittsburgh, PA 15202
(412) 761 – 5666
artrep1.com
E-mail: cliff@artrep1.com
(send resumé, flier & tear sheets by e-mail)

Sharon Kurlansky Associates
192 Southville Rd.
South borough, MA 01772
(508) 733 – 2761
laughing-stock.com
E-mail: sharon@laughing-stock.com
(Send online portfolio by e-mail)

MB Artists
775 Sixth Ave Ste.6
New York, NY 10001
(212) 689 – 7830
mbartists.com
E-mail: mela@mbartists.com
(Send portfolio by mail with SASE)

Mendola Artist
420 Lexington Ave.
New York, NY 10170
mendolaart.com
(212) 986 – 5680
E-mail: info@mendolaart.com
(send an e-mail with the website link of jpegs)

Munro Campaign Artists Representatives
630 N. State St.Ste.2109
Chicago, IL 60654
(312) 335 – 8925
munrocampagna.com
(send a query letter, bio, tear sheets, SASE)

Painted Words
310 W. 97th St., Ste. 24
New York, NY 10025
(212) 663 – 2891
painted-words.com
E-mail: info@painted-words.com
(send an e-mail with a link to the website)

Christine Prapas, Artist Representative
8402 SW Woods Creek Court
Portland, OR 97219
(503) 245 – 9511
christineprapas.com
(see submission guidelines online)

Retro Reps
Martha Productions
7550 W. 82nd St.
Playa Del Rey, CA 90293
(310) 670 – 5300
retroreps.com
(specializes in vintage styles from the 1920s
to 1970s)

Salzman International
1751 Charles Ave
Arcata, CA 95521
(212) 997 – 0115
salzmanart.com
(20% of art is children's book illustration)

Liz Sanders Agency
2415 E. Hangman Creek Lane
Spokane, WA 99224 – 8514
lizsanders.com
(509) 993 – 6400
(send nonreturnable samples: 8-12 of them)

Freda Scott, Inc.
302 Costa Rica Ave.
San Mateo, CA 94402
(650) 548 – 2446
fredascottcreative.com
E-mail: freda@fredascott.com
(e-mail link to website)

Susan and Co.
(206) 232 – 7873
susanandco.com
E-mail: susan@susanandco.com
(send e-mail letter with samples)

Those 3 Reps
501 Second Ave., Ste. A-600
Dallas, TX 75226
(214) 871 – 1316
those3reps.com
(send query letter and PDFs)

Gwen Walters Artist Representative
20 Windsor Lane
Palm Beach Garden, FL 33418
(561) 805 – 7739
gwenwaltersartrep.com
E-mail: artincgw@gmail.com
(e-mail portfolio)

Deborah Wolfe, Ltd.
731 N. 24t St.
Philadelphia, PA 19130
(215) 232 – 6666
illustrationonline.com
E-mail: info@illustrationonline.com
(send an e-mail with samples)

FINE ARTIST'S REPRESENTATIVES

Brown Ink Gallery
222 E. Brinkerhoff Ave.
Palisades Park, NJ 17650
(973) 865 – 4966
browninkgallery.com
(first contact, send bio, resumé, photocopies)

Joan Sapiro Art Consultants
138 W. 12th Ave.
Denver, CO 80204
(303) 793 – 0792
sapiroart.com
(mail bio, resumé, & CD of JPEG images)

Robert Galitz Fine Art & Accent Art
166 Hilltop Court
Sleepy Hollow, IL 60118
(847) 426 – 8842
galitzfineart.com
(send a query letter and, photographs)

REPRESENTATIVES WHO SPECIALIZE IN LICENSING

MHS Licensing
11100 Wayzata Blvd., Ste. 550
Minneapolis, MN 55305
(952) 544-1377
mhslincensing.com
E-mail: marty@mhslicensing.com
Contact: Marty H. Segelbaum, President
(Send e-mail query, bio, 10 low-res jpegs)
(Submission's guidelines on the website)

Rosenthal Represents
23725 Hartland Street
West Hills, CA 91307
(818) 222-5445
rosenthalrepresents.com
E-mail: eliselicenses@earthlink.net
(Wants artists who have worked in product design)
(Send e-mail, link, jpegs of your work)

*"Art is an adventure into an unknown world, which can be explored
only by those willing to take risks."*
– Mark Rothko

Mark Rothko was an American painter of Russian Jewish descent who painted soft, rectangular forms. He was the leader of New York Abstract Expressionism.

CHAPTER 19

CHILDREN'S BOOK ILLUSTRATION

"One good idea can enable a man to live like a king for the rest of his life."
– Ross Perot

One of the areas in book publishing that always needs artists and illustrators in children's books. But you need a specific drawing skill for these types of books. Some prisoners are already creating their own children's books. You could be next? If you're interested in this avenue, then you may want to join the Society of Children's Book Writers and Illustrators (scbwi.org). A great online community to network with can be found at childrensillustrators.com. Even though I will list some of the children's book publishers that you can submit to, this list is by no means exhaustive. For that, you should get the latest copy of the *Children's Writer's & Illustrator's Market,* edited by Chuck Sambuchino. It would be priceless to you if you started working in this genre.

When submitting your artwork, never send your original artwork. Send photocopies with a brief query letter. You should always check with the publisher first about their specific submission guidelines. You first have to get your foot in the door to get them to look at your illustrations. You do that by submitting your work how they want you to do so. After you've submitted your samples and haven't heard anything for a few months, you can send a postcard inquiring about your submission. As art mentor, Brainard Carey says, "you always deserve an answer to your letter, even if they do not have the time or inclination to meet…" Even if one publisher says no or doesn't respond, there are many other publishers out there. And believe me, they are looking for new artists with fresh ideas and illustrations. Never give up and never say no or the other person.

With that being said, some of the bigger publishers, like Harper Collins Children's Books, won't even work with you unless you have an agent, and the agency submits your materials to them. Because of that, I did not include a lot of the big publishing groups. It would be wise to build your portfolio and then get an agent or representative to contact the big guys in the children's book publishing market. Here are some of the children's book publishers:

The American Bible Society
1865 Broadway
New York, NY 10023 – 7505
(212) 408 – 1200
americanbible.org
(Religious children's books – submit by sending postcard samples)

Atheneum Books for Young Readers
Simon & Schuster
1230 Avenue of the Americas
New York, NY 10020
kids.simonandschuster.com
(Book catalog free upon request. Send postcard samples of work)

Candlewick Press
99 Dover t.
Somerville, MA 02144
(617) 661 – 3330
candlewick.com
(submit to the art coordination associate by e-mail at
illustratorsubmissions@candlewick.com)

Clarion Books
Houghton Mifflin Co.,
215 Park Ave. S.
New York, NY 10003
hmhco.com
(SASE for book catalog. Send samples and query letter)

Dial Books for Young Readers
The imprint of Penguin Group (USA)
345 Hudson St.
New York, NY 10014
(212) 366 – 2000
penguin.com/children
(send a query letter, photocopies, and SASE)

Dutton Children's Book
Penguin Random House
375 Hudson St.
New York, NY 10014
penguin.com
(Send postcard Samples with SASE)
(Pays $1,800 - $2,500 per project)

Grosset & Dunlap
Penguin Group Publishers
375 Hudson St.
New York, NY 10014 – 3657
(212) 366 – 2000
us.penguingroup.com
(Specializes in mass-market children's books, ages 1 – 10! Send postcard sample or query letter with resumé, photocopies, SASE.)

Holiday House
425 Madison Ave.
New York, NY 10017
(212) 688 – 0085
holidayhouse.com
(art submissions guidelines on the website)
(send cover letter, photocopies w/ SASE)

Homestead Publishing
1068 14th St.
San Francisco, CA 94114
(307) 733 – 6248
homesteadpublishing.net
(submission guidelines online)
(looks for watercolor illustrations for children's books)

Immedium
P.O. Box 31846
San Francisco, CA 94131
(415) 452 – 8546
immedium.com
(send a query letter, samples, and SASE)

Jewish Lights-Publishing
Long Hill Partners Inc.
Sunset Farm Offices, Rt. 4
P.O. box 237
Woodstock, VT 05091
(802) 457 – 4000
jewishlights.com
(send postcard samples)

Kaedan Books
P.O. Box 16190
Rocky River, OH 44116
Kaeden.com
(send a postcard sample or query letter with photocopies. Needs drawings of children)

Laredo Publishing Co./Renaissance House
465 Westview Ave.
Englewood, NJ 07631
(201) 408 – 4048
renaissancehouse.net
(e-mail samples to laredo@renaissancehouse.net)
(specializes in children's and juvenile books for the Hispanic market)

Lee & Low Books
95 Madison AveSte.1205
New York, NY 10016
(212) 779 – 4400
leeandlow.com
(submit a query letter, resumé, photocopies, and SASE)
(looking for samples that feature children of diverse backgrounds)

Onstage Publishing
190 Lime Quarry Rd., Ste. 106-J
Madison, AL 35758-8962
(256) 542-3213
onstagepublishing.com
(send samples, one should be color, one should be b/w. Needs to see how you portray children in action, ages 8 – 18).

Richard C. Owen Publishers, Inc.
P.O. Box 585
Katonah, NY 10536
(914) 232 – 3903
rcowen.com
(books for 5-7 years old kids, nonfiction)

Peachtree Publishers
1700 Chattahoochee Ave
Atlanta, GA 30318-2112
(404) 876 – 8761
peachtree-online.com
Nicki Carmack, creative director
(specializes in children's and young adult titles)
(prefers acrylic, oils, watercolor, or mixed media on flexible material for scanning)

Albert Whitman Company
250 S. Northwest Hwy., Ste. 320
Park Ridge, IL 60068
(800) 255 – 7675
albertwhitman.com
(specializes in picture books for young children. Send a postcard sample and at least 3 tear sheets.)

CHAPTER 20

COMIC STRIPS, COMIC BOOKS, AND GRAPHIC NOVELS

"Those who do not want to imitate anything, produce nothing."
– Salvador Dali

When you think of comics you may think of the ones you see in the many newspapers around the country. My grandfather used to call them "the funny pages." Most of those comic strips were placed there by syndicates. In the art world, a syndicate is an agent who sells comic strips, panels, and editorial cartoons to newspapers and magazines. So, if you want to see your comic strip in a newspaper you first should pitch your idea to a syndicate. It will be hard for an emerging artist to crack the comic strip code and get into a major newspaper. To do so, you'll have to bump an already existing comic strip. It can be done though.

Another avenue for a cartoonist is to put their comic strip online. You might not make the big money at first, but you could certainly use it for promotional purposes. A top comic strip, like *Garfield®,* or *Blondie®,* can be seen in over 2,500 daily newspapers. Most newspapers pay $10 - $15 a week for a daily comic feature. Doesn't sound like much until you do the math. The more newspapers you get in the more money you'd make. $10 a week in 50 newspapers equals $500 a week. 200 newspapers would equal $2,000 a week. Most syndicates split the profits 50/50 with the cartoonist. Of course, you don't have to even go through a syndicate. You can always self-syndicate your comic strip. That way you would get all the profits. But you'll have to do all the work. It will be a lot harder that way. One way would be to start with the alternative newspapers or weeklies Then once you break into the market you could go back and pitch your comic strip to the major syndicates.

To submit your comic strip to a syndicate you should have at least twenty-four of your best samples ready. They should be photocopies of your work, not the originals. These should be on 8 ½ x 11 paper, six daily strips per page. That's a month worth of samples in the comic strip world. You have to submit this number of strips to prove that you can do consistent work and carry the idea and story with the names and descriptions of your major characters. Lastly, you should have a cover letter explaining your idea.

RESOURCE BOX

If this is something you want to pursue, here are some books you should consider reading:

- *How to Draw and Sell Comics, 3rd Edition* by Alan McKenzie
- *The Insider's Guide to Creating Comics and Graphic Novels* by Andy Schmidt
- *Comics and Sequential Art: Principles and Practices from the Legendary Cartoonist* by Will Eisner
- *Your Career in Comics* by Lee Nordling
- *Successful Syndication: A Guide for Writers and Cartoonists*

All of these books can be found online. Contact Freebird Publishers about ordering them if you don't have someone to help you.

FOR MORE INFORMATION

Here are the major syndicates in the United States:

City News Service, LLC.
P.O. Box 86
Willow Springs, MO 65793-0086
(417) 469 – 4476
cnsus.org
E-mail: cns@cnsus.org
(editorial cartoons, and business themes)

Creators Syndicate, Inc.
737 Third St.
Hermosa Beach, CA 90254
(310) 337 – 7003
creators.com
E-mail: info@creators.com
(submission guidelines online)

Continental Features
501 W. Broadway
P.O. Box 265, Plaza A
San Diego, CA 92101-3802
(858) 492-8696
continentalnewsservice.com
(submission guidelines for #10 envelope
SASE with First-Class Postage)

King Features Syndicate
Hearst
300 W. 57th St., 15th Floor
New York, NY 10019-5238
(212) 969-7550
kingfeatures.com
(ATTN: submissions Editor [Your Name] and
Address on every page you submit)

Universal Uclick
1130 Walnut St.
Kansas City, MO 64106
univerrsaluclick.com
E-mail: submissions@amuniversal.com
(Art guidelines available on the website)

Washington Post Writers Group
1150 15tth St. N.W.
Washington, DC 20071
(202) 334-5375
postwritersgroup.com
Contact: Comics Editor
(submission guidelines for #10 envelope
SASE)

Whitegate Features Syndicate
71 Faunce Dr.
Providence, RI 02906
whitegatefeatures.com
E-mail: webmaster@whitegatefeaturres.com
(Guidelines available on the website)

Another great resource that provides books, links, and other sources is Stu's Comic Strip Connection @ stus.com/index2.htm.

COMIC BOOKS & GRAPHIC NOVELS

When I first started doing time, I was a lot younger and didn't know how to capitalize on great ideas

when I heard them. Some 20 years ago in the Joliet maximum-security prison in Illinois, another prisoner approached me with an idea. He saw that I was always reading and writing, and he was a great artist, so he wanted to combine our talents. That way we both could make some money. He was really into playing football and I was really into watching it and gambling on it. His idea was to do a graphic novel series about football-playing prisoners who were zombies and vampires. But I was too stupid to do anything with his idea.

Years later as I watched AMC's hit tv show, *The Walking Dead,* I cringed. *The Walking Dead* started as a graphic novel series and was part of a huge zombie craze that hit the entertainment industry. But I totaled it because I fumbled the ball, he tried to give me. He was a great artist, and his preliminary illustrations were awesome. Hey, "Sleepy," if you're reading this, hit me up, maybe we can still collaborate?

RESOURCE BOX

If you're interested in doing a comic book or graphic novel, then consider reading the following:

- *Graphic Storytelling & Visual Narrative* by Will Eisner
- *Comic Book 101: The History, Methods, and Madness* by Chris Ryall and Scott Tipton
- *Making Comics: Storytelling Secrets of Comics, Manga, and Graphic Novels* by Marques Vickers

All these books can be found online. Contact Freebird Publishers about ordering them if you don't have someone to help you. You can also check out the online websites:

- gocomics.com
- comicsreporter.com
- the-nose.com

Here are some of the comic book and graphic novel publishers in the United States:

Antarctic Press
7272 Wurzbach, Ste. 204
San Antonio, TX 78240
(210) 614 – 0396
antarctic-press.com
(submissions guidelines on the website)

NBM Publishing
160 Broadway, Ste. 700
East Bldg.
New York, NY 10038
nbmpub.com
(adult graphic novels only!)
(check website for submission guidelines)

Dark Horse
10956 SE Main St.
Milwaukee, OR 97222
(503) 652-8815
darkhorse.com
(submission guidelines on the website)

Fantagraphics Books, Inc.
7563 Lake City Way NE
Seattle, WA 98115
(206) 524 – 1967
fantagraphics.com
(guidelines available on the website)

Heavy Metal Media, LLC
116 Pleasant St., Box 18
Easthampton, MA 01027
(413) 527 – 7481
heavymetal.com
(submission guidelines on the website)

Papercutz
160 Broadway, Ste. 700E
New York, NY 10038
(646) 559 – 4681
papercutz.com
(graphic novels for teens, especially manga!)

IDW Publishing
2765 Truxtun Rd.
San Diego, CA 92106
idwpublshing.com
(submission guidelines on the website)

Image Comics
2701 NW Vaughn St, Ste. 780
Portland, OR 97210
imagecomics.com
(detailed guidelines online)

New England Comics (NEC Press)
732 Washington St.
Norwood, MA 02062
(508) 857-3530
newenglandcomics.com
(submissions script on the website)

Baen Books
P.O. Box 1188
Wake Forest, NC 27588
(919) 570 – 1640
baen.com
(scifi/fantasy book catalog free on request).

Daw Books, Inc.
Penguin Random House
375 Hudson Street
New York, NY 10014
(212) 366-2096
dawbooks.com
(guidelines available online)

These listings are by no means exhaustive. You are encouraged to review the latest edition of *The Artists' Market* for more publishers. There are some major comic book publishers, like DC Comics, that do not take unsolicited submissions. To break into DC Comics, you must drop off photocopied samples of your work at their booth during a comic convention. If DC Comics representatives like what they see they'll contact, you for a discussion on your interests and portfolio. That does not help prisoners, so I didn't include their contact information. If you're an avid comic book/graphic novel reader, then you can always look at your comics to see if their contact information is listed. Write it down in your files. When you're ready, have someone go online and get their submission guidelines for you. Then put your best work together and send it in. It only takes one "yes" to change your life. Keep practicing and keep submitting. Listen to constructive criticism and get better. Your comic or graphic novel could be the next *Walking Dead.*

Another great place to look for inspiration and ideas is:

Buds Art Books
P.O. Box 1689
Grass Valley, CA 95945
(530) 273-2166
budsartbooks.com
(rare comics/graphic novels and nude photo books)

Lastly, I have saved the best for last. The godfather of the Marvel studios and comic book kingdom is Stan Lee. He passed away and is drawing comics for the gods now, but you can read his story and get plenty of tips in both of the below books:

- *Marvelous Life: The Amazing Story of Stan Lee*, by Danny Fingeroth
- Stan Lee's How to Draw Comics, by David Campiti

"Art is an experience, not an object."
– Robert Motherwell

Robert Motherwell was an American painter, printmaker, and editor.
His work featured simple shapes, bold color contrasts, and dynamic balances.

CHAPTER 21

CONTESTS

"One surefire way to get some buzz going is to win a few awards – or even become a finalist."
– Peter Bowerman

Contests can be a great way to build your résumé and make some money. In *The Millionaire Prisoner,* I tell the story of a Latino prisoner named "Cocaine" that I met in 2013. He entered a *Lowrider Arte* magazine contest and won the best picture with a prize of $400. For a lot of you that $400 would go a long way to helping you. When entering art contests, you should keep in mind two things: the entry fee, and rights to the entrant's work. Here's why. A lot of contests charge fees and that's how they make their money. They get all these artists who hope to win paying the fees, but even if they win an award, it hardly means anything. The second problem is that once you pay the entry fee and submit your artwork, the contest owns all the rights to your submission no matter if you win or not. That's why you should always check the contest's rules before you submit your work. Here's what Jackie Battenfield says about contests in *The Artist's Guide:*

- Look for shows that don't charge entry fees to enter. You may need to pay to ship if selected, but the jury process should be free.

- Select shows with a specific theme that applies to your work.

- consider shows open only to regional artists; these can be a good way to expand your connections to your community.

- Most of all, apply only to those juried exhibitions sponsored by an organization you value and trust.

Pretty good rules to follow. But it's your career and your art. You can do whatever you want. Just remember that you're trying to become a Prison Picasso. The object is to go from doing arts and crafts in our cell for commissary items to making thousands of dollars in free-world money. So never assign rights to your work without first getting paid or having a written agreement saying you still own the rights to the work. Or that you will be paid if the work is sold, which should be put into a signed written agreement as well. With that in mind here are some contests that you could enter. This list is by no means exhaustive and there are plenty of art contests that are announced in art magazines every month. Make sure you write the rules and entry forms before you send any money or artwork.

440 Gallery Annual Themed show
440 Sixth Ave.
Brooklyn, NY 11215
(718) 449 – 3844
440gallery.com
(Visit the website late Sept./early Oct. on the "Call for Entry" page for theme/rules)

American Society of Aviation Artists
International Art Exhibition
581 Airport Road
Bethel, PA 19507
(732) 735 – 6545
asaa-avart.org
($50 entry fee for non-ASAA members)
(See website for rules and deadlines)

Annual Hoyt Regional Art Competition
124 E. Leasure Ave.
New Castle, PA 16105
(724) 652 – 8882
E-mail: hoytexhibits@hoytartcenter.org
(Entry fee: $25, open to all artists who live within a 250-mile radius of New Castle, PA> 1st place $500, 2nd place $300, 3rd place $150, 6 $50 merits. E-mail for rules/deadlines.)

Another World Art Contest
Diana Perry Books
P.O. Box 1001
Reynoldsburg, OH 43068
dianaperrybooks.com
(Entry fee is $15 money order. 1st place $200, 2nd prize $150, 3rd prize $100, 4th prize $50, 5th prize $25. Rules and entry form on the website)

Artist Fellowships
Virginia commission for the Artis
1001 E. Broad St., Ste. 330
Richmond, VA 23219
(804) 225 – 3132
arts.virginia.gov
(Open to legal residents of Virginia)
(Amounts awarded: $4,000. Write for more
information in July.)

Artistic Dreams
159 N. Main St.
Smithfield, UT 84335
(435) 755-8126
artisticdreams.net
(Have to enter online. Winners receive $100
and a copy of the anthology. Free to enter.
See the website for more information about
rules.)

Artists Alpine Holiday
Ouray County Arts Association
P.O. Box 167
Ouray, CO 81427
(970) 626 – 5513
ourayarts.org
($30 entry fee for 2 entries; cash awards for
1sst, 2nd, and 3rd prizes in all categories total
$7,200. See the website for more
information.)

The Artist's Magazine All-Media
F&W Media, Inc., Competition Dept.
10151 Carver Rd., Ste. 200
Blue Ash, OH 45242
(715) 445-4621, ext. 13430
artistsnetwork.com/competitions
E-mail: art-competiton@fwmedia.com
($25/entry fee. The Grand prize is $500. E-
mail for more information.)

The Artist's Magazine Over 60 Competition
(Same information as above.
$25 per entrant, 10 winners get $100. E-mail
for more information.)

The Artist's Magazine's Annual Art
Competition
(Same information as above.
$25 per entry, $2500 1st place prize. E-mail
for more information.)

Artslink Project Award
CEC Artslink
291 Broadway, 12th Floor
New York, NY 10007
(212) 643 – 1985, ext. 23
cecartslink.org
(See website for rules/details.)

Bucktown Arts Fest Poster Contest
2200 N. Oakley
Chicago, IL 60647
bucktownartsfest.com/posters
Contact: Amy Waldon, committee member
(Check the website for more details, a fee to
enter)

Colored Pencil Magazine Annual Art
Competition
P.O. Box 183
Efland, NC 27243
(919) 400 – 8317
coloredpencilmag.com
(See website for more information.)

Comic Book Art Contest
Diana Perry Books
P.O. Box 1001
Reynoldsburg, OH 43068
dianaperrybooks.com
($15 entry fee. Contest guidelines and entry
forms are online. $200 to 1st place.)

Creative Quarterly Call for Entries
244 Fifth Ave., Ste. F269
New York, NY 10001-7604
(718) 775 – 3943
cqjournal.com
(Fees vary, quarterly contest.)
(See website for more details.)

Direct Art Magazine Publication Competition
Slow Art Productions
123 Warren St.
Hudson, NY 12534
slowart.com
(Send SASE for more information)

Embracing Our Differences
P.O. Box 2559
Sarasota, FL
(941) 404 – 5710
embracingourdifferences.org
(No fee. Prize $4,000. See the website for
more information.)

Emerging Artists
Slow Art Productions
123 Warren St.
Hudson, NY 2534
(518) 828-2343
slowart.com
Contact: Tim Slowinski, director
(Cost: $35. $2,200 in awards. See the
website for more information.)

Love Unlimited Film Festival & Art Exhibitions
100 Cooper Point Rd, Ste. 140-136
Olympia, WA 98502
communitygardentlove.org
(Over $30,000 in awards. See the website for
more information.)

Michigan Annual Art Competition & Exhibition
125 Macomb Place
Mt. Clemons, MI 48043
(586) 469 – 8666
theartcenter.org
(For Michigan residents, $35 entry fee,
$1,000 for 1st place, $600 for 2nd, $400 for 3rd.
Send SASE for more information.)

Motion In Art and Art in Motion
Art League of Long Island
107 E. Deer Park Rd.
Dix Hills, NY 11746
artleagueli.org
($40 entry fee, open to NY artists who live in
Suffolk, Nassau, Brooklyn, and Queens.
Prize: $500 awards.)

Pastel 100
F+W Media, Inc.
Competitions Dept.
10151 Carver Rd., Ste. 200
Blue Ash, OH 45242
artistsnetwork.com/pasteljournalcompetition
Contact: Anne Hevener
(Cost $25 - $30, cash prizes. See the website
for more information.)

A Show of Heads
Slow Art Productions
123 Warren St.
Hudson, NY 12534
(518) 828 – 2343
slowart.com
(Cost $35, a contest for art depicting a human
head. The website for more information

Splash: The Best of Watercolor
F&W Media, Inc.
Competition Department
101451 Carver Road
Blue Ash, OH 45242
(715) 445-4612, ext. 13430
splashwatercolor.com
($30 entry, winners get published in a book.
See the website for more information.)

Strokes of Genius: The Best of Drawing
[Same address as above]
artistsnetwork.com/strokes-of-genius
($30 entry fee, winners get published in the
book. See the website for more information.)

Tallahassee International Juried Competition
530 W. Call Street, Room 250FAB
Tallahassee, FL 32306-1140
(850) 644-3906
mofa.cfa.fsu.edu/participate/Tallahassee-
international
Contact: Jean D. Young, Coordinator
(Cost $20/ 2 images, $1,000 for 1st place,
$500 for 2nd. See website for more
information.)

Game Informer Reader Art Contest
724 First Street North, 3rd Floor
Minneapolis, MN 55401
(Video game magazine. Include name and
address with art.)

FINE ARTS & CRAFTS COMPETITION VIRTUAL AUCTION & SALE

SUBMISSION GUIDELINES

Carefully Read & Follow Guidelines to Avoid Disqualification

The 13th Annual InterNational Prisoner's Family Conference will feature a Prisoners' Arts Competition for currently incarcerated artists. The two submission categories include: 1) small fine art drawings or paintings, and 2) crafts (including leatherwork; jewelry & woodwork). Winners will be announced on the final day of the 2021 InterNational Prisoner's Family Conference and prizes distributed by mail the following month. The conference is established as a nonprofit organization strengthening all persons affected by incarceration personally and/or professionally. Conference presenters and attendees are prison family members, former prisoners and representatives of secular and faith-based organizations serving prisoners and their families.

PRIZES WILL BE AWARDED IN BOTH FINE ART AND CRAFTS CATEGORIES AS FOLLOWS:
 1st Place - $200
 2nd Place -$100
 3rd Place- $50

New for 2021: The InterNational Prisoner's Family conference is excited to announce that artists who receive 1st, 2nd, and 3rd place awards will have their works featured in the ATLaS Justice Center's *Freedom of Art* virtual art gallery and if eligible, may be selected for a live show at the Walnut Gallery in Denver, Colorado.

Judges for the 2021 competition include incarcerated and formerly incarcerated artists.

SUBMISSION GUIDELINES

- Original Fine Art and Craft Pieces – No larger than 18" x 18"
- Maximum Number of submissions per person: 3 in each category (either fine art or crafts)
- Matted Drawings preferred but not required
- **The subject matter for the art pieces must be family friendly and cannot contain overtly sexual themes or images.**
- Entry DEADLINE: Postmarked no later than **August 1, 2021.**
- Judging criteria: Originality; Composition; Technique

Additional Guidelines:

- Label identification on **back OR bottom** of each submission, including: Title of Work, Artist's name & mailing address
- Complete and sign the enclosed Entry Form, including the agreement indicating an understanding submissions **cannot** be returned, but are donated to and become the property of the InterNational Prisoner's Family Conference.
- **SILENT AUCTION/SALES OF ART & CRAFT WORKS:** Submissions will be offered for silent auction at the conference and/or for sale on conference website. Artist/Craftsperson receives **25% of this revenue in excess of $20.00.** o Funds from auction of donated art and craft works are applied to contest prizes and conference scholarships.

Mail submissions to: *Art Competition Coordinator,*
InterNational Prisoner's Family Conference
P.O. Box 532
Carrizozo, NM 88301

INFORMATION FOR FAMILIES & FRIENDS

Family and friends are encouraged to assist artists/crafts-persons as follows:

- Upon request this document will be e-mailed in Word format to best assure receipt and printing by those inquiring.
 - o Do not alter the document.
- Send a **SELF ADDRESSED STAMPED ENVELOPE** if requesting guidelines be sent to prisoners, OR
- Provide these guidelines to the artist(s)/author(s).
- Discuss and agree with artist(s)/author(s) on arrangements for any prize money that may be won
- Assist artist(s)/crafts-persons/author(s) as needed in submitting and mailing their work.
 Confirm submission has been received after mailing by e-mailing Jacquelyn Frank:
 jbfrank@eiu.edu

For information on the InterNational Prisoner's Family Conference, visit the conference website: www.prisonersfamilyconference.org. For additional information and questions, you may e-mail: info@prisonersfamilyconference.org or phone: 915-86p1-7733.

NOTE: TO RECEIVE A REPLY TO WRITTEN CORRESPONDENCE ENCLOSE A SELF ADDRESSED, STAMPED ENVELOPE (SASE).

InterNational
PRISONER'S
FAMILY
CONFERENCE

| 2021 Fine Arts & Crafts Competition |
| Auction/Sale |
| **ENTRY FORM & SUBMISSION AGREEMENT** |

Name/#: _____

Mailing Address: Unit: _____

For additional submissions, attach separate page. You may create your own form, but type or print legibly. For additional forms send SASE to:

Art Competition Coordinator,
InterNational Prisoner's Family Conference
P.O. Box 532
Carrizozo, NM 88301

Submitting: ☐Fine Art ☐Crafts ☐ Leatherwork ☐ Jewelry ☐Woodwork ☐ OTHER

Entry #1: Title/Description:_____

Medium (Art/Craft material): _____

Entry #2 Title/Description:_____

Medium Art/Craft material):_____

Entry #3: Title/Description:_____

Medium (Art/Craft material): _____
Please send competition prize money and/or money earned from silent auction/sales (25% of $20 or more) to:

Name: _____

Full Address: _____

- If being sent to a facility, provide the PROCEDURE & NECESSARY FORM (use back of this form, if necessary)
- If being sent to an apartment, include apartment number.

NOTE: PAYMENT MADE TO PRISON ACCOUNT/TRUST FUND OR COMMUNITY MEMBERS ONLY. (NO payments will be made through any prison vendor, i.e. Jpay, GTL, etc.)

By signing this form I acknowledge my understanding that my submission(s) cannot be returned. I am donating my submitted work to The InterNational Prisoner's Family Conference is a a nonprofit organization. Any funds raised from the silent auction/sale of my work, **except as specified in submission guidelines** above will be applied to contest prizes and/or conference prison family scholarships.

Please sign to denote you have read and understand these guidelines

Signature

Printed Name

Date _____

All submissions must be postmarked no later than August 1, 2021.

CHAPTER 22

GREETING CARDS

"Remember that there are typically many paths to achieving your goals.
You only need to find one that works."
– Ray Dalio

A LESSON FROM GOAT BOY

In my prison system, we can't control who is assigned to our cells. When you have been locked up 20 years like I have you get all kinds of weirdos as cellmates. After a short period of having a cell to myself, I watched as the gallery officer put the key in my door to let a goofy-looking white guy in my cell. After I screened him and checked his paperwork, I decided he could stay on the top bunk. After a few days I kept noticing that every time the officers walked by our cell, or my celly went by them, they made goat noises at him! WTF? He looked like he could have sex with goats. Could he be something from a *Hills Have Eyes* movie? Out of curiosity, I asked him. He said that before he came to prison, he worked for a strip club and adult video store. His job was to walk around the block with the store mascot – a goat – and advertise the club and the latest sale. Because the strip club was close to my prison, a lot of the officers who worked at the prison had seen him doing that. So, they made fun of him. By the way, he was in prison for shooting the store clerk and robbing it. So that's how he became known as "Goat Boy."

One day we were debating how to make money from prison. He saw me getting money and kept asking me why I didn't make and sell greeting cards? I kept laughing because his cards looked like a 3rd grader did them. At that time, I had just got a $405 royalty check off one of my books. So, I made him a bet. If he could show me how he could make $400 off a greeting card, I would make

burritos for him. If he couldn't show me, then he would have to make them. He said it was a bet and I thought it would be the easiest burritos I ever got. Then he went into his property box and pulled out the Hallmark ® Letter. When I read it, I knew I was making burritos that night for him, and I also knew that my next book would be the one you're holding in your hands. What the letter said was that they would consider any poetry and greeting card designs for their company and they would be willing to pay up to $400 for them if they felt they fit their stated guidelines. After I made burritos that night, I went on a research quest to find out more about how to design and license cards for greeting card companies. My research is included in this chapter. And yes, I list the addresses of companies that pay for designs. But this example shows you that there are ways to make better money with your art. Even goat boys have been known to think outside the cell sometimes.

HOW TO MAKE $2,400 A YEAR WITH GREETING CARDS

Would that change your life while inside prison? Here's how one prisoner does it. He makes specialty cards. He told me that his goal is to make at least one card a day that he can sell for $10 to somebody in our prison. You may think that $10 is a lot for a greeting card? It's not when you consider that his cards are the best on the compound and that he caters to the pen pal crowd. Those customers see greeting cards as an investment. And some of those guys have special requests for which he charges more. What type of cards you may ask? Big 8 x 10 pop-up cards. Special Valentine's Day cards. His cards aren't just the cookie-cutter cartoon cards you put inside a regular envelope and sell for $3 in the commissary. He does those when he just wants to make some quick money. But he told me that his goal is $50 a week in incoming merchandise. He normally meets that goal and does better during February and December. Makes sense as those days and months are the two biggest card buying months of the year because of Valentine's Day and Christmas. After we talked, I went back to my cell and did the math: $50 a week times 4 weeks = $200 a month. Or $2,400 a year from cards! But he's smart with his money and has been selling excess merch that he builds up for money orders to his books. He also has some customers that

put money directly into his trust fund account. He showed me his account balance and it had over $4,000 in it. He's winning. A nice little hustle. You could do the same thing.

RESOURCE BOX

If you're interested, then you should order some of (if not all) the following books:

- *The Cardmaker's Bible* edited by Cheryl Brown
- *Quick & Clever Handmade Cards* by Julie Hickey
- *The Ultimate Cardmaker* by Assorted card makers
- *Paper Pop Up* by Dorothy Wood
- *100 Great Ways to Make Cards* by Shirley Toogood
- *Surprisingly Simple Novelty Cards* by Sue Nicholson
- *Quick & Clever Christmas Cards* by Elizabeth Moad
- *Quick and Easy Handmade Cards* by Petra Boase
- *How To Make Super Pop-Ups* by Joan Irvine
- *Paper Flower Note Cards* by Emiko Yamamoto
- *Origami Card Craft* by Karen Elaine Thomas
- *100 Simple Paper Flowers* by Kelsey Elam
- *Hand-Lettering Ledger* by Mary Kate McDevitt
- *Hand Lettering* by Thy Doan Graves

The above books will give you a ton of great ideas and techniques to stop your card game up. You can get a lot of them from Edward R. Hamilton Bookseller Company, P.O. Box 15, Falls Village, CT 06031-0015.

The universe has a funny way of the things we have been overlooking. As I started working on this book, I got a beautiful card in the mail from one of my pen pals. It had two cardinals sitting on a tree limb with some flowers around them. It was signed by artist Abraham Hunter. When I turned it over, I saw that the art had been licensed to the greeting card company by MHS Licensing. In my book *The Millionaire Prisoner,* I wrote that a prisoner could license their art to a greeting card company. How did I know that? Because one of my cellmates had a letter from Hallmark that he showed me. In the letter, they told him to go online to get the submission guidelines and if he submitted his poetry and artwork in the proper format, they would consider it. Wow! How would that change your life? You could go from selling cards in your cell house for $3 to making a card once and getting paid off it forever. It's possible. This chapter will list the addresses of companies who will take your art and put it on greeting cards, t-shirts, coffee mugs, calendars, and many more products. Some of these companies even look for fine art that they put on limited-edition collectibles. The sky's the limit.

Here are some tips when submitting your artwork to these companies:

- Do not send your original artwork. Try to get color photocopies made if possible? Some of these companies accept digital JPEGs via e-mail.

- Art should be upbeat and suitable for use on major holidays like Christmas, Easter, and Valentine's Day. FYI: Christmas cards account for 60% of the sales in the 47.5 billion greeting card market.

- Make sure your submitted samples each are labeled with your full contact information, including your website and e-mail address if you have them.

- Send four samples tailored to that company's market. Include a cover letter and SASE with your samples.

There are other factors that you should consider. Women buy 80% of all greeting cards so your art should be slanted to what women like. There are a lot of greeting card categories and there are over 3,000 greeting card companies. Pay attention to all of the cards you get in the mail and the ones your fellow prisoners get. Keep a notebook with ideas you see on the cards. Also, write down the companies who make the cards in your notebook if they are not listed in this chapter. If you want to take advantage of this market, you should consider subscribing to the official magazine of the Greeting Card Association. It's called *Greetings Etc.* (greetingsmagazine.com).

GREETING CARD COMPANIES

Alef Judaica, Inc.
15020 S. Figueroa St.,
Gardena, CA 90248
(800) 262 – 2533
alefjudaica.com
(Judaica products, pays $300)

Allport Editions
716 NE Lawrence Ave.
Portland, OR 97232
(503) 223 – 7268
allport.com
(Guidelines on the website, specializes in pen and ink, and watercolor cards.)

Artful Greetings
2104 Riddle Rd.
Durham, NC 27713
(919) 598 – 7599
artfulgreetings.com
(No b/w art, must be color. Pays $50 - $100. Send samples by e-mail.)

Barton-Cotton, Inc.
3030 Waterview Ave.
Baltimore, MD 21230
(800) 348 – 1102
bartoncotton.com
(Free art guidelines with SASE, specify which area of interest? Religious? Christmas? Spring?)

Bellmuse
71 Nassau St., 2nd Floor
New York, NY 10038
(212) 727 – 0102
bellamuse.com
(Send a query letter, postcard sample with résumé, and tear sheets.)

Bloomin' Flower Cards
3080 Valmont Rd.
Boulder, CO 80301
(800) 894 – 9185, est.2
bloomin.com
(Samples must be digital and only wants flowers, garden scenes, birds, and butterflies.)

Blue Mountain Arts, Inc.
P.O. Box 5459
Boulder, CO 80306
(303) 449 – 0536
sps.com
E-mail: editorial@sps.com
(Art guidelines via e-mail. Wants hand-painted art in 5x7 vertical format for greeting cards. Pays $150 – $250 if chosen.)

Ashleigh Brilliant Enterprises
117 W. Valerio St.,
Santa Barbara, CA 93101
(805) 682 -0531
ashleighbrilliant.com
Contact: Ashleigh Brilliant, President
(Publisher's postcards. Wants single panel,
maximum size 5 ½ x 3 ½, horizontal only.
Pays $60 minimum. Send b/w line drawings
and SASE.)

Brush Dance, Inc.
3060 El Cerrito Plaza, Ste. 400
San Rafael, CA 94530
brushdance.com
E-mail: art@brushdance.com
(Submission guidelines available online.)

Calypso Cards
166 Valley Street
Providence, RI 02909
(978) 287 – 5900
calypsocards.com
E-mail: nicky@calypsocards.com
(E-mail query letter, samples.)

Cardmakers
424 Fore St.
Portland, ME 04101
(207) 761 – 4279
cardmakers.com
(Art guidelines available online.)

Courage Cards
Courage Kenny Cards
1750 Tower Blvd.
North Mankato, MN 56003
(800) 992 – 6872
couragecards.org
E-mail: artsearch@couragecenter.org
E-mail name and address to receive Art
Search guidelines. Pays $400 per selected
image! Wants colorful holiday artwork.)

Design Design, Inc.
19 La Grave Ave.
Grand Rapids, MI 49503
(616) 771 – 8319
designdesign.us
(Send a query letter with samples and SASE.)

Emery-burton Fine Cards & Gifts
P.O. Box 31130
Seattle, WA 98103
(866) 617 – 1259
emery-burton.com
(Fine art should be 5x7, send a query letter
with SASE.)

LPG Greetings, Inc.
813 Wisconsin St.
Walworth, WI 53184
(262) 275 – 5600
lpgcreative.com
E-mail: judy@lpgcards.com
(Send e-mail for art guidelines.)

Madison Park Greetings
The Madison Park Group
800 S. Michigan St., Ste. B
Seattle, WA 98108
(206) 324 – 5711
madisonparkgreetings.com
(Art guidelines available for SASE.)

MEAD
4751 Hempstead Station Dr.
Kettering, OH 45429
(800) 565 – 5396
ataglance.com
(Art guidelines available for SASE.)

Nobleworks Cards
500 Paterson Plank Rd.
Union City, NJ 07087
nobleworkscards.com
(Funny, raunchy, adult cards! Send SASE for
art guidelines.)

Oatmeal Studios
P.O. Box 191
Rochester, VT 05767
(800) 628 – 6325
oatmealstudios.com
(Art guidelines for SASE.)
(Cards are 5x7 so art must match that size.)
(Cards are funky, cartoony type art in color.)

The Occasions Group
E-mail: dknutson@theoccasionsgroup.com
theoccasionsgroup.com
(Pays $250 - $500 per project)

Paper Magic Group, Inc.
54 Glenmaura National Blvd., Ste. 200
Moosic, PA 18507
(800) 278 – 4085
papermagic.com
(Send a query letter with résumé, color photocopies, and SASE to ATTN: Creative Director.)

The Printery House
Conception Abbey
P.O. Box 12
37112 State Hwy. IN
Conception, MO 64433
(660) 944 – 3110
printeryhouse.org
prineryhouse.org
(Publishes Christian greeting cards. Pays $300 - $650 for illustration. Art guidelines are available upon request.)

Prudent Publishing
65 Challenger Rd., 5th Floor
Ridgefield Park, NJ 07660
(201) 641 – 7900
gallerycollection.com
(Art guidelines for SASE.)

P.S. Greetings
5730 N. Tripp Ave.
Chicago, IL 60646
(773) 267 – 6150
psgreetings.com
(Artist guidelines for SASE.)

Recycled Paper Greetings, Inc.
111 N. Canal St., Ste. 700
Chicago, IL 60606 - 7206
(800) 777-3331
recycledpapergreetings.com
(Send submissions to the "Art Department." Send 10 Birthday ideas to mimic 10 complete cards, vertical 5x7. Send photocopies.)

The Regal Line/ACME Graphics
P.O. Box 2052
Cedar Rapids, IA 52406
(319) 364 – 0233
regalline.com
(Art guideline for SASE)

Paula Skene Designs
1250 45th St., Ste. 240
Emeryville, CA 94608
(510) 654 – 3510
paulaskenedesigns.com
(Send tear sheets and photocopies. Only 2 samples.)

Syracuse Cultural Workers
P.O. Box 6367
Syracuse, NY 13217
(315) 474-1132
syracuseculturalworkers.com
(Art guidelines for SASE.)
(Pays $70 - $450.)

Wanda Wallace Associates
323 E. Plymouth, Ste. 2
Inglewood, CA 90302
(310) 419 – 0376
wandawallacefoundation.org
(produces black/ethnic Christmas cards. Send a query letter with samples.)

Warner Press, Inc.
1201 E. Fifth St.
Anderson, IN 46012
(800) 741 – 7721
warnerpress.org
Contact: Curtis Corzine
(Christian children's greeting cards. Send postcard samples with the query letter. Art guidelines are available online.)

Ziti Cards
601 S. Sixth St.
St. Charles, MO 63301
(800) 487 – 5908
ziticarrds.com
E-mail: mail@ziticards.com
(Art guidelines are available via e-mail. Pays $50 advance plus 5% of royalties at end of the season.)

Wistful Expressions
P.O. Box 1284
Campbell, CA 95009
(888) 748 – 9333
wistfulexpressions.com
(Open to art submissions.)

LICENSING ART

When you grant another company the right to use your artwork on greeting cards, coffee mugs, t-shirts, or other merchandise, you are entering into a licensing deal. The best guide for artists on this subject is *Licensing Art & Design* by Caryn Leland. It's available from Allworth Press, 10 East 23rd Street, Ste. 510, New York, NY 10010. Write for a free catalog of art books.

Here's a painting by artist Jim Daly. Yes, it is copyright protected. You cannot use it for commercial purposes. This was on the front side of a greeting card my mother sent me. It was licensed to the greeting card company by Ansada Licensing Group, LLC out of Sarasota, Florida. That information was on the back of the card. I've included it here for two reasons. One is so you can begin to get the idea that there's more money in greeting cards than you might think. Two, so you begin to start noting how art is licensed outside prison walls. Pay attention to all the greeting cards you get. Look on the back of them to see if the art was licensed to the company? Be inspired. *Prison Picassos* think outside the cell!

OTHER COMPANIES

AR-EN Party Printers, Inc.
3416 Oakton St.,
Skokie, IL 60076
(847) 673 – 7390
ar-en.com
(Send a query letter with brochure, résumé, and SASE. Specializes in personalized party accessories for weddings and other affairs. Likes b/w line art that is small (2x2) format.)

Beistle Co.
1 Beistle Plaza
Shippensburg, PA 17257-9623
(717) 532 – 2131
beistle.com
(Party goods, art guidelines available.)
(Looks for color illustrations.)

Bergquist Imports, Inc.
1412 Hwy. 33 S.
Cloquet, MN 55720
(800) 328 – 0853
bergquistimports.com
(Produces paper napkins, mugs, and tile. Likes Scandinavian designs. Pays $50 - $300 per project.)

Cape Shore, Inc.
86 Downeast Dr.
Yarmouth, ME 04096
(800) 343 – 2424
cape-shore.com
(Gifts and stationery. Art guidelines for SASE.)

Centric Corp.
6712 Melrose Ave.
Los Angeles, CA 90038
(323) 936 – 2100
centriccorp.com
(Specializes in watches, pens, t-shirts, and mugs. Classic licensed celebrities like Elvis, Lucy, Marilyn Monroe, Betty Boop, etc.)

City Merchandise, Inc.
228 40th St.
Brooklyn, NY 11232
(718) 832 – 2931
citymerchandise.com
(Calendars, gifts, mugs, souvenirs of New York. Send query letter with photocopies, résumé.)

Creatif Licensing
31 Old Town Crossing
Mt. Kisco, NY 10549 – 4030
(914) 241 – 6211
creatifusa.com
(Licenses art for consumer products. Send the letter with photocopies, SASE.)

DALOIA Design
100 Norwich E.
West Palm Beach, FL 33417-7910
(561) 452 – 4150
E-mail: daloiades@aol.com
(Produces art for gift products such as magnets, photo frames, coasters, bookmarks, home décor, etc. Send samples of your work.)

Delta Creative, Inc.
3225 Westech Dr.
Norcross, GA 30092
(800) 842 – 4197
deltacreative.com
(Considers pen and ink for original art for rubber stamps. Looks for whimsical, feminine styles, and fashion trends. Send nonreturnable samples.)

Fiddler's Elbow
101 Fiddler's Elbow Rd.
Greenwich, NY 12834
(518) 692 – 9665
fiddlerselbow.com
(Produces decorative doormats, pillows, totes, mousepads, mugs, etc. Send samples by mail. Check the website to see current product lines.

Goes Lithographing Co.
111 Hallberg St.
Delavan, WI 53115
goeslitho.com
(Produces stationery/letterheads/custom calendars. Pays $100 - $200. Send nonreturnable samples.)

Graham & Brown
239 Prospect Plains rd., Ste. D201.
Monroe Township, NJ 08831
(609) 395 – 9200
grahambrown.com
(Produces residential wall coverings and home décor products. Send a postcard sample of work.)

Harland Clarke
15955 LaCantera Parkway
San Antonio, TX 78256
(210) 694 – 1473
clarkeamerican.com
(Produces checks. Prefers to see art at twice the size of a standard check. Send postcard sample or query letter with résumé, and brochure. Keep red and black in the illustration to a minimum.)

The Noteworthy Company
336 Forest Ave.
Amsterdam, NY 12010
(518) 842 – 2660

(Produces bags and pays $200 for bag designs. Send a query letter with brochure, résumé, samples, and SASE.)

Nova Media, Inc.
1724 N. State. St.
Big Rapids, MI 49307 – 9073
(231) 796 – 4637
novamediainc.com
(Specializes in CDs, games, posters, and t-shirts. Considers oil, and acrylic. Sa end query letter with samples.)

For a complete listing of the companies that license designs and the types of goods licensed you should see if your library has a copy of the directory by the Licensing Industry Merchandiser's Association? If not, they sell copies of it for $250 at:

Licensing Industry merchandisers' Association
350 Fifth Avenue
New York, NY 10118
(212) 244 – 1944
licensing.org

You could always do your cards via print-on-demand technology. If interested, check out invitationbox.com.

"It's like caller ID. You get to see who's
calling before you pick up."

"Action is the foundational key to all success."
– Pablo Picasso

It's not easy to stay focused on a goal, and often we drift away from it or trade it for something else. However, it's important to remember that to achieve our dreams, we need to stop dreaming about them and start working on finding ways of turning them into reality.

CHAPTER 23

DREAMING OF A GALLERY

"Many places that call themselves galleries primarily make their money as poster or frame shops, with original art as a sideline. Added to this, there are far more artists who want to exhibit and sell their work than galleries to show it."
– Daniel Grant

Traditionally, getting a gallery to represent you was what every artist wanted. They could then sit back and paint, while the gallery puts on the show and makes the sale. In a perfect world that would be the case. But most of us prisoners understand that life isn't perfect. Not even close. Getting a gallery to take you on as a client is still a nice goal to have. It just isn't the be-all, end-all, answer for an artist. You still must do everything you can to promote yourself and your art on your own. Because a gallery does have connections to collectors, and others in the art world that you don't, you should try to get a gallery to represent you. In this chapter, I'll give you some guidelines to remember as you go about the process. And at the end of the chapter, I'll give you the contact information of some retail galleries in the United States. Lastly, I'll show you some sample contracts to open your eyes to the process.

WHAT IS AN ART GALLERY?

A retail gallery is a business. Its goal is to make money. The gallery should strive to make its artwork as appealing as it can, so customers (and collectors) buy it. That's what they are in business to do: sell artwork. There are three main types of art businesses that may choose to call themselves a "gallery." They are:

- *Commercial Gallery:* a place of business that sells artwork by putting on exhibits (or shows) for a piece of the retail price (or "commission.").

- *Co-op Gallery:* typically, a place of business where the artists pay a fee (as members) to show work regularly. I did not include these types of galleries in the listings at the end of the chapter because most co-ops want you to donate time to help in the gallery. A prisoner would not be able to do that.

- *Vanity Gallery:* a place of business that charges the artist for the production costs of the exhibits upfront. These frauds advertise in the back of the big art magazines and prey on artists who are thirsty to get an exhibition. NEVER pay for gallery representation. Real galleries do not charge artists to put on shows!

For your purposes, it would be favorable to your career to get a gallery to represent you. A gallery would give your art the ability to be seen, and sold, in a city, you can't personally visit because of your incarceration. And a gallery has connections in the art world you can't really make sitting in a prison cell.

HOW TO GET A GALLERY TO REPRESENT YOU

The reason this chapter is towards the back of this book is that this will be one of the hardest things for you to accomplish. Why? Because a gallery wants to see that you can produce work that will sell. It will be easier to get a gallery to represent you if you have an emerging résumé. Win some contests and juried shows. Show sales records. Build your online presence. Or don't. You can approach a gallery right now if you want to? It's up to you. This is your career, and you are the ultimate captain of your ship. No matter when you decide to approach a gallery, you should try to do the following first:

- Research galleries to see which ones show art like yours. Some don't like drawings. Some don't like pastels. Find out before you submit to them. Their websites will list what they prefer.

- Have a family member or friend visit the gallery in person if they can? Have them look at the quality of the artwork? Prices? How it's displayed? Were the staff nice, or snooty? Then have them tell you what they think?

- Check out any social media reviews of the gallery if you can? What do other people say about the gallery?

- Try to narrow your search down to 5 – 10 galleries that you want to approach about representing your work. Prepare your initial letters of contact.

- Always follow the gallery's rules about submissions and initial contact. Great first impressions make the best impressions. A typical submission after the first inquiry would consist of:

 o A cover letters

 o A biography

 o An artist's statement

 o Your résumé

 o 10 – 15 images of your work

 o a SASE

- Be prepared for rejection. Artist Kristy Gordon says rejection letters are a normal part of the process. She says that those same "no's" can be delayed "yeses." What's most important is the reason behind their rejection? Did they comment on your work? Offer tips? Sometimes they'll say they want to see where you're at in a certain time frame. So, keep them up to date on your progress, and then resubmit at the proper time!

- Keep any deadlines they set, and properly fill out all paperwork and contracts. Be professional.

If a gallery likes your work and agrees to represent you, then you're straight, right/ Not yet. You have a few more questions to consider, and guidelines to follow. When negotiating with a gallery you should ask the following questions:

- What else do they do besides hanging art on the walls?

- Do they advance money for production or supplies? Or do you only get paid when a piece is sold?

- What is their territory? Be careful about agreeing to exclusive worldwide or national representation.

- Who else can you work with? Are you allowed to exhibit on your own?

- How will sales be taken care of? Know the financials ahead of time. Most galleries split sales 50/50. That' standard. Anything more is too much.

If a gallery puts on a show of your work, they should get first chance to sell those pieces for a limited time after the show. Reward them and they will reward you. Don't ever undercut your gallery to cut them out of their commission. If you are approached by a collector on their own about a

piece, they saw at the show refer them to the gallery. Some collectors will try to do this to get a lower price. An artist could be tempted to do it because they will make more off the sale. Don't fall for it. The art world is a small world. And being a prisoner already causes people to be super cautious and wary about working with us. We must be professional, do things right, and ethically, and then doors will open up for us. Once you get a gallery door open you don't want to have it slammed in your face because of greed.

TECHNICAL PROBLEMS OF A GALLERY

The biggest problem a prisoner faces with a gallery is getting your artwork to the gallery. The majority of the galleries that I researched for this book want the artist to send the work to the gallery already framed. Some don't, but most do. And it's normally the artist who pays for the shipping fees to get the art to the gallery. Ouch. Most prisoners will not be able to do this. If you have some money saved from previous sales, or your crowdfunding campaigns, and someone in the free world to assist you, then you can do it.

Frames help collectors imagine how the art will look on the walls of their homes or offices. A good frame draws the eye into the piece. You should not pay more than 10 percent of your artwork's retail price on a frame. 4% is normal in the gallery world. So, if your painting is priced at $1,000, your frame should be $100 at most, $40 would be better. Because most of you have no experience with framing artwork you may want to read:

- *Matting and Framing Works of Art on Paper* by the American Institute of Conservation
- *Matting and Hinging of Works of Art on Paper* by Merrily A. Smith
- *How to Care for Works of Art on Paper* by Ron L. Perkinson and Francis W. Dollof

There are also frame shops, photography studios, and even some of the big box retail home improvement stores that provide framing services. Network with your fellow artists. Find out who they use/ Remember, it's more about your resourcefulness than your resources. Think outside the cell.

Finally, I'll say it again; *never, ever* pay a gallery upfront fee to represent you. Real galleries make their money by commission from the sales of your work. Don't try to rush the process. Picasso and Michelangelo weren't born masters. They worked at it and became masters. You can too. A gallery can help you.

RESOURCE BOX

For more about this process, you should read:

- *The Artist-Gallery Partnership: A Practical Guide to Consigning Art, 3rd Edition* by Tad Crawford and Susan Mellon

Available on Amazon, Simon and Schuster, and other book retailers.

*A note about the gallery listings I've included. I tried to find galleries that were opened to working with "emerging artist" and were for-profit. I did not list all the museums, co-op artists galleries, or some of the university galleries. For a comprehensive listing you should see *Art in America: Annual Guide to Museums, Galleries, and Artist*, which lists over 4,500 entries. It is published every August. (artinamericamagazine.com). Also, the latest edition of *The Artist's Market*, published at the end if each year, provides a huge list of galleries, their guidelines, and terms.

ART GALLERIES IN THE UNITED STATES

5+5 Gallery
620 Fort Washington Avenue, Ste. 3N
New York, NY 10040
(718) 624-6048
5plus5gallery.com
E-mail: gallery1@fodde.com
(Online gallery only – no exhibitions.)

Adirondack Lakes Center for the Arts
3446 St. Rt. 28
Blue Mountain Lake, NY 12812
(518) 752-7715
adirondackarts.org
E-mail: office@adirondackarts.org
(30% commission; average prices 1$100-
10,000.)

Akron Art Museum
1 S. High Street
Akron, OH 44308
(330) 376-9185
akronartmuseum.org
E-mail: mail@akronartmuseum.org

Alaska State Museum
395 Whittier St.
Juneau, AK 99801-1718
(907) 465 – 2901
museums.alaska.gov

Jean Albano Gallery
215 W. Superior
Chicago, IL 60654
(312) 440 – 0770
jeanalbanogallery.com
E-mail: info@jeanalbanogallery.com
(50% commission; average prices $1,000-
$20,000.)

Albuquerque Museum
2000 Mountain Rd., NW
Albuquerque, NM 87104
(505) 243 – 7255
cabq.gov/museum

Alex Gallery
2106 R St. NW
Washington, DC 20008
alexgalleries.com
E-mail: info@alexgalleries.com
(Overall price range $1,500 - $60,000)

Charles Allis Art Museum
1801 N Prospect Ave.
Milwaukee, WI 53202
(414) 278 – 8295
charlesallis.org
E-mail jsterr@cavtmuseums.org
(For Wisconsin Artists only!)

The Ann Arbor Art Center Gallery Shop
117 W. Liberty St.
Ann Arbor, MI 48104
(734) 994 – 8004
annarborartcenter.org
E-mail: nrice@annarborcenter.org
(Prefers Michigan artists.)

Anton Art Center
125 Macomb Place
Mount Clemens, MI 48043
(586) 469 – 8666
theartcenter.org
E-mail: information@theartcenter.org
(40% commission; overall prices $5 - %1,000)

Arizona State University Art Museum
P.O. Box 872911
Tempe, AZ 85287-2911
(480) 965 – 2787
asuartmuseum.asu.edu

The Arkansas Arts Center
501 E. Ninth St.
Little Rock, AR 72202
(501) 372 – 4000
arkansasartscenter.org
(10% commission, write for more info.)

Arnold Art
210 Thames t.
Newport, RI 02840
(401) 847 – 2273
arnoldart.com
E-mail: info@arnoldart.com
(40% commission; prices $100 - $35,000)

The Arsenal Gallery
the Arsenal Bldg., Room 20
830 Fifth Ave.
New York, NY 10065
(212) 360 – 8163
nycgovparks.org/art
E-mail: artandantiquities@parks.nyc.gov

Art Center of Burlington
301 Jefferson St.
Burlington, IA 52601
(319) 754 – 8069
artenterofburlington.com
E-mail:
artsforliving@artcenterofburlington.com
(25% Commission; overall price $25 -
$1,000).

Art Encounter
5720 S. Arville Street, Ste. 119
Las Vegas, NV 89118
(800) 395 – 2996
artencounter.com
E-mail: scott@artencounter.com

Art League of Houston
1953 Montrose Blvd.
Houston, TX 77006
(713) 523 – 9530
artleaguehouston.org
E-mail: alh@artleaguehouston.org
(30% commission; price range $100 - $5,000.
Must be from Houston.)

Art Source L.A., Inc.
2801 Ocean Park Blvd, #7
Santa Monica, CA 90405
(800) 721 – 8477
artsourcela.com
(50% commission; no geographic limitation.)

Art Without Walls, Inc.
P.O. Box 341
Sayville, NY 11782
(631) 567 – 94418
E-mail: artwithoutwalls@outlook.com
(20% commission; price's $1,000 - $25,000)

Atelier Gallery
153 King St.
Charleston, SC 29401
theateliergalleries.com
E-mail: gabrielle@theateliergalleries.com
(50% commission; prices $50 - $15,000)

Alan Avery Art Company
315 E. Paces Ferry Rd.
Atlanta, GA 30305
(404) 237 – 0370
alanaveryartcompany.com
E-mail: info@alanaveryartcompany.com
(Commission negotiable; prices $1,500 -
$150,000)

Sarah Bain Gallery
110 W. Birch St., Ste. 1
Brea, CA 92821
(714) 990 – 0500
sarahbaingallery.com
E-mail: info@sarahbaingallery.com
(Prices $700 - $15,000)

Baker Arts Center
624 N. Pershing Ave.
Liberal, KS 67901
(620) 624 – 2810
bakerartscenter.org
E-mail: dianemarsh@bakerartscenter.org
(30% commission; prices $10 - $1,000)

David Barnett Gallery
1024 E. State St.
Milwaukee, WI 53202
(414) 271 – 5058
davidbarnettgallry.com
E-mail: inquiries@davidbarnettgallery.com
(50% commission; prices $50 - $375,000)

Barron Arts Center
582 Rahway Ave.
Woodbridge, NJ 07095
(732) 634 – 0413
twp.woodbridge.nj.us
E-mail: barronarts@twp.woodbridge.nj.us
(Prices $200 - $5,000)

Seth Jason Beitler Fine Arts
250 NW 23rd St., Ste. 202
Miami, FL 33127
(305) 438 – 0218
sethjason.com
E-mail: info@sethjason.com
(50% commissions; prices $2,000 - $300,000)

Bennett Galleries and Company
5308 Kingston Pike
Knoxville, TN 37919
(865) 584 – 6791
bennettgalleries.com
E-mail: info@bennettgalleries.com
(50% commissions; prices $200 - $20,000)

Mona Berman Fine Arts
78 Lyon St.
New Haven, CT 06511
(203) 562 – 4720
monabermanfinearts.com
E-mail: info@monabermanfinearts.com
(50% commission)

Blue Gallery
118 Southwest Blvd.
Kansas City, MO 64108
(816) 527 – 0823
bluegalleryonline.com
E-mail: kellyk@bluegalleryonline.com
(Prices $50 - $80,000)

Blue Spiral 1
38 Biltmore Ave.
Asheville, NC 28801
(828) 251 – 0202
bluespiral1.com
E-mail: jsours@bluespiral1.com
(50% commission; prices $100 - %50,000)

Rena Bransten Gallery
1639 Market St.
San Francisco, CA 94103
(415) 982 – 3292
renabranstengallery.com
E-mail: info@renabranstengallery.com

Broadhurst Gallery
2212 Midland Rd.
Pinehurst, NC 28374
(910) 295 – 4817
broadhurstgallery.com
E-mail: judy@broadhurtgallery.com
(Prices $5,000 - $40,000)

Brunner Gallery
215 N. Columbia St.
Covington, LA 70433
(935) 893 – 0444
brunnergallery.com
E-mail: curator@brunnergallery.com
(50% commission or bought for 90% of retail.
Prices $200 - $10,000)

William Campbell Contemporary Art
4935 Byers Ave.
Ft. Worth, TX 76107
(817) 737 – 9566
williamcampbellcontemporaryart.com
(50% commission; prices $500 - $20,000)

Cantrell Gallery
8206 Cantrell Rd.
Little Rock, AR 72227
(501) 224 – 1335
cantrellgallery.com
E-mail: cantrellgallery@sbcglobal.net
(Prices $100 - $10,000)

Center For Diversified Art
P.O. Box 641062
Beverly Hills, FL 34465
diversifiedart.org
E-mail: diversifiedart101@gmail.com
(20% commission; prices $150 - $4,000)

Chabot Fine Art Gallery
P.O. Box 623
Greenville, RI 02828
(401) 432 – 7783
chabotgallery.com
E-mail: chris@chabotgallery.com
(50% commission; prices $1,200 - $10,000)

The Chait Galleries Downtown
218 E. Washington St.
Iowa City, IA 52240
(319) 338 – 4442
chaitgalleries.com
E-mail: attendant@thegalleriesdowntown.com
(50% commission; prices $50 - $10,000)

Chapman Friedman Gallery
1835 Hampden Court
Louisville, KY 40205
(502) 584 – 7954
imagesol.com
E-mail: friedman@imagesol.com
(50% commission; prices $75 - $10,000)

ClampArt
531W. 25th St.
Ground Floor
New York, NY 10001
(646) 230 – 0020
clampart.com
E-mail: info@clampart.com
(50% commission; prices $300 - $50,000)

Catharine Clark Gallery
248 Utah St.
San Francisco, CA 94103
(415) 399 – 1439
cclarkgallery.com
E-mail: info@cclarkgallery.com
(50% commission; prices $200 - $300,000)

Coleman Fine Art
79 Church St.
Charleston, SC 29401
(843) 853 – 7000
colemanfineart.com
E-mail: info@colemanfineart.com
(45% commission; prices $3,000 - $80,000)

Cornerhouse Gallery and Frame
3318 First Ave. NE, Ste. A
Cedar Rapids, IA 52402
(319) 365 – 4348
cornerhousegallery.com
E-mail: info@cornerhousegallery.com
(50% commission; price $200 - $20,000)

James Cox Gallery at Woodstock
4666 Rt. 212
Willow, NY 12495
(845) 679 – 7608
jamescoxgallery.com
E-mail: info@jamescoxgallery.com
(50% commissions; $500 - $50,000)

Coyote Woman Gallery
160 E. Main St.
Harbor Springs, MI 49740
coyotewomangallery.com
E-mail: office@coyotewomangallery.com
(50% commissions; prices $25 - $4,000)

Davidson Galleries
313 Occidental Ave. S.
Seattle, WA 98104
(206) 624 – 7684
davidsongalleries.com
E-mail: sam@davidsongalleries.com
(50% commission; prices $50 - $70,000)

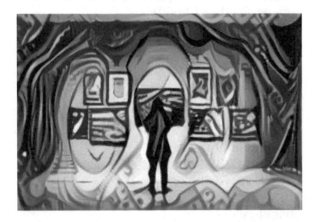

The Dayton Art Institute
456 Belmonte Park N.
Dayton, OH 45405-4700
(937) 223 – 5277
daytonartinstitute.org
E-mail: info@daytonart.org

The Delaware Contemporary
200 S. Madison St.
Wilmington, DE 19801
(302) 656 – 6466
thedcca.org

Dolphin Galleries
230 Hana Hwy., Ste. 12
Kahului, HI 96732
(800) 669 – 5051
dolphingolleries.com
E-mail: info@dolphingalleries.com
(Prices $100 - $100,000)

M.A. Doran Gallery
3509 S. Peoria Ave.
Tulsa, OK 74105
(918) 748 – 8700
madorangallery.com
E-mail: maryann@madorangallery.com
(50% commission; prices $500 - $40,000)

Dot Fiftyone Gallery
187 NW 27th St.
Miami, FL 33127
(305) 573 – 9994, ext. 450
dotfiftyone.com
E-mail: info@dotfiftyone.com
(50% commission; prices $1,000 - $20,000)

Thomas Erben Gallery
526 W. 26th St., Floor 4
New York, NY 10001
(212) 645 – 8701
thomaserben.com
E-mail: info@thomaserben.com

Etherton Gallery
135 S. Sixth Ave.
Tucson, AZ 85701
(520) 624 – 7370
ethertongallery.com
E-mail: info@ethertongallery.com
(50% commission; prices $800 - $50,000)

Evolve the Gallery
P.O. Box 5944
Sacramento, CA 95817
(916) 572 – 5123
evolvethegallery.com
E-mail: info@evolvethegallery.com
(50% commission; most works sold at $3,000)

Far West Gallery
2817 Montana Ave.
Billings, MT 59101
(800) 793 – 7296
farwestgallery.com
E-mail: farwest@180com.net
(Most work sold at $300 - $700)

Fleisher/Ollman Gallery
1216 Arch St., 5A
Philadelphia, PA 19107
(215) 545 – 7562
fleisherollmangallery.com
E-mail: info@fleisherollmangallery.com
(Prices $2,500 - $100,000)

The Flying Pig, LLC.
N6975 State Hwy. 42
Algoma, WI 54201
(920) 487 – 9902
theflyingpig.biz
(50% commission; most work sold at $300)

Focal Point Gallery
321 City Island Ave.
City Island, NY 10464
(718) 885-1403
focalpointgallery.net
E-mail: ronterner@gmail.com
(30% commission; prices $175 - $750)

Tory Folliard Gallery
233 N. Milwaukee St.
Milwaukee, WI 53202
(414) 273 – 7311
toryfolliard.com
E-mail: info@toryfolliard.com

Foster/White Gallery
220 Third Ave. S
Seattle, WA 98104
(206) 622 – 2833
fosterwhite.com
E-mail: seattle@fosterwhite.com
(Prices $300 - $35,000)

Galerie Bonheur
2534 Seagrass Dr.
Palm City, FL 34990
(314) 409 – 6057
galeriebonheur.com
E-mail: galeriebonheur@gmail.com
(50% commission; prices $25 - $25,000)

Gallery 72
1806 Vinton St.
Omaha, NE 68108
(402) 496 – 4797
gallery72.com
E-mail: info@gallery72.com
(50% commission)

Gallery 1988
7308 Melrose Ave.
Los Angeles, CA 90046
(323) 937 – 7088
gallery1988.com
E-mail: gallery1988west@gmail.com
(Prices $75 - $15,000)

Gallery M
180 Cook St., Ste. 101
Denver, CO 80206
gallery.com
(Prices $1,000 - $75,000)

Garver Gallery
18 South Bedford St. #318
Madison, WI 53703
(608) 256 – 6755
garvergallery.com
E-mail: jack@garvergallery.com
(50% commission; prices $100 - $10,000)

David Gary Ltd. Fine Art
P.O. Box 619
Millburn, NJ 07041
(973) 467 – 9240
davidgaryfineart.com
E-mail: davidgaryfineart@gmail.com
(50% commission; prices $250 - $25,000)

Sandra Gering, Inc.
14 E. 64th St.
New York, NY 10065
(646) 336 – 7183
geringlopez.com
E-mail: info@sandrageringinc.com

Gold/Smith Gallery
8 McKnown St.
Boothbay Harbor, ME 04538
(207) 633 – 6255
goldsmithgallery.net
E-mail: goldsmithgallerybbb@gmail.com
(50% commissions; prices $350 - $5,000)

Judith Hale Gallery
1693 Copenhagen Dr.
Solvang, CA 93463
(805) 686 – 2322
judithhalegallery.com
E-mail: info@judithhalegallery.com
(50% commission; prices $500 - $15,000)

William Havu Gallery
1040 Cherokee St.
Denver, CO 80204
(303) 893 – 2360
williamhavugallery.com
E-mail: info@williamhavugallery.com
(50% commission; prices $250 - $15,000)
(Accepts Rocky Mountain/Southwestern
Region artists)

Hudson Gallery
5645 N. Main St.
Sylvania, OH 43560
(419) 885 – 8381
hudsongallery.net
E-mail: info@hudsongallery.net
(40% commission; prices $50 - $10,000)

Hudson Guild Gallery
441 W. 26th St.
New York, NY 10001
(212) 760 – 9837
hudsonguild.org
E-mail: info@hudsonguild.org
(20% commission)

Jailhouse Gallery
310 North Center Ave.
Hardin, MT 59034
(406) 665 – 3239
jailhousegallery.org
E-mail: jhghardin@hotmail.com
(30% commission; prices $20 - $2,000)
(Prefers western, Native American, and
landscapes.)

Ashok Jain Gallery
58 Hester St.
New York, NY 10002
(212) 969 – 9660
ashokjaingallery.com
E-mail: info@asokjaingallery.com
(50% commission; prices $1,000 - $20,000)

Stella Jones Gallery
201 St. Charles Ave.
New Orleans, LA 70170
(504) 568 – 9050
stellajonewsgallery.com
(50% commission; prices $500 - $150,000)

JVA Art Group
4151 Taylor St.
San Diego, CA 92110
(619) 299 – 3232
jvaartgroup.com
E-mail: contact@jvaartgroup.com
(50% commission; prices $175 - $10,000)

The Kentuck Art Center
503 Main Ave.
Northport, AL 35476
(205) 758 – 1257
kentuck.org
E-mail: kentuck@kentuck.org
(40% commission; prices $150 - $10,000)

Angela King Gallery
241 Royal St.
New Orleans, LA 70130
(504) 524 – 8211
angelakinggallery.com
E-mail: angela@angelakinggallery.com
(Prices $650 - $100,000)

Kirsten Gallery, Inc.
5320 Roosevelt Way NE
Seattle, WA 98105
(206) 522 – 2011
kirstengallerry.com
E-mail: kirstengallery@questoffice.net
(50% commission; prices $75 - $15,000)

Landing Gallery
409 Main St.
Rockland, ME 04841
(207) 239 – 1223
landingart.com
E-mail: landinggallery@gmail.com
(50% commission; prices $100 - $12,000)

David Leonardis Gallery
1346 N. Paulina St.
Chicago, IL 60622
(312) 863 – 9045
DLGgallery.com
E-mail: david@dlg-gallery.com
(50% commission; prices $50 - $5,000)

Richard Levy Gallery
514 Central Ave., SW
Albuquerque, NM 87102
(505) 766 – 9888
levygallery.com
E-mail: info@levygallery.com

Lizardi/Harp Gallery
P.O. Box 91895
Pasadena, CA 91109
(626) – 791 – 8123
E-mail: lizardiharp@earthlink.net
(50% commission; prices $900 - $80,000)

Anne Lloyd Gallery
125 N. Water St.
Decatur, IL 62523-1025
decaturarts.org
E-mail: sue@decaturarts.org
(35% commission: prices $100 - $5,000)

Malton Gallery
3804 Edwards Rd.
Cincinnati, OH 45209
(513) 321 – 8614
maltonartgallery.com
E-mail: srombis@maltonartgallery.com
(50% commission; prices $1,000 - $8,000)

Mathias Fine Art
10 Mathias Dr.
Trevett, ME 04571
(207) 633 – 7404
mathiasfineart.com
(50% commission; prices $50 - $25,000)

McGowan Fine Art, Inc.
10 Hills Ave.
Concord, NH 03301
(603) 225 – 2515
mcgowanfineart.com
E-mail: art@mcgowanfineart.com
(50% commission; prices $125 - $9,000)

The Munson Gallery
1455 Main St.
Chatham, MA 02633
(508) 237 – 5038
munsongallery.com
E-mail: art@munsongallery.net
(50% commission; prices $450 - $150,000)

Michael Murphy Gallery M
2701 S. MacDill Ave.
Tampa, FL 33629
(813) 902 – 1414
michaelmurphygallery.com
(50% commission; prices $500 - %15,000)

Nuance Galleries
804 S. Dale Mabry
Tampa, FL 33609
(813) 875 – 0511
nuancegalleries.com
E-mail: nuancegalleries.com
(50% commission)

Oxford Gallery
267 Oxford St.
Rochester, NY 14607
(585) 271 – 5885
oxfordgallery.com
E-mail: info@oxfordgallery.com
(50% commission; prices $100 - $30,000)

Palladio Gallery
2231 Central Ave
Memphis, TN 38104
(901) 276 – 1251
galleryfiftysix.com
E-mail: rollin@galleryfiftysix.com
(40% commission; prices $200 - $3,000)

Pentimenti Gallery
145 N. Second St.
Philadelphia, PA 19106
pentimenti.com

Pierro Gallery of South Orange
Baird Center
5 Mead St.
South Orange, NJ 07079
(973) 378 – 7754
pierrogallery.org
(15% commission; prices $100-$10,000)

Portfolio Art Gallery
2007 Devine Street
Columbia, SC 29205
(803) 256-2434
portfolioartgal@gmail.com
(40% commission; prices $150-$5,000)

Pucker Gallery, Inc.
240 Newbury Street, 3rd Floor
Boston, MA 02116
(617) 267-9473
puckergallery.com
E-mail: contactus@puckergallery.com
(prices $20-$200,000)

River Gallery
400 E. Second Street
Chattanooga, TN 37403
(423) 265-5033, ext. 5
river-gallery.com
E-mail: details@river-gallery.com
(50% commission; prices $5-$10,000)

Palladio Gallery
2231 Central Avenue
Memphis, TN 38104
(901) 276-1251
galleryfiftysix.com
E-mail: rollin@galleryfiftysix.com
(50% commission; prices $200-$3,000)

Pentimenti Gallery
145 N. Second Street
Philadelphia, PA 19106
pentimenti.com

Pierro Gallery of South Orange
Baird Center
5 Mead Street
South Orange, NJ 07079
(973) 378-7754
pierrogallery.org
(15% commission; prices $100-$10,000

Portfolio Art Gallery
2007 Devine Street
Columbia, SC 29205
(803) 256-2434
portfolioartgal.com
(40% commission; prices $150-$5,000)

Pucker Gallery, Inc.
240 Newburg Street, 3rd Floor
Boston, MA 02116
(617) 267-9473
puckergallery.com
E-mail: contactus@puckergallery.com
(Prices $20-$200,000)

River Gallery
400 E. Second Street
Chattanooga, TN 37403
(423) 265-5033, ext. 5
river-gallery.com
E-mail: details@river-gallery.com
(50% commission; prices $5-$10,000)

Select Art
1025 Levee Street
Dallas, TX 75207
(214 521-6833
selectartusa.com
(50% commission: prices $500-$15,000)

Snyderman-Works Gallery
303 Cherry Street
Philadelphia, PA 19106
(215) 238-9576
Snyderman-works.com
(50% commission; prices $50-10,000)

State Street Gallery
1804 State Street
La Crosse, WI 54601
(608) 782-0101
(40% commission; prices $150-$25,000)

Tew Galleries, Inc.
425 Peachtree Hills Avenue, #24
Atlanta, GA 30305
(404) 869-0511
tewgalleries.com
E-mail: info@tewgalleries.com
(50% commission; prices $1,800-$14,000)

Tilt Gallery
7077 E. Main Street, Ste. 14
Scottsdale, AZ 85251
(602) 716-5667
tiltgallery.com
E-mail: info@tiltgallery.com

Walter Wickiser Gallery
210 11th Avenue, Ste. 303
New York, NY 10001
(212) 941-1817
walterwickisergallery.com
E-mail: wwickiserg@aol.com

Woodward Gallery
133 Eldridge Street, Ground Floor
New York, NY 10002
(212) 966-3411
woodwardgallery.net
E-mail: art@woodwardgallery.net

Riva Yares Gallery
3625 Bishop Lane
Scottsdale, AZ 85251
(408) 947-3251
rivayaresgallery.com
E-mail: art@rivayaresgallery.com
(50% commission; prices $1,000-1 million)

Yeiser Art Center, Inc.
200 Broadway Street
Paducah, KY 42001
(270) 442-2453
theyeiser.org
E-mail: jewhite@theyeiser.org
(40% commission; prices $200-$8,000)

Yellowstone Gallery
P.O. Box 472
Gardiner, MT 59030
(406) 848 – 7306
yellowstonegallery.com
E-mail: YellowstoneArt@aol.com
(45% commission; prices $25 - $8,000)

Lee Youngman Galleries
1316 Lincoln Ave
Calistoga, CA 94515
(707) 942 – 9585
leeyungmangalleries.com
E-mail: leeyg@comcast.net
(50% commission; prices $500 - $24,000)

Zenith Gallery
1429 Iris St. NW
Washington, DC 20012
(202) 783 – 2963
zenithgallery.com
E-mail: margery@zenithgallery.com
(Prices $5,000 - $15,000)

CHAPTER 24

MAGAZINES

"One huge advantage of magazines is that the publisher prints and distributes your work to thousands of readers, giving you exposure to a wider audience then you might garner on your own."
– Robert W. Bly

Do you know a magazine you could do an illustration for and make $4,000, after finishing this chapter you will. As a writer, I've always known that magazines could provide a nice income if I was to write articles for them. Magazines are normally published monthly, or quarterly (4 times a year0. So, their editors need timely content and will pay for that content. When I first started out in my writing career some years ago, I got a hold of a copy of *Writer's Market*. I would sit there at night and peruse the magazine listings to see how much money I could get for an article in one. That exercise was good for me because it did two things. One, it showed me that there were all kinds of places that needed writing and would pay for it. Two, through the process of studying those listings and constantly seeing the dollars paid out for writing, I brainwashed myself. I began to believe that someone could, and would, pay me for my writing. I then won honorable mention in a poetry contest, and then George Kayer paid me $50 for an article in *Inmate Shopper*. As they say, the rest is history. How would it help you out if some magazine editor paid you $50 for a drawing you did? And then they published your drawing in that magazine? Would that be the catalyst that sent you on your journey to become a *Prison Picasso*? I bet it would. So let me help you get started.

Do you have any magazines laying around your cell? If so, I want you to pick one up. Open it up and turn to the page where the masthead is. This is normally found in the first few pages and lists the founder, publisher, editors, and normally, the advertising department. What you're looking for is the "art director" or "art consultant." You want that person's name. If you find it, write it down. Then write down the e-mail address, or snail mail address, of where submissions are supposed to be sent to. After that, your next step is to go through the magazine looking for illustrations. Note which ones you think you could do. Take note of the style of illustration in each magazine. A lot of the magazines that pay read dollars for illustrations you may have never heard of. That's ok. I will list numerous magazines at the end of this chapter that pays for illustrations. But there are hundreds and hundreds more.

When you get a chance, go to your prison's library if there is one. See if they have either of these huge directories:

- *Standard Rate and Data Service (SRDS)*

- *Bacon's Newspaper and Magazine Directory*

These will list thousands of magazines on the market. Or you can have someone check out mrmagazine.com for a wealth of information about magazines. When you find lists like at the end of this chapter, study them. One great book that every artist should own is the latest edition of *Artist's Market*. It has a section all about magazines. Get it and study it like I used to study the *Writer's Market* book.

Before you look further you need to know the lingo and what these types of illustrations are:

- An "editorial illustration" is a drawing or a piece of art that illustrates a story in a magazine or newspaper.

- A "caricature" is an illustration that distorts or overamplifies the features of a person or animal.

- A "spot" is an illustration that is a half-page or smaller.

The easiest one to break into is spots. They are used to move the reader's eye down the page or as filler. But if you can do these small drawings well, in your style, you could make good money. Better than those $2 or $3 cards you have been spending all day making just to get some commissary.

Once you find some magazines that you think you could do some illustrations for, your next step is to contact them. You should send them a letter requesting their art submission guidelines. be sure to enclose a SASE (self-addressed stamped envelope) with first-class postage (a "Forever" stamp works). I've enclosed a sample letter for you to use as a guide. Once you get the art guidelines, follow their rules and submit your samples. A lot of illustrators use postcard size samples, and these are not returned. If the magazine's art director/editor likes your work, they will contact you. Ok, I know you want to know about money. So, look at the listings I've included. Now you'll see why you should quit working for peanuts in your cell house. There are hundreds of dollars, maybe thousands, out there. It could be yours?

FYI: These magazine listings are by no means extensive. I've included these either because you could write and get their art guidelines. Or to show you how much money you are missing out on. Even if you never really use them, they can help you realize that there's money out there for art!

By the way, *Cave Wall* magazine pays up to $4,200 for artwork they include in their publication. You'll have to send for their art guidelines to see how you might qualify.

<div align="center">Sample Letter</div>

A&U Magazine
25 Monroe St., Ste. 205
Albany, NY 12210 Date: _____

Dear Mr. Editor:

I'm an artist looking to submit some illustrations for your consideration. Please send me your art guidelines. I have enclosed a SASE to cover the cost of postage.

Thank you in advance for your cooperation in this matter. I look forward to hearing from you soon.

Respectfully Requested,

[Your Signature]
[Your Name Printed]
[Your Address]
[Your E-mail address]

Encl: SASE

MAGAZINE LISTINGS

A&U Magazine
25 Monroe St., Ste. 205
Albany, NY 12210
(518) 426 – 9010
aumag.org
(Prefers unique illustrations about the HIV/AIDS crisis. Art guidelines are free with SASE)

AARP THE MAGAZINE
601 E St. NW
Washington, DC 20049
(888) 687 – 2277
aarp.org/magazine
Contact: art/design director
(Pays $700 - $3,500. The magazine for people who are 50 or older, retired)

Alfred Hitchcock Mystery Magazine
Dell Magazines
44 Wall Street, Ste. 904
New York, NY 10005-2401
(212) 686 – 7188
themysteryplace.com/ahmm
(Pays $1,000 for color cover, $100 for b/w
inside, $35 - $50 for spots. Send SASE for art
guidelines)

All Animals Magazine
2100 L St. NW
Washington, DC 20037
humanesociety.com
Contact: Jennifer Cork, creative director
E-mail: jcord@humanesociety.org
(Pays $700 for 2-page spreads, $100 - $300
for spots)

The American Legion Magazine
P.O. Box 1055
Indianapolis, IN 46206-1055
(317) 630 – 1253
legion.org
(Likes good humor, not sex, liquor, religion, or
race. Cartoons and pays $150. Send your
finished color cartoons)

American Libraries
American Library Association
50 E. Huron St.
Chicago, IL 60611
(800) 545 – 2433
(Send SASE for art guidelines. Pays $50 for
cartoons)

American School Board Journal
1680 Duke St.
Alexandria, VA 22314
(703) 838 – 6739
asbj.com
(Pays $1,200 max for color cover: $250 -
$235 for b/w, $300 - $600 for color inside.
Likes new ways of seeing kids and education.
Send postcard sample)

ANALOG
Contact: Victoria Green, Senior Art Director
Dell Magazines
44 Wall St., Ste. 904
New York, NY 10005-2401
(212) 686 – 7188
analogsf.com
(Send SASE for art guidelines. Pays $35
minimum for b/w cartoons: $35 - $50 for
spots. $1,200 for color cover, $125 for b/w
inside)

Asimov's Science Fiction
Dell Magazines
44 Wall St., Ste. 904
New York, NY 10005
asimovs.com
(Pays $35 minimum for cartoons, $600 -
$1,200 for color cover. Send SASE for art
guidelines)

The Bear Deluxe Magazine
ORLO
240 N. Broadway #112
Portland, OR 97227
orlo.org
(Pays $200 for b/w or color cover; $25 - $75
for inside; $20 for spots.)
(Environmental art magazine. Send postcard
samples)

Birmingham Parent
Evans Publishing, LLC
3590B US Hwy 31 S. Ste.289
Pelham, AL 35124
(205) 987 – 7700
birminghamparent.com
(Send SASE for art guidelines)

BizTimes Milwaukee
BizTimes Media
126 N. Jefferson St., Ste. 403
Milwaukee, I 53202-6120
(414) 277 – 8181
biztimes.com
(Pays $200 - $400 for color cover, $80 - $100
for inside)

Brewer's Association
P.O. Box 1679
Boulder, CO 80306
(303) 447 – 0816
brewerszssociation.org
(Pays $700 - $800 for color cover, $200 - $300 for b/w inside, $200 - $400 for color inside, $150 - $300 for spots)

Bride's Magazine
Conde Nast
4 Times Square
New York, NY 10036
brides.com
(Pays $250 - $350 for inside, $250 for spots)

Cave Wall
Cave Wall Press, LLC
P.O. Box 29546
Greensboro, NC 27429-9546
cavewallpress.com
(Pays $3,000 - $4,200! Send SASE for art guidelines)

Charisma
600 Rinehart Rd.
Lake Mary, FL 32746
(407) 333 – 0600
charismamedia.com
(Send SASE for art guidelines. Pays $5 - $75 for b/w; $50 - $550 for spots; $100 - $550 for color covers)

Chesapeake Bay Magazine
601 Sixth St.
Annapolis, MO 21403
(410) 263 – 2662
chesapeakebaymagazine.com
(Send SASE for art guidelines. Pays $75 - $200 for spots, up to $500 - $800 for color insides)

Chess Life
P.O. Box 2967
Crossville, TN 38557
(931) 787 – 1234
uschess.org
(Send SASE for art guidelines. Pays $400 for cover, $100 for inside full-page, $50 – ½ page, $25 – ¼ page)

City Limits
Community Service Society of New York
31 E. 32nd St., 3rd Floor
New York, NY 10016
(212) 481 – 8484, ext. 313
citylimits.org
(Pays $50 for b/w cartoons, $50 - $100 for b/w cover, $50 for b/w inside, $25 - $50 for spots)

Claretian Publications
205 W. Monroe
Chicago, IL 60606
(312) 236 – 7782
uscatholic.org
(Send SASE for art guidelines. Pays $100 - $400 for color insides)

David C. Cook
4050 Lee Vance View
Colorado Springs, CO 80918
(800) 708 – 5550
davidccook.com
(Send SASE for art guidelines. Pays $400 – 700 for color cover, $250 - $400 for color inside, $150 - $250 for b/w inside, $500 - $800 for 2-page spreads, $50 - $75 for spots)

Dakota Country
P.O. Box 2714
Bismarck, ND 58502
(701) 255 – 3031
dakotacountrymagazine.com
(Send SASE for art guidelines. Pays $15 per cartoon, $20 - $25 for b/w inside, $12 - $30 for sots, always needs good quality hunting and fishing live art and cartoons)

Electronic Musician
New Bay Media, LLC.
28 E. 28th St., 12th Floor
New York, NY 10016
(212) 378 – 0400
emusician.com
(Send SASE for art guidelines. Pays $100 - $400 for b/w, $800 - $1,200 for color cover)

Faultline Journal of Art & Literature
University of California, Irvine
Dept. of English
435 Humanities Instructional Bldg
Irvine, CA 92697-2650
(949) 824 – 1573
Faultline.sittes.uci.edu
(Submit up to 5 8x10 color or b/w art pieces
for consideration)

Forbes Magazine
499 Washington Blvd.
Jersey City, NJ 07310
(800) 295 – 0893
forbes.com
(Pays $450 - $700 for inside illustrations)

Game & Fish
3330 Chastain Meadows Pkwy. NW
Ste. 200
Kennesaw, GA 30144
gameandfishmag.com
(Pays $25 minimum for b/w inside, $75 - $100
for color inside)

Georgia Magazine
Georgia Electric Membership Corp.
P.O. Box 1707
2100 E. Exchange Place
Tucker, GA 30085
(770) 270-6500
georgiamagazine.org

Golf Tips Magazine
Werner Publishing Corp.
12121 Wilshire Blvd., 12th Floor
Los Angeles, CA 90025-1176
(310) 820 – 1500
golftipsmagazine.com
(Pays $500 - $700 for color cover, $100 -
$200 for b/w inside, $250 - $500 for color
inside, $500 - $700 – for 2-page spreads)

Greenprints
P.O. Box 1355
Fairview, NC 28730
(828) 628 – 1902
greenprints.com
(Send SASE for art guidelines. Prefers plants
and people together)

Honolulu Magazine
Pacific Basin Communications
1000 Bishop St., Ste. 405
Honolulu, HI 96813
(808) 537 – 9500
honolulumagazine.com
(Send SASE for art guidelines. Pays $300 -
$500 for cover, $100 - $350 for inside, $75 -
$150 for spots.)

The Illustrated News
PO Box 63
Freeport, MN 56331
(320) 285-2124
illustratedextra.com
(Buys black & white illustrations)

The Independent Weekly
PO Box 1772
Durham, NC 27702
(914) 286-1972
indyweek.com
(Pays $150 for cover illustrations, $25-$50 for
inside spots)

Islands
460 N. Orlando Ave., Ste. 200
Winter Park, FL 32789
(407) 628-4802
islands.com
(Pays $100-$400 per inside image)

Main Line Today
Today Media, Inc.
4645 West Chester Pike
Newtown Square, PA
(610) 325-4630
mainlinetoday.com
(Sample copy with SASE, pays $400
maximum for color cover, $125-$250 for
inside, $125 for spots)

Michigan Out-of-Doors
PO Box 30235
Lansing, MI 48912
(517) 371-1041
michiganoutofdoors.com
(Pays $30 for pen and ink illustrations,
hunting and fishing magazine)

National Enquirer
4950 Communication Ave.
Boca Raton, FL 33431
(561) 997-7733
nationalenquirer.com
(Pays $200 for black & white cartoons)

The Nation
33 Irving Place, 8th Floor
New York, NY 10003
thenation.com
(Pays $135 for color inside artwork)

Naturally
Internaturally, LLC
1240 Winchester Grade Road
Berkeley Springs, WV 25411
(973) 697-3552
internaturally.com
(Send SASE for art guidelines, Pays $20-$80
for cartoons, $200 for cover, $80 page-wide)

New York Magazine
New York Media, Editorial Submissions
75 Varick Street
New York, NY 10013
nymag.com
(Pays $1,000 for cover, $800 for color inside,
$400 black and white full-page, $150 for black
and white spots)

Oklahoma Today
P.O. Box 1468
Oklahoma City, OK 73101-1468
(405) 230-8450
oklahomatoday.com
(Sample copy for SASE)

The Optimist
4494 Lindell Blvd.
St, Louis, MO 63108
(314) 371-6000
optimist.org
(Sample copy for SASE)

Oregon Quarterly
5228 University of Oregon
Eugene, OR 97403
(541) 346-5046
oregonquarterly.com
(Sample copy for SASE)

Paint Horse Journal
American Paint Horse Association
P.O. Box 961023
Ft. Worth, TX 76161-0023
(817) 834-2742
alpha.com/phj/welcome
(Send SASE for art guidelines)

Parabola Magazine
20 W. 20th Street, 2nd Floor
New York, NY 10011
(212) 822-8806
parabola.org
(Pays $150 max for black and white inside,
$50-$100 for spots)

The Progressive
30 W. Mifflin Street, Ste. 703
Madison, WI 53703
(608) 257-4626
progressive.org
(Pays $1,000 for cover, $300 for inside)

Robb Report
CurtCo Robb Media, LLC
29160 Heathercliff Road, Ste. 200
Malibu, CA 90265
(310) 589-7700
robbreport.com
(Send SASE for art guidelines)

Sacramento Magazine
231 Lathrop Way, Ste. A
Sacramento, CA 95819
(916) 426-1720
sacmag.com
(Pays $300-$400 for color cover, $200-$500
for inside, $100-$200 for spots)

Scientific American
75 Varick Street, 9th Floor
New York, NY 10013-1917
(212) 451-8200
sciam.com
(Pays $750-$2,000 for color inside, $350-
$750 for spot)

Scrap
1615 L St. NW, Ste. 600
Washington, DC 20036
(202) 662-8547
scrap.org
(Pays $1,200-$2,000 for color cover, $300-
$1,000 for color inside)

SGA Magazine
17782 Cowan, Ste. C
Irvine, CA 92614
(949) 660-6150
seamag.com
(Sample copy for SASE; Pays $50 for black
and white, $250 for color inside)

Solidarity Magazine
UAW Solidarity House
8000 E. Jefferson
Detroit, MI 48214
(313) 926-5000 uaw.org
(Pays $500-$600 for color cover, $200-$300
for black and white inside, $300-$400 for
color inside)

Sun Valley Magazine
Valley Publishing, LLC.
313 N. Main Street
Hailey, ID 83333
(208) 788-0770
sunvalleymag.com
(Send SASE for art guidelines; Pays $*0-$240
for inside, $350 for cover)

TV Guide
11 W. 42nd Street, 16th Floor
New York, NY 10036
(212) 852-7500
tvguide.com
(Pays $1,500-$4,000 for color cover, $1,000-
$2,000 for full page color, $200-$500 for spot)

UBM Advanstar
Advanstar Communications, Inc.
2450 Colorado Ave., Ste. 300 East
Santa Monica, CA 90404
(310) 857-7500
advanstar.com
(Pays $1,000-$1,5000 for color cover, $250-
$800 for color inside, $200-$600 for black and
white)

U.S. Kids Magazines
1100 Waterway Blvd.
Indianapolis, IN 46202
(317) 634-1100
uskidsmags.com
(Send SASE for art guidelines, pays $275 for
color cover, $35-$90 for black & white inside,
$70-$155 for color inside, $35-$70 for spots)

Watercolor Artist
F & W
10151 Carver Rd., Ste. 200
Blue Ash, OH 45242
(513) 531-2690
watercolorartistmagazine.com
(Send SASE for art guidelines)

Wooden Boat Magazine
Wooden Boat Publications, Inc.
PO Box 78
Brookline, ME 04616
(207) 359-4651
woodenboat.com
(Send SASE for art guidelines)

CHAPTER 25

NICHE ART MARKETS

"[T]he art world is not monolithic. There are niches for every type of artist and specific markets for all varieties of art."
– Daniel Grant

The biggest mistake I see prison artists make is that they try to do all kinds of art. Don't do that. Don't be a jack-of-all-trades. Pick a theme, a genre, or a technique. Master that and get famous for that. There are riches in niches! What type of art/craft do you like to do? Do you enjoy sculpture, ocean seascapes, mountain landscapes graffiti art, portraits, black and white ink drawings, or oil paintings? Pick the genre that you love and master it. That's how you will become a Prison Picasso.

"Determining one's audience is crucial, because not all art appeals to everyone."
– Daniel Grant

Think about famous artists you know. For the most part, they are known for one style. They become famous for that style. Can you pick one style of art and master it? If you can, you could become famous from it. It's the same in my line of work…books. I'm getting name recognition as the creator of the Millionaire Prisoner brand, and my books reflect this. I have other ideas for some books, like a romance novel. Did you just laugh? Do you see what I mean? If I did write a romance novel, I would write it under a pseudonym. That way I don't dilute my work with the Millionaire Prisoner brand. Think about this and your art.

That's not to say you can't do other art, or different crafts or sculptures. If you are a beginner and are trying out different styles or genres, that's fine. Follow your instincts. Trust your gut. Do the art that you love to do and keep doing it. There's a market for it. In this chapter, I'll give you some specialized markets that you could do art for. Each has its own specifics. I've included them here so you can begin to think outside that box you live in. And yes, there is a specific market for prison art. I've included a few of the companies that specialize in prison art as well. The one thing that I want you to remember is that for each market you try to work in you will need different marketing plans. That's more work on your end and whoever you have helping you. Simplify your life. Find your niche and master it.

"If you want to get rich, target a niche. If you want to go broke, market to all the folks."
– Stephen Pierce

CRUISE SHIP ARTWORK

Just as you can sell artwork to hotels, you can also sell it to cruise ships. Why? Because a cruise ship is just a big floating hotel, people who take cruises normally have a little bit of money. You can sell artwork that the cruise ship puts in its staterooms, restaurants, bars, and hallways. Or you can sell artwork that is auctioned off by the cruise ships as part of an event on board the ship for its passenger. On the Royal Caribbean cruise ships over 20,000 pieces of art are sold each year. There are specific auction houses that work with artists who want to sell their work on cruise ships. Check with these houses to see what you need to send in for a review of your work. Normally, you send 15-20 hard copy prints, a brief biography of yourself, and any history of exhibits and/or sales of your work. The auction houses that sell artwork to, and on cruise ships are:

Richmond Fine Art Sales, Inc.
1169 N.W. 163rd Drive
Miami, FL 33169
(205) 625-9566

Fine Art Wholesalers
1410 S.W. 29th Avenue
Pompano Beach, FL 33069
(954) 917-4770
fineartwholesalers.com

Park West Gallery
29469 Northwestern
Southfield, MI 48934
parkwestgallery.acmeinfo.com

West End Gallery
19048 N.E. 29th Avenue
Aventura, FL 33180
ATTN: Phyllis Brown
(305) 935-0255
westend-gallery.co.uk

HOSPITALS, CLINICS, AND DOCTORS' OFFICES

You can sell artwork to hospitals and clinics, especially those that are new or being built. To do so you should contact the members of the following:

Society for the Arts in Healthcare
2437 15th Street, N.W.
Washington, DC 20001
(202) 299-9887
thesah.org

International Arts Medicine Association
714 Old Lancaster Road
Bryn Mawr, PA 19010
(610) 523-3784
members.aol.com/iamaorg/

TATTOO ART

Celebrity Tattoo
ATTN: Brian
11730 West Colfax Ave.
Lakewood, CO 80215
(720) 436-2912
findthattattoo.com
(Buys and sells tattoo line art)

Real Artist Tattoo Art Gallery
(205) 545-3656
kdsartworld.com

Tattoo Flash
Box 3000
Agoura Hills, CA 91376
(Full page pays $75, smaller pays $25)

RELIGIOUS & SPIRITUALITY ART

Church Publishing, Inc.
19 E. 34th St.
New York, NY 10016
(800) 223-6602
churchpublishing.org
Contact: Nancy Bryan, VP Editorial
E-mail: nabryan@cpg.org
(Samples are filed for future evaluation)

CRC Ministry Support Services
1700 28th St., S.E.
Grand Rapids, MI 49508-1407
(616) 224-0780
crna.org
E-mail: dheetderks@crna.org
(Send query, letter, résumé, and photocopies,
pays $300-$1000 per project)

Harvest House Publishers
990 Owen Loop
Eugene, OR 97402
(541) 343-0123
harvesthousepublishers.com
(Send query, a letter with resume, and
photocopies)

Ignatius Press
1348 Tenth Avenue
San Francisco, CA 94122
(415) 387-2324
ignatius.com/default.aspx
(Catholic theology publisher, send brochure
and photocopies, looks for Christian
symbols/calligraphy and illustrations of Jesus,
saints, etc.)

KAR-BEN Publishing
Lerner Publishing Group
1251 Washington Ave., N.
Minneapolis, MN 55401
karben.com
(Jewish themes for young children and
families, send postcard samples, pays $4000
per project!)

Llewellyn Publications
Llewellyn Worldwide, Ltd.
2143 Wooddale Dr.
Woodbury, MN 55125
(651) 291-1970
llewellyn.com
(New Age spirituality, astrology, occult, pays
by the project)

Pauline Books & Media
50 St. Paul Ave,
Boston, MA 02130
(617) 522-8911
Pauline.org
(Religious publisher, sends samples, SASE;
Does children's religious books also)

Torah Aura Productions
2710 Supply Avenue
Los Angeles, CA 90040
(800) 238-6724
torahaura.com
Contact: Jane Golub, Art Director
(Specializes in Jewish educational books,
send postcard samples)

Waterbrook Multnomah Publishing Group
10807 New Allegiance Dr., Ste. 500
Colorado Springs, CO 80921
(719) 590-4999
waterbrookmultnomah.com
(Send postcard sample with a brochure, tear
sheets, specializes in Christian titles)

TTVR Books Crafts
PO Box 572
Antioch, IL 60002
(Sells prisoner art/crafts that are Nordic/Indo-
European/Wiccan/Asatru)

CORPORATIONS

Not only can corporations be a good source of money for grants to artists, but they also buy artwork to hang in their offices. Remember pencil artist Owen Garrett (pencilneck.com)? He sells his work in sets to corporations for thousands of dollars, which is a great strategy. That's the keyword—strategy. To approach a corporation, you should have a strategic reason behind your pitch. What theme do you have behind your art? Does it match those of the corporations? Does your artwork fit the region where the corporate headquarters resides? Can you combine the two? For instance, a Colorado corporation may like mountain landscapes, while an Atlantic corporation may like seascapes. A company that has a sports-related business may like artwork with a sports theme. For more on this, there's a directory that's put out every other year dealing with corporations and their art collections (although it does cost $175):

Directory of Corporate Art Collections
The Humanities Exchange
2480 West Bay Drive
Belleair Bluffs, FL 33770
(514) 935-1228
humanities-exchange.org/corporateart

SPORTS ART

One of my homies #Braintrust did a huge poster in memory of Kobe Bryant. It was an ink portrait. A person in Los Angeles that plasters huge murals on the sides of buildings bought it for $18,000! Sports art is a very specialized market. He did a Kobe portrait and it sold to a person in LA, which makes sense. I live in Illinois, so if I were to do sports-related art I would do Chicago teams like the Cubs, White Sox, Bears or Bulls, maybe even the Blackhawks. If I lived in Southern Illinois I would draw St. Louis Cardinals art, famous players' portraits, and things like that. Someone who collects team memorabilia for those teams might buy a painting or portrait of their favorite player to hang in their den. You could find someone like #Braintrust did. Or your associates could set up at sports collectors' conventions and sell your art, or they could get permission to set up outside the arena or ballpark. Don't be afraid to think outside the box!

National Sports Collectors Convention
PO Box 35200
Las Vegas, NV 89135
(702) 515-0636
natlconv.com/national

PRISON ART

Art with Conviction
P.O. Box 12255
Tucson, AZ 85732
(Send SASE for submission form)

CellBlockArt.com
E-mail: frank@mesaart.net

Con-Art
P.O. Box 61
Lankin, ND 58258
(701) 331-2518
Contact: Colten Pede/Kellie Warner

Concert Consignment, L.L.C.
2300 E. Fry Blvd.
P.O. Box 909
Sierra Vista, AZ 85635
($3.00 for 85 plus page catalog)

Caged Kingdom
4023 Banbury Way
Antioch, CA 94531
cagedkingdom@gmail.com
(Send SASE for more information)

Contexts Art Project
4722 Baltimore Ave.
Philadelphia, PA 19143
(215) 727-8170, ext. 5
E-mail: contexts@booksthroughbarn.org

PrisonArt.com.mx

Ink From The Pen Magazine
1440 Beaumont Ave., Ste. A2-266
Beaumont, CA 92223
inkfromthepenmagazine.com
E-mail: inkfromthepen@yahoo.com
(Guest artists can submit one piece, SASE,
featured artists, 10 pieces)

Prison Creative Arts Project
University of Michigan
Ann Arbor, MI 48109
(Michigan prisoners only)

Safe Street Arts Foundation
2512 Virginia Ave., N.W.Ste.58043
Washington, DC 20037
OutsiderArtUSA.com

Sticks from the Yard, Inc., LLC
2283 Sunset Dr
Wickliffe OH 44092

PrisonArtWear.com
304 S. Jones Blvd., Ste. 1683
Las Vegas, NV 89107
prisonartwear.com
(702) 570-9219

I've included this website here because when I had my virtual assistant google prison art, this is what came up. She clicked on it and a video started playing of a Latino woman with a purse made by Mexican prisoners. She said, "Oooh, I want that, it's so cute." That's the type of video you need for your website and/or social media pages. By the way, the other thing that came up was the Facebook group Prison Art and Hobby Craft, just another reason why you need to get onto Facebook and join that group!

Dear Interested Artist,

I'm Intern Mandy from PrisonArtWear.com. I'll be your rep in charge of the buildout and curation of your ortfolio, should you decide to take advantage of any one of our newest suite of curation options. You're actually one of the first to receive this new offering; previously we offered just our lifetime Prison Art Listing and Archival Services (PALAAS) for $129.95, and it was quite popular.

Still, the founders were concerned that the price point was too high, noting that artists either did not have the money, or did not produce the volume of work required for the lifetime PALAAS offering to make sense. This expansion of our offerings is our best attempt at trying to include everyone, and still manage the workload with the staff on hand in these uncertain times.

When your decision is made, please send an institution check, or have your people contact me at At my email below and I'll arrange for payment. You can also provide me with *their* email address and I'll send an invoice so they can pay quickly with a credit card, debit card, even gift cards.

PrisonArtWear.com is the *only* full service online gallery in the English speaking world. Our curation approach allows our artists to retain total ownership of their work. We're also the only curators of prison art that actively use social media, plus eBay and YouTube to promote our artists. Our mission statement—new for 2020—presents our core objectives in that "We strive to give prison artists everywhere a safe and lasting place to archive their work, while simultaneously expanding their digital footprint on the internet". Five years in business, 150+ artists represented, and over 2500 works under curation has taught us one thing: the healing power and universal language of art cannot be silenced. Join us today.

Intern Mandy
Account Representative, North America
PrisonArtWear.com
InternMandy@prisonartwear.com

P.S. Please protect yourself from Covid 19 by using every available means to keep clear of infection. Our thoughts and prayers are with every incarcerated artist whose work we curate, those around them.

1

PrisonArtwear.com has a curation package for every level of artist

Starter Prison Art Listing And Archival Service Only $10.95
- One-time opportunity to submit one work.* Additional works can be submitted at the rate of $5 each.
- Includes portfolio and retail exhibit space buildouts. (requires profile pic and 100 word artist bio).
- Free listing on PrisonArtWear.com website, and linked to portfolio and online exhibition space.

Career Prison Art Listing And Archival Service Only $21.95
- One-time opportunity to submit 10 works.* Additional works can be submitted at the rate of $2 each.
- Includes portfolio and retail exhibit space buildouts. (requires profile pic and 100 word artist bio).
- Free listing on PrisonArtWear.com website, and linked to portfolio and online exhibition space.
- Free 90-day reprints listed on eBay ($20 per quarter to have any 10 works relisted).**

Professional Prison Art Listing And Archival Service Only $69.95
- Opportunity to submit 10 works 3x per year(30 per year total). Additional works can be submitted at the rate of $1 each.*
- Includes portfolio and retail exhibit space buildouts. (requires profile pic and 100 word artist bio).
- Free listing on PrisonArtWear.com website, and linked to portfolio and online exhibition space.
- Free 120-day reprints listed on eBay ($20 per quarter to have any 10 works relisted).**
- Generic Featured Artist Page buildout with three PayPal buttons for visitors to donate $1, $10, or $35 to pay your yearly curation fee of $35.

Lifetime Prison Art Listing And Archival Service Only $129.95
- Unlimited yearly submission of work.* No charge for additional work.
- Includes portfolio and retail exhibit space buildouts. (requires profile pic and 100 word artist bio).
- Free listing on PrisonArtWear.com website, and linked to portfolio and online retail space.
- Free lifetime listing of every reprint work on eBay.**
- Free for one year: Fully functional Featured Artist Page buildout, with "Support Now" PayPal donation button under profile pic. Unlimited PayPal "Buy Now" buttons on all works added to the Page (*overflow pages are $5 each per year)
- Free dedicated YouTube channel and 2-5 minute exhibition video of up to 20 works

2

Send your payment today. For quicker, more convenient service, please let your friends, family, and supporters know they can pay online at: http://bit.ly/ALServices. Or send us their email address, along with your artwork, profile pic, and 100 word bio, and we'll send them a convenient invoice by email where they can pay with credit cards, debit cards, even prepaid gift cards.

PrisonArtWear.com 304 S. Jones Blvd Suite 1683 Las Vegas, NV 89107

*Need a safe climate-control place to store your original work? We charge just $6 year, per mailing. No more than 10 works per mailing. All work submitted must be on 8.5x11 inch paper, canvas, cardstock or other material. For photography and storage of larger works, ask your account rep.

**Reprints sold on eBay are printed on 8.5x11 cardstock, and include a "placard of authenticity" on the reverse side that bears your signature, title of work, inventory number, and full color thumbnail image. Sample of actual work shown here.

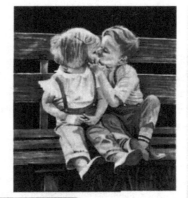

PrisonArtWare.com uses eBay to promote its artists and their work. While the marketing and sale of the work we curate is not our primary goal, we recognize that eBay is a marketplace and sales will occur. We give our artists 70% of the profit on all sales of reprints sold at auction through eBay.

When we receive your payment, artwork, profile pic and artist bio, we will send you a blank placard of authenticity for your signature. We will then convert this image to a MS Word file, fill in the relevant information, then store it, and the digital copy of your work in your cloud account.

Placard below enlarged for clarity

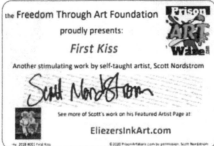

the **Freedom Through Art Foundation**
proudly presents:

First Kiss

Another stimulating work by self-taught artist, Scott Nordstrom

Scott Nordstrom

See more of Scott's work on his Featured Artist Page at:
EliezersInkArt.com

3

GENERAL INFO & HOW TO SUBMIT ARTWORK

INK FROM THE PEN MAGAZINE comes out quarterly on Dec. 1st, March 1st, June 1st, and Sept. 1st.

I have been in business since December 2014.

I do not do yearly subscriptions due to the fact that I ship to prisons, and you never know when they may change their rules on published material and I don't want people to be pre-paid for something that might be disallowed at some point.

Each issue is $19.95 + $5.95 S&H (Combine shipping for up to 5 issues)

I offer a "Buy 4 get 1 FREE" in a single order and shipped to a single address

(Please make sure your facility will allow you to receive 5 issues in one package)

Each issue is 48 pages of FULL PAGE ART.

I do not accept strips of stamps as payment. I can accept payment by a state check or money order from your facility taken from your books, or a loved one on the outside can order for you at www.InkFromThePen.com

I am the publisher so I ship direct to the prison.

Magazines are allowed in MOST State and Federal prisons.

There is no nudity or gang related material allowed.

No refunds for magazines that get rejected by mail room because we all know these facilities can be petty and deny something one day, but accept it the next depending on the CO and their mood.

Submission of artwork to be considered for publication may be done one of several different ways.

If you submit original artwork and want it returned or sent on to a loved one, you must include a self-addressed stamped envelope as I will NOT pay to forward or return artwork. (This might take awhile as I deal with HUGE quantities of mail.)

You may also submit good quality color copies by mail, or have a loved one submit for you using one of the following:

- Pictures taken in good lighting and highest quality setting on phone camera, or scanned JPEG or PDF file sent to inkfromthepen@yahoo.com.

- Original artwork submitted without a return self-addressed stamped envelope will be considered a gift, and may be displayed for sale at events hosted by INK FROM THE PEN.

I look forward to seeing your work. I'm very excited about this project and really hope you will come aboard with us.

– Pam Delgado

INK FROM THE PEN
1440 BEAUMONT AVE., STE. A2-266
BEAUMONT, CA 92223
760-616-0557

INK FROM THE PEN is not responsible for any artwork that is lost or stolen by prison staff or the United States Postal Service

Joshua Kruger

Dear Mr. Kruger:

In answer to your letter I will try to explain what we at Sticks From the Yard Inc. LLC are about. We are a nationwide wholesaler that deals with a variety of clients, many of whom enjoy purchasing products made by inmates. Our goal is to help incarcerated men and women sell the variety of arts and crafts they make. Selling to us provides both a market for the products and an income for themselves. We send the money directly to the inmate or his designee upon receipt of the item, and also provide shipping in certain cases

Sadly, many prisons do not allow for inmates to mail items to those not on their visiting list and so must employ a third party to accomplish the entire transaction, sending the item out and receiving their money.

The response has been great and we are doing a wonderful business, having helped countless numbers of incarcerated men and women along the way. The outlet we provide is especially helpful to those having found a creative streak within themselves but with no means of support. We have contacted prisons that are described in such instances outlined above and have had some success. In such circumstances with the prison, we have been permitted to send the inmate's check to the prison, who then takes a percentage of the sale price (usually between 15-20%) and puts the remainder in the inmate's prisoner account.

I hope this is helpful. Please write again with any further questions.

Sincerely,

Sticks From the Yard Inc. LLC
2283 Sunset Dr.
Wickliffe, Ohio 44092

SELLING ART

We can help you earn income. You have good creativity and we want to assist you in profiting from it. This is how we can help; we want to get you the most out of your work, so for your drawings, paintings, and all art on paper, we will make replicates of and sale in our online store. This way you can have a continuous income as long as people are buying your art. Replicates will be sold at a lesser price than the original artwork. Caged Kingdom will keep 50% of all revenue collected from sales of replicates. Caged Kingdom will keep 40% of the purchase price of original art work that is sold. Here's an example of what you can earn:

Replicate art price: $10 and original art price $100. If 5 replicates are sold, that's $50. Your profit will be $25 from replicates, that is 50%. Then your original art sells for$100, 60% of $100 is $60. $60 is your profit.

Also, your replicates will continue to sell until you choose to cancel your subscription or request to remove it from our store. Four arts and crafts that can't be replicated, we will sell the original creation and split Revenue 60/40, with 60% going to you. Also, if art is made into a other product such as t-shirt or other item our cost of investment of development of each item will be deducted prior to splitting the revenue. We understand the passion that goes into some of your artwork and that you want to get the most value for your creativity. With that said, we will only sell work at the most reasonable prices. Caged Kingdom's experienced staff we'll set a price that is fair based on comparisons of other artists work that is similar in style, medium, color, and size. Caged Kingdom has a minimum disbursement total of $10. This means you have to have accumulated at least $10 individual profit for your art that has sold. Money transactions and sending fees will also be paid out of your profit. For example:

You have $20 in your Caged Kingdom account, there is a $5 fee to send money to your trust account. $5 will deduct from your $20 to pay that fee. You will receive $15. All artwork will not be worth selling throw Caged Kingdom so you need to be sure that your creation has enough value to earn you a prophet given the requirements stated on this form. Caged Kingdom will not be responsible to pay you for art that doesn't not sale and that cannot be returned to you at your facility. Additionally, you will be responsible to pay any shipping cost for Caged Kingdom to return artwork to you. Artwork that can't be replicated, that we determine has minimal value will be priced at $18. This is so, the profit for you, meets the minimum required disbursement total. If you wish for caged Kingdom to sell your art on our online store check the boxes that apply and agree to the terms. You must have a valid inmate trust account to have your money sent to. Money will not be sent to any other type of account. You must have a membership with Caged Kingdom to sell your artwork through us.

I have already sent my artwork to Caged Kingdom [] Describe the art that you sent in:

I am mailing in my art that is described as
follows:_____

I agree that Caged Kingdom we'll set the prices that my art will sell for on Caged Kingdom's store and the revenue will be split in accordance with this form. []

Print Name:_____ **Inmate #:**_____ **This name and number will be**
used to send your money to your trust account.

Signature:_____

If you do not agree to these terms and want your art returned send an SASE with sufficient postage for return of your artwork. Payments will be disbursed at the end of each month if you have earned the minimum disbursement amount.

Name of company to transfer payment to your account:_____ **What information is required when**
depositing funds to your account?:_____

Caged Kingdom, 4023 Banbury Way, Antioch CA 94531/ cagedkingdom@gmail.com/ www.cagedkingdom.net

Caged Kingdom LLC

"The Bridge of Creative Freedom"

About Us

We created The Bridge of Creative Freedom with the vision of becoming the economic and social bridge of opportunity for the forgotten members of a thriving society. With the rapid changes in social connectivity, we now have the ability to showcase your gifts of creativity on a global scale across all digital mediums.

The Bridge recognizes America's incarcerated are some of the brightest and most talented individuals in our society. Through artistic expression, we aim to provide society the opportunity to see incarcerated individuals equally and humanely. We want the world to understand sometimes people make bad choices, but those choices do not define the individual for the entirety of their life.

The way it works

1. The artist submits his/her artwork *(paintings, drawings, pictures, poetry)* to us with a seller quote.
2. Our Content Management Division will determine the quality of submitted artwork.
3. If interested in purchasing, the artist will be contacted by our Purchasing Coordinator.
4. Upon contact the artist will be presented with a buyer option, release of intellectual property, and payment forms.
5. If our offer is accepted, the artist **must sign** our notarized release of intellectual property to "Creative Freedom, LLC." for the artwork submitted and return it to the following address: **Creative Freedom, LLC., P.O. Box 119, Williamson, WV 25661**
6. Upon receiving the documents of release, Creative Freedom, LLC. will provide the agreed upon payment for purchase to the artist.

Why?

The best gifts to provide someone in life are exposure and opportunity. The Bridge of Creative Freedom will expose the world to your artistic expression, providing the opportunity to have impact on a global scale. Becoming imprisoned is accompanied by longlasting stigma, voice suppression, the sting of dehumanization, and the feeling of being exiled to the shadows of society. This is why we feel it is our social responsibility to shine a positive light on our forgotten. The possibilities to change the public perception of the incarcerated are endless.

We, The Bridge of Creative Freedom, are asking that you, the artist, trust us to represent you in pioneering this change.

Regards,

Durand L. Warren, CEO

Hasani S. Warren, President

"I'm just here for the dental."

"Painting is just another way of keeping a diary"
-Pablo Picasso

Pablo Picasso likened his paintings to maintaining a diary. The way he describes substituting a paintbrush for a pen demonstrates how similar the branches of the arts can be. It's not so much about being a painter or a writer; they are two beasts of the same species. We could also guess that creativity of all types essentially draws form the same well of genius.

CHAPTER 26

FEMALE ARTISTS

"Study after study shows that women tend to be better investors because they don't overestimate their abilities to anticipate the future accurately."
– Tony Robbins

WOMEN PRISONERS AND ART

All of a prisoner's success will come through her ability to network, so why not take advantage of the networks that are already available? For women artists there are numerous networks, why not include women artists who also happen to be in prison? (I'm also including transgender women prisoners in the discussion; in case you're wondering.) You may wish to contact these organizations to see if you can join and how much the membership fees are, if any. Here are the networks of women artists:

American Academy of Women Artists
3935 County Road 250
Durango, CO 81301
(970) 375-1366
aawafineart.com

Art Table, Inc.
270 Lafayette Street, Ste. 608
New York, NY 10002
(212) 343-1735
arttable.org

Catharine Lorillard Wolfe Art Club
802 Broadway
New York, NY 10003
clwac.org

Guerrilla Girls
532 LaGuardia Place, Ste. 237
New York, NY 10012
guerrillagirls.org

National Association of Women Artists
80 Fifth Avenue
New York, NY 10011
(212) 675-1616
nawanet.org

The Women's Art Center
345 Pierpont Avenue
Salt Lake City, UT 84101
(801) 577-8367
nationalwca.com

Women Artists of the American West
PO Box 1644
Bemidji, MN 56619
(218) 854-7517
waow.org

Women in the Arts
National Women's Artist Foundation
PO Box 1427
Indianapolis, IN 46206-1427
(317) 713-1144
wiaonline.com

Women's Studio Workshop
PO Box 489
Rosendale, NY 12472
(845) 658-9133
wsworkshop.org

There are also some women-specific gallery co-ops' that could possibly show your work. Here is their contact information:

AIR Gallery
511 West 25th Street
New York, NY 10001
(212) 255-6651
airnyc.org

ART Gallery
734 North Milwaukee
Chicago, IL 60622
(312) 733-2787
artgallery.org

Ceres Gallery
547 West 27th Street
New York, NY 10001
(212) 947-6100
ceresgallery.org

Hera Gallery
Hera Educational Foundation
327 Main Street
PO Box 336
Wakefield, RI 02880-0336
(401) 789-1488
heragallery.org

Impact Artists' Gallery
Tri-Main Center
2495 Main Street
Buffalo, NY 14214
(716) 856-2447
members.tripod.com/ImpactArtist

The Pen & Brush, Inc.
16 East Tenth Street
New York, NY 10003
(212) 475-3669
penandbrush.org

San Francisco Women Artists
PO Box 156934
San Francisco, CA 94115
(415) 263-0705
sfwomenartists.org

Sotto 20 Gallery
511 West 25th Street
New York, NY 10001
(212) 367-8994
soho20gallery.com

Three Arts Club of Chicago
1300 North Dearborn Parkway
Chicago, IL 60610
(312) 944-6250
threearts.org

Women Artists Rising
PO Box 8247
Tampa, FL 33647
(813) 213-4444
womenartistsrising.com

Woman Made Gallery
2418 West Bloomingdale
Chicago, IL 60647-4301
(773) 489-8900
womanmade.net

Women & Their Work
1710 Lavaca Street
Austin, TX 78701
(512) 477-1064
womenandtheirwork.org

Another traditional route for artists is to get a grant to help them pay for their supplies and living expenses. Most foundations that give out grants are geared toward a specific people or place. Here are some foundations that provide fellowships and grants to women artists:

Astraea Lesbian Foundation for Justice
116 East 16th Street
New York, NY 10003
(212) 529-8021
astraeaffoundation.org

The Fund for Women Artists
PO Box 60637
Florence, MA 01062
(413) 585-5968
womenarts.org

Money for Women
Barbara Oeming Memorial Fund, Inc.
PO Box 630125
Bronx, NY 10463

The Kentucky Foundation for Women
1215-A Heyburn Building
332 West Broadway
Louisville, KY 40202
(502) 562-0045

The Leeway Foundation
123 S. Broad Street, Ste. 2040
Philadelphia, PA 19109
(215) 545-4078
leeway.org

McKenzie River Gathering Foundation
Lilla Jewel Award for Women Artists
2705 East Burnside
Portland, OR 97214
(503) 289-1517
mrgfoundation.org
(For artist who live in Oregon)

National Museum of Women in the Arts
Library Fellowship Program
1250 New York Avenue, N.W.
Washington, DC 20005-3920
(202) 783-7366
nmwa.org

Serpent Source Foundation for Women
Artists
3311 Mission Street
San Francisco, CA 94110
(415) 597-3545
home.flash.net/~serpents/

Thanks Be to Grandmother Winifred
Foundation
P.O. Box 1449
Wainscott, NY 11975-1449
(631) 725-0323
(Women artist aged 54 and over)

CHAPTER 27

POSTERS & REPRINTS

"We have been endowed with the capacity and the power to create desirable pictures within and to find them automatically printed in the outer world of our environment."
– John McDonald

When former President Obama first got elected my neighbor painted a huge portrait of him with the word *change* in all capital letters at the bottom of it. It took him a while to do it and he ended up selling it for $400.00 to someone in the free world. Shortly after that he was approached by someone else to do another one. At that time, he told me he wished he had some connections with an art publisher to make prints of his painting so he wouldn't' have to keep doing the same one over and over again. He wouldn't' make $400.00 off a print, but he could sell more prints and make up the difference while he worked on another painting. I didn't know what an art publisher was or did back then. Now I do. An art publisher is a person or a company that works with you to publish a piece of your art into a print or poster. There are also art distributors, not to be confused with art publishers. An art distributor helps you market a pre-existing print or poster. Some companies will do both for you. I wish I knew back then what I know now. I could have helped my neighbor and made a little money myself.

Let's compare some numbers with different examples. A print is different than a poster. It is a limited-edition print of a piece, numbered from one to 250. If there are only 250 prints in existence, they become collector's editions and are highly prized. These prints are made in several different ways. They can be original prints (or by hand), offset reproductions (or posters), giclee prints (an inkjet fine art printer), and/or canvas transfers. Some publishers print your artwork onto a canvas, so it looks like a real painting. Most publishers pay royalties for the prints that are sold. Typically, the royalties are 5% to 20% for hand-pulled prints, and 2.5% to 5% for posters. Signed, limited edition prints average about $175-$200, while canvas transfers sell for $400-$500. Using these numbers, my neighbor would have made $10 off each Obama limited edition print that sold for $200.00. That's at the low-end 5% royalty rate. At the high end, he would have made $40.00. If his art publisher would have run a 250 limited-edition canvas transfers at $400.00 each, he would have made $20.00 apiece at 5%, for a total of $5,000.00. At 20% he would have made $20,000.00. These numbers make me want to quit writing books and start an art business!

Now you're probably wondering how you can do it. The first thing you should do is research this avenue. If you were in the free world, you could go to art galleries, furniture stores or other places that sell prints so you could see how you fit in. But since you're still inside a box, you will need to start trying to get the catalogs of art publishers. Have someone check their websites for you to see if they have print catalogs they will send or that are for sale. You can also read magazines like *DÉCOR* (decormagazine.com) and *Art Business News* (artbusinessnews.com) to see what is selling and to get tips. Then you'll have to approach one of these companies to seek their business. The normal practice is to send them a query letter, résumé (or bio), and a small sample of JPEG's, TIFF's or slides. You should always check with the company to get their exact submission guidelines first. If and when you find a company that is willing to work with you, make sure you get a signed contract. Do not sign anything unless you understand it. Because it's your art, you have a right to approve a lot of things. For instance, you should have the final say on the size, printing method, paper, number of images to be produced and your royalties. Some companies don't pay royalties, instead they pay a flat fee. That's a decision you'll have to make on your own. You should always try to keep complete control of your original artwork. Sell only publication rights. You can also try to put a time limit on how long you'll sell rights. That way you can reuse it later for some other licensing income stream. At the end of this chapter, I've included the contact information for some art publishers and distributors. Where possible I list what type of art they prefer.

Yet there's' another option. You could self-publish your own prints and have an art distributor market them for you in exchange for a percentage of the profits. It will be a little harder for you since you're in prison, but not impossible. I self-published my first book, *The Millionaire Prisoner*, from inside a maximum-security segregation cell without access to a phone or computer. Anything is possible.

If you're just starting out and decide to self-publish your own art reprints, go the same route I did–POD. POD stands for *Print on Demand*. That way you don't have to spend thousands of dollars on a large quantity of reprints not knowing if you can sell them. Instead, with POD technology, you only print out your reprint or poster after someone has ordered it. Here are some of the major POD art printers:

FineArtAmerica.com
ImageKind.com
ArtistRising.com
CafePress.com
Zazzle.com

"Never spend your money till you have earned it"
– Thomas Jefferson

Art Publishers/Distributors
Arnold Art Store &Gallery
210 Thames St.
Newport, RI 02840
(401) 847-2273
arnoldart.com (Poster company that specializes in sailing images, racing, boats, etc., send query letter and 4-5 samples.)

Herbert Arnot, Inc.
250 W. 57th Street, Tenth Floor
Ste. 1014
New York, NY 10107
(212) 245-8287
arnotart.com
(Art distributor of oil and acrylic paintings, send query letter, brochure, resume and samples, SASE)

Art Brokers of Colorado
7615 Jeffrey Lane
Colorado Springs, CO 80919
(719) 520-9177
artbrokers.com
(Publishes Western-theme oils, watercolor, and acrylic, send query letter with sample photographs, SASE)

Art Dallas, Inc.
2325 Valdina St.
Dallas, TX 75207
(214) 688-0244
artdallas.com
(Distributes hand-pulled originals, offset reproductions, pays flat fee of $50-$5,000, send a query letter, resume and photocopies)

The Benjamin Gallery
419 Elmwood Ave.
Buffalo, NY 14222
(716) 886-0898
benjamangallery.com
(Publisher of art décor and florals, considers oil, acrylic, and watercolors, send query letter, SASE, photocopies, resume)

Bon Art
66 Fort Point St.
Norwalk, CT 06855
(203) 845-8888
bonartique.com
(Art publisher and poster company)

Joe Buckalew
1825 Annwicks Dr.
Marietta, GA 30062
(800) 971-9530
joebuckalew.com
(Considers oil, acrylic, and watercolor, prefers florals, landscapes, Civil War and sports, art guidelines free with SASE)

Carpentree, Inc.
2724 N. Sheridan
Tulsa, OK 74115
(800) 736-2787
carpentree.co
(Prefers traditional, family-oriented subjects, Biblical themes, and landscapes, send JPEG files to smorris@carpentree.com)

Chalk & Vermilion Fine Arts
55 Old Post Rd., #2
Greenwich, CT 06830
(203) 869-9500
chalk-vermilion.com
(Submission guidelines online, considers oil,
mixed media, and acrylic)

Cirrus Editions
2011 S. Santa Fe Ave.
Los Angeles, CA 90021
(213) 680-3473
cirrusgallery.com
(Prefers abstract, conceptual work, like CD or
JPEG's)

Color Circle Art Publishing, Inc.
791 Tremont St., Box A, Ste. N104
Boston, MA 02118
(800) 254-1795
colorcircle.com
(Prefers ethnic themes, send query letter,
slides, SASE)

Dare to Move
6621 83rd St. E.
Puyallup, WA 98371
(206) 380-4378
daretomove.com
(Considers oil and acrylic, wants naval,
marine, firefighter, civil service, and aviation-
related art, send query letter with
photographs.)

DelJou Art Group
1616 Huber St.
Atlanta, GA 30318
(404) 350-7190
deljouartgroup.com
(Considers oil, acrylic, pastel, and mixed
media, send five images in JPEG format,
smaller than 5MB each, bio, resume, artist
statement)

Editions Limited Galleries, Inc.
4090 Halleck St.
Emeryville, CA 94608
(510) 923-9770, ext. 6998
editionslimited.com
(Prefers landscape, floral and abstract
imagery, considers oil, acrylic, and watercolor
paintings, send query letter, resume and
photographs.)

Encore Graphics & Fine Art
PO Box 32
Huntsville, AL 35804
(256) 509-7944
egart.com
(Considers all media, prefers African
American and abstract, art guidelines on
website)

Eleanor Ettinger, Inc.
24 W. 57th St.
New York, NY 10019
(212) 925-7474
eegallery.com
(Seeks classically inspired, realistic work
involving landscapes and still life's, prefers
American realism, send query letter, SASE,
resume and visual samples)

Fairfield Art Publishing
430 Communipaw Ave., Second Floor West
Jersey City, NJ 07304
(800) 835-3539
fairfieldpublishing.com
(Publishes posters and reproductions, send
query letter, brochure, and SASE)

Russell Fink Gallery
PO Box 250
Lorton, VA 22199
(703) 550-9699
russelfinkgallery.com
(Publishes wildlife and sports themes, send
query letter with photographs and SASE)

Fortune Fine Art
7825 E. Redfield Rd., Ste. 105
Scottsdale, AZ 85260
(480) 946-1055
fortunefa.com
(Send query letter, resume, bio, photos, and
SASE)

Gallery Graphics, Inc.
PO Box 631
2210 S. Main St.
Ft. Scott, KS 66701
(620) 223-5190, ext. 7014
gallerygraphics.com
(Seeks art with nostalgic look, country,
Victorian, children, angels, florals,
landscapes, and animals, send query letter
with brochure)

Geme Art, Inc.
209 W. Sixth St.
Vancouver, WA 98660
(800) 426-4424
gemeart.com
(Publishes Mid-American art, sends brochure,
photos, and SASE)

Haddad's Fine Arts, Inc.
3855 E. Mira Loma Ave.
Anaheim, CA 92806
(800) 942-3323
haddadsfinearts.com
(Submission guidelines online)

Hadley House Publishing
4816 Nicollet Ave. S.
Minneapolis, MN 55419
(800) 423-5390
hadleyhouse.com
(Art guidelines free for SASE)

Image Connection
456 Penn Street
Yeadon, PA 19050
(650) 626-7770
imageconnection.biz
(Prefers contemporary, popular themes,
realistic and abstract art, send query letter,
brochures, photocopies, and SASE)

Inspiration Art & Scripture, Inc.
(319) 651-3419
inspirationart.com
(Produces Christian posters for preteens,
teens and young adults, looks for art that
portrays a scripture passage)

Jadei Graphics, Inc.
4943 McConnell Ave., Ste. Y
Los Angeles, CA 90066
(800) 717-1222
jadeigraphics.com
(Poster company that seeks creative,
decorative art for the commercial market,
considers oil, acrylic, and watercolor, send
query letter, samples, and SASE)

Lola Ltd. Lt'ee
1817 Egret St., S.W.
Shallotte, NC 28470-5433
(910) 754-8002
E-mail: lolaltd@yahoo.com
(Likes birds and nautical color network, send
a query letter with samples)

Marco Fine Arts
4860 W. 147th St.
Hawthorne, CA 90250
(310) 615-1818
marcofinearts.com/contact_us.php
(Prefers landscapes, florals, Southwestern
art, send a query letter, brochure,
photocopies, and SASE)

Military Gallery
821 E. Ojai Ave.
Ojai, CA 93023
(800) 248-0317
militarygallery.com
(Prefers aviation & maritime art, send query
letter, photos, and SASE)

Munson Graphics
7502 Mallard Way, Unit C
Santa Fe, NM 87507
(888) 686-7664
munsongraphics.com
(Send query letter, slides and SASE)

Museum Masters International
185 E. 85th, Ste. 27B
New York, NY 10028
(212) 360-7100
museummasters.com
E-mail:
MarilynGoldberg@museummasters.com
(E-mail with sample download of art)

New York Graphic Society
130 Scott Rd.
Waterbury, CT 06705
nygs.com
(Send query letter with samples to: *ATTN: Artist Submissions* and SASE)

Old World Prints, Ltd.
808 Villa Park Dr.
Richmond, VA 23228
(804) 213-0600, ext. 634
oldworldprintsltd.com
(Pays flat fee of $100 plus 10% royalties, can use black & white pen & ink art, send query letter, brochure, and samples)

Penny Lane Publishing, Inc.
1791 Dalton Drive
New Carlisle, OH 45344
(937) 849-1101
pennylanepublishing.com
(Publishes creative, decorative art. Send query letter, 6-10 samples, SASE)

Posner Fine Art
1212 S. Point View Street
Los Angeles, CA 90035
(323) 933-3664
posnerfineart.com
(Prefers very contemporary styles. Art guidelines free with SASE)

Sagebrush Fine Art
3065 S. West Temple
Salt Lake City, UT 84115
(*00) 643-7243
sagebrushfineart.com
E-mail: submissions@sagebrushfineart.com
(Prefers an e-mail of Pdf presentation of your art portfolio sent to the attention of Pansy Winterburn)

Segal Fine Art
11955 Teller Street, Unit C
Brownfield, CO 80020
(303) 926-6800
segalfineart.com
Contact: Ron Segal
(Publishes limited edition giclees. Clients: bikers at motorcycle rallies)

Sohn Fine Art
69 Church Street
Lenox, MA 01240
(413) 551-7353
sohnfineart.com
(Send query letter, postcard sample)

Somerset Fine Art
P.O. Box 869
Fulshear, TX 77441
(800) 444-2540
somersetfineart.com
(Send query letter, photo, SASE)

Sulier Art Publishing
PMB 55
3735 Palomar Centre, Ste. 150
Lexington, KY 40513
(859) 621-5511
neilsulier.com
(Send query letter, photocopies, resume and SASE)

Sun Dance Graphics & Northwest Publishing
9580 Delegates Dr., Building B
Orlando, FL 32837
(800) 617-5532
northwestpublishing.com
(Art guidelines free for SASE)

Taku Graphics
5763 Glacier Hwy.
Juneau, AK 99801
(800) ART-3291
takugraphics.com
Contact: Adele Hamey
(Seeks art from Alaska or Pacific Northwest, submission guidelines available online)

Bruce Teleky, Inc.
87 35th h St., Third Floor
Brooklyn, NY 11232
(800) 835-3539
teleky.com
(Prefers music themes, Latino, Caribbean, or African scenes, send query letter with digital files)

Vladimir Arts U.S.A., Inc.
2504 Sprinkle Rd.
Kalamazoo, MI 49001
(800) 678-8523
vladimirarts.com
(Send query letter, photocopies, brochure,
and SASE)

Wild Apple Graphics, Ltd.
2513 W. Woodstock Rd.
Woodstock, VT 05091
(800) 756-8359
wildapple.com
(Submission guidelines online)

Wild Wings, L.L.C.
2101 S. Hwy. 61
Lake City, MN 55041
(800) 445-4833
wildwings.com
(Send query letter, color printouts and
resume)

"WE HAD ROAST BEEF FOR DINNER TONIGHT . . . NO MOM, IT'S *NOT* BETTER THAN YOURS!"

"Art washes away from the soul the dust of everyday life."

-Pablo Picasso

The nature of this quote by Picasso makes one thing creating art served as a kind of renewing experience for him. It's interesting to think of the act of creation as one that reveals a cleaner or less aged version of oneself.

CHAPTER 28

BRANDING YOUR ART

"Becoming a brand name is an important part of life. It's the world we live in."
– Damien Hirst

The American Marketing Association defines a brand as a name, term, sign, symbol of design, or a group of sellers that differentiates them from those of other sellers. A brand is a visual, emotional, rational, or cultural image that one associates with a product. McDonald's, Starbucks, and Taco Bell are all brands. Robert Kiyosaki created his own brand in the *Rich Dad, Poor Dad* (richdad.com) series of books. Donald Trump branded his last name and rode it into the White House. Karrine Steffens of, *Confessions of a Video Vixen* fame, branded the *Superhead* moniker and turned it into a clothing line and more. In the art world, Pablo Picasso, Andy Warhol, Bob Ross, Norman Rockwell, and many more became brands. To create a brand, you form an image that stays in the minds of your prospects and customers. Branding would make selling easier because people want to buy from companies they know, like, and trust.

You might think that all the well-known art brands have a stranglehold on the marketplace, but there's room for an emerging artist. There's especially room for an artist in prison. The art world has many different niches, and if you find your target niche, you can chisel your way in and build your personal brand. In this chapter, I'll give you some tips on how to do this.

HOW TO BUILD YOUR OWN BRAND

Here's how you could start to build your own personal brand around your art or craft:

- Don't try to be everything to everybody. Find your target collectors. Spend time with them. What do they have in common? Where do they hang out? How can you stay in front of them?

- Always use personal language and slogans that link back to you and your art. Tell your story, (more on this in a minute.)

- Stay connected with your collectors through social media and try to respond to all inquiries. Always use tact and talk to them about your processes.

- Always use a photo of yourself when building your brand. Think Walt Disney. Not only did we see Mickey Mouse, but we also saw Uncle Walt.

- Come up with a catchy tagline for your brand and place it everywhere. Think of Nike's, "Just Do It."

- Be honest and trustworthy. If you can't do something, let your collectors know it. If you'll be late on a painting or sculpture, let them know. If you need something, let your fans and collectors know. Build your tribe.

- Don't be fake. Don't promote stuff that your collectors will know that you don't like, use or have any connections to. Live your brand!

- Make it about a movement, not just selling arts or crafts. Prison reform, equality, Black Lives Matter, and accountability are all movements you could tie your art to. An artist who paints seascapes could tie into animal rights or other wildlife movements.

There are some quick tips for you to remember. Let's look at some other powerful tips you can use to carve out your own personal brand in the art world.

YOUR PERSONAL STORY

In their books, *Celebrity Branding You* and *Story Selling*, Nick Nanton and J. W. Dicks do a great job showing you how to brand yourself and your business. One real-life example they use in *Story Selling* is Stan Lee of Marvel Studios fame. He started working for his uncle's comic business at

seventeen. He almost quit until his wife told him to try it one more time. Stan Lee was the writer and Jack Kirby was the artist. Together, they created *The Fantastic Four*, *Spider-Man*, *The Incredible Hulk*, *The X-Men*, *Iron Man*, *The Mighty Thor,* and *The Avengers*. Then Stan Lee rebranded it all as *Marvel Comics* and put out every cover with the same distinctive design. He also started putting funny storylines in the comics about the artists and writers behind the characters. He created a group of people, of collectors who worshipped *Marvel Comics*. Stan Lee built a brand that Disney bought years later for four *billion* dollars! That's not bad for a guy who was going to quit. It just goes to show you that art can become a brand, even a billion-dollar brand!

"Your brand is more than just a pretty logo, a catchy slogan, a great name–although all of those elements are important. Your brand is your identity. It is the essence of who you are and what you're selling. It is everything about you and your product. Your lifestyle and the image you project online and in your daily life are all part of your brand."
– Kari Chapin

What is unique about your personal story? What is unique about your technique? What is unique about the materials you use? Don't downplay the fact that you're in prison. Make your prison past dance. One of my friends uses 4-inch flexible segregation pens to do all his art. He should hype that up in all his marketing materials. I know a guy that used to paint when we were in the county jail. He would buy M&Ms off the commissary and soak them in water to make color ink. That's a great story. Do you have anything like that in your background? If so, use it in your personal story as you build your brand.

YOUR BRAND IMAGES & LOGOS

You want to create consistent designs and names across all your pieces, all your website pages, and social media outlets. Take your time when you come up with your logo and any other brand images. Think this out. Try to make your logo/images appeal to your target collector. Make sure your logo looks good in both black and white, as well as color. How would it look on a website banner or a business card, or maybe even as a square avatar for social media use? Think Playboy Bunny, and Mickey Mouse, the iconic images we recognize anywhere. Can you come up with your own image that represents your art or craft?

YOUR BRAND SYNERGY

You must be consistent in everything that you do. All the parts you put forth should work together to create the image you want. Your story, your logo, your art, your marketing materials, and your lifestyle should all portray the message behind your brand, including those you associate with. Stacy Minero leads Twitter Art House. It's a global team working with artists and influencers to develop content for brands. You can use your art to take a stance against social injustices.

"Creative ideas from creative people are always in demand, and the best entrepreneurs know that artists are at the center of creative ideas."
– Brainard Carey

YOUR BRAND MARKETING

Once you come up with all your brand images and the story behind your brand, you have to get the word out. This will probably be the hardest part for artists who are in prison. Some tools will help. Some social media groups can help, like the 131,000-member Facebook group, Prison Art, and Hobby Craft. It would be free to join that group and start telling your story and share other's stories as well.

"If you share generously, others are more inclined to talk about you positively. So being kind is possibly the biggest marketing asset we can possess."
– Jean Haines

The one thing you can't do is spend your money on brand marketing like Coca-Cola or Nike or Apple does. For one, you don't have millions of dollars for a marketing budget. And number two, the only marketing you should like is the type that gets collectors to purchase your art or craft. What type of marketing is that you may ask? Marketing that produces a direct response, ads that are measured, and even free social media pages should be measured. Everything you do should be set up so you can track the numbers. That way you can continue what is working and tweak what isn't working. I'm a huge believer in direct-response marketing principles and encourage you to read everything you can by Dan S. Kennedy. Until you do, here are some tips to remember when conducting any marketing for your art or craft line:

- Not every person who likes artwork will be interested in *your* work. A lot of people won't want to deal with a prisoner. That's okay because tons of people will. Find your ideal collector first, then learn the easiest ways to reach them. You can start for free on the Facebook group, Prison Art, and Hobby Craft.

- Keep in touch with people who like your art. That means you must capture names, e-mail addresses, phone numbers (if possible), and other contact info. This is much easier to do online on your website and social media pages.

- Write your blog as if you're speaking to your ideal collector. Talk about what interests you, and the causes you believe in. Tie it into your art. Be bold and provocative. As an artist, you get liberty that others don't. Use it. My mentor told me, "Go out on the limb because that's where the fruit is!" That is so true.

- Remember the comment on other people's blogs, newsfeeds, and stories. Don't forget to newsjack. Tie it into your art. For instance, last night on my GTL newsfeed I saw that the U.S. Supreme Court ruled that it's okay to sentence juveniles to life without parole as long as it was discretionary. An artist in prison could have written a blog post about the injustice in that ruling and made a piece of artwork symbolizing that travesty. That's how you newsjack with your art.

- Use lots of testimonials from your customers and collectors as soon as you get them. Post them on your social media pages and website. How do you get these testimonials? You ask for them as I do at the back of this book.

- Once again, always measure any marketing efforts that you spend money on.

TRADEMARK YOUR BRAND IMAGES

Most of you understand that your drawings, paintings, and/or sculptures are copyright protectable. But you could (and should) trademark your brand's name and logo. You should do it on the federal level, so it has the most reach. In the Artists & the Law chapter, I talk about both intellectual property laws. For more information about how to trademark your brand's name and logo, be sure to write for your free booklet, *Protecting Your Trademark*, at:

Commissioner for Trademarks
PO Box 1451
Alexandria, VA 22313-1451

AMAZON-SPONSORED BRANDS

Amazon.com has become the de facto leader in e-commerce. More people search for products on Amazon than on any other website. Think art is any different? Think again. In *How to Sell Your Art Online*, Cory Huff says that in 2015, Amazon had over 2,300 paintings listed at $10,000.00 or more. Were any of those yours? You need to get on Amazon. I know firsthand the power of Amazon because every three months I get royalty checks from Amazon based on my book sales. To take advantage of the Amazon marketing platform you need to enroll in the Amazon Brand Registry. You can do that after you register your trademarked intellectual property and own your brand. That way you can lock it down on Amazon so no one can alter it. Once you enroll in the Amazon Brand Registry, you'll get access to Enhanced Brand Content, Amazon Stores, and Sponsored Brands. These programs could take you and your art to a whole new level. There is so much to this that I urge you to get and read the following book, *Ultimate Guide to Amazon Advertising* by Timothy P. Seward.

> *"Optimizing your brand on the Amazon Advertising platform has never been more critical in today's marketplace."*
> *– Patrice Fontaine Nealon*

A FINAL THOUGHT ABOUT BRAND

The reason, I put this chapter way back in this book is because building a brand is not that important. If you just practice good business etiquette, do smart, measured marketing, and put out quality products you'll stand out. Cater to your ideal customers and collectors. Let them spread the word about your art or your craft line. Remember the tips in this chapter when you first start. But don't worry about the brand as much as Coca-Cola or McDonald's does. And you don't want to market as they do. You can't afford to. Use the rest of this book to become a *Prison Picasso*.

RESOURCE BOX

There are hundreds of books that talk about branding, but here are my favorites that I highly recommend:

- *Build Your Own Brand* by Robin Landa
- *Billion Dollar Brand Club* by Lawrence Ingrassia
- *Celebrity Branding You* by Nick Nanton & J. W. Dicks
- *No B.S. Guide to Brand-Building by Direct Response* by Dan S. Kennedy with Forrest Walden & Jim Cauale
- The 22 Immutable Laws of Branding by Al and Laura Ries

> *"The only purpose of advertising is to make sales. It is profitable or unprofitable according to its actual sales. It is not for general effect. It is not to keep your name before the people . . . Treat it as a salesman. Force it to justify itself. Compare it with other salesmen. Figure its cost and result. Accept no excuses, which good salesmen do not make. Then you will not go far wrong. Take the opinion of nobody who knows nothing about his returns."*
> *– Claude Hopkins*

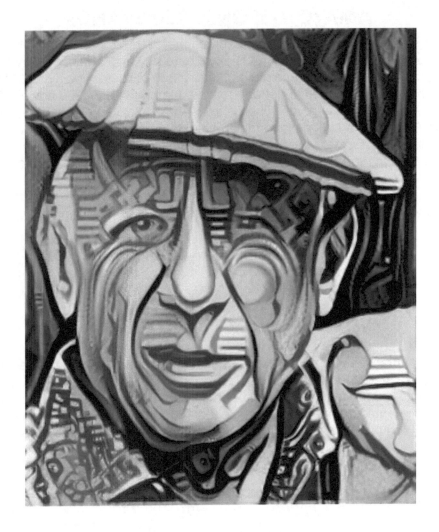

"Others have seen what is and asked why. I have seen what could be and asked why not."
— Pablo Picasso

"Only put off until tomorrow what you are willing to die having left undone"
— Pablo Picasso

"Inspiration exists, but it has to find you working."
— Pablo Picasso

"The meaning of life is to find your gift. The purpose of life is to give it away."
— Pablo Picasso

CHAPTER 28

YOUR OWN ART BUSINESS

"Even though business is often the last thing an artist thinks about, artists who want to make a living selling art should understand that they are running a business."
– Cory Huff

In The Millionaire Prisoner, I ask a question, "Why to rob a bank when you can own one?" That question hits home for me. I have an identical twin brother who did 14 years in the fed joint for bank robbery. Then he got out and became a serial bank robber in the Midwest. Now he's doing 40 years and facing more federal time. I wish he could have learned another way. One prisoner who did was Felix Dennis. He went inside over the censorship of one of his magazines. He went from being, in his own words, "a hippie dropout on welfare, living in a room without money to pay rent, to being rich." How rich? He is a billionaire rich and listed on the Top 100 of Britain's wealth. He did it without a college degree or any capital. He vowed to never go back to prison. His company, Dennis Publishing, owns magazines like *Stuff, Computer Shopper,* and *Maxim*. His book, *How to Get Rich*, is a must-read for anyone desiring to get rich. One of the best principles that I learned from Felix Dennis is that the owner is the one that gets rich. In this chapter, I'll show you how to be the owner and give you some tips when running your own art business.

OWNERSHIP IS EVERYTHING

Years ago, when I first came to prison, I played parlay tickets. I would put up a dollar, pick four football teams, and win 10 to 12 times my money. Most of you know what a parlay ticket is. I would win here and there. But I soon realized that the guy who was making the most money was the man who ran the parlay ticket business. So, I became a partner with him, learned how he did it, then started my own parlay business. I learned a valuable lesson in those days that has only been reinforced over the years. Only the owner gets rich!

"Never be a minion, always be an owner."
– Cornelius Vanderbilt

Just like my books are intellectual property, so are your paintings, drawings, sculptures, and craft items. Used right, they are assets that can appreciate and bring forth royalties in your future. But that means you keep control of them so that you can profit from them. You can see it in the music business all the time. An artist has a hit song and his sales go through the roof, but he stays broke. Why? Because whatever contract he signed was a bad one. He doesn't own and controls the masters, the rights to his songs. (If he does, and doesn't have any money, that means he has bad money management skills!) So, rule number one for you is to try and keep control of all the rights to your art.

"If you don't own your masters, your master owns you."
– Prince

307 SHOP ANTIQUE STORE

I was around a small business when I was a kid. My grandpa owned a 307 Shop. It was an antique store that started at 307 Main St., then moved to Madison Square in Danville, Illinois. When I used to get suspended from school, I was sent to the shop to spend time with my grandparents. It was a whole lot more fun than school because I got to watch my grandpa run a business. I went with him to the auctions and suppliers to get products. I watched him hustle out of the back rooms. Sadly, he passed away when I was 13 years old in 1991. My grandma couldn't run the store by herself, and it was sold. Here I am, over 30 years later, and those lessons I learned besides my grandpa are still influencing me. I'll share some of them with you so can have your successful art or craft business.

STARTING A BUSINESS FROM A PRISON CELL

When I first started my writing career, I wanted to keep control of all my books. To do that properly, I knew I had to open my own publishing business. The first one I started was with my mom. It was called O'Barnett Publishing in honor of my grandpa, Walter Barnett. She couldn't continue it

because she got sick, so I moved things to a partner. Then I started Carceral Wealth through Prisoner Assistant, Inc. I published my first book myself from a maximum-security prison cell. Unfortunately for a lot of us that had accounts through Prisoner Assistant, it didn't last. The owner, Michael Benanti, started robbing banks and that was the end of that. (I tell the full story about him and Prisoner Assistant in my book, *Cellpreneur*, if you want to read more.) All of this is proof that you can start a business from a prison cell. Most experts say that if you start making at least $2,500.00 a year from your arts and crafts, you should probably have a separate bank account and credit card. There are several ways to do this while you're inside. One possibility is to use a family member or loved one. Another is to use a prisoner service business. The only one that I can vouch for in that regard is Help from Outside. I used them for a few years after Prisoner Assistant shut down and had no problems. No matter who you choose, they will need to open a bank account, rent a PO Box and forward the mail. You should sign a Limited Power of Attorney giving them the right to do this in your name. On the next page is a sample you can use. A lot of artists and crafters are now using a Limited Liability Company (LLC) to protect themselves. I like an LLC over a corporation because you don't have to keep all the normal meeting records and bookkeeping paperwork. In my book *Cellpreneur*, I give you all the forms you need to start an LLC as well as a corporation. You can start a business from a prison cell. I'm living proof of that fact.

THE PERFECT BALANCING ACT

Art business mentor Cory Huff says that you should spend 50% of your time on your art and 50% of your time on marketing your art. That's a good idea. But at first, I believe you should be prolific in your art/craft. Why? For one, you need to get the experience of working faster and putting out products, because without arts or crafts you will not have any collectors or customers. Second, you need a lot of pieces out on the market, so you get the experience of all the ins and outs of running the business side of things. How many pieces should you have? I'll let Kim Solga of sellingartsandcraftsonline.com tell you:

> "If you can assemble fifty or more excellent pieces, both small and large, you will gain the practice you need to begin production on a commercial level. You will know how long each piece takes to create, and what the materials will cost when purchased in quantity. Most importantly, you will be able to open your website or marketplace shop with sufficient items to become professional and provide a variety of choices for your early customers."

So, my question for you is this: do you have those fifty base pieces yet? She is right. Once you get it up and running you will learn so much about the business side of things. Before I self-published my first book in 2014, I read a lot of publishing books. Those books kind of prepared me for what was to come. But there was nothing like getting in the field and making book sales, having to fill orders, getting royalty checks from Amazon, and dealing with it all from a prison cell. I'm not telling you this to scare you off your dream, only to tell you that it's okay to go slow, build up your inventory and then start selling. Kim Solga said you need 120 different craft items on Etsy.com to get consistent sales. What's the gist of all this? One painting doesn't make an art business!

Limited Power of Attorney

Be it known that I, [You, the reader], the undersigned, do hereby grant a limited power of attorney to [another person], as my attorney. My attorney shall have full power and authority to undertake and perform the following on my behalf:

1. Make deposits and write checks on my account at [name of bank].

2. Form, amend and cancel limited liability companies in any state.

3. Write letters, make requests, and order and receive goods in my name.

4. Send and receive letters, instructions, and e-mails in my name.

5. Accept payments on my behalf, sell and deliver arts and crafts and other information on [subject of your business].

6. Engage in any other legitimate business on my behalf, including but not limited to the World Wide Web, and to receive payments in my name.

7. Use funds sent to me for any purpose whatsoever.

My attorney agrees to accept this appointment subject to its terms and agrees to act and perform in the said fiduciary capacity consistent with my best interests as he/she in his/her sole discretion deems advisable.

This Power of Attorney may be revoked by me at any time, provided that any person relying on this Power of Attorney shall have full rights to accept the authority of my attorney until in receipt of actual notice of revocation.

Signed this _____ day of _____, 202___.

Signature of Nominee, with name printed below

Subscribed and sworn before me on _____ _____

 Date Notary Public

PRISON PICASSO OUTSOURCING

Even if you can't handle all of the business side of things from a prison cell, you can outsource it. That way you focus on your most important skill, doing arts and crafts. Some of the people you may need to hire for help are:

- Lawyer
- Bookkeeper
- Tax Accountant
- Graphic Designer
- Virtual Assistant
- Printer
- Intern

This list is by no means exhaustive. Other stuff will come up. What you need to learn is how to delegate tasks. You need to orchestrate your overall game plan. It doesn't matter if you do everything yourself or if someone else does it. All that matters is that things get done on time and get done right. You will have noticed that in this book there's a lot you must do, and the majority of it you can't do without someone in the free world helping. For the last ten years, I have accomplished a lot using outside help. Here are some tips to remember:

- Only ask for one task to get done at a time from family or friends on business-related requests. In his great book, *Think Outside the Cell*, Joseph Robinson said to make one request and then wait a week before you request something else to be done. I never paid attention to that at first. But now I realize that it's great advice. Be patient with family and friends when outsourcing tasks to them.

- Teach them to use sites like Elance.com or Fiverr.com. Go on those websites and find the *Top 50* or *Top 100* lists. Then hire ten or twenty people to do a simple task online. Like a logo design? See who does the best work. Your family member or virtual assistant could post jobs as they are going to sleep and wake up the next day to a completed task. You hire the ones who did the best work for future jobs.

- Once you start making a nice income from your art, you need to hire a free world personal assistant (PA). That way your energy could be put into producing your art or craft and overseeing the marketing of your products. As an online marketing guru, Perry Marshall says, "A good PA will save you 30 hours per week and clear your plate for bigger, better, more lucrative opportunities."

- Never let one person have complete control over your business. I violated this rule when my twin brother got out of the feds. I felt guilty that I had an HFO account when my twin could do a better job, so I closed my HFO account and turned it over to him. That experiment ended disastrously. The only person who should have complete control over the business is you!

- The worst number in business is one: one customer, one product, one sales system. Quickly build more than one. I wish I could say this was my original thought, but I stole this from Dan Kennedy's book, *No B.S. Business Success in the New Economy*.

MINI ART MOGUL

After you get your business up and running, you want to try and move into other areas that are in line with you. Put together a book of all your art and sell that. Sell patterns and kits. Start your own gallery helping other artists and get a chop off their sales. If you're a crafter, sell in different sizes. Sell products in sets (three for the price of one). Look for other products you could sell to your customers. Start small but think big. Keep an eye out for ways to expand.

PRACTICE GREAT CUSTOMER SERVICE

Building your business will depend on how your customers and collectors feel about you. One of the most important times in a business' life is right after a sale is made. Does the customer get the product on time? Do they get a thank you e-mail? You can have your artwork and designs made into personalized stickers and labels using PsPrint.com and Vistaprint.com. Some of your early customers will buy a small item to see how your customer service is before they buy a larger, more expensive item. So, treat all customers like they could become VIP's! Here are some more tips:

- Always communicate with your customers and collectors. Your business cards should have your name, business name, website, social media URLs and e-mail address. Your e-mails should be answered as soon as possible. You can set up e-mail auto-responses that will immediately reply.

- Wherever you sell whether online or a brick-and-mortar store, make sure your return policy is written down and posted for all to see. Stand by your policy.

- Listen to your customers. Pay attention to any complaints that keep coming up. That is an opportunity for you to solve a problem and demonstrate that you care about your business and your customers.

- Don't immediately offer refunds. Ask to repair an item or swap it out for another piece. But don't violate your written return/refund policy and don't let customers take advantage of you.

- Once you start selling very expensive pieces of art or handcrafted items, then you should take care of shipping charges to the customer and any repairs. That would help you turn a customer into a lifetime collector.

- Protect your art when shipping to contests, collectors, and other people. Flat pieces should be protected by foam, cardboard, bubble wrap or rolled into a cardboard tube. The more expensive the item, the better it should be protected when shipping.

- Ship using first class mail for quicker service. The U.S. Postal Service has shipping insurance that can be purchased up to $5,000.00 worth of coverage. Registered mail can be insured up to $25,000.00. Federal Express automatically ensures packages for $100 and ships art valued up to $500.00. They have 24-hour tracking, so you know where your package is at. UPS offers insurance up to $25,000.00 and has next day service to specific zip codes.

BOSTON TEA PARTY

Since the Colonial days Americans have been rebelling against paying taxes, just like our Founding Fathers who organized the Boston Tea Party. You don't have to start a revolution to try and avoid paying taxes. Becoming a Prison Picasso is not only about how much money you make, but how much you get to keep. The IRS considers someone who makes a profit three out of five years to be

running a business. Here are the criteria that the IRS uses to determine if you are running a business or just a hobby:

- The way you conduct your business
- Expectation of future profits
- History of profit and losses
- Your expertise and financial status
- Amount of time you put into your work

You may be wondering, why does it matter if the IRS considers you a hobbyist or a business owner? It matters because of the deductions. If you're labeled as a hobbyist, you can only deduct expenses on art-related income, and you won't be able to deduct a loss from other income. But if you're running a business, you get to make a lot more deductions. You can deduct all of the following:

- Advertising and marketing costs
- Brochures and business card costs
- Subscription to art/craft magazines
- Lawyer fees if it pertains to your art business
- Office supplies and equipment
- Books that you used to learn from (like this one)

And there's a whole lot more that you can deduct. Don't forget to register with your state tax department. Because this is such an important step in your business life, make sure you keep accurate records. Save all receipts for any money you spend to further your career/business. One way to do this easily is to set up an online account and pay all your business-related costs through that account. That way you would have a record of it all in one place. Most prisons keep a record of money transactions to and from a prisoner's trust fund account. You may have to use that if you're doing it all from your cell. I go a step further. I have a black composition notebook where I keep a record of all my expenses and sales and profit. I learned this from my grandpa while watching him run the 307 Shop. Of course, if I was out, I'd keep track on the computer, but I like doing it in my notebook because I can see if I'm really winning or not. And if you input all money costs or sales right after they happen, you can see where the leaks are.

You're going to put your blood, sweat and probably some tears into your products and art. Do you want to give away 40% or more to the government? I think not. Poor people call tax laws like deductions, loopholes. The rich call them tax advantages. I like having an advantage and I bet you do too. Starting your own business will give you a way to deduct all the expenses you acquire to perfect your art. Please never cheat on your taxes. But do everything in your power to legally lower your tax bill. As soon as you're able to do so, hire a good tax lawyer/accountant to help you. A good one will help make you money.

> *"The avoidance of taxes is the only intellectual pursuit that carries any reward."*
> *– John Maynard Keynes*

RESOURCE BOX

Further reading on this subject should start with the following books:

- *Doing Business Tax Free* by Robert Cooks
- *Tax Deductions for Professionals, 4th Edition* by Stephen Fishman

If you're serious about starting an art business I suggest you read the following:

- *The Business of Being an Artist* by Daniel Grant, make sure you get the latest edition
- *Start Your Own Business* by Rieva Lesonsky, et.al., make sure you get the latest edition

Contact Freebird Publishers about ordering if you don't have anyone to help you.

ONE LAST TAX TIP

If you donate your art to a charity auction you can deduct the cost of the art from taxes. There are some limits to how much you can deduct each year for charity donations, but you should consider doing this for two reasons. One is the tax deduction. Two, it is good karma, and you'll be able to highlight it on your website, blog, and social media pages. You could also use it to raise your prices if your work fetches a hefty price at auction. So, look for causes that you can donate your art to.

LOOKING FORWARD TO THE FUTURE

This book is not the be-all, end-all book on making a living with your art/crafts. I only hope to inspire you and get you to see that a lot more is possible than just settling for commissary items. I make thousands of dollars a year off my books. There's no reason why you can't do the same with your art. I seriously believe that you can do better than me. I can't sell a book for thousands of dollars. Books go for $20.00, maybe $49.95 at the most. I wish I would have paid more attention to art when I was younger. Take it seriously. Turn it into a business. Become a Prison Picasso.

"To become rich, you must be an owner. And you must try to own it all."
– Felix Dennis

CHAPTER 27

CONCLUSION

"On the human chessboard, all moves are possible."
– Miriam Schiff

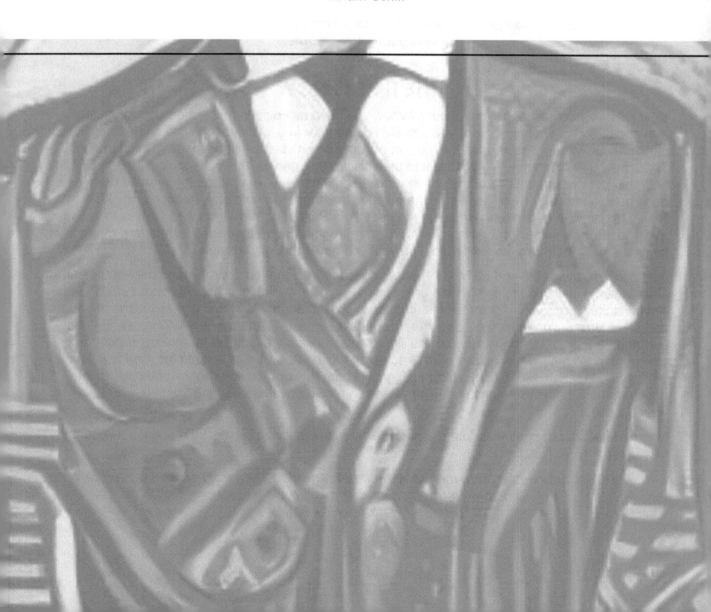

Congratulations! You've arrived at the end of *Prison Picasso*, but the real beginning of your journey is just starting. Thoreau said, "For every thousand hacking at the leaves of evil there is one striking at the root." The root for us is the attitude that brought us to prison. The root is also the American prison system. I have no political power. So, I can't influence from the outside in. But that would only be a superficial change anyway. Real change comes from within. That was, and is, the quest and vision behind the Millionaire Prisoner brand.

We need to change the prison system. We can start from the inside out. Those of us on the inside can influence those on the outside. You can join the prison reform movement by using this book to lead a productive life. Art has the ability to make people stop and take notice. When those on the outside take notice, they may start to give prisoners better opportunities. Years ago, Supreme Court Chief Justice Warren Burger said, "We must accept the reality that to confine offenders behind walls without trying to change them is an expensive folly with short-term benefits winning battles while losing the war." I do believe that America as a nation is finally taking notice. But we prisoners need to push for more change. A change with the quick fix in mind won't work. It must be a deep change from within that will enable us to succeed. Together, we can become Millionaire Prisoners. That will allow us to change the system legally. Why? Because change starts in the heart, and we are the heart of the system.

"Success for the most part attends those who act boldly, not those who weigh everything, and are slow to venture."
– Xerxes

THE TIME IS NOW

Now that we've come to the end of our journey, you have a choice to make. You can continue to arts and crafts for commissary, or you can start doing it for free-world recognition and money. You can continue to be a prison artist, or you can become an artist who just happens to be in prison. There's a huge difference. Do you want to be a jailbird or a genius? It's your choice. This book can help you get your art outside of the prison walls that confine you. But please understand that you don't have a thousand years to live. In the game of life, those who are slow to act are the losers. Now is the time to begin. Now is the time to become a Prison Picasso. Keep this book with you and use it to remind yourself that you can achieve your dreams. Share these tips with others who do not know them. By doing so, you will reap a harvest you never thought possible.

Just because this is the end of *Prison Picasso* doesn't mean that our journey together should end. Once again, I invite you to contact me or Freebird Publishers with your thoughts about this book. Any mistakes, omissions and/or failures in *Prison Picasso* are my fault and my fault alone. If you find some errors, I'd like to know about them so that I can correct them in any future, revised and updated editions of this book. Should you like to give additional examples for future editions, or if you want to tell me what you liked or disliked about this book, you may write to me, or if you have e-mail, you can reach me at: freejoshkruger@gmail.com. This book is your book. It belongs to the prisoners housed in the American gulag system, so I look forward to hearing from you, especially of your success.

May you be blessed in all your future endeavors. May you succeed against the odds. May you find true prosperity. Remember, all moves are possible!

"Make opportunities present themselves and never give up. Even from prison a person can accomplish much more than those in the outside world."
– Christopher Zoukis

SELECTED BIBLIOGRAPHY

"One could get a first-class education from a shelf of books five feet long."
– Charles Eliot, Former President of Harvard University

There are many great books that will assist you on your quest to become a Prison Picasso. These are some of the ones that were used in researching the principles and examples in this book. Any prisoner wishing to conduct research further would have a great start by utilizing this list. They are listed in alphabetical order of their titles and not by order of importance.

Art in America: Annual Guide to Galleries, Museums, Artists

Art, Inc. by Lisa Congdon

Art Law Conversations by Elizabeth T. Russell

Art Law, 4th Edition by Ralph E. Lerner and Judith Bresler

Art Law in a Nutshell, 4th Edition by Leonard D. Dubuff and Christy King

Art Without Compromise by Wendy Richmond

Beware the Naked Man Who Offers You His Shirt by Harvey Mackay

Business and Legal Forms for Fine Artists, Third Edition by Tad Crawford

Buzz Marketing: Get People to Talk About Your Stuff by Mark Hughes

Create Your Art Career by Rhonda Schaller

Dig Your Well Before You're Thirsty by Harvey Mackay

Facebooking Marketing: An Hour a Day by Mari Smith

Fine Art Publicity Guide, 2nd Edition by Susan Abbott

Guide to Getting Arts Grants by Ellen Liberatori

How to Get Control of Your Time and Your Life by Alan Lakein

How to Grow as an Artist by Daniel Grant

How to Sell Your Art Online by Cory Huff

How to Sell Yourself by Joe Girard

How to Promote Art by Jenny Bruckman

How to Start and Run a Commercial Art Gallery by Edward Winkleman

How to Survive & Prosper as an Artist by Carol Michels

How to Talk to Anybody about Anything, 3rd Edition by Leil Lowndes

How to Think Like Leonardo da Vinci by Michael J. Gelb

How to Win Friends and Influence People by Dale Carnegie

Legal Guide for the Visual Artist, Fifth Edition by Tad Crawford

Letters to a Young Artist by Anna Deavere Smith

Licensing Art and Design by Caryn R. Leland

Making a Living in Crafts by Donald Clark

Make Art Make Money by Elizabeth Hyde Stevens

Making it in the Art World by Brainard Carey

Marking Time: Art in the Age of Mass Incarceration by Nicole Fleetwood

New Markets for Artists by Brainard Carey

Open Your Mind to Prosperity by Catherine Ponder

Real Artists Don't Starve by Jeff Goins

Secrets of Mind Power by Harry Lorayne

Selling Art Without Galleries by Daniel Grant

Show Your Work! by Austin Kleon

Starting Your Career as an Artist by Angie Wojak & Stacy Miller

Steal Like an Artist by Austin Kleon

Swim with the Sharks without Being Eaten Alive by Harvey Mackay

The Artist's Complete Health and Safety Guide, Third Edition by Monoma Rossal

The Artist – Gallery Partnership, 3rd Edition by Tad Crawford & Susan Mellon

The Artist's Guide to Public Art by Lynn Basa

The Business of Being an Artist, Fourth Edition, by Daniel Grant

The Complete Idiot's Guide to Guerrilla Marketing by Susan Drake & Colleen Wells

The 8th Habit: From Effectiveness to Greatness by Steven R. Covey

The Everything Guide to Selling Arts & Crafts Online by Kim Solga

The Fine Artist's Career Guide by Daniel Grant

The Gift by Helen McCarthy

The Greatest Salesman in the World by Og Mandino

The Lives of Artists by Giorgio Vasari

The Path of Prosperity by James Allen

The Philosophy of Andy Warhol by Andy Warhol

The Profitable Artist by Artspire

The $12 Million Stuffed Shark by Don Thompson

The War of Art by Steven Pressfield

The Wealth of Michel Angelo by Rab Hatfield

The Wealth of Art by Judith Benhamon-Hurt

Why Are Artists Poor? by Hans Abbing

You are What You Think by Doug Hooper

Your Magic Power to be Rich by Napoleon Hill

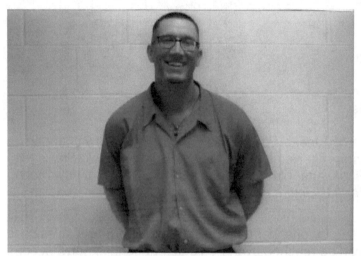

Josh Kruger is the Millionaire Prisoner, a Cellpreneur, author, and leading authority on how prisoners can live productive and happy lives by thinking outside the cell, networking, and breaking down carceral barriers.

He and his work have been seen in *The Commercial News*, *The News-Gazette*, *Prison Legal News*, *Kite Magazine*, *Straight Stuntin*, *Inmate Shopper*, *The Best Resource Guide for Prisoners*, *Conscious County Courier,* and others.

In 1999, Josh was arrested for felony murder, home invasion, and robbery. He refused to turn State's evidence against his co-defendant in return for a 20-year sentence. At the subsequent 2000 bench trial, he received a directed verdict of acquittal when the state of Illinois refused to participate in an evidence dispute. Josh was released but eventually rearrested after the State successfully got the not guilty verdict vacated on appeal. See *People v. Kruger*, 327 Ill. App. 3d 839, 764 N.E. 2d 138 (4th Dist. Ill. 2002). At the 2003 jury trial, Josh was convicted based on a theory of accountability and sentenced to life in prison without parole. See *People v. Kruger*, 363 Ill. App. 3d 1113, 845 N.E. 2d 96 (4th Dist. Ill. 2006).

After reading several of Zig Ziglar's books, Josh reached out to the late, great motivational speaker and began corresponding with him. He adopted Ziglar's philosophy that you can have everything you want in life if you just help enough people get what they want.

Tired of depending on friends and family for support, the graduate of Crown Financial Ministries decided to leverage his extensive juvenile and adult prison experiences into a freelance writing career. In 2011, Josh launched his micro-publishing empire from his maximum-security prison cell by self-publishing two booklets, *How to Get FREE Pen Pals* and *How to Win Your Football Pool*. Prison authorities seized his property and threw him in segregation by alleging that was violating prison rules. Not to be dismayed, Josh kept going and published his first book, *The Millionaire Prisoner*. His goal was to help prisoners turn their prisons into stepping-stones to success.

A fierce defender of prisoner rights, especially those under the First Amendment, Josh has filed numerous successful lawsuits challenging prison conditions and bogus censorship practices. See *Kruger v. Boland, et.al.,* 15-CV-1261 (C.D. Ill.); *Kruger v. Pfister, et.al.*, 15-CV-1325 (C.D. Ill.); *Kruger v. Lashbrook, et.al.*, 18-CV-512 (S.D. Ill.); *Kruger v. Baldwin, et.al.*, 19-CV-268 (S.D. Ill.);

Kruger v. Baldwin, et.al., 19-MR-144 (Sangamon County Circuit Court, Ill.); *Kruger v. State,* 18-CC-2903 (Ill. Ct. Cl.); *Kruger v. State*, 15-CC-963 (Ill. Ct. Cl.); and *Kruger v. Lashbrook,* 20-CV-24 (S.D. Ill.). He believes that prisoners should have the same rights extended to them that free world people have, and that the protection afforded by the Constitution does not end at the prison gates.

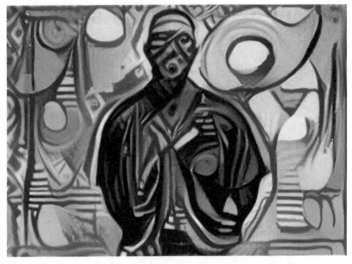

It took Josh only 30 days to write his second book, *Pen Pal Success,* based on his personal experiences from behind the iron veil of prison. After the success of both of his books, a lot of prisoners started asking him how he did it. So, he wrote, *Cellpreneur: The Millionaire Prisoner's Guidebook*, to show prisoners how to legally start a business from their prison cell. He also compiled *Celebrity Female Star Power: The Millionaire Prisoner's Address Book*, after his cellmate, JuBoy, showed him how much prisoners love celebrities. His latest book, *The Millionaire Prisoner 3: Success University* has just been released by The Cell Block.

Josh has vowed to never stop writing or fighting for prisoner rights and prison reform. His mission is to change lives, one prisoner at a time. He can be reached by the GTL app at connectnetwork.com, or by snail mail at:

Josh Kruger
620 Sager St.
Danville, IL 61832
freejoshkruger@gmail.com
Facebook.com/millionaireprisoner

OTHER TITLES BY JOSH KRUGER:

Cellpreneur
Wish you could start a legitimate business from your cell? And not violate your prison rules?

Celebrity Female Star Power
Want to contact your favorite female celebrity? This book will show you how!

Pen Pal Success
The ultimate guide to getting and keeping pen pals.

Available for purchase at Amazon.com and Freebirdpublishers.com

From Josh Kruger

To: His Millionaire Prisoner Friends and Colleagues

We want to help you make your prison stay more profitable, and more organized. Let us! Take a minute –right now – to fill out the questionnaire below. Send this form back to us and we promise to work on helping you achieve what you need.

Reader Survey/Questionnaire

1. Why did you purchase/read a copy of *Prison Picasso?*

2. How did you learn about *Prison Picasso?*_____

3. What other prisoner-related books have you purchased/read in the last 6 months or year?

4. What did you like best about *Prison Picasso?*_____

5. What did you dislike about *Prison Picasso?*_____

6. What can you suggest to make *Prison Picasso* better?_____

7. Would you recommend *Prison Picasso* to your friends, and, if so, why?_____

Name: _____

State: _____

Signature: _____

By signing this questionnaire, you give Josh Kruger the right to use your testimonial and/or words above in his future books or ads. Thank you in advance for your cooperation.

Please return this to:

Josh Kruger
620 Sager St.
Danville, IL 61832

WE NEED YOUR REVIEWS

Rate Us & Win!

We do monthly drawings for a FREE copy of one of our publications. Just have your loved one rate any Freebird Publishers book on Amazon and then send us a quick e-mail with your name, inmate number, and institution address and you could win a FREE book.

FREEBIRD PUBLISHERS
Box 541
North Dighton, MA 02764

www.freebirdpublishers.com
Diane@FreebirdPublishers.com

Thanks for your interest in Freebird Publishers!

We value our customers and would love to hear from you! Reviews are an important part in bringing you quality publications. We love hearing from our readers-rather it's good or bad (though we strive for the best)!

If you could take the time to review/rate any publication you've purchased with Freebird Publishers we would appreciate it!

If your loved one uses Amazon, have them post your review on the books you've read. This will help us tremendously, in providing future publications that are even more useful to our readers and growing our business.

Amazon works off of a 5 star rating system. When having your loved one rate us be sure to give them your chosen star number as well as a written review. Though written reviews aren't required, we truly appreciate hearing from you.

⭐⭐⭐⭐⭐ **Everything a prisoner needs is available in this book.**

A necessary reference book for anyone in prison today. This book has everything an inmate needs to keep in touch with the outside world on their own from inside their prison cell. Inmate Shopper's business directory provides complete contact information on hundreds of resources for inmate services and rates the companies listed too! The book has even more to offer, contains numerous sections that have everything from educational, criminal justice, reentry, LGBT, entertainment, sports schedules and more. The best thing is each issue has all new content and updates to keep the inmate informed on todays changes. We recommend everybody that knows anyone in prison to send them a copy, they will thank you.

* No purchase neccessary. Reviews are not required for drawing entry. Void where prohibited.
 Contest date runs July 1 - June 30, 2019.

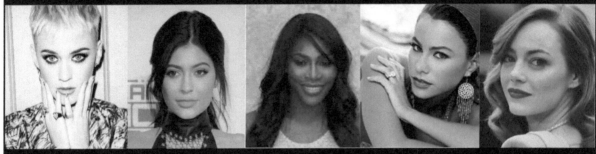

Made in United States
Troutdale, OR
07/20/2024

21400209R00184